The Culture of Efficiency

Steve Jones
General Editor

Vol. 55

PETER LANG
New York • Washington, D.C./Baltimore • Bern
Frankfurt am Main • Berlin • Brussels • Vienna • Oxford

The Culture of Efficiency

Technology in Everyday Life

Edited by
Sharon Kleinman

PETER LANG
New York • Washington, D.C./Baltimore • Bern
Frankfurt am Main • Berlin • Brussels • Vienna • Oxford

Library of Congress Cataloging-in-Publication Data

The culture of efficiency: technology in everyday life / edited by Sharon Kleinman.
p. cm. — (Digital formations; v. 55)
Includes bibliographical references and index.
1. Technological innovations—Social aspects.
2. Technology—Social aspects.
I. Kleinman, Sharon.
HM846.C85 303.48'3—dc22 2009018317
ISBN 978-1-4331-0421-3 (hardcover)
ISBN 978-1-4331-0420-6 (paperback)
ISSN 1526-3169

Bibliographic information published by **Die Deutsche Bibliothek**.
Die Deutsche Bibliothek lists this publication in the "Deutsche
Nationalbibliografie"; detailed bibliographic data is available
on the Internet at http://dnb.ddb.de/.

Cover design by Jean Galli

The paper in this book meets the guidelines for permanence and durability
of the Committee on Production Guidelines for Book Longevity
of the Council of Library Resources.

© 2009 Peter Lang Publishing, Inc., New York
29 Broadway, 18th floor, New York, NY 10006
www.peterlang.com

All rights reserved.
Reprint or reproduction, even partially, in all forms such as microfilm,
xerography, microfiche, microcard, and offset strictly prohibited.

Printed in the United States of America

*Dedicated with love
and admiration to my parents,
Arthur R. Kleinman (1926–2008)
and Elaine Caplan Kleinman*

Table of Contents

Acknowledgments xi
Introduction xiii
 Sharon Kleinman

▶ **Part 1: Birth Eat Connect**

 1. Efficiencies of Pregnancy Management:
 From Penciling in Pregnancy to Elective C-Sections 3
 Suzy D'Enbeau and Patrice M. Buzzanell

 2. From Taylor to Just-in-Time Sustainability:
 A Short History of Efficient Eating 20
 Yvonne Houy

 3. Hyping the Efficiencies of Fast(er) Food:
 The Glocalization of McDonald's Snack Wrap in Japan 39
 Michael L. Maynard

4. Efficiency, Effectiveness, and Web 2.0 51
Nathan Jurgenson and George Ritzer

Part 2: Work Play Rest

5. Clocks, Synchronization, and the Fate of Leisure: A Brief Media Ecological History of Digital Technologies 71
Corey Anton

6. No Punctuation: Searching for an Architecture of Time in the Culture of Efficiency 88
Brenda L. Berkelaar

7. Varieties of Efficiency: How Automatic Asset Tracking Changes the Way Businesses Work 106
Mickey Brazeal

8. Profiling the Likelihood of Success of Electronic Medical Records 124
J. David Johnson

9. The Multitasking of Entertainment 142
Daniel G. McDonald and Jingbo Meng

10. Rethinking Access: Why Technology Isn't the Only Answer 158
Dominika Bednarska

Part 3: Speed Multitask Displace

11. E-tymology of Inefficiency: How the Business World Colonized Academe 173
Michael Bugeja

12. Mobile Learning in the Digital Age: A Clash of Cultures? 191
Letizia Caronia and André H. Caron

13. Procrustean Pedagogy: The Architecture of Efficiency in a New Medium 212
Julian Kilker

14. Stalking Made Easy: How Information and Communication Technologies Are Influencing the Way People Monitor and Harass One Another 230
Penny A. Leisring

15. The Politics of Disaster: Crises, Communication, and Marginalization in the United States 245
Mikaela L. Marlow and Howard Giles

Table of Contents

16. Efficiency Techniques in Journalistic Practice, Scientific Rigor, and Religious Rhetoric 266
 Gene Burd

▸ **Part 4: Balance Breathe Renew**

17. Mind over Multitasking: What Would Buddha Do? 285
 Peg Oliveira

18. Transportation Transformation 300
 Holly Parker

19. The Future Starts at 5:00 312
 David F. Donnelly

20. Whither Boundaries? The Internet and the Blurring of Work and Personal Life 322
 Mark E. Hoffman and Carrie A. Bulger

21. A Technologically Gendered Paradox of Efficiency: Caring More About Work While Working in More Care 339
 Annis G. Golden

Conclusion: Win-Win Sustainability in the Culture of Efficiency 355
 Sharon Kleinman

Afterword: Reflections 359
 Jarice Hanson

About the Contributors 365
Index 375

Acknowledgments

I thank the chapter authors for their absolutely exceptional contributions and Jarice Hanson for the insightful afterword that puts the perfect fine point on this volume.

I am grateful to Steve Jones, Mary Savigar, Patricia Mulrane, Bernadette Shade, Sophie Appel, Valerie Best, and the entire staff at Peter Lang for their guidance and support for this project.

I also appreciate the wonderful support from my colleagues at Quinnipiac University. Special thanks to David Donnelly, Edward Kavanagh, Mark Thompson, John Lahey, Jean Husted, Kathleen McCourt, Cynthia Gallatin, Michele A. Moore, Jennifer Burns, Danielle Reinhart, Rich Hanley, John Gourlie, Grace Levine, Larry Levine, Raymond Foery, Liam O'Brien, Margarita Diaz, Paul Janensch, Thomas Gillespie, Alexander Halavais, Ewa Callahan, Kent Golden, Karin Schwanbeck, Bill Schwanbeck, Vicki Todd, Robin D'Errico, Brian Salerno, John W. Morgan, Janet Waldman, Angela Mattie, Janice Ammons, Charles Brooks, Jonathan Blake, Lynne Hodgson, Michele

Hoffnung, Janet Valeski, Robert Young, Sheila Pallatto, June DeGennaro, Frances P. Kelly, Carol Marro, Angela Bird, Barbara Baker, Aileen Moran, Kathy Cooke, David Valone, Jill Fehleison, and Bernard Grindel.

Jean Galli designed the compelling cover and drew the playful illustrations that mark the four parts of this book.

Ellis Perlswig, M.D., Heidi Sormaz, Scott Abbott, Lauren Erardi, Frances Rowe, Ti Badri, Angela Anderson, M.D., and Nathalie Durand reviewed chapters, sharing their enormous expertise.

Erica Viviani and Katherine Chacon, my graduate research assistants, provided superb research and editorial assistance.

I thank the staff and regulars of two landmark New Haven cafes, Lulu's and Koffee, for the conversations and caffeine that greatly aided my writing and editing.

I thank my students for their terrific insights about living in the culture of efficiency.

I am grateful to my amazing family, Arthur R. Kleinman, Elaine Caplan Kleinman, Yale Asbell, Audrey Asbell, Sara Asbell, Bertram Bradley, and Bernice Bradley, and my fantastic friends, Joan Bombalicki, James Williams, Katie Tranzillo, Jerry Saladyga, Daniel Pardy, Mary Mayer, Nancy Meyer-Lustman, Tucker Sweitzer, Jerry Boryca, Theo Forbath, Diane Bauer, Harvey Jassem, Cameron Staples, Donna Staples, Alex Heonis, Nita Maihle, Jennifer Jacobs, Dena Miller, M.D., Mary Zihal, and Colleen Sexton, for their love and tremendous support.

Finally, I thank the community at Fresh Yoga in New Haven for inspiring me, again and again, to balance, breathe, and renew. Namaste.

Sharon Kleinman
New Haven, Connecticut

Introduction

▶ SHARON KLEINMAN

The Culture of Efficiency: Technology in Everyday Life was inspired by a fascination with innovations and the desire to learn more about how we can promote environmental, societal, and human health long-term—that is, sustainability. This book builds on concepts addressed in *Displacing Place: Mobile Communication in the Twenty-first Century,* my recent edited collection (Kleinman, 2007). *Displacing Place* focuses on the portable technologies that connect us to people, information, and entertainment anytime and anywhere—cell phones, global positioning systems, laptop and handheld computers, digital media players, and more—showing their extensive, often unforeseen uses and impacts. *The Culture of Efficiency,* in comparison, examines a much broader array of efficiency-oriented technologies and practices and their implications for individuals, organizations, society, and the environment.

In *The Culture of Efficiency,* 28 distinguished experts from the United States, Canada, Italy, Poland, Germany, and China explore what it means

to live in this era in which activities are quantified down to the nanosecond—a billionth of a second—and what it means to work, play, teach, learn, parent, give care, communicate, create, rest, and love within cultures of efficiency—contexts in which the optimization of time and resources is emphasized. With extraordinary perspective and unflinching candor, the authors show how people are innovatively using the latest technologies to manage and transform fundamental aspects of life literally from conception onward and the surprising benefits and outcomes.

Life Cycle in the Culture of Efficiency

The Culture of Efficiency is divided into four parts that follow a life cycle structure, beginning with conception and ending with renewal. It provides readers with important sociological and historical contextualization and analysis in a balance of theoretical and empirical chapters that build upon, cross-reference, and inform one another. The chapters are accessible, stand-alone essays that can also be appreciated fully when read individually or nonsequentially.

Reflecting the broad scope of this project and the extensive expertise brought together in this volume, the authors draw on numerous analytical frameworks as they address specific aspects of the digital age from their distinct perspectives. Combined, these analyses offer a rich interpretation of the meanings of living in a culture of efficiency.

In Part One: Birth Eat Connect, the first four chapters show how the essentials of life have changed dramatically.

In Part Two: Work Play Rest, the next six chapters look at the far-reaching economic and social impacts of older technologies, such as the clock, and leading-edge technologies, such as radio frequency identification tags used for asset tracking.

In Part Three: Speed Multitask Displace, the following six chapters expose myths, misconceptions, and unintended outcomes of contemporary quests for greater efficiency and effectiveness in vital domains: higher education, interpersonal communication, risk and disaster management, and journalism.

In Part Four: Balance Breathe Renew, the last five chapters explore strategies for sustainably managing everyday life and offer forecasts about the future of work, transportation, and leisure.

Part One: Birth Eat Connect

Suzy D'Enbeau and **Patrice M. Buzzanell** begin at the beginning, conception, focusing on the complications of fertility, workplace pregnancy, and

elective C-section in their astute analysis of the knotty intersections of work, gender, medicine, and technology.

Yvonne Houy presents a short history of another of life's essentials—eating. From 1920s "Taylorized" kitchens for efficient cooking (Taylor, 1911) to today's open kitchen for efficient socializing, the evolving design of kitchens, optimization of mass food delivery for rapid at-home or on-the-go eating, peddling of ever-changing efficiency-promising cooking products, and chatter of celebrity cooks on television all promise to solve a central problem of modern life: how to nutritiously feed the body while keeping up with other demands on our time. Houy addresses the critical challenge of our era regarding efficient eating: what does responsible efficiency mean amid growing concerns about global warming and diminishing natural resources?

Michael L. Maynard draws on George Ritzer's (1998) McDonaldization thesis in a perceptive and witty examination of an advertisement for McDonald's Snack Wrap in Japan. The low-calorie, eat-and-go Snack Wrap embodies the values of the nonstop 24/7 fast(er) lifestyle, a paradigm shift away from three square meals and toward smaller portions throughout the day. The Snack Wrap is advertised as having the benefits of portability, "you need just one hand to eat it," and multitasking, "you can eat it while text messaging."

Nathan Jurgenson and **George Ritzer** present a groundbreaking analysis of the paradigm shift that has occurred on the Internet with respect to production. Users are increasingly not only the consumers of material on the Internet but also the producers. This bottom-up turn taken by the Web marks the era of user production, which has brought an explosion of technologies facilitating online content prosumption. A global, immaterial world characterized by an abundance of virtually everything imaginable has been created. With virtually unlimited resources and personnel, Web 2.0 concentrates less on efficiency in favor of developing that which is effective, regardless of how many people, how much time, or how many resources are employed. Jurgenson and Ritzer discuss exemplars of this process, including Wikipedia, Facebook, and Second Life, all of which consume enormous amounts of time and energy as users create and edit cultural products and self-performance in a highly effective manner.

Part Two: Work Play Rest

Corey Anton contextualizes digital technologies, including the World Wide Web, cell phones, and social networking sites such as MySpace, Facebook, and YouTube, showing how they are part of a grand dialectic, a counterbalance to the massive straitjacket imposed within the past 200 years: synchronized objective time. Anton reviews how time became increasingly objectified

and commercialized and exposes the social and psychological consequences of the synchronicity demands imposed by objective time. He argues that emerging digital technologies promise, but fail to deliver, a more leisured environment; the digital age offers a world of increasingly flexible but progressively more commercialized time.

Brenda L. Berkelaar shows how in response to profound time pressure and stress some individuals and groups are adopting and co-opting spiritual practices to resist the influence of information and communication technologies. The rhythms and practices of traditional religions, including Sabbath rest and fasting, are being reworked to accomplish goals seemingly outside of traditional religious purposes, and they are being employed by people with and without formal religious affiliations. Conversely, members of some religious groups are using the same technologies to better fulfill their commitment to the temporal rhythms of their religions. Berkelaar sensitively and insightfully interprets what engagements and disengagements with information and communication technologies and religious practices say about contemporary life.

Mickey Brazeal illustrates how radio frequency identification tags (RFIDs) are revolutionizing customer experiences and business models. These tiny, inexpensive tags create, in effect, a search engine for things. RFID technology enables people to locate a particular item, for example, a steak or a screwdriver, and track where it is in real time. Brazeal details the second layer of functionality that is added when the tags carry sensors that report on the condition of things in real time. Sensors can report simple measurements, such as temperature and radiation, as well as complex events, including heart arrhythmias, epileptic seizures, and food freshness. This new visibility transforms processes because it shows what is actually happening, rather than what someone, such as a manager or physician, deduces is taking place.

J. David Johnson tackles a critical efficiency issue on the U.S. national agenda—healthcare. There are growing concerns about healthcare quality, skyrocketing costs, the responsiveness of the public health system to emergencies, and whether services are provided in such a way that people can learn from past practices in order to continuously improve. Johnson analyzes electronic medical records as a potential solution to these and other healthcare challenges.

Daniel G. McDonald and **Jingbo Meng** trace the history of entertainment multitasking in order to make sense of contemporary entertainment trends. They explore fascinating contradictory developments, such as the simultaneous diffusion of huge, high-definition televisions and handheld, low-definition video devices, which are used to enjoy the same content.

Introduction xvii

Dominika Bednarska focuses on the impact of technology on people with disabilities, especially those with sensory impairments. While acknowledging the benefits of technological developments, she argues that technological solutions often fail to address other accommodation issues. In other words, technology is not always a desirable or viable substitute for human assistance. Moreover, technological solutions often exacerbate the need for everyone, disabled or not, to function under increased time pressure, which leaves people with disabilities, who often have an alternate relationship to time regardless of technology, even more outside of normative time structures. Bednarska brings to light controversial issues that need to be thoughtfully addressed to promote a society that is accessible on multiple levels and inclusive of people with disabilities.

Part Three: Speed Multitask Displace

Michael Bugeja exposes higher education's insatiable appetite for technology to deliver efficiency at the expense—monetary and human—of standards that have withstood historical upheavals. He boldly advocates for a new pedagogy that instills in students the sense of transformation and commitment they will need in order to address today's complex global problems.

Letizia Caronia and **André H. Caron** contrast the efficiency-oriented culture of education in schools that promotes mobile learning with students' own culture of education. They report startling findings from their pioneering study of Canadian students in which they gained access to students' ways of interpreting and resisting the mobile turn in education.

Julian Kilker explains why proponents of online educational environments assert that they provide efficient education that benefits students, instructors, and learning institutions even though many of these environments provide relatively inefficient and unsophisticated user experiences, particularly for instructors, when compared to related new media and physical architectural environments. In this case study, Kilker discloses limitations of online educational environments that are typically under-addressed.

Penny A. Leisring reveals that stalking with technology (cyberstalking) is surprisingly common, especially on college campuses, and that most cyberstalking is perpetrated by people who know their victims. Perpetrators may send repeated e-mails or text messages, or constantly phone their victims. Some monitor their victims' activities by reading their e-mails, away messages, and postings to sites like Facebook. Some use global positioning systems to track their victims' whereabouts and computer spyware to monitor their Web activity and computer keystrokes. Leisring details the most common types of cyberstalking, explains the characteristics of stalkers, and

examines the effects on victims. She also provides suggestions for how individuals can reduce their likelihood of being stalked.

Mikaela L. Marlow and **Howard Giles** bring to light the unconscionable communicative exclusion of the disabled, non-English speaking, and other marginalized social groups during disasters in the U.S. such as September 11, 2001, and Hurricane Katrina in 2005. They present valuable strategies for improving the efficiency and effectiveness of risk and crisis communication.

Gene Burd addresses the striking changes in how journalism is taught, practiced, and perceived today as compared to the way it was in previous generations. He highlights the negative consequences of promoting technology and technique as panaceas for journalists.

Part Four: Balance Breathe Renew

Peg Oliveira explains that while being mindful is often understood as the antithesis of multitasking, it is actually a means for focusing attention on in-the-moment experiences. In the culture of efficiency, why are so many people turning to meditation and mindfulness training? Are they running away from the incessant, frenetic toggling of the mind they have been convinced is their only hope for meeting demands for efficiency? Or, ironically, could training the mind to be mindful provide a backdoor entrée into better multitasking?

Holly Parker addresses the matter of sustainable transportation, noting that the pedestrian and bicycle are the original zero-emission transportation technologies. The horse, as well as other beasts of burden used to transport humans, generated emissions that degraded the quality of life in cities. When the Model T car arrived on the scene, it was viewed as a hygienic improvement! Parker asserts that because it is now known that car emissions adversely affect the environment and human health, we must advance technologies that transport people sustainably, acknowledging that feet and bicycles cannot always move individuals the required distances and with appropriate velocity. This forward-thinking and optimistic chapter demonstrates how technology can enhance the speed and ease of using mass transit, encourage shared car rides, and discourage drive-alone trips at times of day when demand is highest.

David F. Donnelly articulates how the accelerated pace of technological change in the twenty-first century has profoundly altered the way we appreciate what we have now as well as how we conceptualize the future. "The future is now" mind-set is influencing our dreams, fears, and creative endeavors in subtle and complex ways.

Mark E. Hoffman and **Carrie A. Bulger** tackle common fallacies about work-personal life balance and technology issues, describing how the Internet affords but does not dictate the permeability of the work-personal life boundary. Drawing on their empirical findings, they detail what the Internet means for the strength of the work-personal life boundary now and offer forecasts for the future.

Annis G. Golden teases out the multifarious impacts of information and communication technologies on work-life interrelationships in an engaging case study of employees at a global, high-tech company and their families.

In the conclusion, I synthesize the key issues addressed in the book and reflect on how our opportunities, expectations, priorities, and temporal sensibilities are changing.

In the afterword, **Jarice Hanson** offers a sage response to the complexity of concerns facing us today.

Together, the provocative essays in this book convey fresh insights about contemporary society and practical suggestions for improving everyday life that I hope will be useful for everyone living in the culture of efficiency.

References

Kleinman, S. (Ed.). (2007). *Displacing place: Mobile communication in the twenty-first century*. New York: Peter Lang.

Ritzer, G. (1998). The McDonaldization thesis: Is expansion inevitable? *International Sociology, 13*, 291–308.

Taylor, F. W. (1911). *The principles of scientific management*. New York: Harper & Brothers.

PART

1

Birth
Eat
Connect

CHAPTER 1

Efficiencies of Pregnancy Management

From Penciling in Pregnancy to Elective C-Sections

▶ SUZY D'ENBEAU & PATRICE M. BUZZANELL

> A few weeks ago I turned 30. My mom now ends her voicemail messages to me with "tick-tock, tick-tock." This morning she called me about a prophetic dream she had last night. It was about a stork. (Suzy's journal, July 2008)

While the best intentions of her mother weigh on her conscience, Suzy is reminded of the many conversations she has had with young women thinking about becoming pregnant, wondering when it can happen, and when is a good time. Patrice, too, has had pregnancy and infants foremost on her mind as so many of her doctoral advisees are pregnant. Indeed, there have been 11 pregnancies in one year in their department at Purdue University. Patrice recalls instructing a recent communication career seminar for graduate students in which one student asked—while others sat nodding in interest and agreement—when the best time was to have a baby in an academic career. The woman revealed that she felt she needed to be strategic about pregnancy decisions to maximize her chances for obtaining an academic job and, later, for promotion and tenure. She also noted that her male partner

was not having these same conversations with his employer. So she and her female graduate student colleagues had been asking faculty about the control and timing of two major deadlines—birthing babies and beginning postdoctoral academic careers—with the dual intentions of minimizing career disruptions and avoiding potential future age-related fertility problems.

Patrice recalled the words she voiced when a junior faculty member at a prestigious university said that her senior male faculty mentor adamantly proclaimed that she should not become pregnant until she had become established in her career. Patrice remembered saying, "You could wait forever to find a good time to become pregnant. The question is, what would you regret more—not having a child or not getting another publication?" These words present the decision about whether to have a child as a choice under the woman's control. Yet to equate giving birth to a child with having an academic article published is an inappropriate analogy, considering the differences in events, "objects," and timing to completion. Indeed, many academic and legal cases about managing workload, promotion, and workplace pregnancy question the timing of pregnancy and birth as if having children and scheduling when they are born are totally voluntary processes that can be regulated, with the burden resting with the childbearing woman (e.g., Esarey & Haslberger, 2007; Mock & Bruno, 1994). In this chapter, we do *not* question what it means to be a good mother or when it is "right" for an individual woman to make choices about having children or remaining childless. Instead, our goal is to challenge contemporary Western thinking about efficiencies in pregnancy management and how this thinking impacts the lives of heterosexual women and many other women in the United States.

Specifically, we question assumptions that women can control, monitor, and reshape all aspects of their own and their children's lives through technology. Moreover, we explain why eschewing the latest technologies for pregnancy management and childrearing is perceived as naïve as well as potentially damaging to one's self and one's children. As we have done in another collaborative project (Buzzanell & D'Enbeau, in press), we integrate multiple forms of academic, popular culture, and personal data and analyses in our writing to surface and problematize our subject (see MacDermid, Roy, & Zvonkovic, 2005). We present three stories, from conception to delivery, titled Penciling in Pregnancy: Women versus Biological Clocks; Monitoring Baby; and C-sections and Other Elective Surgeries. We extract some lessons at the end and construct one version of today's modern woman. As the Call for Chapters for this book stipulates, we focus on "how the latest technological advances are altering nitty-gritty aspects of everyday life; reveal how people are multitasking with technologies in a burgeoning array of contexts; and assess the benefits and implications of various technologies."

Technology and Motherhood Stories
Penciling in Pregnancy: Women versus Biological Clocks

> Some of my friends' doctors have recommended that they get pregnant sooner rather than later, as their "biological clocks" are ticking away. For my academic friends, this talk often leads to a stifling panic as we count out the days, weeks, months, and years that we have left in our programs. After you receive the Ph.D., it does not mean you are off the hook because then you have to work for tenure. Friends have strategically gotten pregnant so as to give birth in April and have the summer off. Others have attempted to openly schedule an anticipated pregnancy, only to later regret this candidness because something could go wrong, such as their body not cooperating with their day planner. (Suzy's journal, November 2007)

Although some of Suzy's and Patrice's graduate student colleagues do not have the economic resources or health insurance benefit packages to avail themselves of the most innovative reproductive technologies, other women's concern about optimal times to become pregnant can be addressed by technologies like oocyte cryopreservation (egg-freezing) and routine fertility tests. Indeed, "as more women delay marriage and child-bearing, a small but growing number are having their eggs frozen in hopes of improving their chances of having children later" (Shellenbarger, 2008, p. D1). The American Society for Reproductive Medicine (ASRM) notes that research is inconclusive about the long-term success rates of egg-freezing as well as the effects of freezing on the egg, the woman, and the baby (ASRM Practice Committee, 2007). However, some single women as well as some women on a fast career track in their 30s and 40s still pay the $9,000 to $14,000 to cover the entire elective procedure. The investment is short term, and the frozen eggs have a fixed shelf-life. Clients of one egg-freezing clinic have described the process as "empowering," and have exclaimed, "I feel truly amazing....Relieved." Clients also warn other women, "You will NEVER regret having frozen eggs...but you could very seriously regret not having preserved your eggs or participating in an egg freezing program when you had the chance" ("Extend Fertility," 2007), despite research that indicates young women who freeze eggs often never use them because they end up marrying and having children by the time they reach 35 years of age (ASRM Practice Committee, 2007). In addition, most research explores the options and choices of young, heterosexual women, leaving a gap in knowledge about older, nonheterosexual women who may elect not to marry or parent.

Those who choose not to freeze eggs can use other technologies to determine optimal pregnancy timing. Women can now test the time they have left on their biological clocks. The Pounds 179 Kit is a blood test that measures fertility hormones and is "designed to be a 'wake-up' call for women

whose fertile years are running out" (Smith, 2006, p. B1). Such tests offer new technologies that can optimize the timing of pregnancies and births around work projects (Smith, 2006), just as the woman executive having a C-section in Martin's (1990) deconstruction of a CEO's family-friendly talk about female employees' work-life balance did. In this narrative, the CEO of a large multinational corporation praised one of his female employees for scheduling her C-section around an important product launch. Martin pointed out that the employee's pregnancy was constructed as a private matter that needed to accommodate the public priorities of the corporation.

It is not simply childbearing cycles that have been subject to technological scrutiny but, as a recent *Newsweek* article reported, new technologies can predict when women will experience menopause (Raymond, 2008). Doctors are now looking more closely at the anti-Müllerian hormone (AMH), an ovarian hormone that is related to the quality and number of eggs in ovaries (Raymond, 2008; Van Disseldorp et al., 2007). Technologies associated with this hormone may be able to predict the beginning of menopause within one to two years, giving women more control over their reproductive destiny. Indeed, women can get this test so that they know how much more time they can devote to their career before they need to get serious about having children.

For those women who wait too long to have children or for those who must address issues of infertility for other reasons, there is the option of using a surrogate, when a woman "carries a child who is genetically linked to one or both" parents and who gives that child to the parent or parents after birth (Beckman & Harvey, 2005, p. 2). Advanced technologies have made this a more viable option as in-vitro fertilization procedures "now boast a 70 to 90 percent pregnancy success rate—up 40 percent in the past decade" (Ali & Kelley, 2008). However, surrogacy is not legal in all countries. In Italy, Germany, Portugal, and Sweden, the process of using a surrogate is illegal. In France, senators are working toward making it legal again, under strict rules. In Great Britain, there are strict rules. It is legal in Greece, India, Russia, Canada, and in almost all of the states in the United States ("Mères Porteuses," 2008).

While we certainly recognize the utility and value of technologies that promote women's abilities to have both family and career, we question the assumptions, reasons, and situational constraints that lead some women to employ these technologies, especially when decision-making criteria rest so heavily on a desired balance between work and nonwork lives. It is problematic that many work environments do not support women who want to successfully engage in paid work outside the home, advance their careers, and parent children simultaneously. As such, women make choices about parenting, work, and life balance in a way that privileges and accommodates,

albeit sometimes temporarily, career and workplace priorities. Women can opt for an individual (and expensive) choice to have it all via egg-freezing and fertility tests. They can pay to defer their biological clocks so they can advance on an unrelenting career timetable that is based on the life cycle of men (Buzzanell & Lucas, 2006), then find the right partner, unfreeze their eggs, and parent later in life. Or they can take a fertility test to determine if they need a "wake-up call" to tell them that they can't wait much longer to start a family. These elective reproductive technologies shape and are shaped by social norms that maintain current gender and workplace dynamics by placing much of the burden in terms of tests, procedures, and decision making on women (Johnson, 2006). Thus, these norms do not advance structural solutions to women's and men's desires to better integrate work and life.

Even for women who "pencil in pregnancy," the assumption that conception leads to a live, healthy birth underpins their career-life planning. Dominant pregnancy discourses rarely address the potential of pregnancy loss through miscarriage (loss of pregnancy before 20 weeks) and deviations from fast-track careers necessitated by premature births and sick infants. Even "how-to books of pregnancy, which themselves can be considered technologies of reproduction, typically take a woman step-by-step through a pregnancy from conception to birth without making clear that a pregnancy may end at any point along the way" (Layne, 2006, p. 125). Linda Layne argues that virtually all pregnancy how-to books and movies ignore the possibility of miscarriage and instead present a linear timeline from pregnancy to childbirth with the assumption that once conception happens, everything else will proceed according to the projected schedule. In fact, the American College of Obstetricians and Gynecologists (2005) reports that 10 to 15 percent of all pregnancies end in miscarriage. Moreover, from a career standpoint, premature or ill infants, as well as women's physiological and emotional responses to such events, can shatter the ideal worker images so carefully constructed by women using reproductive and birth technologies, because these women cannot predict when they can return to work (Buzzanell, 1994). Patrice recalls when her twins were born prematurely during her doctoral program. During her six-day labor, one faculty member called to ask when she would return to her classes because the course schedule could be disrupted. With four children born within less than four years and two very sick infants, few anticipated that Patrice would complete her degree at all, let alone in a timely fashion. To handle her worker role while on bed rest in the hospital, Patrice organized others to take care of her class by recording student presentations until she could return.

The healthy conception-pregnancy-childbirth timeline can cause distress for the mother seeking control as well as for the organization where she is

employed. Suzy recalls her peer's experience when the woman's baby was unexpectedly born four weeks early:

> The baby was due to arrive at the end of the semester when my friend's teaching load was scheduled to be covered by other teaching assistants. To everyone's surprise, the baby came early. Rather than working with the mother's teaching assignment and seeking out alternatives that could accommodate her situation, the professor she was working with attempted to take away her funding because the new mother was unable to attend all the scheduled lectures. In this situation, the early delivery inconvenienced the professor in charge of the course who, ironically, was also pregnant. (Suzy's journal, April 2008)

Patrice e-mailed Suzy about the horror she felt about this incident. She wrote:

> I cannot believe what I just learned. It was so unbelievable that I contacted a member of the student's department to find out if the story I heard was exaggerated or just plain wrong. It was even worse than I originally thought. Not only was the baby in the hospital because of birth complications but the mother was on bed rest for several weeks. By putting through paperwork to terminate her TA [teaching assistant] assignment, the mother would have lost her stipend and tuition coverage as well as her own and her infant's medical insurance. Fortunately, the person I talked to said that he saw the paperwork and stopped the process. He said that it "wasn't rocket science—it was the right thing to do." I remarked, "well, it must be rocket science to someone…." I am so horrified by this incident that I can barely speak. (April 2008)

This student's early delivery prevented her from fulfilling her ideal work roles as outlined by the professor and could have led to her termination. The professor who tried to terminate the student's teaching assistant assignment apparently did not consider possible litigation or reputational damage for wrongful termination. The work identity of the student's husband was not disrupted by the early delivery of their baby.

Monitoring Baby

Suzy journaled,

> Today, my good friend posted a picture of her baby boy's ultrasound on her blog. I get lots of ultrasound photos these days from expectant friends. They all agree that it somehow makes the pregnancy more real to them. I have to admit that while I can appreciate their enthusiasm over their baby's first photos, I often have a hard time telling exactly what's going on in these black and white, blurry photos. Nevertheless, I always reply that the baby is beautiful and I can't wait to meet them! (January 2008)

Ultrasound images of their babies help women to begin to fill in the contours of their identities as mothers just as they fill out their maternity clothes. The images make pregnancy more real; the women are not imagining the

changes in their bodies. Reproductive technologies also facilitate prenatal bonding—from home pregnancy tests that allow women to find out if they're pregnant before a missed period to sonograms that identify the sex of the fetus and show parents images of their babies (Layne, 2006). The ability to identify a pregnancy at home before going to the doctor gives expectant parents that much more time to prepare and adjust. Providing parents with the opportunity to know the sex of their child minimizes the perceived problem of receiving gender-neutral gifts at the baby shower, or worse, pink onesies for a boy or blue hoodies for a girl. Parents can now efficiently and appropriately design their nursery in advance around the sex of the fetus.

Other technologies also enable parents to connect with their child during pregnancy. DeAnne Messias and Jeanne DeJoseph (2007) describe mothers who make videos of themselves throughout their pregnancy so that the baby can later learn more about his or her mother's pregnancy and her thoughts and feelings during this period. Record-keeping has become more elaborate with new technologies. Suzy has many friends (both fathers and mothers) who create blogs (Web logs) during their pregnancies and after their children are born. They provide information about the pregnancy for family and friends and document the baby's growth and development. They invite others' comments and links.

Fathers also benefit psychologically from visual reproductive technologies. Jan Draper (2002) notes that seeing an ultrasound scan "heightened men's awareness of the baby and triggered a realization that deep within their partner's body, outward signs of which yet were unobserved, was a real baby, a human being, not an abstract concept" (p. 780). It was this visual verification that provided the most evidence of the baby's existence and can heighten men's involvement in the pregnancy process.

An emphasis on visual reproductive technologies like ultrasounds also impacts pregnancy loss (Layne, 2006). Ultrasounds can be done anytime during the pregnancy, allowing parents to see very early what is happening inside the mother (American College of Obstetricians and Gynecologists, 2007). These technologies often make pregnancy loss even more challenging for women and their partners. In the past, women would miscarry and sometimes not even know they were pregnant. But now pregnancy loss can also be identified early through reproductive technologies. Layne (2006) adds,

> After a demise has been discovered, options about how, when, and where to end the pregnancy may give both patient and caregiver a measure of comfort in being able to assert some choice or control over at least one aspect of a pregnancy that has swung so devastatingly and irrevocably out of control. Even so, there are costs associated with this. Women may, for instance, do as I once did: use hormone therapy to prolong a pregnancy after demise had been determined via

sonogram so that I could attend a professional conference before having the D & C [dilation and curettage surgical procedure]. While this was certainly an effort on my part to reassert control of my life and minimize my losses, this control is not without costs—the psychic costs of dissimulation (pretending at the conference that I was fine) and self-alienation and disgust (feeling like I was carrying a rotting corpse inside). (p. 147)

Layne believed that she was unable to miss a conference as a good employee. We are left wondering if an employee who suffers from an unpredictable medical illness or needs surgery would lose favor with an employer. Yet, with reproductive technologies, women can and are expected to control not only when they will get pregnant and deliver but also how they miscarry.

C-sections and Other Elective Surgeries

Suzy and Patrice's good friend recently scheduled her C-section, a procedure where the baby is surgically removed from her or his mother's abdomen. Once scheduled, the mother-to-be then posted the birth date on her blog. This C-section was necessary because the baby was breeched (when the baby's buttocks, feet, or both are in place to come out first during birth). While the new mom was initially sad that she would be unable to deliver her baby "naturally," she became excited that out-of-town family will be able to schedule in advance a trip for the delivery. The ability to put the delivery date in one's day planner makes the birthing scenario so much more convenient and efficient that the C-section is now the birthing route of choice. The C-section is considered ideal for women looking for ways to control their delivery date, eliminate the inconvenience and potential embarrassment of water breaking at an inopportune time, and maintain an image as a self-reliant, motivated, responsible, and professional worker (Du Gay, 1996; Rose, 1989; Trethewey, 2000; Trethewey, Scott, & LeGreco, 2006).

Today, women can schedule C-sections, instead of having emergency C-sections, and it is the "efficiency factor" that is so attractive (Kotz, 2008, p. 74). In the past, C-sections were not scheduled to accommodate a family's needs but rather to guarantee the health of the mother and infant (Yabroff, 2008). But recent statistics indicate that "nearly 1 in 3 pregnant women had a C-section in 2006, compared with about 1 in 5 a decade earlier" (Kotz, 2008, p. 74). Celebrity C-sections have made this surgical procedure even more popular. Despite their claims that a C-section is necessary for the health of the baby, speculation abounds that stars such as Angelina Jolie, Britney Spears, and Victoria Beckham, who is credited with starting the "too posh to push" trend, elect for C-sections to maintain their svelte figures and make the entire birthing experience more convenient (Kotz, 2008; Martin, 2007).

However, other celebrities are using their star power to fight against this trend. Former talk show host Ricki Lake recently produced and starred in the documentary *The Business of Being Born,* which questions the way American women choose to have babies, the emphasis on reproductive technologies, and the popularity of C-sections (Lake & Epstein, 2007).

The issues go beyond the use of surgical procedures like C-sections for efficiency and convenience; they concern the use of technology for the monitoring and shaping of all aspects of the pregnancy, delivery, and post-pregnancy body. In addition to C-sections, other surgical procedures offer women ways to control their physical appearance. Rather than working off the excess weight postpartum, it is now possible for women to get liposuction and tummy tucks to minimize the impact of the pregnancy on their body soon after the time of the C-section. The American Society for Aesthetic Plastic Surgery (2008) reported that liposuction and breast augmentation were the top surgical procedures in 2007, an increase of 9 percent from the previous year. Part of this recent rise in plastic surgeries "can be attributed to the heavy marketing of so-called 'mommy makeovers': a breast lift or augmentation, or a tummy tuck—or a combination of the three—which surgeons say help women reclaim their pre-pregnancy bodies" (Barrett & Springden, 2007). There are so many women with children electing to have these procedures that one plastic surgeon has created a children's book in which a superhero-like plastic surgeon gives the mom a tummy tuck and breast augmentation because "as I got older, my body stretched and I couldn't fit into my clothes anymore. Dr. Michael is going to help fix that and make me feel better" (Springden, 2008).

Professional and celebrity women's increasing use of elective reproductive technologies for control over career and body problematically reinforces notions that the responsibility for career and life decisions and consequences rests in the hands of (affluent) women, and that there is no need for a community to care for new mothers and infants, for time to readjust to new bodies and familial relationships, or for changes in professional expectations and organizational career structures, because women can presumably handle life events and their consequences on their own. The emotional costs of elective C-sections on the mother, including feeling as if she missed out on the actual birth, are diminished as well (Porter, Van Teijlingen, Yip, & Bhattacharya, 2007). Finally, these dominant discourses rarely mention the role and potential support of partners and spouses.

Lessons and Further Questions

Before we integrate the lessons learned, we lay out some of the central factors and assumptions that underlie our stories:

- Time (timing of pregnancy, possible age-related infertility, academic career time and timing);
- Choice (best time to become pregnant and give birth, optimal way to give birth, resources to have choice);
- Relationship (the ways having a child may change relational dynamics);
- Control (beliefs in the ability to control reproduction, such as assumptions that once one decides to become pregnant, it will happen without difficulty, prolonged waiting, or complications in the pregnancy, birth, and [neo]natal and postpartum course); and
- Technology use (assumptions that technology should be used to regulate the timing, course, and end of pregnancy).

Of particular concern to us is that, despite these assumptions, the abilities to schedule all aspects of conception through delivery are seen by many people as unproblematic. Moreover, reproductive technologies discourses rarely address the role of a partner when "penciling in pregnancy" or electing for C-sections, while both parents/partners are included in discourses of baby monitoring. Indeed, the role and rights of fathers and/or sperm donors involved with innovative technologies like egg-freezing and in-vitro fertilization remain unclear, creating a "fragmented" fatherhood (Sheldon, 2005, p. 547).

Many questions remain: When did we move from using fairly simple technologies to assist in childbirth to overseeing prenatal care through sonograms and amniotic fluid tests to challenging when and how infants are born? How do reproductive technologies impact gendered norms and relationships? While we could easily track some technology use, we wonder: Why isn't the same attention devoted to transforming career and organizational structures and expectations that is devoted to if, when, and how female workers and celebrities use reproductive technologies?

Arguably, this move toward an overreliance on reproductive technologies has been brought about by changing workplace and societal discourses designed to diminish dominant bureaucratic tendencies and promote hyper-individualism where individuals are held accountable and responsible for strategically crafting and controlling all aspects of their lives, including conception, pregnancy, and delivery. Hyper-individualism is an outcome of the discourses of enterprise that privilege identities of self-reliance and self-monitoring and encourage individuals to constantly work to improve themselves and to blame themselves when they fail to achieve career goals (Ainsworth & Hardy, 2008; Du Gay, 1996).

We have considered how and why assumptions about valid uses of technologies for efficiencies have reached into some of the most sacred aspects

of women's lives in the U.S.—giving birth, childrearing, and quality time for caregiving and bonding. Will Miller and Glenn Sparks (2007) suggest that "today...we believe that science and technology can overcome all our challenges. We believe that sooner or later, we will find that cure for cancer. We're convinced that high-tech will make our lives simpler, easier, better—that we'll have more choices, more control" (p. 165). Moreover, Miller and Sparks add that rationality and predictability are prioritized today to avoid issues of uncertainty and the unexpected. Not having control is the equivalent to vulnerability; these values are also privileged in masculine organizational discourses of cause-effect linear thinking and individualism (Buzzanell, 1994). And these dominant masculine discourses have seeped into the traditionally feminine world of pregnancy and caregiving.

Thus the logics behind women's control via technology can be traced to these larger discourses of individualism and enterprise. Controlling when and how she gets pregnant, vigilantly monitoring the pregnancy, and having an elective C-section enable the individual mother to regulate her career. In the process, these technologies often remove women from intimate connections with their own bodies and with the rhythms of their infants' birth and life processes (Saetnan, 2005). We are not calling into question whether or not women who engage these technologies for work and efficiency reasons can be good mothers. Rather, we are calling into question the ethics of efficiency, individualism/independence, and career in an era when new media and technologies offer electronically mediated connection and support, and "choice" enables us to retain our busy lifestyles that preclude questioning the character and quality of our own lives and our responsibilities to others (Buzzanell, 1994; Buzzanell et al., 2005). To *not* rely on the technological advantages we have in choosing our birthing and childrearing moments and styles means that we would acknowledge dependence on natural rhythms and the uncertainties of life.

In her journal, Patrice noted her ambivalence in all this discussion:

> I want women to have control over their own lives and bodies. I also want women to be able to succeed at work and at family in whatever configuration their work-life issues take. But I am conflicted that women always seem to need to shortchange themselves to make things happen—less sleep to be able to get work done and spend time with the family, work harder for competence evaluations and promotion opportunities, believe that they have to have more education than men to obtain the same positions. Now we need to be perfect mothers, utilize technological inventions, and do it all well and alone. (July 2008)

And yet it seems impossible to overlook the relationship between gender and technology when constructing today's modern woman. She works, thanks to advice on personal branding (Lair, Sullivan, & Cheney, 2005). She enhances her appearance post-pregnancy with liposuction and enlarged breasts. She

decides that her biological clock is ticking (or takes a test that confirms the sound of the tick-tock), finds the perfect mate, and tries for children. After a while, they fail to conceive. They go for fertility testing, genetic counseling, or in-vitro treatments. They select the eggs to implant (freezing other eggs for future pregnancies), and time the pregnancy according to vacation schedules and project deadlines. When she becomes pregnant, they monitor the fetus's progress, blog about the sex of the baby, and select a date for a C-section and then a date for the subsequent tummy tuck. According to this construction, technologies ironically offer women a way to integrate their private, caregiving roles with their public, work roles and enterprising selves (Messias & DeJoseph, 2007).

In reflecting on this scenario, we acknowledge the limitations of this chapter in its exploration of reproductive technologies. We consciously chose to address how these technologies impact the lives of women "because women are the ones who carry and bear children" (Beckman & Harvey, 2005, p. 16). With this focus, we did not intend to diminish the role of partners and spouses. Indeed, we recognize that reproductive health decisions are often made by couples (Ciccarelli & Beckman, 2005). The examples in this chapter also largely focus on issues in the U.S., although we know that there are differences in terms of acceptability, access, and use of reproductive technologies throughout the world.

It is also important to consider the stories that are suspiciously lacking in this consideration of reproductive technologies, including those of parents from lower socioeconomic households. Reproductive technologies such as at-home pregnancy tests, routine ultrasounds, and baby-monitoring devices require middle-class incomes and adequate health insurance. And so, the hyper-individualistic behaviors that we've described require at least a middle-class socioeconomic status. However, Daniel Lair and colleagues (2005) note that discourses of personal branding, similar to those of hyper-individualism, not only ignore issues of class but also often blame the lower classes for their own poverty and inability to successfully engage in crafting acceptable entrepreneurial identities. Thus a dominant assumption is that lower-class women should be able to monitor and control their pregnancies in the same ways as those who have access to more financial resources and health insurance. Moreover, elective reproductive technologies seem to create even greater possibilities of inequity and divides among women as they are touted as used mostly by professional and celebrity women who presumably cannot afford time out of their careers or perceived negative changes in their appearance. One must be privileged to obtain access to many of these expensive technologies, and yet they are not elective in societies that consider women's primary role to be mother (Beckman & Harvey, 2005).

Other stories missing from this chapter would address the backlash against women who want to opt out of any reliance on reproductive technologies. For example, another of Suzy's close friends is pregnant with her third baby and wants to deliver at home and use a midwife. With two relatively easy births under her belt (pun intended), she would like more control over her third birthing experience, but her insurance will not cover her delivery at home.

Furthermore, many reproductive technologies testing for fetal abnormality are not presented as a choice to mothers but rather as routine. Alison Pilnick (2004) found that choice is often presented as between old forms and new forms of screening, rather than as between screening and no screening. And although the results can be inaccurate, women often choose to have the suggested screenings, somewhat afraid to ignore their access to reproductive technologies. In these examples, women attempt to exert their choice to refuse technologies and reject dominant pregnancy discourses, waging a somewhat futile resistance as they typically receive little support in these endeavors.

Lastly, stories of single mothers by choice and same-sex parents are also missing. One possible reason for this omission is that many reproductive technologies work to combat "medical" infertility, but the use of reproductive technologies by single mothers and same-sex couples has called into question societal issues related to infertility (Kaariainen, Evers-Kiebooms, & Coviello, 2005). Both circumstances appear to question the role of fathering. However, children of single mothers by choice, many of whom use reproductive technologies like donor insemination, show little developmental and psychological differences when compared to children from heterosexual two-parent families (Golombok, 2005). In fact, children of single mothers by choice "showed fewer emotional and behavioral problems but no difference in cognitive functioning" (Golombok, 2005, p. 12).

Lesbian mothers, as well, often use donor insemination to conceive. However, the use of donor insemination by heterosexual couples is often framed as in response to infertility issues, while lesbian couples' use of donor insemination is seen as a "positive opportunity" (Haimes & Weiner, 2000, p. 478). Today same-sex couples have access to self-semination technologies. Indeed, a recent feature in the men's lifestyle magazine *Details* describes a gay baby boom as more same-sex male couples are using self-semination with surrogacy technologies to start families (Lewine, 2008). Through self-semination, same-sex couples effectively reclaim reproductive technologies in a de-medicalized and de-professionalized manner (Haimes & Weiner, 2000), a feat that can seem threatening to medical professionals who privilege professional expertise in these areas.

In addition, both single mothers by choice and same-sex couples are often viewed as rejecting traditional familial norms in raising children (Golombok, 2005; Haimes & Weiner, 2000). And yet, research shows that there is no difference in developmental outcomes of children raised by same-sex couples and those raised by heterosexual couples (Golding, 2006). These cases raise provocative questions of access to reproductive technologies. In addition, it is assumed that single mothers by choice and same-sex parents utilize reproductive technologies only to conceive. A fruitful opportunity for research would consider how these individuals and couples also work to "pencil in pregnancy," monitor the development of their baby, and how technologies intersect with delivery and postdelivery. Where one group's use of reproductive technologies may align with beauty, efficiency, and self-discipline norms under a hegemonic gaze, another group's use may constitute resistance to societal norms that still refuse to acknowledge their familial rights.

Conclusion

From conception to pregnancy to delivery, women's bodies and circumstances are regulated by technologies that purport to offer convenience, efficiency, and control. In the process, gendered norms are reinscribed on work and other identities that prescribe self-monitoring and self-reliance. Gender and technology are constitutive (Johnson, 2006) such that reproductive technologies make pregnancy more convenient and in alignment with organizational and societal discourses that privilege enterprise, branding, and individualism. It is impossible to avoid technologies altogether and naïve to reject the many benefits of technological innovations. At the same time, our hope is for a future in which reproductive technologies are not primarily used as a means for women to adapt their identities, their pregnancies, and their bodies to enterprising discourses that privilege individualism and self-reliance to the detriment of community and connectedness.

References

Ainsworth, S., & Hardy, C. (2008). The enterprising self: An unsuitable job for an older worker. *Organization, 15,* 389–405.
Ali, L., & Kelley, R. (2008, April 7). The curious lives of surrogates: Thousands of largely invisible American women have given birth to other people's babies. Many are married to men in the military. *Newsweek,* 44–51.
American College of Obstetricians and Gynecologists. (2005). *Repeated miscarriage.* Retrieved August 24, 2008, from http://www.acog.org/publications/patient_education/bp100.cfm.

American College of Obstetricians and Gynecologists. (2007). *Routine tests in pregnancy.* Retrieved August 24, 2008, from http://www.acog.org/publications/patient_education/bp133.cfm.

American Society for Aesthetic Plastic Surgery. (2008). *Cosmetic procedures in 2007.* Retrieved August 24, 2008, from http://www.surgery.org/press/news-release.php?iid=491.

American Society for Reproductive Medicine (ASRM) Practice Committee. (2007). Essential elements of informed consent for elective oocyte cryopreservation: A practice committee opinion. *Fertility and Sterility,* 88, 1495–1496.

Barrett, J., & Springden, K. (2007, December 17). Mommy wants her body back: More older women are getting breast surgery than ever before, in the hopes of reclaiming their pre-pregnancy figures. *Newsweek Online.* Retrieved July 1, 2008, from http://www.newsweek.com/id/78042/page/1.

Beckman, L. J., & Harvey, S. M. (2005). Current reproductive technologies: Increased access and choice? *Journal of Social Issues,* 61, 1–20.

Buzzanell, P. M. (1994). Gaining a voice: Feminist organizational communication theorizing. *Management Communication Quarterly,* 7, 339–383.

Buzzanell, P. M., & D'Enbeau, S. (in press). Stories of caregiving: Intersections of academic research and women's everyday experiences. *Qualitative Inquiry.*

Buzzanell, P. M., & Lucas, K. (2006). Gendered stories of career: Unfolding discourses of time, space, and identity. In B. J. Dow & J. T. Wood (Eds.), *The Sage handbook on gender and communication* (pp. 161–178). Thousand Oaks, CA: Sage.

Buzzanell, P. M., Meisenbach, R., Remke, R., Bowers, V., Liu, M., & Conn, C. (2005). The good working mother: Managerial women's sensemaking and feelings about work-family issues. *Communication Studies,* 56, 261–285.

Ciccarelli, J. C., & Beckman, L. J. (2005). Navigating rough waters: An overview of psychological aspects of surrogacy. *Journal of Social Issues,* 61, 21–43.

Draper, J. (2002). "It was a real good show": The ultrasound scan, fathers and the power of visual knowledge. *Sociology of Health and Illness,* 24, 771–795.

Du Gay, P. (1996). *Consumption and identity at work.* London: Sage.

Esarey, S., & Haslberger, A. (2007). Off-ramp—Or dead end? *Harvard Business Review,* 85(2), 57–60, 62.

Extend fertility. (2007). Retrieved July 11, 2008, from http://www.extendfertility.com/egg-freezing.htm.

Golding, C. A. (2006). Redefining the nuclear family: An exploration of resiliency in lesbian parents. *Journal of Feminist Family Therapy,* 18(1/2), 35–65.

Golombok, S. (2005). Unusual families. *Reproductive Biomedicine,* 10(1), 9–12.

Haimes, E., & Weiner, K. (2000). "Everybody's got a dad . . .": Issues for lesbian families in the management of donor insemination. *Sociology of Health and Illness,* 22, 477–499.

Johnson, D. G. (2006). Introduction. In M. F. Fox, D. G. Johnson, & S. V. Rosser (Eds.), *Women, gender, and technology* (pp. 1–11). Urbana: University of Illinois Press.

Kaariainen, H., Evers-Kiebooms, G., & Coviello, D. (2005). Medically assisted reproduction and ethical challenges. *Toxicology and Applied Pharmacology,* 207, S684-S688.

Kotz, D. (2008, April 7). A risky rise in C-sections: Experts worry that the trend is bad for mom and baby. *U.S. News & World Report*, 74.

Lair, D. J., Sullivan, K., & Cheney, G. (2005). Marketization and the recasting of the professional self: The rhetoric and ethics of personal branding. *Management Communication Quarterly, 18*, 307–343.

Lake, R. (Producer), & Epstein, A. (Director). (2007). *The business of being born* [Motion picture]. U.S.: Red Envelope Entertainment and New Line Home Entertainment.

Layne, L. L. (2006). Some unintended consequences of new reproductive and information technologies on the experience of pregnancy loss. In M. F. Fox, D. G. Johnson, & S. V. Rosser (Eds.), *Women, gender, and technology* (pp. 122–156). Urbana: University of Illinois Press.

Lewine, E. (2008). The gay baby boom. *Details Blog.* Retrieved August 20, 2008, from http://men.style.com/details/blogs/details/2008/04/the-gay-baby-bo.html.

MacDermid, S. M., Roy, K., & Zvonkovic, A. M. (2005). Don't stop at the borders: Theorizing beyond dichotomies of work and family. In V. L. Bengston, A. C. Acock, K. R. Allen, P. Dilworth-Anderson, & D. M. Klein (Eds.), *Sourcebook of family theory and research* (pp. 493–516). Thousand Oaks, CA: Sage.

Martin, J. (1990). Deconstructing organizational taboos: The suppressing of gender conflict in organizations. *Organization Science, 1*, 339–359.

Martin, D. (2007). *Too posh to push: Celebrity C-sections.* Retrieved July 14, 2008, from http://www.fims.uwo.ca/NewMedia2007/page4731844.aspx.

Mères porteuses: Un enfant à tout prix. (2008, July). *Paris Match, 3085,* 54–57.

Messias, D. K., & DeJoseph, J. (2007). The personal work of a first pregnancy: Transforming identities, relationships, and women's work. *Women & Health, 45*(4), 41–64.

Miller, W., & Sparks, G. (2007). *Refrigerator rights: Creating connections and restoring relationships* (2nd ed.). White River Junction, VT: White River Press.

Mock, C., & Bruno, A. (1994). The expectant executive and the endangered promotion. *Harvard Business Review, 72*(1), 16–22.

Pilnick, A. (2004). "It's just one of the best tests that we've got at the moment": The presentation of nuchal translucency screening for fetal abnormality in pregnancy. *Discourse & Society, 15*, 451–465.

Porter, M., Van Teijlingen, E., Yip, L. C., & Bhattacharya, S. (2007). Satisfaction with cesarean section: Qualitative analysis of open-ended questions in a large postal survey. *Birth, 34*, 148–154.

Raymond, J. (2008, May 6). Biological alarm clock: Researchers can now predict the age of menopause more accurately. How this could help women and why some might want to know. *Newsweek Online.* Retrieved July 1, 2008, from http://www.newsweek.com/id/135651.

Rose, N. (1989). *Governing the soul: The shaping of the private self.* London: Routledge.

Saetnan, A. R. (2005). All foetuses created equal? Constructing foetal, maternal and professional bodies with obstetric ultrasound. In D. Morgan, B. Brandth, & E. Kvande (Eds.), *Gender, bodies, and work* (pp. 139–150). Hampshire, England: Ashgate.

Sheldon, S. (2005). Fragmenting fatherhood: The regulation of reproductive technologies. *The Modern Law Review, 68*, 523–553.

Shellenbarger, S. (2008, February 14). Why some single women choose to freeze their eggs. *Wall Street Journal,* p. D1.

Smith, R. (2006, January 25). Career women fertility test: Simple Pounds 179 kit can show how much time left to start family. *The Evening Standard* (London), p. B1.

Springden, K. (2008, April 15). Mommy 2.0: A new picture book about plastic surgery aims to explain why mom is getting a flatter tummy and a "prettier" nose. *Newsweek Online*. Retrieved July 1, 2008, from http://www.newsweek.com/id/132240.

Trethewey, A. (2000). Revisioning control: A feminist critique of disciplined bodies. In P. M. Buzzanell (Ed.), *Rethinking organizational and managerial communication from feminist perspectives* (pp. 107–127). Thousand Oaks, CA: Sage.

Trethewey, A., Scott, C., & LeGreco, M. (2006). Constructing embodied organizational identities: Commodifying, securing, and servicing professional bodies. In B. J. Dow & J. T. Wood (Eds.), *The Sage handbook on gender and communication* (pp. 123–141). Thousand Oaks, CA: Sage.

Van Disseldorp, J., Faddy, M. J., Themmen, A. P., De Jong, F. H., Peeters, P. H., Van der Schouw, Y. T., et al. (2007). Relationship of serum anti-Müllerian hormone concentration to age of menopause. *Journal of Clinical Endocrinology & Metabolism, 93*(6), 2129–2134.

Yabroff, J. (2008). Birth, the American way. *Newsweek, 151*(4), 46.

CHAPTER 2

From Taylor to Just-in-Time Sustainability

A Short History of Efficient Eating

▶ YVONNE HOUY

This new century may see a revolution in food equally startling to the twentieth century's—only this one will be much better for us.

Alex Steffen, 2006

May suitable doses of guaranteed sensual pleasure and slow, long-lasting enjoyment preserve us from the contagion of the multitude who mistake frenzy for efficiency.

Folco Portinari, 1989

Eaters must understand that eating takes place inescapably in the world, that it is inescapably an agricultural act and that how we eat determines, to a considerable extent, how the world is used.

Wendell Berry

What happens in a home kitchen has global consequences. Everyone has to eat. The daily repeated act of preparing food adds to the greenhouse gas emissions that will lead to global warming, unless humankind works together to decrease emissions. The volume of gases pumped into the atmosphere for

each meal for each person is infinitesimal compared to the considerably larger carbon footprints—one popular shorthand for freed greenhouse gases—of heavy industries, coal-fired power plants, fossil fuel transportation, and forest destruction around the globe. But the infinitesimal carbon footprint of each meal for the 6.7 billion people on Planet Earth adds up. Food production is a major greenhouse gas producer. Just to give one example: raising domesticated animals for meat consumption in the U.S., the largest per capita greenhouse gas emissions producer in the world, adds 20 percent—yes, a full one-fifth—of the methane emitted, and methane is a major greenhouse gas component (U.S. Environmental Protection Agency, 2006). Since nourishing our bodies is a continual source of necessary consumption that inevitably leaves a carbon footprint, how can the eco-conscious consumer reduce the inevitable greenhouse gas emissions?

As Earth's population grows, so too will the overall carbon footprint of all of the life-sustaining meals needed to feed the population. Current discussions of what individuals can do to lower their personal carbon footprint are thus one crucial, if small, aspect of the larger discussion of how humankind needs to decrease the impact of global warming by cutting greenhouse gases. While wealthy developed countries worry about greenhouse gas emissions, the world's poor have a related problem that is even more significant: food insecurity. Mass starvation is a possible outcome of probable disruptions in food production because of climate change due to global warming. We must all eat, but can we nourish ourselves and our children's children without destroying our planet and our sustenance?

What do carbon footprints, climate change, and food security have to do with efficiency, the topic of this book? The efficiency of food production and consumption has become a contentious issue over the past few years, as recent publications proclaiming the "end of food" as we have known it proliferate (Kingsolver, 2007; Pollan, 2006, 2008; Roberts, 2008; Steffen, 2006). The idea that food production and consumption need to be sustainable has become a discussion about "efficiency," although some sustainability advocates would shy away from this term: some of the most vociferous advocates (see, for example, Kingsolver, 2007; "Our Philosophy," 2008) critique the current "culture of efficiency" (Kleinman, 2007) and blame it for the mess we're in. However, within that potent critique of efficiency lies the seed of a new envisioning of what efficiency means and how to create food production efficiencies that are sustainable and nourishing.

When I set out to write about efficiency in daily life with a focus on eating, I did not plan on writing about looming environmental and food crises. Rather, I was thinking about a more quotidian notion of efficiency: how to eat well fast. My husband and I have two small children and getting a nutritious meal on the table that everyone will eat is difficult, sometimes impos-

sible. Food preparation needs to happen fast, between the toddler's and preschooler's antics. The common supermarket aisle is full of fast meal helpers, but do they help our planet, too?

As concerns over climate change have been growing, so have concerns about the entire food production chain. The discussion about efficiency around food and food preparation is taking a new turn in the face of challenges in the new millennium, as signs of global warming are increasing, and uncertain and inclement weather has affected some global food staples like rice and corn (Seager, 2008). Sustainability in food preparation and consumption is becoming the new efficiency of the kitchen. The definition of efficiency for the twentieth century was based on efficiency of time and movement. Now we have to think about efficiency of the eco-footprint. How do we reduce inefficiencies and waste in energy and materials used to produce, transport, and prepare foods, and do so in ways that promise sustainable efficiency in the future? What does efficient food production mean in this age of concern over global warming and finite resources?

A Short History of the Modern Kitchen

Before I explain the current controversy over the meaning of food efficiency, I need to give a short history of efficient food. The evolving discussion about sustainability in home kitchens is part of the century-old evolution of what it means to have an efficient kitchen, but it also shows signs of a significant break from that history. At the forefront of the evolution of efficient food preparation over the past century has been the idea that architectural and product design, particularly within the kitchen, can bring answers to social problems, particularly inequality and poverty.

In order to understand why kitchens have been a focus of social reform-minded designers since the beginning of the twentieth century, we need to go back to the Industrial Revolution. The food preparation area that someone in the twenty-first-century industrialized world would recognize as a kitchen did not exist in most homes in the industrializing world even a hundred years ago, and today's kitchens are positively revolutionary compared to preindustrial-era hearths. What we in the industrialized world now take for granted wasn't available to most homes: running, drinkable water; long-term storage of perishables in refrigerators and freezers; milled grains in standardized sizes; energy at the turn of an oven knob; and reliable temperature controls for cooking and baking. Preparing food in the early twentieth century required enterprising, localized design solutions and on-the-fly management by the tender of the hearth.

Certain aspects of preparing a meal that are simple today were a bit of a black art before industrialization and the standardization of cooking equip-

ment and ingredients. Dishes that even a relatively untrained cook like me can create successfully with a bit of practice—I'm thinking of light, moist cakes and fluffy soufflés—would have been nearly impossible to produce a century ago, except by the most accomplished chefs who could work with unstandardized milled ingredients and difficult to regulate wood- or coal-fired ovens. Putting sophisticated food on the table was an art and science, and people who could cook and bake well were valued even more highly than they are today. Eating sophisticated food was the privilege of the wealthy who could afford kitchens and cooks. The large layouts of the early kitchens for the well-to-do attest to the assumption that there would be multiple cooks.

In contrast, average households had rather primitive food preparation areas—one could hardly call them kitchens—before the 1910s and 1920s. A simple, wood-fired, sooty hearth with no running water was the norm in all but the most privileged households. In rural areas, where the vast majority of the population lived before industrialization, there was easy access to water and wood, and having a sooty hearth and no running water was inconvenient and inefficient, but generally not life-threatening. But as rural populations left the countryside for wage work in industrializing areas starting in the mid-nineteenth century, the common ways of preparing food became dangerous. The family of the average industrial worker in the crowded tenements of rapidly growing industrial centers like New York City, Chicago, Manchester, and Berlin might have a tiny stove spewing soot into cramped quarters, and they probably had no running water. Water and heating fuel such as coal or wood had to be carried long urban blocks and then up flights of stairs. But inefficiency was the least of the problems of early twentieth-century food preparation spaces: they were health hazards.

As modernization became a rallying cry of architects in Europe and North America in the 1910s and 1920s, the modernist, sleek, streamlined designs of buildings were one focus, but the humble hearth received attention, too. Social reform-minded architects attempted to rethink the dank, dark, steam- and soot-filled home hearths of poor urban dwellers. New, light-filled apartment buildings for that multitude of industrial and administrative workers sprang up as the Roaring Twenties changed the lives of urban dwellers in the U.S. and Europe. The new, small apartments in these buildings were designed in part with the hope of making the lives of all urban dwellers more pleasant, including the often miserable lives of workers in heavy industry. These modern apartments almost always included a feature not seen before in living spaces for the poor: a kitchen set off from the rest of the living space. Instead of a large common room that included living and often even sleeping areas in the same space as a soot-producing hearth, the modern design paradigm set a small kitchen with some basic modern appli-

ances apart from rooms designed for living and sleeping (Lupton & Miller, 1992).

This new layout not only was supposed to be healthier, it also showed off its modernity through the "form follows function" streamlining characteristic of 1910s and 1920s modernist architecture as well as by its adherence to the new efficiency paradigm: Taylorism. Around the turn of the twentieth century, Frederick Winslow Taylor (1905, 1911), an American engineer, argued that looking at work-flow patterns "scientifically"—that is systematically, by using time and motion studies—could help "man" (in the common rhetoric of the time) become more efficient. Studying how people performed specific activities and then optimizing the work space and work flow helped industrialists like automobile tycoon Henry Ford make manufacturing processes more efficient and therefore faster and more profitable. Taylorist time and motion studies also examined home food production for the typical small household—defined as a middle-class small family dwelling—and influenced the overall layout of the new modern kitchen in such dwellings. No longer was the woman of the house—in the gendered, small family-oriented society of the West, usually the main, and often sole, tender of the hearth—to move unnecessarily all over the living area in order to prepare food. Instead, architectural design along Taylorist lines was to help her become efficient in the movements necessary for food preparation: the sink with running water only a step away from the food preparation counter only a step away from the cooling box only a step away from the wastebasket, and a few steps away from the dining area just outside the small kitchen. All aspects of food preparation were supposed to be arranged for optimal work flow. In the Taylorist model, the home cook was the equivalent of a worker in a food preparation assembly line (Lupton & Miller, 1992).

At the heart of this design revolution was the belief by architects such as Walter Gropius and Le Corbusier that good design alone can transform society, that changes in architectural paradigms can even lead to social revolution ("Bauhaus," 2008; Fishman, 1982). How designed spaces are used cannot be entirely predicted by the designer, of course—a lived-in space evolves with its inhabitants. However, home design decisions are based on underlying assumptions about how the residents should live. These lovely, light-filled, small, modern kitchens were indeed efficient for their singular design purpose—food production—but such Taylorist design assumed one cook who could concentrate on simply cooking. The size of Taylorized kitchens assumed a small household, and thus a small family. Although small families were the anticipated client of these Taylorized homes, the cook was only cooking and was not multitasking within the larger home at the same time, such as taking care of small children. My German mother, for example, had a small, efficient, modern kitchen while she raised three children.

Now that I'm a mother of two little boys, I do not understand how she ever got anything done in that set-apart kitchen. While developing one kind of efficiency, in this case food preparation, another kind of efficiency is neglected, in this case the efficiency of multitasking food preparation while watching over children.

In 1960s North American architecture, kitchens opened up again to living spaces to allow the tender of the modern oven—typically the wife and mother within this gendered society—to participate in other aspects of home life besides cooking. Here the model of kitchen efficiency shifted from Taylorist time-and-motion efficiency toward another kind of efficiency—efficient entertaining—and the kitchen became the heart of the home social scene. The Great Rooms popular in 1990s North American home architecture continued this trend and fully reintegrated the kitchen with living spaces, allowing food preparation to be combined with almost all aspects of family and social life. Thus, within a short century, the architecture of the typical middle-class home had moved away from the hearth in the living room and then back again, all in the name of efficiency. First was the efficiency of movement within the food preparation area, then it combined with entertainment efficiency—no more running from kitchen to dining and living rooms to socialize. Now cooking and socializing all happen in the same area.

These shifts in architecture-driven models of kitchen efficiency went hand in hand with the gadget efficiency that emerged in post-World War II America and a decade later in Europe and elsewhere in the industrialized world. Marketing aimed at the housewife, a stay-at-home middle-class homemaker according to the ideals of 1950s America, promised that food preparation gadgets, many of them powered by electricity, could help prepare fabulous meals rapidly. This equipment included newly designed refrigerators that worked simply by plugging into the electricity grid, rather than the earlier cooling boxes that needed frequent maintenance to keep food cold. Housewives no longer needed to buy fresh food almost daily, because the modern refrigerator-freezer kept food fresh longer (Lupton, 1993). From the convenient refrigerator and easy-to-heat oven, the must-have appliance list grew impressively in the second half of the twentieth century in consumerist developed countries: toaster ovens and microwaves joined regular ovens and stoves; crêpe makers, waffle irons, and sandwich presses joined humble pans; slow cookers and rapid steam cookers joined normal, pedestrian pots.

My mother, who is of the post-World War II generation, has an impressive number of kitchen gadgets, many of which have been used a couple of times and then pushed to the back of bulging cabinets. Who makes her buy

even more cooking gear? Marketers, who adhere to the currently dominant notion of what efficiency means in the kitchen—preparing food fast.

A Short History of Fast Foods and Slow Foods

In the 1960s and 1970s, the frozen TV dinner promised family food fast to harried mothers, who in increasing numbers joined the workforce (Marcus, 2003). That fast food trend continued to accelerate. Today, it is not just Burger King and KFC that promise fast food. Food prepared fast has many adherents, from mass-producing industries preparing meals for harried families to great chefs advocating the fast gourmet meal. Prepared foods can be found in almost every supermarket aisle, and the market for convenience foods has grown tremendously since the 1970s (Kingsolver, 2007; Pollan, 2006, 2008; Schlosser, 2001). Recently, celebrity chefs and food writers working from the mainstream (for example, Rachael Ray and Martha Stewart) to the sustainable alternatives (Alice Waters and Mark Bittman) have started to promote simple gourmet cooking, a departure from the complex art of cooking that television chefs like Julia Child popularized from the 1960s to the 1990s.

Child was able to make the complex flavors and textures of French cuisine accessible to the masses, starting with her classic book *Mastering the Art of French Cooking.* According to the gourmet cooking model promoted by Child and others of that generation (Child, Beck, & Bertholle, 1961), the great hobby chef was only able to create fine cuisine by mastering complicated preparation methods using precise measurements of numerous specific, and sometimes esoteric, ingredients. This cooking philosophy couldn't be more different from the philosophy of some of the most popular celebrity chefs today: Ray's cookbooks, such as *Rachael Ray 365: No Repeats* (2005) and *Just in Time!* (2007), feature recipes that can be prepared in 30 minutes or less with the small number of ingredients limited to pantry staples or commonly available foods, while Waters's *The Art of Simple Food* (2007) focuses on easy-to-follow basic steps to great taste that, like all of her cookbooks, emphasize using locally available in-season ingredients. Bittman, writer of the "The Minimalist" *New York Times* food column, shows readers how to create gourmet meals with three to ten ingredients and simple steps. All of these chefs are brilliant in their efficient cooking, but note their different notions of efficient food preparation: Ray is all about time, Bittman about few ingredients and steps with time efficiency only a side effect, and Waters focuses on neither of those efficiencies but rather on the local sourcing of ingredients.

Efficiency is not Waters's (2007) goal per se—good food and sustainable agricultural practices are. Her perspective is similar to the eating and cook-

ing philosophy of the Slow Food movement. This almost two-decades-old movement has inspired many of today's sustainability advocates (Steffen, 2006), providing an eloquent critique of the dominant notion of efficiency in eating—fast food:

> We are enslaved by speed and have all succumbed to the same insidious virus: Fast Life, which disrupts our habits, pervades the privacy of our homes and forces us to eat Fast Foods....In the name of productivity, Fast Life has changed our way of being and threatens our environment and our landscapes. (Portinari, 1989)

A celebration of the opposite of fast food, "Slow Food," is their recipe to combat what the movement calls the viral "contagion" of "Fast Life": "May suitable doses of guaranteed sensual pleasure and slow, long-lasting enjoyment preserve us from the contagion of the multitude who mistake frenzy for efficiency. Our defense should begin at the table with Slow Food" (Portinari, 1989). Savoring the preparation of a meal and eating with pleasure combats this "frenzy" that is not efficiency, according to the Slow Food manifesto (Portinari, 1989). What is really efficient food then, if not fast food?

This eloquent fight against fast food efficiency is fueling a reconceptualization of efficiency in food production that might mean that a future generation of eaters will live with a new definition of efficiency emerging from the kitchen fringes today. While the Slow Food movement at first glance seems to be against efficiency, it actually promotes a type of efficiency—not the fast delivery and consumption of calories, but the efficiency of buying and preparing locally produced food. Like the snail that is their logo, proponents of this anti-fast food movement advocate the pleasures of cooking locally treasured foods. This movement is not about cooking or eating slowly but rather about being mindful about food.

The Slow Food movement, like many of the sustainability advocates it has inspired (Kingsolver, 2007; Pollan, 2006, 2008; Steffen, 2006; Waters, 2006), is particularly concerned about the consequences of the globalization of American-style fast food on local food production. Global fast food chains impact local food cultures in ways that have wide-ranging effects beyond the local context. Fast food chains promise this kind of efficiency: large amounts of calories fast, produced (although not necessarily sold) cheaply. Often their products are foreign to the local context, with clever marketing bridging the gap between indigenous tastes and culture and imported multinational—specifically U.S.-inspired—fast food culture: the "glocalization" of McDonald's McWrap in Japan analyzed in the next chapter highlights how a popular food item in the West, the wrap, is marketed to look like it adheres to local Japanese cultural preferences. No matter what the marketing campaign looks like, the

McWrap is a new food item in Japan. While such food preference innovations can certainly be viewed positively as a broadening of taste horizons, some observers, such as adherents of the Slow Food movement, see such fast food chain-driven food preference shifts as threatening to local food culture ("Who We Are," 2008).

According to local food and grower advocates, the Slow Food movement included, such shifts in food preferences can have far-reaching, damaging effects on local communities. Multinational companies like fast food chains tend to buy foods from the cheapest sources available, sometimes locally, but often from afar to reduce costs and maximize profits (Schlosser, 2001). Such a globalized food marketplace fueled by multinational fast food chains threatens small food growers: when small local food growers go out of business, crop diversity and long-term land stewardship are threatened. The cheap products of large agribusiness favored by the fast food industry overwhelmingly use artificial fertilizers and pesticides and large-scale monoculture farming, which temporarily create high crop yields, but rapidly deplete the soil and decrease plant diversity by crowding out different types of crops in favor of one disease-resistant or high-yield, often genetically modified (GMO), species. With reduced plant diversity, large-scale crop failure becomes more likely (Kingsolver, 2007). By focusing on short-term, high-yield crops using chemical fertilizers and pesticides, soil becomes contaminated, which affects not only the plants but also the whole food chain that feeds on these plants (Kingsolver, 2007; Waters, 2006).

In contrast, sustainable farming practices rely on natural soil enhancers and pest control, use diverse plants, and practice smaller-scale crop rotation. Such practices use 30 percent less fossil fuel, reduce soil erosion, conserve water, and protect biodiversity (Steffen, 2006), but farming practices that rely on organic methods are not considered efficient in the rhetoric of agribusiness practices because they do not produce high yields quickly, and they tend to be more human-labor intensive than nonorganic farming practices. However, sustainable practices are better for long-term fertility and biodiversity (Bourne, 2008; Mann, 2008), and large-scale crop failures are considerably less likely when biodiversity is protected (Kingsolver, 2007).

Because efficiency is associated with typical agribusiness practices, the term has been associated with current problems, not their solution (Kingsolver, 2007). However, because of the continued dominance of the "culture of efficiency" (Kleinman, 2007), those interested in creating sustainable food production practices can't seem to get away from employing the notion of efficiency to argue against common agribusiness and for organic methods. Notice the ambivalence in this argument by an advocate for organic local food production: "If efficiency is the issue, resources go furthest when people produce their own food, near to where it is consumed" (Steven L. Hopp,

qtd. in Kingsolver, 2007, p. 19). This is a reenvisioning of what efficient food production means, but the ambivalence in the phrase "if efficiency is the issue" suggests that efficiency should not really be the prime concern—what he does not say here specifically, but emphasizes elsewhere in the same text, is that sustainability of the food supply through organic methods and less dependence on oil-based, greenhouse gas-producing fertilizers and transportation is more important.

However, in a nod to the dominance of efficiency as ultimate value, Hopp and other advocates of sustainable food production deliberately use the notion of efficiency to argue for the benefits of local and organic food production. In an article on "Local Food," on the online crowd-written Wikipedia.org, efficiency is used as an argument why businesses should sell locally produced food: "Business leaders have adopted food miles as a model for understanding inefficiency in a food supply chain. Wal-Mart, famously focused on efficiency, was an early adopter of food miles as a profit-maximizing strategy. More recently, Wal-Mart has embraced the environmental benefits of supply chain efficiency as well" ("Food Miles," 2008). Citing the successful business Wal-Mart as a proponent for the efficiency of local food (part of an effort at greening itself) (Little, 2006) just might help convince other businesses to embrace Wal-Mart-style efficiency of selling locally produced food, as well as other local products. The rest of the Wikipedia article on local food does not use efficiency as an argument. By arguing for efficiency sometimes, and deemphasizing it elsewhere, local food advocates are using a bifurcated approach to try to reach both those concerned about costs and profits and those concerned about greenhouse gases and sustainable practices.

The new concept of efficiency that is becoming popular with the public is concerned with supplying the nutrition of fresh produce with minimal impact on the environment. The argument of sustainability advocates is this: for the health of our food supply, the efficiency of today's agribusiness needs to be replaced by a definition of efficiency that applies to every stage of the food production chain, from growing to packaging to transportation to preparation to waste management, and it needs to be sustainable over generations.

A Short History of Just-in-Time Sustainability and the Emergence of Locavores

As the sustainability advocates argue above, one of the most efficient ways to decrease the carbon footprint created by food is to grow it close to the mouths it feeds. The realization that this type of efficiency—the energy effi-

ciency of food production—could help the planet has created a new concept: the "locavore," a term voted word of the year by *Oxford Dictionary* in 2007 ("Oxford Word of the Year," 2007). A locavore is a person who eats food prepared within a defined, close radius, perhaps 100 miles, perhaps 400 miles, depending on local conditions. A resident of California, the year-round produce basket of North America, does not need to work very hard at being a locavore with a small radius. My family lives in the arid Mojave, where locavores need to extend their range to at least a 250-mile radius, or subsist mostly on desert fruits and mesquite.

Surprisingly, even in an ideal locavore environment like fertile California, conscientious consumers can be stymied by the lack of local food choices: in a typical supermarket, grapes are more likely to be from Chile than from the proverbial California backyard. In the globalized food marketplace, it is cheaper for grapes to travel 3,000 miles than to be grown and harvested locally. In contrast to previous generations, today's shoppers can get almost anything at any time of year: raspberries in fall, peaches in winter, grapes in spring. This might be convenient, but the convenience has strong consequences for the planet's health: the miles logged by all that food crossing oceans and continents add to the carbon footprint considerably (Kingsolver, 2007; Specter, 2008).

Just being a locavore does not guarantee a lower carbon footprint, however—a fact that complicates conscientious shoppers' buying decisions. It is not only the miles logged by a unit of food that determine its carbon footprint; other important factors influence that footprint, including water use and sources, cultivation and harvesting methods, quantity and type of fertilizers and pesticides used, and packaging methods. Therefore, knowing the miles logged by a product is not that useful in determining its carbon footprint. For example, when all the factors are added up, a kiwi grown in New Zealand and shipped to New York State has a smaller carbon footprint than a kiwi produced in a greenhouse just a few miles from a greengrocer in the Big Apple (Specter, 2008). Kiwis cannot be grown in the American Northeast without significant climate modifications—and heating greenhouses adds significantly to each kiwi's carbon footprint. However, from midsummer to late fall, the fertile Northeast can be awash in fresh local produce. So, not only does the diet of the conscientious shopper need to be tied to what is available locally but also what is in season locally (Waters, 2006).

How do the conscientious ensure a small carbon footprint? A host of writers about food sustainability subtly and not so subtly suggest that people who are able to grow their own food should do so (Creasy, 1982; Ellison, 2006; Flores, 2006; Haeg, 2008; Kingsolver, 2007; Kourik, 1986; "Peak Oil?" 2008; Thompson, 2008). Kitchen gardens and edible landscapes have become the new Victory Gardens, similar to those of the small-plot garden-

ers in the 1940s who showed their patriotism by growing food on their own soil during wartime, allowing the resources that normally went into food production to go toward the war effort. Recently, books, articles, Web sites, and blogs (Web logs) about the global benefits of the kitchen garden have proliferated. Sales of seeds and home gardening equipment quadrupled from the 2007 to 2008 growing season (Raver, 2008), and kitchen garden advocates cite the rising cost of food and the diminishing quality of supermarket produce as factors for the increase in produce gardening ("KGI in the Press," 2008; Morgan, 2008; Raver, 2008).

As "locavore" has become the new eco-conscious buzzword, the decades-old concepts of the kitchen garden and edible landscape have gotten a facelift: they have moved from creating diets for a small planet to being carbon footprint reducers. The idea that food production just outside one's home has ecological benefits has been around at least since the publication of two encyclopedic books about edible landscaping: Rosalind Creasy's *The Complete Book of Edible Landscaping* (1982) and Robert Kourik's *Designing and Maintaining Your Edible Landscape Naturally* (1986). Both tomes argue forcefully for the importance of minimizing resource waste, influenced by Ernst Friedrich Schumacher's seminal critique of Western economics, *Small Is Beautiful* (1973). Kourik and Creasy were part of the diffuse movement to put into everyday practice Schumacher's ideas to create a sustainable world by limiting pollution and resource waste. At a time when "organic farming" was not yet a popular term, they argued for the importance of responsible land stewardship through the minimization of waste and use of natural means for increasing yields and combating pests, and incidentally promoted increased consumption of vegetables and fruit, thereby supplanting resource-guzzling meat at meals.

Efficiency was not Creasy's or Kourik's concern—conservation of precious resources was. Growing food uses resources, but these published gardeners, as well as many of the gardening hobbyists that I've queried, argue that thoughtful planning and execution of edible landscapes minimizes waste, and that good land stewardship through organic farming methods actually improves soil and helps water retention. Perhaps the most significant conservation of resources is through the conversion of unproductive acreage into food. As Eric Schlosser (2008), author of the influential food book *Fast Food Nation,* succinctly says: "Instead of mowing your lawn, you should eat it" (p. 211). Some notable gardeners have been "eating their lawns" for decades—but they have been considered radical until now. Creasy (1982) practiced what she preached when, in the late 1980s, she converted her suburban lot's back and even front yard in California into a cornucopia. That she emphasized aesthetics in her front yard edible landscape, strategically interspersing ornamentals with edibles (Smith, 1991), points to a pervasive

attitudinal roadblock against productive uses of suburban lots, especially front lawns. Two decades after Creasy's work, there is still an air of the radical in food-producing front yards: for example, landscape artist Fritz Haeg (2008) recently did what he called an "Attack on the Front Lawn" by designing edible landscapes in the—gasp—front yards of suburban neighborhoods in various North American locations, including California and Kansas. This has gotten notice as radical innovation (Coper, 2007), although Haeg's idea is neither new, nor as radical as guerilla farming, advocated by Heather Coburn Flores's *Food Not Lawns* (2006). Guerilla farmers just plant some fruit trees or seeds in spare plots of land and see what comes up.

These radical landscapers and guerilla gardeners are taking on an unacknowledged ideology that has been tightening its grip since the World War II Victory Gardens went out of fashion in the late 1940s. In the effort to move up the social ladder, the postwar generation moved away from growing food. This was not only because urban populations became larger than rural populations; there was less space in suburban lots and urban apartment complexes to grow food. The move from rural to urban life was bound up with the move from poverty to middle class. Digging in the dirt, growing food, and keeping chickens was the lot of those who had to for survival. Leaving that hard, precarious life behind meant leaving the dirt and what comes out of it, too. For those who got away from the farm, the money economy would provide food: money would buy what before mostly backbreaking work could get. For most in urbanizing Western society, gardening became a pastime meant to bring pleasure, rather than life-sustaining food. Suburban lots and balconies were meant for ornamentals—visible signs that suburban and urban dwellers no longer needed to grow food. At best, some vegetables, herbs, and a couple of fruit trees might be hidden away in the backyard (Kingsolver, 2007).

After a century of deliberately moving away from the dirt and labor of rural life, an expanding public that is more environmentally aware is advocating moving back. Barbara Kingsolver (2007) has eloquently written about her family's experience of growing food and raising animals on her southern Appalachian farm, and she has advocated that her readers try going locavore, too. However, we can't all move back to the family farm. The economic foundations of industrialized and postindustrialized nations are based on urban populations with a small percentage of workers working the land, feeding the large rest. For many of us in industrialized or postindustrial regions, our work, our social life, and our daily routines are inextricably bound with the forty-plus-hour workweeks that make producing food difficult, although many farmers must also work full-time in nonfarming jobs to supplement their meager farm income (Kingsolver, 2007). Land is scarce in

urban and suburban settings, and it takes significant innovations to produce food from the available small spaces.

Living off the land is hard. It might well bring joy to those who love planting and harvesting, but I'm under no illusion that the extreme locavore experience à la Kingsolver can be replicated by many. It takes significant amounts of land, know-how, time, and effort to feed a family largely off of one's own farm labor. And it takes some luck—with weather to provide water and sunshine in the right balance at the right time, with wandering wildlife that passes by the fruit of one's labor for other pastures, and with pests that either don't come, are a rare event, or that can be fended off so they don't ruin the harvest. Farmers have always lived with uncertainty—the vagaries of weather, wildlife, and pests can spell disaster, and in the past have meant hunger, even starvation, if the infrastructure to shift food resources was not in place. In today's urbanized regions, many families do not have enough land to feed themselves, and industrialized areas are unlikely to return to a rural model of living. Modern society is built on division of labor—some farm and provide the nourishment to others who work in other sectors. So the beautiful experiment in mindful living off the land that Kingsolver (2007) writes about is, unfortunately, not the answer for modern global needs.

To feed the billions that will inhabit our planet in the coming century, we need efficient farming, but the current model of food production efficiency—large-scale, monoculture farming supplied by agribusiness—is very risky. With this model we live one pest away from massive crop failure, and soil depletion and chemical run-off and cross-contamination are constant challenges (Kingsolver, 2007). The new model of efficiency promoted by sustainability advocates—eating more local food sources, using organic agriculture methods (Kingsolver, 2007), and cutting down on meat consumption (Pollan, 2006, 2008)—has the advantage of being sustainable over the long run. However, there are agricultural experts such as Cornell University professor Craig Meisner (2007) who argue that organic farming cannot feed the growing world population. This would suggest that we are faced with untenable choices: continue on the current risky agribusiness path and hope that it can continue to feed us or change to the organic alternative and perhaps not have enough food.

Today, as in the past, prominent architects and product designers continue to be techno-optimists, believing that good design can improve the world, even that we can design ourselves out of the current environmental mess. This optimism is exemplified by the influential writing of the design team of William McDonough and Michael Braungart (2002):

> We see a world of abundance, not limits. In the midst of a great deal of talk about reducing the ecological footprint, we offer a different vision. What if humans designed products and systems that celebrate an abundance of human

creativity, culture, and productivity? That are so intelligent and safe, our species leaves an ecological footprint to delight in, not lament? (p. 16)

Such seductive enthusiasm for human ingenuity is fueling food production design innovations: architects and product designers, who have been for a long time considerable driving forces behind kitchen efficiency innovations (remember the Taylorized kitchens!), are also at the forefront of the new efficiency of homegrown food (Franck, 2005; Gopnik, 2007; Johnson, 2005; Reith, 2006; Schäfer, 2007).

Some architects and microbiologists are now thinking about how even densely populated urban centers can provide efficient local gardening spaces in an ecologically sustainable manner through "vertical gardens," sometimes also called "farmscrapers" (Despommier, 2008; Matt, 2008). Recently, architects Tagit Klimor and David Knafo designed an award-winning high-rise apartment building that will be built in China that includes 100 square feet of greenhouse space for every apartment ("Award-Winning," 2008). The trellised greenhouses use hydroponics, a growing method that uses nutrient-rich water rather than soil as the growing medium. The water for these systems comes from recycling water used in the apartments and rainwater captured from the building rooftop. According to Knafo, "among its advantages are significant savings in energy, providing fresh, pesticide-free organic food, freeing agricultural land for forests, which contribute to the environment, preventing soil pollution by pesticides, and intelligent use of recycled water for irrigation" ("Award-Winning," 2008). Knafo uses the concept of energy saving, but at issue here is food production efficiency. These small hydroponic greenhouses are so efficient that they could produce a variety of vegetables for a family of four, "with enough left over to generate additional income" ("Award-Winning," 2008).

Building designs like this that allow growing significant amounts of fresh food in small spaces are revolutionary. According to Knafo, the "project constitutes a revolution in the existing social and urban order" ("Award-Winning," 2008). He does not elaborate on what kind of revolution he anticipates, but I would agree that projects like this up-end the existing social order of rural and urban populations. The heretofore nearly impermeable boundary separating rural food production from urban food consumption becomes permeable. With large-scale implementation of systems that employ this new kind of efficiency in food production—homegrown food—the urban dweller is no longer solely dependent on the currently dominant food production process and its risky definition of efficiency. By decentralizing food production and putting individuals in charge of some of their own food production, people become empowered, and they can create responsible land stewardship and decrease dependence on fossil fuels for chemical fertilizers, pesticides, and food transportation.

Conclusion

When I first began this research, I thought that personal efforts for sustainability in food preparation and consumption were a privilege of the wealthy, who could afford to think about and effect sustainable practices in their home kitchens. After reading accounts of the long-term effects of today's food chain from production to consumption, I came to a different conclusion. The dire predictions about future food insecurity in the face of global warming and typical agribusiness practices are truly alarming. That they are steeped in economic reality, and not needlessly alarmist, has been borne out by recent events in places affected first by food scarcity: developing countries. There has been rationing in some countries, like Pakistan, and food riots in many others, including Haiti and Morocco (CBS News, 2008; Seager, 2008). It is only a matter of time before developed countries feel more of the effects of food scarcity and not just in the rapid rise of food prices. Practices that today are considered personal virtues are likely to become economic necessities. Environmental design advocate James Howard Kunstler (2008) states this succinctly: "we'll be forced to make very different arrangements for virtually everything that constitutes everyday life in our society. Living much more locally will increasingly be the only choice....We'll have to grow food differently, at a smaller scale, closer to home, with fewer oil-and-gas-based 'inputs'" (p. 154). No one—rich, poor, young, or old—can afford to ignore the looming crisis; long-term food security is at stake. I for one want to look into my children's eyes in 20 or 30 years and know that I was part of the solution, not the problem.

References

Award-winning technion design for "green building." (2008). American technion society. Retrieved July 15, 2008, from http://www.ats.org/agro.

Bauhaus. (2008). *Tate collection*. Retrieved September 20, 2008, from http://www.tate.org.uk/collections/glossary/definition.jsp?entryId=40.

Bourne, J. (2008, September). Dirt poor. *National Geographic, 214*(3), 108–111.

CBS News The Early Show. (2008, April 23). *As food prices soar, some shortages appear*. Retrieved September 19, 2008, from http://www.cbsnews.com/stories/2008/04/23/earlyshow/main4036816.shtml.

Child, J., Beck, S., & Bertholle, L. (1961). *Mastering the art of French cooking*. New York: Knopf.

Coper, A. (2007). The lawn good-bye. *Dwell, 7*(5), 136, 138, 140.

Creasy, R. (1982). *The complete book of edible landscaping*. San Francisco: Sierra Club.

Despommier, D. (2008). *Environmental Health Science Faculty and Their Research*. Columbia University. Retrieved September 19, 2008, from http://www.cumc.columbia.edu/dept/sph/ehs/4.html.

Ellison, K. (2006). A small answer to a big problem. *Frontiers in Ecology & the Environment, 4*(10), 560.

Fishman, R. (1982). *Modern utopias in the twentieth century*. Cambridge, MA: MIT Press.

Flores, H. C. (2006). *Food not lawns, How to turn your yard into a garden and your neighborhood into a community*. Eugene, OR: Chelsea Green.

Food miles. (2008). Wikipedia.org. Retrieved September 17, 2008, from http://en.wikipedia.org/wiki/Food_miles.

Franck, K. (2005). The city as dining room, market and farm. *Architectural Design, 75*(3), 5–10.

Gopnik, A. (2007, September 3). New York Local. *New Yorker, 83*(26), 60–69.

Haeg, F. (2008). *Edible estates: Attack on the front lawn*. Metropolis Books. Retrieved July 15, 2008, from http://www.fritzhaeg.com/garden/initiatives/edibleestates/main.html.

Johnson, L. (2005). Design for food: Landscape architects find roles in city farms. *Landscape Architecture, 95*(6), 30, 32–38.

KGI in the press: Gardens help families stretch food budgets. (2008, March). *Kitchen Garden International (KGI) Newsletter, 57,* 3.

Kingsolver, B. (2007). *Animal, vegetable, miracle: A year of food life*. New York: HarperPerennial.

Kleinman, S. (2007). Anytime, any place: Mobile information and communication technologies in the culture of efficiency. In S. Kleinman (Ed.), *Displacing place: Mobile communication in the twenty-first century* (pp. 225–233). New York: Peter Lang.

Kourik, R. (1986). *Designing and maintaining your edible landscape naturally*. Santa Rosa, CA: Metamorphic Press.

Kunstler, J. H. (2008, March). Going local. *Metropolis,* 150–154.

Little, A. (2006, July 19). *Writing on the Wal-Mart*. Retrieved September 17, 2008, from http://www.grist.org/news/muck/2006/07/19/gore-walmart/.

Lupton, E. (1993). *Mechanical brides: Women and machines from home to office*. New York: Princeton Architectural Press.

Lupton, E., & Miller J. A. (1992). *The bathroom, the kitchen, and the aesthetics of waste: A process of elimination*. New York: Princeton Architectural Press.

Mann, D. (2008, September). Our good Earth. *National Geographic, 214*(3), 80–107.

Marcus, E. (2003, March 25). TV dinners hit 50. *Daily Press*. Retrieved September 20, 2008, from http://www.dailypress.com/topic/nyc-tvdinner25,0,2302694.story.

Matt. (2008, June 16). *Vertical farms: Growing up sustainably*. Retrieved October 9, 2008, from http://greenupgrader.com/2057/vertical-farms-growing-up-sustainably/.

McDonough, W., & Braungart, M. (2002). *Cradle to cradle*. New York: North Point Press.

Meisner, C. (2007, September 24). Why organic food can't feed the world. *Cosmos*. Retrieved September 19, 2008, from http://www.cosmosmagazine.com/features/online/1601/why-organic-food-cant-feed-world.

Morgan, R. (2008, July 11). Boulder, curbside gardeners spar over right-of-way. *Daily Camera*. Retrieved July 15, 2008, from http://www.dailycamera.com/news/2008/jul/07/boulder-curbside-gardeners-spar-over-right—way/.

Our philosophy. (2008). *Slow Food*. Retrieved November 1, 2008, from http://www.slowfood.com/about_us/eng/philosophy.lasso?-session=slowfoodstore_it:46EB420D1ae1c2E765NLm21209E0&-session=slowsitestore_it:46EB420D1ae1c2E765Qqv21209E2.

Oxford word of the year: Locavore. (2007). *OUP Blog*. Retrieved July 15, 2008, from http://blog.oup.com/2007/11/locavore/.

Peak oil? Peak soil! (2008, March). *Kitchen Garden International (KGI) Newsletter, 57*, 7.

Pollan, M. (2006). *The omnivore's dilemma*. New York: Penguin.

Pollan, M. (2008). *In defense of food*. New York: Penguin.

Portinari, F. (1989). The slow food manifesto. *Slow Food*. Retrieved September 19, 2008, from http://www.slowfood.com/about_us/eng/manifesto.lasso?-session=slowfoodstore_it:4735A5F31676818BCANtU411EDD0&-session=slowsitestore_it:4735A5F31676818BCAjQY411EDD1.

Raver, A. (2008, April 17). Out of the yard and onto the fork. *New York Times*, pp. D1, D6.

Ray, R. (2005). *Rachael Ray 365: No repeats*. New York: Random House.

Ray, R. (2007). *Just in time!* New York: Random House.

Reith, C. (2006). A more protective urban landscape: As the world warms and becomes more populous and urban, more is expected from cityscapes. *Urban Land, 65*(10), 134–136.

Roberts, P. (2008). *The end of food*. Boston, MA: Houghton Mifflin.

Schäfer, R. (2007). Climate, water supply, energy and food: Challenges for the future. *Topos: The International Review of Landscape Architecture and Urban Design, 60*, 16–21.

Schlosser, E. (2001). *Fast food nation*. Boston, MA: Houghton Mifflin.

Schlosser, E. (2008, March). Advertisement for *Edible estates: Attack on the front lawn*. *Metropolis*, 211.

Schumacher, E. F. (1973). *Small is beautiful: Economics as if people mattered*. London: Blond & Briggs.

Seager, A. (2008, Feb. 26). Feed the world? We are fighting a losing battle, UN admits. *The Guardian*. Retrieved September 19, 2008, from http://www.guardian.co.uk/environment/2008/feb/26/food.unitednations.

Smith, M. R. (1991). A garden of edible plants: Design by Rosalind Creasy. In M. R. Smith, *The front garden: New approaches to landscape design* (pp. 141–147). Boston, MA: Houghton Mifflin.

Specter, M. (2008, February 25). Big foot. *New Yorker*, 44–53.

Steffen, A. (Ed.). (2006). *Worldchanging: A user's guide to the 21st century*. New York: Abrams.

Taylor, F. W. (1905). *Shop management*. New York: Harper & Brothers.

Taylor, F. W. (1911). *The principles of scientific management*. New York: Harper & Brothers.

Thompson, P. (2008). Top of the crops. *New Zealand Gardener, 64*(5), 91.

U.S. Environmental Protection Agency. (2006, October). *Methane: Source and emissions*. Retrieved July 15, 2008, from http://www.epa.gov/methane/sources.html.

Waters, A. (2006, September 11). Slow food nation. *The Nation.* Retrieved July 15, 2008, from http://www.thenation.com/doc/20060911/waters.

Waters, A. (2007). *The art of simple food.* New York: Random House.

Who we are. (2008). *Slow Food.* Retrieved September 18, 2008, from http://www.slowfood.com/about_us/eng/campaigns.lasso.

CHAPTER 3

Hyping the Efficiencies of Fast(er) Food

The Glocalization of McDonald's Snack Wrap in Japan

▶ MICHAEL L. MAYNARD

Efficiency means getting things done quickly. Speed in service is king. Who could possibly be against the concept of efficiency? Is it not a positive value in and of itself? Some even claim that the primary, if not the only, goal of human labor and thought is efficiency (Taylor, 1911).

Leaving aside for the moment the question of whether or not an ever-increasing level of efficiency is a positive value in all societies, this chapter examines how an even fast(er) fast food product endorses and enhances a cult of efficiency in an already efficiency-oriented society. The specific case discussed is how McDonald's Snack Wrap product is introduced to Japan.

In fact, efficiency is nearly synonymous with the fast food industry. Part of McDonald's success is attributed to its fast, friendly service. George Ritzer's (1998) McDonaldization thesis postulates that one of the key principles in the worldwide success of McDonald's restaurant chain is, in fact, its emphasis on efficiency.

Clearly, the efficiencies gained from its assembly line structure, division of labor, rigid procedures and structures, as well as the drive-through option, greatly quicken the eating experience. Moreover, Ritzer (2000) claims that McDonald's entire operation of efficiently serving "fast food" has contributed to the worldwide spread of rationalization, a method of process, he cautions, that will tend to make institutions and societies around the world homogenous. The term "McDonaldization," essentially pejorative, assumes an imperialist tone and calls to mind the loss of local culture wherever in the world a McDonald's restaurant breaks ground.

Considering that Ritzer has, by and large, accurately described the drive for production efficiencies McDonald's has pioneered in spreading around the world, this study offers a more neutral assessment of any negative impact such efficiencies have made on other cultures, namely, Japan. To be sure, McDonald's represents a kind of hyper-modernization. But what country could be more hyper, or moving at a faster pace, than modern Japan? McDonald's entrance to Japanese society in 1971 (Watson, 1997), it would seem, represented a matchup of two efficiency-conscious entities from the start.

This study interprets the phenomenon of efficiency as evidenced in the advertising and promotion of the McWrap product as presented to the Japanese market. As a framework for analysis, I draw from the concept of "glocalization," which refers to global products or services customized to suit local cultures (Lamb, n.d.), and discuss how it relates specifically to Japan. In this case study, I closely analyze one advertisement and interpret how the introduction of a new fast food item in Japan exemplifies the process of glocalization while, at the same time, serves to further promote a fast(er), more efficient society. More concretely, I analyze a two-page print advertisement introducing McWrap and explore the marketing tools McDonald's Japan has employed in its promotion, specifically, collaboration with Rip Slyme, a Japanese hip-hop group.

My analysis emphasizes that through the introduction of a made-for-efficiency food product such as the McWrap, McDonald's Japan is promoting a "culture of efficiency" (Kleinman, 2007) in the ever-accelerating lifeworld of contemporary Japan.

Glocalization and the Japanese Market

Originally developed by Japanese business circles in the 1980s (Ohmae, 1990; Robertson, 1996), "glocalization" refers to the process whereby global corporations tailor products and marketing to particular local circumstances to meet variations in consumer demand.

Glocalization is sometimes reported to be a reaction to globalization, which is, in one sense, the fear of transnational domination and uniformity. Thus glocalization is thought to be a reinforcement of cultural identity at the local community level. In terms of how the word applies in the marketing sense, glocalization means that companies have to deal not only with worldwide considerations but also, very expressly, with the specific rules and conditions of each country in which they operate. Glocalization represents the need for multinationals to be global and local at the same time. Put simply, whereas globalization is a move toward centralization, glocalization is a move toward decentralization.

Interestingly, the term "glocalization" applies most appropriately to Japan because the neologism itself, in its synthetic combination of two words, captures the proportionality of local to global. Its root form, "localization," is the foundation for the word. So Japan is the foundation, the dominant actor in the process of the interpretation of the global and local, as it applies to images presented in Japanese media. Everything starts with the local. The local forms the basis of interaction.

In Japanese, "glocalization" is translated as *dochakuka* (Robertson, 1996). The English translations of the three ideographs *do, chaku,* and *ka* are "land," "arrive at," and "process of." Thus a most literal translation of *dochakuka* conceptualizes the relationship between the multinational marketer and the host country as one of agency, that is, the outsider arrives and acts upon the host culture, attempting to be perceived as native.

This said, however, the global reality of an increasingly integrated world of communications cannot be ignored. Thus, particularly in terms of marketing, the "g" of "global" joins the "local" to create a "glocal" entity. The "g" fused onto the word "localization" graphically captures the melding process of interpenetration.

Global advertising fosters the creation of "one sight, one sound, one sell" (O'Barr, 1989), but it rarely succeeds as a standardized communication strategy. Contrary to Theodore Levitt's (1983) call for global marketers to ignore cultural differences, transnationals such as McDonald's inevitably make adjustments to the persuasive tactics, the endorsements made, even the naming of the product, to conform to the various cultures where the product is marketed. Note, for example, that McDonald's has modified its menu so that it serves kosher food in Israel, mutton burgers in India, and teriyaki burgers in Japan (Frith & Mueller, 2006).

Background:
Japan's Efficiency in Communication and Food

Modern-day Japan is emblematic of a culture of efficiency. From its fast, reliable bullet trains to its miracle post-World War II economic success, Japan has often set a dizzying pace for innovation. Japan is considered to have one of the world's most technologically advanced media infrastructures, with widespread use of broadband Internet connections, direct-broadcast satellite networks, and, significantly, a highly sophisticated mobile phone system. All of these advanced technologies have contributed to an increase in the speed of connectivity. Speed, of course, is rational. Speed can be counted upon to deliver practical, material, calculable advantages. Speed has an "almost Darwinian explanation of its economic advantages" (Gitlin, 2002, p. 103). The speed and efficiency in communication have been augmented through Japan's "*keitai* culture," a recent explosion of personalized, generally socially networked, digital connectivity. The Japanese word *keitai* means "portable," and specifically refers to personal cell phones. Being "mobile" is a significant cultural movement among the young in Japan. According to Mizuko Ito (2003), "Among college, high school and middle school girls who own *keitai*, *keitai* e-mail use is effectively 100 percent. Boys are not far behind with 88 percent in the middle school and high school group, and 96 percent among college students."

The *keitai* culture in Japan is nothing short of phenomenal. In 2007, overall mobile cell phone penetration in Japan topped 83 percent (International Telecommunications Union, 2008). By now, the numbers for the youth in Japan must be staggering, because according to a survey conducted in 2001, already among twenty-somethings, *keitai* penetration was 89.6 percent, among those enrolled in college, 97.8 percent, and among high school students, 78.8 (Ito, 2003).

The ability to connect with others whenever and wherever has quickened the pace and frequency of everyday communication, especially among youth. The mobile phone has become such an integral part of the contemporary young Japanese person's life that having one is simply something taken for granted. In addition to the increased number of calls and text messages with friends and family, typically multiple times each day, the accelerating rate of innovation in digital technology, such as newer capacities for camera, video, even *karaoke,* has increased the potential for efficiency. From anywhere, at virtually any time, those fully engaged in *keitai* culture can quickly connect with others. The almost obscene level of frequent contacts is reported in Ito's (2003) participant observational study: "One teenage couple exchanged 30 text messages over the course of three hours as they watched television, ate dinner, and did their homework, before engaging in a one-hour phone

conversation. This voice contact was followed by another trail of 22 messages that kept them in contact until bedtime."

Note that the frequency of contact requires at least one hand constantly engaged in the activity, either by holding the phone or by text messaging. The introduction of a new snack food that fits this lifestyle, a new snack food that one can eat using just one hand—the other one—would be welcomed.

It should be added here that the concept of efficiency in food consumption, that is, fast food, is not an entirely new phenomenon in Japan. The concept of fast food, at least since World War II, seems to have been one part of Japanese eating culture. Arguably, on the run and in a hurry, Japanese workers who have short lunch breaks have probably always sought out places where they can quickly slurp up noodles, efficiently nibble on those paper-thin slivers of pork atop the broth, snappily pick up those gossamer bits of green onion with chopsticks, and fast be on their way.

Since the 1980s, the ubiquitous convenience stores in Japan, such as Family Mart and 7-Eleven, have catered to those hurried individuals who prefer quick, ready-made, inexpensive, and easy-to-eat snacks. The inexpensive, more traditional Japanese easy-to-eat food *onigiri* (a rice ball wrapped in seaweed) is readily available at these convenience stores and has become quite popular. Its popularity, no doubt, stems in large part from its efficiencies. A key benefit of the *onigiri* is that it can be eaten cleanly with just one hand.

First introduced to Japan in 1971 (Watson, 1997), today McDonald's is just as much a part of Japan as the local noodle shop. An entire generation of children has grown up with the golden arches. With the by-now-familiar option of Western fast food available to the Japanese, coupled with the recent popularity of portable food items, it is not surprising that McDonald's Japan would introduce its glocalized version of the McDonald's Snack Wrap.

The McDonald's U.S. Product: Snack Wrap

McDonald's Snack Wrap falls into the portable food category because it can be eaten neatly with just one hand. It is made with juicy premium chicken breast meat; cheddar jack cheese; crisp lettuce; choice of ranch sauce, honey mustard, or Chipotle barbeque dressing; and wrapped with a soft flour tortilla. When the choices are grilled chicken with honey mustard as the topping, the reported number of calories is just 260.

Given the declining trend of U.S. families sitting down together for shared eating experiences, and at the same time, following the trend of individuals seeking health, or at least healthy food, the Snack Wrap appears to be right for its time. Moreover, according to Barbara Young (2007), the concept of

"grazing," where instead of following the traditional three-squares a day habit, people are eating smaller portions of food throughout the day, supports the launch of the Snack Wrap. After all, it is more efficient.

The Snack Wrap was introduced in the U.S. on August 1, 2006. In November, it was introduced to Australia, and, at least according to the advertisement examined in this chapter, the Snack Wrap (with modification) became available in Japan in December 2007.

Introducing McWrap for the Japanese Market

In North America, the product name is Snack Wrap. In Japan, the product name has been changed to McWrap. This is an example of glocalization where the home country (U.S.) accommodates the host country (Japan) in order to more intimately identify with, and relate to, the Japanese culture, specifically with respect to consumer expectations and linguistic features.

Two points plausibly explain the decision to change the name for the Japanese market. First, from a branding perspective, the McDonald's identity in Japan gains its strength from the "Mc" prefix. McDonald's owns it. It is a familiar tag, one clearly distinguishing McDonald's from its competitors. Put it in front of another food item and the consumer easily grasps the line extension connection to the franchise (for example, McMuffin and McNuggets). Arguably, management would not like to give it up.

Second, from a linguistic perspective, retaining the "Mc" would appear to cause problems in English because attaching "Mc" to "wrap" produces an unfortunate combination that forces the enunciation of the word "crap." (One would read it "Mc-Crap.") This poses no problem for the Japanese, however, since "crap" is not commonly understood by Japanese consumers. And, in fact, other neologisms of strange English brand names have become accepted in Japan's modern, linguistically hybrid culture (for example, "Creap" powdered cream, "Calpis" soft drink, and Pokari "Sweat" sports drink).

Beyond the accommodation of the name change, the Japanese McWrap offers customers a second selection. In addition to the Chicken Caesar, McDonald's customers in Japan can order a Shrimp McWrap. Again, exemplifying the process of glocalization, adding this seafood option to the menu specifically caters to Japanese tastes.

Advertising McWrap

A two-page advertisement for McDonald's McWrap appears on pages 241 and 242 in the December 2007 issue (Number 259) of *Men's Non-no*, a fashion/lifestyle magazine targeting young, urban, hip Japanese males. The right-hand page (the page read first in traditional Japanese printed material)

prominently features a hand that is holding the Chicken Caesar McWrap. The hand is extended forward, as if the product is being offered to the reader. This visually invites us to try the product. Additionally, the visual communicates the key selling point of portability. Perhaps more important, the visual presentation demonstrates that the McWrap can be eaten with just one hand.

Indeed, the benefit of convenience is heavily emphasized in the copy. Appealing (indirectly) to the benefit of "hands free," which is closely associated with the values fostered in the electronic, gadget-filled *keitai* culture, the subheading advocates the benefit of "free style," literally saying, "The birth of this new food item, McWrap, is okay with only one hand."

The text in the copy, presented vertically in classical Japanese style, further stresses the benefit of one-hand convenience:

> McWrap, newly introduced at McDonald's, is the one-hand-style food item you can bite into with just one hand. Because it isn't the kind (like hamburgers and sandwiches) you'd bite into while holding with both hands, your other hand is completely free. It's really stylish. (Author's translation)

Additionally, the subsequent paragraph situates for the reader the suggested environment in which the fast(er) food item McWrap might ideally be consumed. Note that in addition to the benefits of being handy, the copy directly refers to *keitai* culture. McWrap is a product that enhances the efficiency required to sustain the *keitai* culture.

> This style is okay even when you're text-messaging on your *keitai*, or holding hands with your girl. Besides, because it's small in size, it's perfectly handy when you feel "I'm a bit hungry." It's also great when you want to add something extra to your menu when you're ready to eat a big meal. In short, McWrap is a free-style new food type you can eat wherever you happen to be, regardless of the situation. If you haven't tried it, hurry to McDonald's right away. And get a taste of freedom along with the taste of new food. (Author's translation)

Promoting McWrap Through Collaboration with Rip Slyme

It is no secret that in Japan celebrities are often featured in advertisements. They may not directly endorse the product or service. Merely their presence, in association with the product, is considered a positive boost to the brand's image. Beyond the choice of a currently popular actor, singer, athlete, or what the Japanese call a celebrity "talent," advertisers may even select a cartoon character. Foreign celebrities also are sometimes recruited to add star quality to domestic brands. Brad Pitt, for example, appeared recently in com-

mercials for SoftBank, a Japanese *keitai* and telecommunication service company.

In this case, the celebrity endorsers for McDonald's are the five members of the hip-hop group Rip Slyme. Similar to the custom in the U.S., where rappers and hip-hop bands project edgy personae and often take liberties with grammar in the construction of their names (for example, Outkast, Three 6 Mafia, Tech N9ne), the Japanese also take on raunchy, playfully constructed names. The Japanese penchant for cultural play, in particular with the English language, accounts in part for the group's so-bad-it's-good name.

As the story goes, the thinking behind the group's name was based on the phrase "lip rhyme," which succinctly sums up the rapid-fire rhymes in the music made popular by American rappers. Three of the key players in the group have first names whose initial letters spell R-I-P. Since "Rip Rhyme" poses pronunciation issues, the group changed the second word to "slyme," apparently fully aware that it is a mischievous play on "slime," and thus instantly contributing to the group's identity as (at least in its first seven years or so) a countercultural Japanese-as-rapper-lite, hip-hop band.

Rip Slyme is arguably the most popular contemporary Japanese hip-hop group in Japan. The group has won many awards for their music, and their popularity has led to the use of their music in advertising for major brands such as Nike, Sony, and, in this case, McDonald's.

Curiously, McDonald's association with Rip Slyme in the promotion is billed as a collaboration, but the collaboration is simply the marketing tie-in of the introduction of McWrap with Rip Slyme. In Japan, however, it should be noted that the English word "collaboration" has come to carry a very positive connotation of group togetherness, even team spirit. It may be a bit faddish, but marketers in Japan who put together a promotion that can be called a collaboration seem to be riding a trend that signals a collectivist social value that reflects quite positively on the brand.

Prominently displayed in the upper right corner of the first page, a box reads "Pick Up Collaboration." Again, unintentionally creating a phrase that might give English speakers pause, the initial letters of the first two words stand out by being in a larger font and in a different color so that one reads "P-U," the exclamation one might blurt out when confronted with an unpleasant odor. But this interpretation doesn't register and is not offensive to the Japanese market.

Turning now to the other half of the two-page spread, the dominant vertical visual on the left-hand page of the McDonald's advertisement features the five Rip Slyme members striking funky poses. The headline reads, "McWrap times Rip Slyme! It's a dream collaboration: WRAP SLYME!" The two words "WRAP SLYME," of course, create an unfortunate image to native

English speakers (slime, somehow, wrapped?). Again, this does not raise concern to the Japanese. And perhaps for those Japanese who can picture the literal English meaning of "wrap slyme," the phrase serves as an inside joke.

Along the side of this second page, blocked rows of horizontal copy appear. In these blocks, in descending order, three collaborations referenced on the first page are described. Collaboration 1: the band will perform live concerts at McDonald's outlets throughout all of Japan. Collaboration 2: the group has recorded a special version of its new release *Speed King*, with new lyrics specifically related to the Wrap Slyme promotion with McDonald's. Collaboration 3: simply by placing a mobile phone against the code at the bottom of the page, the reader (of the advertisement) can view the making of the Wrap Slyme commercial on the Web. In addition, the mobile phone connection allows registration in the special *keitai* site of the McDonald's club, thereby also registering entrance to the lottery for a chance to win Rip Slyme's new album.

Practically every aspect of the two-page McDonald's advertisement plays to a culture that values efficiency and speed. The product is designed to resonate with the faster, if not the fastest, consumers of fast food—those who save time by multitasking. It is more efficient to be able to eat with one hand, as the copy in the text suggests, because with your other hand "you're text-messaging on your *keitai*."

Addressing now what, beyond the product itself, contributes to the hyping of the efficiency related to the new, and even handier, fast(er) fast food item, three elements are most prominent. First, the theme of speed is cleverly captured in the title of the promotional campaign's single, *Speed King*. Both in a literal sense of the words and in the promoted sped-up, hyped lifestyle of a hip-hop culture, speed really is king. In particular, Rip Slyme followers familiar with the fast-paced video are encouraged to identify with the tense, restless, multilayered technopop beat of modern life. The *Speed King* video accessed through the Internet (available on YouTube) shows the five players in skeleton costumes gyrating to the upbeat, repetitive rat-a-rat-rat rhythm and words (sort of like Danny and the Juniors' 1958 hit "At the Hop," only now on steroids). The group nimbly gyrates to the incessantly pulsating video game-like beat, pausing dramatically to strike theatrical in-your-face rapper-style poses. All in all, the *Speed King* video is a pop celebration of the rush one gets from life lived in the fast lane.

Second, the value of fast, efficient connectivity is promoted through the collaboration between McDonald's and Rip Slyme. As mentioned earlier, here the reader is directly invited to participate in Japan's *keitai* culture. By simply holding the cell phone close to the bar code embedded in the page, the reader effortlessly and efficiently joins the McDonald's *keitai* site and

has a chance to win the group's new album. Equally so, the reader quickly and effortlessly identifies membership in the fast crowd of Japan's youthful anywhere-anytime nomadic, mobile *keitai* culture. The link to the site promotes participation in a highly efficient, instantaneous, socially networked communication system.

And third, the influence of U.S. rapper and hip-hop culture, which, by and large, promotes a fast, hyper music and fast-paced lifestyle, contributes to a quickening of the pace of life in Japan.

Conclusion

Although advertising is thought simply to be a somewhat distorted mirror of society, reflecting selected norms and values already extant in the culture (Pollay, 1986), it is reasonable to assume that advertising can also serve as a powerful accelerator of those norms and values. To wit, taking up a fast paced, connected lifestyle is highly valued by the Japanese and the McDonald's promotion introducing its free-style, one-handed snack is a message that resonates with an appeal to the social norm of striving for efficiency. Effective advertising creatively highlights this value, holds it up, valorizes it, and thus consequently reinforces its worth. The McDonald's advertisement, by cleverly celebrating the values of speed and efficiency through its collaboration with Japan's hyper hip-hop group in joint promotion of its "made for efficiency" wrap, contributes to the reification of a faster society. And it does so entirely on Japan's terms, by glocalizing the product, by glocalizing the message, and by glocalizing the celebrity endorser.

Assuming that from a sociological perspective the style of the dominant tends to become the dominant style, advertising plays an important role. Advertising's mirror-like reflection of the norms of efficiency and connectedness accelerates the desired style for even faster-paced efficiencies and even greater connectedness.

There was a time when multitasking raised a few eyebrows. In Japan during the 1960s and 1970s, ironically, at a time when imported fast food chains such as McDonald's as well as Kentucky Fried Chicken were being introduced, the cultural norm, as enforced by parents and adults, was to perform one task at a time. The general consensus held that by doing a single activity, one would concentrate fully and would thus do the chore to the best of one's ability. Accordingly, those who violated this cultural norm were likely to be chided, and thus, for example, were more likely to be instructed not to watch television while doing one's homework. The errant child was told to turn off the television and devote full attention to studying.

As is often the case, the Japanese came up with a phrase to describe this new phenomenon. The phrase *nagara zoku,* which literally translates to "the

while-doing tribe," was often used in a scolding manner to describe anyone who did two (or even more) things at the same time. Eating food while walking down the street, for example, was frowned upon. The correct way of consuming food was to stay put, seated appropriately at a table. Or, in the case of snacking on a candy bar or ice cream sandwich, one was supposed to stand off to the side of the stream of pedestrian traffic and remain stationary until the food was completely consumed.

How quaint this societal norm of one-thing-at-a-time seems to be when observing behavior in Japan today. Multitasking, it would seem, has replaced entirely the single-task norm. Multitasking, once embraced, seems to engender an ever-expanding voracious appetite for adding on even more tasks to take on simultaneously. A combination of factors has contributed to the multitasking faster, busier pace of life. Certainly the revolution in faster, smaller communication technologies has encouraged the trend toward speed and efficiency in doing things.

A McDonald's ad directed to the Japanese back in the 1970s would not likely have highlighted the benefit of being able to eat the food item with one hand, thus freeing up the other hand to perform a separate task. This most likely would have been frowned upon as advocating *nagara zoku*. Today, however, in contrast, *nagara* is very much in style. And given the hyped-up, faster pace of life today, text messaging while biting into the handy McWrap is, after all, quite rational.

Whether an ever-quickening stream of new communication technologies combined with an ever-quickening introduction of fast(er) fast food products is a positive development for any society is a question worthy of much discussion. Given the analysis of the McDonald's advertisement here, the answer might be a qualified yes and no. Yes, speed and efficiency are undeniable assets in achieving a better society. But no, if too fast a tempo in trying to keep up with the ever-evolving changes results in driving people crazy, it would seem prudent that individuals should find ways of slowing things down.

Yet, pragmatically, living and working in a culture already running at a hyper pace, the efficiencies gained in choosing the McWrap for a snack while simultaneously text messaging would seem to make good sense. Equally so, running an advertisement that hypes the benefit of a fast(er) fast food snack and associates the hipness of the snack with a hugely popular hip-hop group in a high-style magazine directed at hip young men in Japan would also seem to make good sense.

What this case study shows is that the McDonald's advertisement is promoting much more than simply the introduction of the McWrap food item to the Japanese market. The McDonald's advertisement is promoting efficiency in every sense of the word.

References

Frith, K. T., & Mueller, B. (2006). *Advertising and societies: Global issues.* New York: Peter Lang.

Gitlin, T. (2002). *Media unlimited: How the torrent of images and sounds overwhelms our lives.* New York: Henry Holt.

International Telecommunications Union. (2008). Retrieved October 8, 2008, from http://www.itu.int/ITU-D/ICTEYE/Indicators/Indicators.aspx.

Ito, M. (2003). A new set of social rules for a newly wireless society. *Japan Media Review.* Retrieved March 12, 2008, from http://www.japanmediareview.com/japan/wireless/1043770650.php.

Kleinman, S. (2007). Anytime, any place: Mobile information and communication technologies in the culture of efficiency. In S. Kleinman (Ed.), *Displacing place: Mobile communication in the twenty-first century* (pp. 225–233). New York: Peter Lang.

Lamb, R. (n.d.). *What is glocalization?* Retrieved October 18, 2008, from http://money.howstuffworks.com/glocalization.htm.

Levitt, T. (1983). The globalization of markets. *Harvard Business Review, 61,* 92–101.

O'Barr, W. (1989). The airbrushing of culture: An insider look at global advertising. Interview with Marcio M. Moreira. *Advertising & Society Review, 2*(1), 1–19.

Ohmae, K. (1990). *The borderless world.* London: Collins.

Pollay, R. W. (1986). The distorted mirror: Reflections on the unintended consequences of advertising. *Journal of Marketing, 50*(2), 18–36.

Ritzer, G. (1998). The McDonaldization thesis: Is expansion inevitable? *International Sociology, 13,* 291–308.

Ritzer, G. (2000). *The McDonaldization of society: An investigation into the changing character of contemporary society* (3rd ed.). Thousand Oaks, CA: Pine Forge.

Robertson, R. (1996). Comments on the global triad and glocalization. In N. Inoue (Ed.), *Globalization and Indigenous Culture* (pp. 221–225). Tokyo: Kokugakuin University.

Taylor, F. W. (1911). *The principles of scientific management.* New York: Harper & Brothers.

Watson, J. L. (1997). *Golden arches east: McDonald's in East Asia.* Berkeley: University of California Press.

Young, B. (2007). Grazing by the handful: McDonald's joins the portable-food category with its new chicken Snack Wrap. *The National Provisioner.* Retrieved November 1, 2008, from http://www.allbusiness.com/retail-trade/food-beverage-stores/3894421–1.html.

CHAPTER 4

Efficiency, Effectiveness, and Web 2.0

▶ NATHAN JURGENSON & GEORGE RITZER

Efficiency was, and to some degree still is, at the center of modernity. However, there is a broad consensus that we are no longer in the heart of modernity. To some (Beck, 1992; Giddens, 1990), this means that we are in some sort of "late" phase of modernity, and others believe that we can glimpse a new postmodern world from our position in late modernity (Bauman, 1992). Still others seem to suggest that we are already well beyond modernity and that we are already living in a postmodern world (Baudrillard, 1983; Virilio, 1995). If we assume, at the minimum, that we are living in a late modern, if not postmodern, world, what does that mean for the emphasis on efficiency that was so central to "high modernity"?

Efficiency, of course, is just one aspect of what Max Weber (1927/1981) saw as the most important aspect of the emergence of the modern world—rationalization. That is, the modern world witnessed the emergence of modern structures and systems, most important for Weber, the bureaucracy that, among other things, operated in a highly efficient manner. However, if we

no longer live in a modern world, does that mean that we no longer live in a rationalized, or even a rational, world? This is suggested by at least some who write about late modernity. For example, Zygmunt Bauman's (1989) work on the irrationalities of the Holocaust can be taken to mean that with it we have entered a less rational, late modern world. More extremely, the postmodernists suggest that the contemporary world is not only less rational, it is downright irrational. Whether we live in a less rational, or irrational, world, the implication is that it is a less efficient, if not completely inefficient, world.

Putting efficiency in this context means, among other things, that it needs to be considered not in isolation, but as one aspect of rationalization. However, it can be argued that the other dimensions of rationalization—calculability, predictability, and control through the substitution of nonhuman for human technology (Kalberg, 1980; Levine, 1981; Ritzer, 2008)—are subordinated to it and serve to permit, or heighten, efficiency.

Before getting to these other dimensions of rationalization, we need to deal with what we mean by efficiency in this context. For one thing, it means that the goals are given; they are not at issue. The presupposition is that there is a best way to achieve such goals. For another, this means that whatever the goals, the emphasis is on discovering and utilizing the best, the optimum, means to those ends. An efficient system is one in which the best possible means is found and used to achieve or attain whatever end is chosen.

Turning to the other dimensions of rationalization, calculability involves an emphasis on quantification, on that which can be counted. Conversely, it means a deemphasis on that which is qualitative since such things are difficult, if not impossible, to quantify. To operate efficiently certainly requires that various aspects of an operation be quantified, be measurable in some way. That which is measured can then be streamlined, reduced, or minimized in various ways in order to maximize efficiency. For example, in a manufacturing facility, that which can be measured includes the amount of time it takes to get needed components, the time needed to assemble those components, how quickly the finished product can be gotten out the door, and so forth.

In a concrete example, the Japanese automobile manufacturers used such calculations in order to move from the less efficient American "just in case" system to the far more efficient "just in time" system (Schonberger, 1982). In the "just in case" system, components and raw materials were stored in or near a production facility just in case they were needed. This was quite inefficient because much of this was stored for long periods of time (at measurably high cost), some components may have been stored so long that they deteriorated and became unusable, and, in any case, this

method was inefficient because parts arrived in the factory long before they were needed. In the "just in time" system pioneered by the Japanese beginning in the early 1970s (Cheng & Podolsky, 1996), close calculation of every step involved in the production of components, their shipment to factories, and exactly when they needed to arrive made for a much more efficient manufacturing process.

Predictability is also central to efficiency. An efficient operation is one that operates in much the same way time after time. Thus, it requires that every aspect of the operation operate in a highly predictable manner. At any step along the way, unpredictable events would lead to inefficient operations. Both the just-in-case and the just-in-time systems required that operations be predictable, but predictability was much more important to the far more efficient just-in-time system. This is clearest at the point of final assembly where if just the right component did not arrive at precisely the moment it was to be installed into the final product, the entire production process could grind to a halt.

Human beings, being human, tend to be inefficient. The result is that most rationalized systems seek to reduce the human element through the substitution of nonhuman for human technologies. Further, management can exert far greater control over nonthinking, nonhuman technologies than they can over thoughtful humans. That control can be, and is, used to, among other things, heighten the efficiency of operations. Just-in-time systems rely on all sorts of nonhuman technologies such as computers and robots, and these serve to heighten efficiency in comparison to just-in-case systems that, themselves, are driven in the direction of substituting nonhuman for human technology, but that have tended to continue to rely more on humans with all of their attendant unpredictabilities.

Thus, it could be argued that rationalization is ultimately all about efficiency, about heightening efficiency to ever-higher degrees. While we are reluctant to go that far here, it is nevertheless clear that efficiency is central to, if not the most central aspect of, rationalization.

This all sounds well and good, but there are many problems with a single-minded focus on efficiency, including the inefficiency of efficiency—traffic jams prevent deliveries of components just in time and lines slow the supposedly efficient drive-through windows at fast food restaurants—and this is just one aspect of the larger problem of the irrationality of rationality (Bauman, 1989; Ritzer, 2008; Weber, 1927/1981). However, in this chapter we address another problem—*in*effectiveness—as it relates to efficiency. That is, we argue that high levels of efficiency tend to be associated with ineffectiveness. Ineffectiveness, of course, depends on a definition of what is effective. For this discussion, effectiveness means a focus on quality rather than quantity. Similarly, to Victor Magagna (1988), effectiveness refers to

the attainment of goals irrespective of cost. This, of course, is the reverse of the emphasis in rationalized systems on quantity (especially cost) over quality, which often leads to poor quality outcomes (cars that roll off the assembly line with all sorts of flaws, hamburgers served without any meat at fast food restaurants). To be effective often means surrendering at least some efficiency. Automobiles may be produced less efficiently so that they are flawless, or nearly so, when they exit the assembly line; hamburgers can always be served with meat because more care is taken in preparing and in serving them. The fatal flaw in rationalized, highly efficient systems has always been their tendency toward ineffectiveness, for example, poor quality of work on the assembly line and red tape in the bureaucracy.

All of this relates to another important distinction in Weber's theory of rationalization, that is, his distinction between formal and substantive rationality. It could be argued that formally rational systems emphasize efficiency and therefore tend toward ineffectiveness. In contrast, substantively rational systems, because they are driven more by larger values and less by structurally determined and practical guidelines for efficient operation, tend to be less efficient, but more effective. In Weber's theory, with the rise of modernity, substantive rationality tended to be subordinated to formal rationality. However, we can ask whether in a late modern or postmodern era we are seeing something of a return to the former and a decline in the latter. This is the case on the Internet where the older and more formally rational Web 1.0 has, to a great extent, been supplanted by the newer and more substantively rational Web 2.0. While Web 1.0 was driven by practical considerations and was structurally determined, Web 2.0 is driven much more by larger values, such as libertarianism. However, the presence of capitalistic businesses on Web 2.0 threatens those values, and substantive rationality more generally, and brings with it a potential return to a more formally rational Web.

Given this conceptual background, we can get closer to the focal concern of this chapter. That is, if we are in a late or postmodern world, does that mean that it is not only one that is less rational, less efficient, but also perhaps more effective? Such a question is difficult, to put it mildly, to answer in the abstract, but it can be better addressed with a specific case. No phenomenon relates better to either a late modern or postmodern world than the Internet. It can be argued that its initial phase, Web 1.0, was highly rationalized, efficient, and, to some degree, ineffective. However, in its emergent phase, Web 2.0, it has arguably grown less rationalized, less efficient, but more effective. In the following pages we will briefly analyze Web 1.0 and then offer an in-depth analysis of Web 2.0, from this perspective.

Before doing this, we should make clear how we are defining Web 1.0 and 2.0. One could simply see these as indicating time periods, where the

Internet that existed before the dot-com bubble burst is Web 1.0 (similarly, it is sometimes seen as the first decade of the Internet, the 1990s). That which exists presently is Web 2.0 (or, the second decade, the 2000s), and whatever the Internet has in store in the future is tentatively labeled Web 3.0. Others might see the shift in terms of connectivity speed, where Web 1.0 was most likely to be experienced through dial-up connections and Web 2.0 by high-speed connections. Still others view this move from Web 1.0 to 2.0 as the Internet shifting from existing exclusively on a computer screen toward other, often mobile, platforms. However, here, we do not accept these definitions that see Web 1.0 and 2.0 as being completely distinct. Instead, we see them as overlapping phenomena. While Web 1.0 and 2.0 have always coexisted, this chapter deals mainly with the emerging importance of the latter. It is the explosion of user-generated content that defines Web 2.0 and differentiates it from the provider-generated content of Web 1.0. Web 2.0 is bottom-up, while Web 1.0 is more top-down.

Web 1.0

Web 1.0 systems are highly efficient, but not necessarily very effective. In the main, their efficiency stems from the fact that they are top-down systems. This makes them not only efficient to create from the point of view of their creators (no time-consuming interference from users) but also from the perspective of those who use them (no need to improvise, just use as directed). The latter have little or no choice in how to use these systems, with the result that they are used in essentially the same way by everyone (efficient in itself), but also in the efficient manner that is intended by their creators. However, because of this, and especially because users have little choice in how to use them, Web 1.0 systems are not highly effective. That is, their effectiveness can be improved by the ability to accommodate changes and inputs from users.

Since we view Web 1.0 as being a top-down experience, we can point to examples of Web sites in the past that had not yet taken advantage of user generation as well as sites that remain top-down today. Examples of Web 1.0 include:

- Switchboard.com and YellowPages.com, which dictate how users are supposed to find people and businesses through the framework of the sites;
- The Apple Store and other shopping sites that dictate the content and users' browsing (and shopping);

- News sites in the past consumed by users without the abilities to comment or for communities to direct searches through "most e-mailed," "most blogged," or "most searched" lists; and
- Fodors.com, whose own tastemakers point tourists to various hotels, restaurants, activities, and so forth. More general information is searched for on sites like about.com, whose creators employ "experts" to help users find information.

It is very tempting to offer a "grand narrative" (Lyotard, 1984) of a shift over time from a top-down and efficient Web 1.0 to a bottom-up and effective Web 2.0. However, not only are such grand narratives passé, but like all grand narratives it would be far too simplistic. The truth is that the cyber-libertarian ideology behind Web 2.0 that seeks to keep the Internet free and open was present in Web 1.0, indeed, at the very beginning of all thinking about the Internet's possibilities. The Internet, much like many other technologies, was conceived by some as a revolutionary, if not utopian, development that would bring great increases in freedom for those involved. In spite of such great hopes and grand ambitions, the Internet did not long resist corporate structures, hierarchies, and control. Companies like AOL and Microsoft sought to control many Internet technologies with their own products and to purchase online real estate much in the same way this occurs in the material world. In this way, Web 1.0 came to lose much of its libertarian ideals as corporate entities began to control it and created Internet products that structured and greatly limited the ways in which individuals used them.

Of course, at the time, this was not how many saw the Internet. It is with the benefit of hindsight that we can conceive of the Internet as ever having been top-down and that we can call it Web 1.0 as a retrospective label in order to contrast it to the Web 2.0 that emerged subsequently. While the Internet today is increasingly a place for users to produce content, it was not always this way. Web 1.0 was an attempt to reposition online the traditional business models of the physical world. At the time, this did not seem, as it might now, overtly top-down or constraining to much of the business community or to many of the users. Web 1.0, heavily supported by venture capital, was a major force in the emergence of the dot-com bubble of online businesses in the late 1990s. In 2000, that bubble burst due to the frantic expenditure of money on business models that were simply incapable, at least at the time, of being profitable.

However, the cyber-libertarian ideals that predated Web 1.0 had not disappeared. Those who bought into these ideals saw the bursting of the Web 1.0 bubble as an opportunity, as having the potential for "creative destruction" (Schumpeter, 1942). According to Joseph Schumpeter, the essence of

capitalism is its continual ability to destroy the old in order to make way for the new. In this case, the destruction of Web 1.0 (or at least some of it) was seen as a needed prerequisite of Web 2.0. To put it in other terms, the possibility of the emergence of a "flat world" (Friedman, 2005) lay under the ruins of hierarchies that were at the base of Web 1.0. Here was the opportunity for another attempt to actualize the libertarian project online. This time it was fueled by, among other factors, the failure of the Internet to produce the expected profits and, more positively, the power of new high-speed technologies that enable infinitely more users to interact online. The Internet as fast, accessible, usable, and as something that is always on, akin to other utilities, opens the door to a new kind of online experience.

Before moving on to Web 2.0, let us look at how Web 1.0 fits the overall argument that it was a modern structure focused on efficiency and a formal rationality. The logic of efficiency drove corporations onto the Internet because of the ability to quickly create Web sites at little cost. The idea was that great output (especially profits) would result from little input (low investment). The Internet was seen as a new field with exciting new opportunities in which to promote products and services, ultimately with the possibility of turning a substantial profit. It would have made little sense to businesses that at that time also existed in the material world to even consider some of the basic tenets of Web 2.0's "Wikinomics" (Tapscott & Williams, 2006); for example, to turn over, to some degree, productive control of a product to the consumers. Instead, Web 1.0, as a corporate system, sought to sell preset products to as many individuals as possible. This is an efficient system, one that has a clearly set goal, and constrains the actions of users in ways best designed to achieve that goal.

Not only was it efficient for producers to create Web 1.0 sites, this arrangement was also efficient from the perspective of the users. That is, they had little if any choice. They did not need to agonize over what they were to do at a Web 1.0 site or how they were to do it. And, they did not need to "work" on the site. There was no need to do so and even if there was, there was no provision for allowing alterations by users.

The user experience on Web 1.0 was characterized by running an operating system and Web browser that were generic and allowed for little personalization. They were constructed by corporations that kept their computer programming code to themselves. One's code was seen as precious and sacred, a product that should be patented, trademarked, and protected. Of course, some production by users did take place in the form of e-mail, on message boards, in chat rooms, and on personal Web pages. However, in comparison to today's Internet technologies, mass user production, social networking, and collaboration were cumbersome and, again, limited to the very few, often experts in computer technology. If people had digital photos and videos, they

were not likely to be shared with many others online. Information on Web 1.0 was to be searched for and consumed by users, as opposed to being created by them. News and opinion were likely to be searched for in a similar fashion. In sum, Web 1.0 could be characterized by the experience of "looking stuff up" with the goal of doing this as efficiently as possible.

AOL dominated the Internet enterprise in the Web 1.0 era, with its ubiquitous "you've got mail." In fact, for many people AOL was synonymous with the Internet experience itself. The company's goal was to structure the Internet experience for users through a framework created by AOL. Customers used its software, which it aggressively sent on CD-ROMs to mailboxes nationwide and in Europe, to access AOL's preset version of the Internet experience.

Eventually, AOL opened the entire Internet to its subscribers, but it still attempted to prepackage users' experience. In 2002, the company was forced to pay $15.5 million to settle a class-action lawsuit because it was claimed that the software worked in such a way that it prevented software from other Internet service providers from working on computers that were running AOL's software (Kopytoff, 2002).

While Zygmunt Bauman (2000) described this digital corporatism (using not AOL, but Bill Gates and Microsoft as the prime example) as being "lighter" and more fluid than the capitalism that came before it, the structured Internet experience that characterized Web 1.0 was still quite "heavy" in the sense that it was run by large corporations that imposed their way of doing things on users. This was the "heavy" Web, based, to a large extent, on bureaucratic control, tight regulation, limitations on users, and the application of the same basic rules to everyone irrespective of their particular needs and interests. All of this is to say that Web 1.0 was characterized by Max Weber's (1921/1968a) "formal rationality" where success (measured here by ease of management by the provider and ease of use by the user) is gained through control through the use of nonhuman technologies.

The efficiency of this formally rational Web 1.0 led to ineffectiveness, as evidenced by lawsuits and the massive drop in AOL subscriptions since 2004 (Hansell, 2006). Users complained of unfair business practices that ranged from questionable minute-usage calculations to delayed service cancellation. The AOL example highlights the ineffectiveness that results when profit-based business models focus on quantities of users instead of the quality of experience. AOL incorrectly thought that their users "aren't going to move" (Lacy, 2008, p. 123). It was not understood fully at the time, but quality Internet experiences would be better created when the control of the environment is further handed over to the users, as we will see is the case with Web 2.0. Web 1.0 was also ineffective because significant expertise was

needed to create or participate in content generation, meaning that the Web 1.0 experience was not relevant to everyone.

Perhaps the most prominent demonstration of the fact that Web 1.0 was ineffective was the bursting of the dot-com bubble in 2000, which profoundly affected many Web 1.0 companies. AOL was hit especially hard, as was Yahoo, which had just bought GeoCities for $3.6 billion. While these companies lost vast amounts of money, others like eToys, The Learning Company, and WebVan disappeared altogether. Many lesser known ventures went bankrupt, too many to list here. What all this tells us is that while Web 1.0 was very efficient, it was not very effective. The Internet experience had to be changed and, most generally, it was its formal rationality that had to go. The old models that focused on efficiency were, at least to some degree, ineffective and have become less important and relevant online. Effectiveness could only be achieved by taking quality into account, and the libertarian engine that could produce this quality, and drive this change, was there all along.

Web 2.0

In contrast to Web 1.0, Web 2.0 accords far less power to the creators of these systems and much more to their users; Web 2.0 sites are, to a large extent, user generated. In addition to the Web 1.0 experience of reading, browsing, and consuming online content, Web 2.0 also allows for writing and producing this very content. One way of describing this is to see the implosion of the consumer and the producer on Web 2.0 into the "prosumer" (Ritzer & Jurgenson, 2008). Because of this user-generated content, sites on Web 2.0 are always in a state of flux. That means that they tend to lose something, perhaps a great deal, in terms of efficiency, but they compensate by tending to be much more effective.

Major examples of Web 2.0, and of the centrality of user generation on them, include:

- Wikipedia, where users generate articles and constantly edit, update, and comment on them;
- Facebook, MySpace, and other social networking Web sites, where users create profiles composed of videos, photos, and text; interact with one another; and build communities;
- Second Life, where users create the characters, communities, and the entire virtual environment;
- The blogosphere, blogs (Web logs) and the comments on them, produced by those who consume them;
- eBay and Craigslist, where consumers rather than retailers create the market;

- YouTube and Flickr, where mostly amateurs upload and download videos and photographs;
- Current TV, where viewers create much of the programming, submit it via the Internet, and decide which submissions are aired;
- Linux, a free, collaboratively built, open-source operating system, and other open-source software applications created and maintained by those who use them;
- Amazon.com, whose consumers do all the work involved in ordering products and write the reviews;
- Yelp, whose users create online city guides by ranking, reviewing, and discussing various locations and activities in their area; and
- The GeoWeb, which consists of online maps where, increasingly, users are creating and augmenting content with Google, Microsoft, and Yahoo tools (Helft, 2007). Google Maps users, for example, can fix errors; add the locations of businesses; upload photos; and link Wikipedia articles to, and blog about their experiences with, or reviews of, places on the map, thereby creating social com munities.

This explosion of user-generated content has massively transformed the Internet. There are many different ways to describe this shift, to describe what is new and unique about Web 2.0—the populist notion that many minds are better than one (the wisdom of the crowds), the productivity and originality of mass self-expression, or the cyber-libertarian notion of the advantages that accrue from breaking down barriers and structures online (creating a flattened world). It is likely that all three, and many others, are important factors in the shift from Web 1.0, where the user experience was best characterized as "looking stuff up" preset by others, to a Web 2.0 experience of production, networking, and collaborating. Let us look more closely at Web 2.0, with special emphasis on efficiency and effectiveness.

At the heart of the shift away from the "mantra of efficiency" online (Alexander, 2008) is the general abundance associated with Web 2.0. The Internet, in its Web 2.0 version, can be said to produce more of everything, an abundance of cultural products and information and, most important, an abundance of users who create them. Web 2.0 allows users to produce the news rather than merely consume it, to give opinions rather than simply read material produced by others, to help write encyclopedia entries rather than read those written by experts, to create entertainment rather than only be entertained by others, to present one's self in many different ways online rather than be represented by others, and so much more. All of this leads to a massive amount of input, much of which would be seen as waste in an efficient system. That is, all sorts of material is produced that is seen by few, if

anyone; lots of work never sees the light of day or is eliminated or superseded almost as soon as it is produced.

The logic of efficiency works best in a world in which scarcity exists. A move away from a world of scarcity to one of abundance brings with it a shift away from a focus on the efficiency of resource usage toward a focus on effectiveness, irrespective of the quantity of resources used. That is, it matters little how extensive the inputs are; what matters is the quality of the outputs. For example, it matters little how many thousands of people contribute to a Wikipedia entry, what matters is the ultimate quality of that entry. Simply put, on Web 2.0, abundance, to a large extent, has replaced scarcity, making concerns about efficiency less relevant and a focus on effectiveness of primary importance.

One of the reasons that Web 2.0 eschews efficiency is because efficiency implies a goal, a single desired outcome, and a single best way of achieving that goal. The focus on efficiency, the best possible means to an end, assumes that there is an end that has already been decided to be desirable. This was true of Web 1.0, but in contrast, Web 2.0 is increasingly open to manipulation and personalization by users. This makes for considerable inefficiency in achieving goals (for example, a Wikipedia article), but for considerable effectiveness in both achieving the goal and in the nature of the goal itself. For example, opposed to the dominating Microsoft Internet Explorer Web browser (a vestige of Web 1.0, and still the most popular browser), the Firefox browser is gaining popularity because users are much more able to edit and personalize it. Unlike Internet Explorer, the Firefox code is not kept secret, it is open to users. As a result, the quality, value, and effectiveness of this free software are increased through endless collaborative advances. The resource input by users is nearly unlimited. Firefox, like much else on Web 2.0, is under endless construction and negotiation with the ultimate goal of building a more effective Web browser.

While the information obtained from Web 1.0 was a finished product, information on Web 2.0 is under continual construction; it is never a finished product. Anyone can easily be part of the process of knowledge production on Wikipedia. The *Encyclopedia Britannica* fits more closely with the ethic of Web 1.0, where a relatively small number of experts efficiently produce a finished product. On Web 2.0, we see a far less efficient paradigm, one where a multitude of users endlessly collaborate on the information created and presented. Furthermore, efficiency on Web 2.0 can be further reduced by such things as "edit wars" and pages being "locked" due to vandalism.

To take another Web 1.0 example, consider Yahoo, where people look(ed) up the news. On Web 2.0, users are given more productive power. Citizen journalism describes the move to harness the collaborative power of the

social web to produce news. Large numbers of people write their own stories and upload their own photos and videos on Web 2.0. The writing of news editorials has been democratized by the free and easy blog technology that allows anyone with computer access to reach, at least potentially, very large and diverse audiences. Through its Web community, Current TV allows viewers to be producers of content and to decide what content is shown on the air.

None of this is very efficient, but it can be quite effective. For example, many people writing many blogs, large numbers of which may be highly redundant and read by almost no one, is not very efficient. However, this can be seen as effective because the overall quantity of information and diversity of views available to users is greatly increased. Furthermore, information that otherwise would not have been available is often produced in blogs. A good example is the Baghdad blogger who produced information during the attack on that city in 2003 that was unavailable on Web 1.0 outlets. Similarly, the photos of prisoner abuse at Abu Ghraib first appeared on Web 2.0.

The Web 2.0 ethic and system are also popular in the realm of video games. On Second Life, a tremendously popular online environment, users create the "game's" environments, characters, and a functioning economy based on Linden Dollars. On the massive multiplayer online game (MMOG) World of Warcraft, it is the users who create the stories and action. There are even plans for an Internet TV series that will follow characters in the game. To have large numbers of users create the plot is not efficient, at least in contrast to the efficiency of a small number of professionals producing and releasing a finished product. All of that input into these games is not very efficient, nor is the endless negotiation involved in them characterized by efficiency, but it certainly leads to the creation of highly effective online environments.

Another example of breaking down the efficient idea of how things should be ordered in favor of endless, and inefficient, negotiation is Web 2.0's rejection of top-down taxonomies of information in favor of folksonomies (Beer & Burrows, 2007; Hanson, 2007; Weinberger 2007). With folksonomies, information is left unordered, or in a "miscellaneous" pile (Weinberger, 2007), where users can create their own order as they proceed. In contrast to taxonomical systems in which everything has one place, like the Dewey decimal classification for books, folksonomies allow users to apply meta-data to items (tagging, digging, linking, and so forth), so that a single item can have many labels at once. In a post-scarcity digital environment, there is no limit to how many labels can be applied to any piece of Web content. A piece of information can exist simultaneously in an infinite number of places, allowing for highly specific searches.

Further, when many users are creating the links, an endless number of interconnections among items can exist and be created. Over time, as millions of users create links, recommendations, and tags, an ever-changing organization of Web content emerges (and, potentially, can be customizable for all users based on their previous behavior and preferences). Folksonomies are produced inefficiently. There are not only many inputs and versions but there are few, if any, expert gatekeepers determining a single order to things. Such a single order may be very efficient from the point of view of users, but not very effective, or not nearly as effective as the many orders produced by users. Folksonomies are not produced very efficiently because they are, by definition, produced collaboratively and are always changing.

While more examples could be offered, and many more are likely to emerge in the future, what underlies all this is the logic of mass collaboration and endless negotiation. This is very much opposed to the efficient Web 1.0 paradigm, which minimizes input and focuses on finished products. The inefficiency of Web 2.0 allows for more effective outcomes when effectiveness is seen as a focus on qualities, such as a diversity of views, democratic representation, and end-products that emerge from many sources and not just corporations.

Another way in which Web 2.0 is inefficient is in its reliance on human instead of nonhuman technologies. Earlier, we mentioned that the tendency to give control to automated nonhuman technologies supports the logic of efficiency and rationality. This control in Web 1.0 is shown by, for example, Yahoo's home page. Unless the user makes a great effort, what may be viewed is determined by what's on that page. In that sense, Yahoo's home page (and many others) is a nonhuman technology that determines what people do and do not see. However, in Web 2.0 the focus is on human and not nonhuman technology. Because humans are not completely rational, Web 2.0's move to empower them is an empowerment of irrationality.

Stanley Vanagunas (1989) describes this sort of process using Harvey Leibenstein's (1966) theory of "x-inefficiency," which maintains that organizations are inefficient because the behaviors, motivations, and decisions of the humans who exist in them are often irrational. This is in line with Weber's (1921/1968b) ideal-typical *zweckrational* action and the fact that, as with all ideal types, reality usually deviates from this ideal type. Furthermore, Weber's other types of action—especially affective and traditional action (although they are ideal types, as well)—also point in the direction of the ubiquity of nonrational, if not irrational, action. The nonrational, and therefore unpredictable, nature of the action of humans on Web 2.0 has little or no place in an efficient system. The embracing of human empowerment in, for example, developing folksonomies, creating entertainment on YouTube, and in the

entire Second Life reality, supports the nonrational, the creation of a system with no predetermined ends or goals nor any single route to attain them.

Web 2.0 also trades efficiency for equality, what Arthur Okun (1975) describes as "the big tradeoff" in the political sphere. Such political analyses have noted that these two goals are often at odds because promoting equality leads to economic (and other) inefficiencies, and because producing efficiency creates inequality. Socialism can, in theory, produce equality at the cost of efficiency (the free rider problem), and bureaucratic dictatorships can produce iron cage-like efficiency at the cost of repressing citizens. This political analysis also demonstrates that while efficient systems, such as Web 1.0, are top-down in order to maximize efficiency, Web 2.0 is more bottom-up, where control is given to individuals. Thus, Web 2.0's more democratized environment is less efficient because a top-down centralized authority oriented toward maximizing efficiency does not exist.

Magagna (1988) makes a similar point in stating that democracy and corporatism are opposed. He highlights the fact that the democratization we observe on Web 2.0 includes some rejection of efficiency and is often an embrace of effectiveness. Magagna argues that pluralistic democracy holds to the principle of effectiveness, specifically, "to effectively represent the widest feasible range of social choices," where "effectiveness refers to the successful achievement of a goal irrespective of its economic cost" (p. 434). In contrast to the corporatist ethic of maximizing profits that dominated what we now think of as Web 1.0, we now see the user-generated Web as effectively representative irrespective of economic/quantifiable costs.

This leads us into perhaps the most fundamental distinction between efficient and effective systems, and one that is highlighted by the turn from Web 1.0 to 2.0. That is, efficiency is about control, discipline, and surveillance (Alexander, 2008), while effectiveness is about independence, freedom, and lack of surveillance. Weber (1927/1981) made the point that bureaucracy's top-down authority is what is needed to operate efficiently, but because of its bottom-up nature, Web 2.0 cannot operate efficiently. Jennifer Karns Alexander (2008) makes the important point that force does not create efficiency, but rather, it is a focus on efficiency that necessitates the use of force through domination, coercion, and surveillance. A focus on efficiency necessarily leads to domination and control, a focus that is at least partly surrendered on Web 2.0. Efficient systems require mechanical and physical discipline imposed by intervening agents in pursuit of a goal. Web 2.0 has no set goals and few intervening agents controlling how things must be done.

Conclusion

The point of this essay is to demonstrate that in contrast to the comparative efficiency and ineffectiveness of Web 1.0, Web 2.0 is often inefficient and effective. While efficiency is mainly a quantitative matter, effectiveness is a qualitative issue. The abundance of everything on Web 2.0 allows for a shift in focus from producing fixed products efficiently to keeping production moving in a more fluid, ever-changing fashion that is highly effective. Web 2.0's "Long Tail" (Anderson, 2006) describes an opposition to a small set of dominating cultural products in favor of the flourishing of niche communities that celebrate difference, uniqueness, and abundance.

Richard Rorty (1979) described this process in terms of "keeping the conversation going" rather than finding the answer that "mirrors" reality (p. 377). He further called on us to abandon the project of building knowledge "for eternity" in favor of constant destruction, wandering, and the promotion of a "nonepistemological sort of philosophy" in order to always generate new ideas. Wikipedia embodies this to some extent as it is not interested in a finished encyclopedia, but, rather, in keeping the epistemic conversation going. Linux, like other Web 2.0 or open-source applications, is said to be in a perpetual state of beta, meaning that it is never finished.

All this follows the idea that Web 2.0 is more in line with Weber's conception of substantive rationality. Web 1.0's formal rationality focused on quantifiable factors, such as the efficiency concern of the amount of input relative to output. Substantive rationality focuses on qualities, such as values and ideologies, and the quality of the outcomes, irrespective of cost. Framing Web 2.0 in terms of substantive rationality highlights the inefficiencies of the more qualitative agenda of keeping conversations going, while still acknowledging that Web 2.0 is not altogether irrational. Wikipedia is not concerned with efficiency—the number of inputs or the amount of debate that goes into an entry—but is instead concerned with the quality of that entry as well as the larger values associated with its more populist epistemology.

We have not argued that Web 2.0 is completely inefficient or irrational; much of Web 2.0 excels at allowing mass collaboration to occur much more efficiently than has been previously possible. Further, the few that have successfully made user-generated content profitable (notably, Facebook, Craigslist, and the Wikimedia Foundation) can view Web 2.0 as efficiently creating value through the unpaid labor of their users with little to no special effort required of the owners of these sites. What we have argued is that the general abundance online reorients how we are to think of efficiency in many important ways, and how this fits into the general conversation on rationalization and modernity.

References

Alexander, J. K. (2008). *The mantra of efficiency: From waterwheel to social control.* Baltimore, MD: Johns Hopkins University Press.

Anderson, C. (2006). *The long tail: Why the future of business is selling less of more.* New York: Hyperion.

Baudrillard, J. (1983). *Simulations.* New York: Semiotext(e).

Bauman, Z. (1989). *Modernity and the Holocaust.* Ithaca, NY: Cornell University Press.

Bauman, Z. (1992). *Intimations of postmodernity.* New York: Routledge.

Bauman, Z. (2000). *Liquid modernity.* Malden, MA: Polity.

Beck, U. (1992). *Risk society: Toward a new modernity.* London: Sage.

Beer, D., & Burrows, R. (2007). Sociology and, of and in Web 2.0: Some initial considerations. *Sociological Research Online, 12*(5).

Cheng, T. C. E., & Podolsky, S. (1996). *Just-in-time manufacturing: An introduction.* New York: Chapman and Hall.

Friedman, T. L. (2005). *The world is flat: A brief history of the twenty-first century.* New York: Farrar, Straus and Giroux.

Giddens, A. (1990). *The consequences of modernity.* Stanford, CA: Stanford University Press.

Hansell, S. (2006, July 10). At AOL, a plan for a clean break. *New York Times.* Retrieved October 8, 2008, from http://www.nytimes.com/2006/07/10/technology/10aol.html?scp=10&sq=AOL+subscriber&st=nyt.

Hanson, F. A. (2007). *The trouble with culture: How computers are calming the culture wars.* Albany: State University of New York Press.

Helft, M. (2007, July 27). With simple new tools on web, amateurs reshape mapmaking. *New York Times,* pp. A1, A16.

Kalberg, S. (1980). Max Weber's types of rationality: Cornerstones for the analysis of rationalization processes in history. *American Journal of Sociology, 85,* 1145–1179.

Kopytoff, V. (2002, May 16). AOL to pay $15.5 million to settle class-action suit. *San Francisco Chronicle,* p. B1.

Lacy, S. (2008). *Once you're lucky, twice you're good: The rebirth of Silicon Valley and the rise of Web 2.0.* New York: Gotham Books.

Leibenstein, H. (1966). Allocative efficiency versus e-efficiency. *American Economic Review, 56*(3), 392–415.

Levine, D. (1981). Rationality and freedom: Weber and beyond. *Sociological Inquiry, 51*(1), 5–25.

Lyotard, J. F. (1984). *The postmodern condition: A report on knowledge.* Minneapolis: University of Minnesota Press.

Magagna, V. (1988). Representing efficiency: Corporatism and democratic theory. *The Review of Politics, 50*(3), 420–444.

Okun, A. M. (1975). *Equality and efficiency: The big tradeoff.* Washington, DC: Brookings Institution Press.

Ritzer, G. (2008). *The McDonaldization of Society* (5th ed.). Thousand Oaks, CA: Pine Forge.

Ritzer, G., & Jurgenson, N. (2008, August). *Producer, consumer...prosumer?* Paper presented at the annual meeting of the American Sociological Association, Boston, MA.

Rorty, R. (1979). *Philosophy and the mirror of nature*. Princeton, NJ: Princeton University Press.

Schonberger, R. (1982). *Japanese manufacturing techniques: Nine hidden lessons in simplicity*. New York: Free Press.

Schumpeter, J. A. (1942). *Capitalism, socialism, and democracy*, New York: Harper.

Tapscott, D., & Williams, A. D. (2006). *Wikinomics: How mass collaboration changes everything*. New York: Portfolio.

Vanagunas, S. (1989). Max Weber's authority models and the theory of e-inefficiency: The economic sociologist's analysis adds more structure to Leibenstein's critique of rationality. *American Journal of Economics and Sociology, 48*, 393–400.

Virilio, P. (1995). *The art of the motor*. Minneapolis: University of Minnesota Press.

Weber, M. (1921/1968a). *Economy and society* (Vol. 2). Berkeley: University of California Press.

Weber, M. (1921/1968b). *Economy and society* (Vol. 3). New York: Bedminster Press.

Weber, M. (1927/1981). *General economic history*. New Brunswick, NJ: Transaction Books.

Weinberger, D. (2007). *Everything is miscellaneous: The power of the new digital disorder*. New York: Times Books.

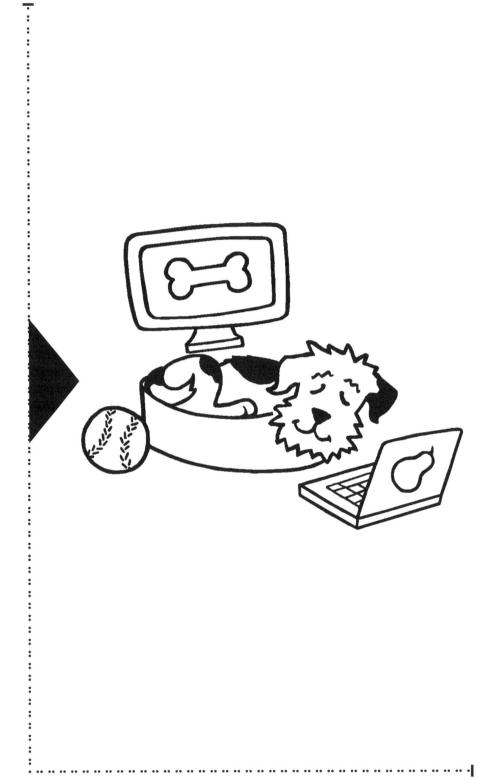

PART

2

Work
Play
Rest

CHAPTER 5

Clocks, Synchronization, and the Fate of Leisure

A Brief Media Ecological History of Digital Technologies

▶ COREY ANTON

America:…"I'll see you at 4:10, then" is a sentence that would have been comprehensible to no other civilization this earth has seen.
<div align="right">Sebastian de Grazia, 1964, p. 294</div>

Prick me, and I bleed time.
<div align="right">Jules Henry, 1965, p. 11</div>

Prelude

Every year more and more U.S. citizens spend more time in the digital world. We hear of digital recording systems, digital cell phones, digital cameras, and high-definition digital television sets. The digital environment also includes various computer-based social networking sites as well as upload and sharing technologies known collectively as Web 2.0 (see Jurgenson and Ritzer, chapter 4). Given these many technological developments in the past decade or so, my goal in this chapter is to sketch a framework for understand-

ing their emergence and to outline the larger and more subtle impetus to the digital age.

Sheer feasibility is a major contributor to the growth of digital technologies. But something else is going on as well. A key to understanding the recent developments in digital technologies can be found all the way back in the mid-1800s with the advent of the telegraph. The telegraph not only separated communication from transportation, it made possible a new kind of substance, one that was divorced from the confines of materiality: information. Without a doubt, telegraphy, and electricity writ large, paved the way for all kinds of digital electronic circuitry. Electricity and circuit boards made all of the newly emerging digital—and largely informational—technologies possible. But this point, important as it is, obfuscates something else that deserves our attention: the telegraph transformed clocks, and this transformation brought profound and thoroughgoing changes in people's temporal sensibilities. In fact, although the contemporary buzzword "digital" now typically refers to the aforementioned communication technologies, its first mainstream use was in reference to digital wristwatches. In seeking to gain or display status (rationalizing their subservience?), many people even today "like watches as a symbol of wealth and modernity," despite the fact that a watch is basically "a despot to be obeyed" (De Grazia, 1964, p. 297). This seemingly trivial observation points to a deeper logic within digital technologies.

If we are to grasp part of the logic of the digital age, we need to understand how the synchronization of clocks introduced something genuinely novel, and arguably, something genuinely tyrannical, something from which people would soon seek relief. With the telegraph came unprecedented coordination and orchestration of action and interaction: electricity transformed not only the meaning of "machines," it radically altered the master machine of machines: the clock. Time itself was radically transformed by electricity and this transformation was nearly all encompassing. It included such now taken-for-granted aspects of our experiences as the standardization of time zones, increasingly accurate weather-prediction, the news, the creation of the distinction between work time and leisure time, the massive scheduling of life into minute-by-minute forms of interaction, and the futures market (cf. Carey, 1989; Czitrom, 1983; McLuhan, 1964).

Within a span of under two centuries, the U.S. increasingly subjugated itself to a pervasive though mostly invisible despot. The despot initially seemed to rule only on the job or at the workplace. He blew his whistle and rang his bell at particular times to help workers synchronize their labors. As Sebastian de Grazia (1964), in *Of Time, Work, and Leisure*, writes,

> The clock, first placed in a tower and later hung up wherever work was to be done, provided the means whereby large-scale industry could coordinate the

movements of men and materials to the regularity of machines...a new conception of time developed and spread over the industrial world. (p. 291)

Soon enough, the despot ruled over the entire land, not only inside the factory but also inside the home. The despot worked his way down into the micro-segments of private lives, and the synchronization of clocks gave birth to today's commonsense distinction between work time and free time. Prior to mass coordination by way of synchronized clocks, the expression "work time" referred to the time when workers showed up to work, whenever that was. Punctuality was calibrated to seasonal or diurnal needs, not as it mostly is today, according to what the clock says.

As mass orchestration through synchronization became more and more possible, workers were led to believe that acceptance of schedules and carefully disciplined economical movements eventually would lead to a world of less work and more leisure. What they ended up with was quite the contrary: an objective, neutralized time, one that became increasingly commercialized. Work time, moreover, became the defining metaphor of the culture, the very ground against which everything else was set in relief. It created a largely invisible yet pervasive tethering effect. As De Grazia (1964) writes, "Most men today may not be aware that they are geared to machines—even while they are being awakened by the ringing of a bell and gulping down their coffee in a race with the clock" (pp. 288–289). Part of the reason we fail to notice the ways we are geared to machines and their inhuman pace is because we are indoctrinated into them from birth:

> The synchronizing of activities by the clock begins early. The child sees the father rise by the clock, treat its facial expression with great respect, come home by it, eat and sleep by it, and catch or miss his entertainment—the movies, a TV show—by it....There is thenceforth less a feeling of imposition that people have for the clock when introduced to it only at a later age. (p. 297)

Although modern life is scheduled down to hour-by-hour and minute-by-minute intervals, time has not always been dealt with this way. The highly modern notion of objective time, the three-armed despot, needs further exploration if we are to understand the emergence of the digital age. Said most directly, not even 200 years old, synchronized clock time enabled the possibility of—and slowly created the warrant for—newly emerging digital technologies.

If media ecology explores how media become environments, then electric clocks are perhaps the supreme example of how a medium has become environmental (see also Strate, 1996). Such clocks are not inside an already existing time and merely registering it. On the contrary, they make possible the kinds of time to which we moderns subject ourselves; we, those who have submitted ourselves to them, are within the kinds of time that they create.

To advance this discussion, I briefly review the history of timepieces and show how the modern notion of time marked a significant change from the past. Questions guiding my exploration are: How different is the modern, electric, notion of time? Why is modern synchronization so different? And how, exactly, does synchronization relate to today's digital environment?

Historical Varieties of Timekeeping

Some of the most well-known and often-cited lines regarding the experience of time come from St. Augustine's (1951) *Confessions*. He writes, "What then is time? If no one asks me, I know: If I wish to explain it to one that asketh, I know not" (p. 224). To this day, time remains more felt or experienced (incorporated and obeyed?) than thematically and analytically comprehended. It remains as one of the ambiguous mysteries of human experience: in a single instant, time can seem to be more objective than any object in the world, while at the next instant it can seem to be completely subjective. It can drag, stand nearly still, or pass quickly without notice. With a single glance, we can look back over a long journey and feel it as having taken no time at all. Such conditions are part of the reason why humans desire to get a handle on time, grasp it, measure it, or, at the very least, subdue it in some way (for more phenomenological considerations of time, temporality, and measured time, see Anton, 2001; Fraser, 1987).

Prior to the modern wholesale objectification and commercialization of time, time was measured, but in a mostly subjective way. This measuring is clearly articulated in Aristotle's definition of time: "something counted which shows itself in and for regard to the before and after in motion, or in short, something counted in connection with motion as encountered in the horizon of the earlier and later" (qtd. in Heidegger, 1982, p. 235). This definition, in rough form, is relevant even today, though the degrees of precision and the notions of objectivity have changed considerably.

The earliest and perhaps most natural form of timekeeping was simple attention to day and night, and then to shadows, even one's own, created by the daytime sun. The high point of the day's sun, what was called noon, was that time when shadows were at their shortest. Stationary clocks were used in ancient Egypt, and the ancient Greeks created the first sundial. In ancient Rome, following the Greek use of sundials, hemicyclia and conical sundials were made for the courtyards of villas. By this period in history there was sophisticated time measurement, including not only attention to the daylight sun but also measurement of seasons of the year. Other quite sophisticated means of timekeeping were hourglass, candle, and incense (McLuhan, 1964).

We might imagine that the ancients subjected themselves to an objective sense of time of the same sort that we do today. That would be an anachronism. By modern sensibilities, all of these timekeeping devices were imperfect; all suffered from various kinds of imprecision. Hourglasses were rather imprecise within the hour and could get clogged. Candles and incense could be blown out and demanded considerable attention and care. Sundials only worked during the day and required a sunny sky. The rough hour was the smallest unit of time registered—and even here, its delineation depended on ideal conditions. The water in early water clocks did not always flow at a constant rate. When a clock tower rings a bell every hour, all within hearing range could know the time by the ringing, but distances could vary between and among the hearers, and, therefore, the task of calling people together would take varying amounts of time. Across these cases, the most important point to note is that all of these forms of timekeeping were local (not portable, not lightweight, and not widely available to everyone). The devices told the time that it was then and there. They were for enabling synchronized coordination or measurement in the present within a mostly local sense of here and now.

The Mechanical Despot

Mechanical clocks, a significant breakthrough, date back to the mid-1300s, but they too suffered from various kinds of imprecision. The escapement mechanisms within mechanical clocks, a significant innovation, were still subject to small variations in measurement and required regular resetting. Making an appearance in Italian cities, the earliest clocks had faces but no hands. They were built to be heard rather than to be watched, and they were mainly used for coordinating activities in the present. As late as the mid-1600s mechanical clocks were regularly "off" by about 15 minutes a day. Then, by 1673, Christiaan Huygens invented the pendulum clock, which used weights and a swinging pendulum (Fraser, 1987). These clocks brought more accuracy than any the world had seen; they were off by less than a minute a day.

The use of early clocks deserves consideration as well. For centuries the use of clocks was limited to churches and monasteries, where clergy intimately compartmentalized their lives according to measured units of time. After the clergy, the next to discipline time were the military and schools. In *Discipline and Punish,* Michel Foucault (1977) explores how the application of power and the subjugation of bodies were made possible through highly disciplined uses of time and schedules. The very notion of the individual changed as bodies became sites for exercising power. With the clock, writes Foucault (1977), "A sort of anatomo-chronological schema of behav-

ior is defined. Time penetrates the body and with it all the meticulous controls of power" (p. 152). Rather than Taylorism in the workplace (still a century or two in the future), there was a meticulous regimentation of behavior, circumscriptions of bodily movements in an attempt to wean more life out of every moment. Describing the changeover from earlier monastic practices to disciplining the body in schools, the military, and the workplace, Foucault (1977) writes,

> The principle that underlay the time-table in its traditional form was essentially negative; it was the principle of non-idleness: it was forbidden to waste time, which was counted by God and paid for by men; the time-table was to eliminate the danger of wasting time—a moral offence and economic dishonesty. Discipline, on the other hand, arranges a positive economy; it poses the principle of a theoretically ever-growing use of time: exhaustion rather than use; it is a question of extracting, from time, ever more available moments, and from each moment, ever more useful forces. This means that one must seek to intensify the use of the slightest moment, as if time, in its very fragmentation, were inexhaustible or as if, at least by an ever more detailed internal arrangement, one could tend toward an ideal point at which one maintained maximum speed and efficiency.... By other means, the "mutual improvement" was also arranged as a machine to intensify the use of time. (p. 154)

The mechanical age, the literate age, was culminating into the bodily use of highly fragmented time units from the 1600s to the 1800s. Minuscule time units exercised their power rather locally, over immediate bodies, and the smallest motions of present persons became subject to control. Much of Foucault's (1977) insight, without explicitly focusing on the alphabet, gives support to McLuhan's (1964) general ideas that both clocks and phonetic literacy conspired together to issue new sensibilities of time and self.

With the increase in highly circumscribed behavior in accordance to temporal units (coupled with increasing pressures of literacy), the mechanical age might seem to be merely continuous with the modern era and its clock time. But telling the story this way too quickly passes over qualitative differences between today's sensibility of time and the notions of time from the ancient world all the way up until the invention of the telegraph. Time in its modern sense is not merely more accurately kept time, and here we need to be precise. Post-telegraphy time (modern time) is in some ways more objective, though it is less accurate. By this I mean that time zones, first invented in the 1840s for railway coordination and then widely adopted by the mid-1880s, somewhat arbitrarily broke the passage of time into units coordinated to clocks in distant lands and around the globe. Time zones help considerably for orchestrating the schedules of trains, planes, and automobiles, but they are not more accurate than carefully attending to shadows. Their arbitrary character is evident if we simply consider that two people can

be in the same time zone despite the fact that both of them are nearer to other people who are in different time zones! Prior to the telegraph, "the distant" was synonymous with "other than now." Today, we can call someone halfway around the globe, and, although it is equally "now" for both of us, we each can be at a different time, perhaps even on a different day. Modern sensibilities of time require a highly abstract management of spacetime: we have learned to break apart time and distance. It is indeed one thing to wake from a church bell. It is quite another to know with confidence what time it is halfway around the world.

To understand the significant changes that arose in the mid-1800s, we need to examine the differences between mechanical clocks and the highly modern (post-telegraphy) clocks.

> What we call time nowadays is but the movement of synchronized clocks....If two persons had moved together at the sight of a smoke signal or the sound of a pistol shot, the signal would have been considered personal because set off by a man, whereas we feel the clock as impersonal because it is automatic and tied in with other clocks. (De Grazia, 1964, pp. 302–303)

For example, consider the significant difference between responding to a sound that then and only then announces what time it is and the visual act of continually looking at a watch to see what time it will be in ten or twenty minutes. The modern clock, depending on clocks synchronized to each other, is mainly used for futural projection of synchronized interaction, for precise schedules, and strict obeisance to them is the key issue to notice. De Grazia (1964) reminds us of the early meaning of the word "watch." As a device worn on the wrists of individuals themselves, watches promoted a vigilant watchfulness over the time, and people's schedules grew synchronized into finer and finer exactitude. In the 1920s, the advent of the quartz watch was also significant as it enabled unprecedented precision, and today, people can have personal computers accurate within milliseconds by accessing atomic clock time online (Gleick, 1999). Note once again that it was synchronization that promoted and legitimated the proliferation of the watch. Timekeeping devices are ancient, but the widespread use of an accurately kept, objective time—an evenly divided and constantly visible time standing uniformly and shared by all, a time that is neutralized and commercialized—was ushered in not simply with mechanical clocks. The essential element was synchronization.

There always have been (and there always will be) seasonal time, rhythmic time (tempo and rhythm), and even kairos (humanly initiated and felt time), and yet, all of these are profoundly different from the time offered up by synchronized clocks. Synchronized clock time, especially to the uninitiated, seems to be utterly inhuman, rudely punctilious, and annoyingly insom-

niatic. And, with everyone's schedules so tightly interlocked, people live less and less according to diurnal time, or even time as measured by the hour. Today, people feel the drive to be calibrated to something more exacting and demanding than even the quarter hour. Deals are made or not—careers are launched or broken—within a matter of minutes or even seconds, and human lives have never before been so scheduled, so bundled into constantly watched units, and so packaged into so many precisely measured moments (cf. Gleick, 1999). Consider, for one example, the amount of advertising dollars spent on thirty-second spots during "prime-time" viewing, and the way that these smaller-than-a-minute "mini-dramas" can make or break advertising executives; people try to "make every second count."

Resisting the Three-Armed Despot

Alan Watts (1966) comically illustrates how easily people create trouble for themselves when they take their own fictions as already given facts:

> Thus in 1752 the British government instituted a calendar reform which required that September 2 of that year be dated September 14, with the result that many people imagined that eleven days had been taken off their lives, and rushed to Westminster screaming, "Give us back our eleven days!" (p. 81)

We can laugh, but we are just as ruled by our own fictions. Today, we do not scream for missing days. We scream when someone is late for an appointment (see Henry, 1965).

We moderns are hyper-scheduled, and the schedules we confine ourselves to are ultra-fine grade. Describing the modern scheduling that has become an accepted part of life in the U.S., De Grazia (1964) notes:

> Today…a dermatologist can schedule patients in his office at 10 minute intervals. Many people in business and government schedule 10 or 15 minute, sometimes 5 minute, appointments. Trains and planes go by a schedule in odd minutes—7:08, 10:43. All appointments must be kept by continual reference to the inexorable clock. (p. 295)

It is almost hard to believe that we have been affected so profoundly by little more than scheduling and synchronizing our lives around the minute. Who could have anticipated that something so small and invisible, the No-Thing that is the minute, could act back on people and precipitate so many forms of dis-ease? Who could have imagined the inhuman pillory on conveyor belts that could be made from these little units?

Early Marxists, to their credit, were among those who were quite concerned about the then emerging applications of automation and the newly emerging demands on workers. The clock and the machine coupled with automation made work something independent of the worker. A new notion

of work time emerged, which now meant the precise time to be at work and doing work, and people came to feel a sharp contrast between work and nonwork as they increasingly were paid for their time rather than their product. Payment by the hour came to be standard practice, and workers were reduced to "labor" and "human resources." The purpose here is not to rehearse this story but rather to stress that life more generally, including dominant communication media that were emerging during this time and subsequently, began to demand as much punctuality as did the workplace. And this arrangement grew more and more problematic because, at least since the early twentieth century, U.S. citizens had been promised a life of leisure. By punctually binding themselves to a machine-paced or automated workplace, people thought that eventually they would be more productive in less time and would have more time for leisure. In fact, people accepted the encroachment of demanded synchronicity in almost all aspects of nonwork life, especially in dinnertime, mass media, and public entertainment.

The promise of more leisure time (after work and on weekends) eventually failed. In its place arose more and more forms of scheduling. Dinnertime, as one example, became a highly scheduled event, one tethered as if it were a satellite entering the visible horizon only around the end of work time. In his interesting studies of dysfunctional families, *Pathways to Madness,* Jules Henry (1965) documents how "waiting" and "being late" with regard to "dinnertime" can be some of the most pointed and emotionally riling aspects of family life. Summarizing the subtle ways that emotional tensions and clock time interweave, he writes,

> The average man...is aware, for example, that if he is not home "on time," dinner will be "kept waiting," "the kids will be hungry and screaming" and his wife "worried and mad" because she "couldn't imagine what had happened" to him, and because, since she has to go out, his getting home later has "spoiled everything." The expressions in quotes demonstrate the close connection between time and mood in our culture....A person's actions in time have this tight connection to other people's moods....Time...binds us to their emotional life. (Henry, 1965, p. 11)

Not only is all of this trying, but it is more and more difficult as the mechanical principle was extended down to the minute. And the stresses should not be surprising given the demand for a calibrated intersection of four horizons of minute-by-minute scheduling: cooking time, commute time, work time, and school time.

Consider, too, the early days of radio, movies, or television and how timebound these media initially were and largely remain. In the U.S., when President Franklin D. Roosevelt gave his fireside chats, people would gather in their living rooms around the radio and listen to the broadcast. Political uses aside, the relevant point here is the synchronicity of the broadcast—

everyone had to tune in at the same time. Television was just as bound: at first, programs came on early in the morning, and then, at night, the station went off. And even today, although most stations now stay on all the time, programs have remained largely unchanged in their punctuality: in the U.S., television shows start exactly every hour or half hour, and, if people do not want to miss any part of their favorite shows, they must be tuned in as punctually as any worker. Movie theaters, too, have changed very little in this regard. Moreover, movie theaters are known for having show times at rather specific times, for example, the 9:20 or 10:35 showing. In light of these highly scheduled and temporally synchronous media, it is easy to see the many drives toward asynchronicity as a palliative.

The resistance roughly began with the phonograph and tape recorder, which could record and then play back recorded material (live performances, lectures, or radio programs) any time the person wanted. Soon thereafter, video-recording technologies allowed people to record television programs or movies and watch them "at their leisure." Next came movie rental stores and services, and the playing of movies on one's own time. As the computer made headway into U.S. popular culture, the digital file, along with digital recording and replaying technologies, appeared. Digital video discs (DVDs) and digital video recorders (DVRs) soon appeared. Netflix, first as an at-home mail service and then as an online service, further broke movies free from the despot's demands of synchronicity. And, Netflix is increasingly changing from the diurnal rhythm of the daily mail arrival to 24/7 all-online availability. Today, people have ample digital technologies for recording and selectively viewing media in an asynchronous and/or 24/7 fashion. With DVRs and with TiVo-like technologies, viewers can even pause live television. There are digital audio (MP3) players and Web sites like YouTube and MySpace where people can not only record and play back audio and video, they can share digital files easily with anyone else who has computer access.

E-mail is perhaps the most obvious form of asynchronous interaction. By communicating through e-mail, people make use of instantaneous transmission akin to the telephone, but they also retain the capacity to stall, wait, or otherwise make the exchange of information asynchronous. In many places, e-mail has displaced the use of the telephone. For example, when college students wish to contact their professors, they typically send an e-mail rather than call on the phone, and the reasons are perhaps obvious: they want the option of an asynchronous mode of communication. Moreover, e-mail does display the time, but at this speed of interaction, time is used more as a record of the past than as a means for synchronizing with each other.

Cellular telephones might initially be offered as an example of increased synchronicity, as users are accessible anywhere at any time. However, the "message" of the cell phone has been felt most by the clock. First, it has considerably lessened the pressure of dinnertime, as people can phone home for sudden schedule changes or updates. But more generally considered, time in the digital world seems less and less for futural projection into a schedule. It is used increasingly for present situations: young people resist scheduling in advance and instead exhibit a kind of swarming behavior in the present. Moreover, today's cell phones have message-recording capacity and so are fully functional in an asynchronous mode. Many people screen their calls so that they can get back to individuals on their own time. Cell phones also commonly display the amount of time spent on a call made or received, and so, once again, time appears more as a past record than as a means of synchronization. As YouTube also records the amount of time logged in, might it be that time that is recorded will, soon enough, need to be paid for?

To discuss the fuller meaning and broader implications of social networking sites such as MySpace, Facebook, and YouTube would surpass the scope of this chapter, but I will offer a few preliminary observations. First and perhaps most obvious, although these connectivity technologies allow users to act with awareness that others are also currently online, they equally display a kind of functionality for endless modes of asynchronous interaction. As Robert Hassan's (2007) essay "Network Time" suggests,

> Connected asynchronicity is a central feature of the network society and network time....Network time fundamentally changes our relationship with the clock—it doesn't negate or cancel it. Instead, the...asynchronous spaces of the networked society...undermine and displace the time of the clock. What we experience, albeit in very nascent form, is the recapture of the forms of temporality that were themselves displaced by the clock. (p. 51)

With shards and fragments of spare time cropping up in overly scheduled lives, MySpace, Facebook, and YouTube fill the void by providing a kind of momentary getaway. For people who are calibrated down to the minute and second, these interfaces offer some kind of relief from work, though the workers themselves often remain somewhere between amusement, lollygagging, and more work. Note that YouTube permits at most a ten-minute video for uploading or viewing, and most clips are significantly shorter, typically a few minutes long. Time is so precise on YouTube that the system displays the user's last login in seconds. Note, too, that video editing, an increasingly popular pastime, works with software packages that measure time down to the hundredth of the second (Gleick, 1999). Social networking sites and other Web 2.0 technologies traffic in a digital world where everything there is available all the time. In addition, these technologies have enabled and

facilitated interactivity in ways that earlier mass media have never been able to do.

In sum, early media technologies such as radio and television began with the mechanical principle and were scheduled around the synchronization of the clock. Within the past decade or so, with the pervasive scheduling of life down to minute-by-minute intervals, people could not keep up. Cell phones, e-mail, YouTube, MySpace, Facebook, and the like can be interpreted as a unified dialectical backlash against two centuries of tightening temporal strictures (see also Strate, 1996). We should not be surprised that in recent times we hear people describing their activity as multitasking. Whether or not multitasking is increasing, and regardless of whether this is boon or bane, I would simply argue that the phenomenon shows itself (makes more and more sense to us) mainly because our lives have been so precisely scheduled. Might multitasking be a symptom of changing sensibilities of time or the product of clashing time frames—a clash between the hours of the older media and the minutes and seconds of the newer ones?

The Future of Work, Leisure, and Time Spent

Do you remember when you couldn't tell the time? You'd say, "the big hand is on the three and the little hand is on the six." "Quarter after six," a parent or teacher would say. There began the early disciplining into a temporally scheduled world. Parents normally are eager to help their children learn to tell time. Knowing the time is taken as a virtue: punctuality equals industriousness and "God loves a workingman." But when digital watches hit the mass market, many parents expressed a fear that children would no longer know how to "read" a clock. They sensed that something was going wrong, but little did they seem to get the real message. Soon enough, digital clocks would be found absolutely everywhere: on automobile dashboards, shoes, hats, pencils, notebooks, ovens, microwaves, cameras, checkbooks, calculators, radios, televisions, computer screens, cell phones, golf bags, and in countless public places, everywhere.

One of Marshall McLuhan's (1964) great insights was to grasp the kind of reversal implied by the electric revolution. The changeover to the electric age was not, he suggested, in contrast to what seemed to be the dominant view, a mere continuation of the mechanical age. Delineating the progression of the mechanical age and then showing the reversal implied by the electronic revolution, he writes,

> In the ancient world the only means of achieving power was getting a thousand slaves to act as one man. During the Middle Ages the communal clock extended by the bell permitted high coordination of the energies of small communities. In the Renaissance the clock combined with the uniform respectability of the

new typography to extend the power of social organization almost to a national scale. By the nineteenth century it had provided a technology of cohesion that was inseparable from industry and transport, enabling an entire metropolis to act as an automaton. Now in the electric age of decentralized power and information we begin to chafe under the uniformity of clock-time. In this age of space-time we seek multiplicity, rather than repeatability, of rhythms. This is the difference between marching soldiers and ballet. (McLuhan, 1964, p. 138)

The ends of electric time and connected asynchronicity are wholly different than the one-at-a-time serial organization characteristic of the clock and mechanical age. At first, modern objective time seemed uniform, progressively enabling more synchronization than had been possible in the past. But the more that people trafficked in that odd immateriality called information (perhaps financial information), the more they were freed up for asynchronous interaction. Whereas the mechanical age used the clock to synchronize group actions, today massive synchronization of information has inverted associations to allow for various forms of asynchronous interaction.

The more that people spend time in digital environments, the less that time is used for futural projection. Moreover, where everything is always already available, there is no longer a need for synchronization: at this speed, we are already there. Part of the meaning of the digital is that we are already synchronized or that synchronicity is no longer needed. To become digital is to live by the minute and the second, but such minutes and seconds are not felt as tyrannical, for they are geared not into the future as much as into the present or the past.

The clock is not disappearing, but there are places, digital spaces, where its uses are changing considerably. Early timekeeping was largely an issue of coordination in the present: it used the ear to gather and orchestrate in the local now. Then came the watch and visual modes of futural projection that enabled the scheduling of life into minute-by-minute intervals. With the emergence of contemporary dawdling and lollygagging online, the clock increasingly serves as a record of time spent. Spare time in the digital age thus approximates a kind of time, the recorded passage of which proves that there was, in fact, a time that was one's own.

Telegraphy first separated communication from transportation so that information could travel faster than any messenger. What this made possible—and we can see it all around us—is the clash we now witness between two kinds of culture: the older material culture that requires various forms of synchronized bodies and the newer culture that handles mainly forms of information and is available anytime anywhere (see also Rifkin, 1987). As an illustration, consider the traditional workplace: people go away to work

and need to be on time and to do work when they are at the work site. In this world, bodies must synchronize in space according to clocks; people need to tightly calibrate themselves, and this is accomplished by the futural projection that clocks and schedules make possible. In contrast, consider the online workplace, where all the materials for the job are completely available at any time. With a laptop in hand, some people no longer go into an office, and they face no machine or coworkers waiting for them come 7 a.m. They may work through the night, or even do work ahead of time to gain a little spare time in the next week. While part of the culture is ultra-scheduled and moves like military soldiers, other parts are less and less scheduled and increasingly flexible regarding the where and when of work time. If the synchronization of time first helped people to work together, today it comes into its own by enabling flextime, working at home, distance education, movies on demand, and a world where work and entertainment can be had at any time by anyone (see also Waite, 2003).

McLuhan, in 1964, wrote that global travelers "have the daily experience of being at one hour in a culture that is still 3000 B.C., and at the next hour in a culture that is 1900 A.D." (p. 141). Something similar to this is happening today within U.S. culture but we need not travel far to experience it. Simply walk around in parks and public places and notice the Wi-Fi world, the cellular users and those who are text messaging. Many people are yearning for a kind of time and a kind of space that are not so tyrannical. They'd like them to be ruled by a kinder and more lenient despot.

Nevertheless, we are and will remain bodies whose health depends on regularly ingesting perishables, and, the distribution of perishables, even regional perishables, depends on tightly interlocked schedules. We must be honest about the distribution of produce and other forms of perishables as well as the demands of mass transportation: there will always be demands of synchronization. Bodies are not digital information. Someone may be a powerful avatar in Second Life, but that person is also someone sitting somewhere in front of a computer screen (Slouka, 1995). This basically means that times that are most exacting and peculiar, times like movie, bus, and plane schedules, are times when bodies must be synchronized in space. Unlike perishable objects, which remain where placed, people can wander around and lose sense of the passage of time. And so, until we are all led to the Big Rock Candy Mountains, or unless robot slaves of the future do all of the work that demands tight synchronization, or unless the future brings cheap, reliable, and easily available food replicators and teleporters, we shall, as bodies, remain within various demands for synchronized interaction.

An important distinction for the arguments made in this chapter is the difference between leisure and free time. Leisure, it would seem, is antithetical to "objectively measured time" (De Grazia, 1964). If something has to be

scheduled in, it is not leisure. Thus, we might be able to contrast free time with leisure, but we begin to make conceptual errors if we thoughtlessly use the expression "leisure time." As De Grazia (1964) writes,

> Not being divided up by time, leisure does not suffer fragmentation as free time does....Self-improvement, the always pursuing-something and bettering-oneself aspects of present free time are negative qualities as far as leisure is concerned. Life is not on a vertical incline, nor is truth. It comes not to him who is always on the run after something that tickles his senses.... Free time is opposed to work, is temporary absence from work, but leisure has little to do with work as with time. (p. 331)

Activities engaged in as ends in their own right and without any reference to time may in fact be leisure, but in a world where the clock and schedules are all pervasive, leisure seems increasingly impossible.

Conclusion

I conclude this chapter by cautioning against the ideas that the digital age is a return to earlier tribal life or the beginning of a global village, or still less, a new age of leisure. There may be various forms of return, but there is also something quite different afoot. We can get at this difference by fixing our attention on the expression that describes where we increasingly find ourselves: "24/7." The notion of 24/7 media, Wikipedia, Google, YouTube, MySpace, and so forth moves us out of seasonal and rhythmic time in a way that preceding media did not (Hassan & Purser, 2007).

One main weakness of the 24/7 digital environment is that it fails to deliver leisure and instead opens new horizons of spare time for the commercialization of identity and selfhood. This commercialization comes in two main forms. First is sheer hardware dependency (F.E.X. Dance, personal communication, November 2007). Today, as more and more people confine themselves to indoor and sedentary lifestyles, people are invited to change their scenery by keeping up with endless upgrades, newer versions, platforms, and products. We are bombarded with messages, announcements, unveilings, and various news flashes regarding anything that is faster, smaller, thinner, better, or cheaper. And all of these messages subliminally chant, "BUY! BUY! BUY!" These new media may well be the preferred means of communication of the commercializing insomniac.

The second commercialization occurs because would-be media presences need to break through anonymity and have their names, voices, and/or images gain public mind-share. In a global world where anyone can contact anyone, and where everyone is potentially available, not everyone can be seen, recognized, and listened to regularly. So, in becoming a blogger, MySpacer, or YouTuber, people basically need to turn themselves into a brand or product.

They need to advertise themselves in order to create brand-name recognition. If there is a concern, it is that the very notion of leisure has been covered over, and in its place we find little other than amusement, lollygagging, and various forms of self-commercialization or branding for consumption.

Some twenty years after De Grazia's (1964) *Of Time, Work, and Leisure*, Neil Postman (1985) published his most celebrated book, *Amusing Ourselves to Death*. Now, more than twenty years after Postman's book, one can't help but see the drive for amusement as a displaced and mostly distracted drive for leisure. So, is there, today, any time left for leisure? E.M. Cioran (1975) offers thoughtful guidance:

> Though we have conquered the universe and taken possession of it, so long as we have not triumphed over time, we remain slaves…. All things considered, the century of the end will not be the most refined or even the most complicated, but the most hurried. (p. 95)

Indeed, people who want to read and think—and by that I mean have the leisure for study and contemplative thought—need more than a few shards of spare time now and again throughout the day. They need good-sized stretches of time, spans that, if measured at all, are measured in hours and days or even weeks and months, certainly not minutes. Without the conditions for leisure—time off of all clocks, the time of no time when we lie still or walk around and contemplate—people will be rushed around in an endless mall, frantically amusing themselves to death, caught in the pillory where they have only enough time to distractedly purchase the next item that tickles their senses.

Acknowledgments

I thank Valerie V. Peterson, Janet Sternberg, Anthony Thompson, Anthony Nelson, Danielle Wiese, Brett Lyszak, Stephanie Bennett, and Sharon Kleinman for their helpful assistance.

References

Anton, C. (2001). *Selfhood and authenticity*. Albany: State University of New York Press.

Augustine, A. (1951). *The confessions of Saint Augustine* (E. B. Pusey, Trans.). New York: Pocket Books.

Carey, J. W. (1989). *Communication as culture*. Boston, MA: Unwin Hyman.

Cioran, E. M. (1975). Civilized man: A portrait. In R. Boyers (Ed.), *Psychological man* (pp. 85–96). New York: Harper & Row.

Czitrom, D. J. (1983). *Media and the American mind*. Raleigh: University of North Carolina Press.

De Grazia, S. (1964). *Of time, work, and leisure*. Garden City, NY: Doubleday.

Foucault, M. (1977). *Discipline and punish* (A. Sheridan, Trans.). New York: Random House.
Fraser, J. T. (1987). *Time: The familiar stranger.* Amherst: University of Massachusetts Press.
Gleick, J. (1999). *Faster.* New York: Pantheon Books.
Hassan, R. (2007). Network time. In R. Hassan & R. E. Purser (Eds.), *24/7: Time and temporality in the network society* (pp. 37–61). Stanford, CA: Stanford University Press.
Hassan, R., & Purser, R. E. (2007). *24/7: Time and temporality in the network society.* Stanford, CA: Stanford University Press.
Heidegger, M. (1982). *The basic problems of phenomenology* (A. Hofstadter, Trans.). Bloomington: Indiana University Press.
Henry, J. (1965). *Pathways to madness.* New York: Vintage Books.
McLuhan, M. (1964). *Understanding media.* Cambridge, MA: MIT Press.
Postman, N. (1985). *Amusing ourselves to death.* New York: Viking.
Rifkin, J. (1987). *Time wars.* New York: Henry Holt.
Slouka, M. (1995). *War of the worlds.* New York: Basic Books.
Strate, L. (1996). Cybertime. In L. Strate, R. Jackson, & S. Gibson (Eds.), *Communication and cyberspace* (pp. 351–377). Cresskill, NJ: Hampton Press.
Waite, C. K. (2003). *Mediation and the communication matrix.* New York: Peter Lang.
Watts, A. (1966). *The book.* New York: Vintage Books.

CHAPTER 6

No Punctuation

Searching for an Architecture of Time in the Culture of Efficiency

▶ BRENDA L. BERKELAAR

Technical civilization is man's conquest of space. It is a triumph frequently achieved by sacrificing an essential ingredient of existence, namely, time.
 Abraham Joshua Heschel, 1975

The culture of efficiency and the production of material goods is deeply affecting the sense of time, which is now at the service of ferocious competition [influencing]... even the way economy and life are integrated.
 Archbishop Mario Cargnello, May 15, 2001

You have reproved me for eating very little, but I only eat to live, whereas you live to eat.
 Socrates

People are trying to get their souls right with technology or perhaps just trying to become a little less addicted to the pull of the screen. In Seattle, home of technology giants Microsoft and Amazon.com, Jay Kimball, former engineer, and Leif Hansen, former computer coach turned social media consul-

tant, developed and now facilitate "Soul Tech" workshops designed to help people live "passionately productive [lives] amidst a tech-stressed world" (SparkNW, 2008). The duo created the workshops in response to their consultancy clients' repeated discussions about technology pressure. Because some prospective clients mistakenly thought the experiences were religious, Kimball and Hansen now refer to them as "Sustainable Technology" workshops (SparkNW, 2008). Hansen himself takes a "low-tech Sabbath" on Sundays, giving himself a day off from technology each week to resist the "time suck" of technology, to slow down, read books, and to connect with his wife and their daughter (Chansanchai, 2008).

Many people experience Western culture as a time-bound, time-compressed, and time-stressed society (Kleinman, 2007) focused on efficiency as the ultimate value (Stein, 2002). The growing influence of globalization and always-on information technologies enables this continuous connection or presenteeism. Traditionally defined as workers who are present at work in spite of illness, presenteeism (as opposed to absenteeism) now incorporates organizational and individual philosophies that value presence at work, whether physical or virtual, regardless of actual productivity (Kleinman, 2007).

The culture of efficiency (or the cult of efficiency) is rooted in modern business methods, particularly the work of American mechanical engineer and management consultant Frederick Winslow Taylor (1911), whose scientific management approach in the early 1900s—sometimes referred to as Taylor's principles or Taylorism—emphasized efficiency and productivity enabled through the measurement of each discrete work behavior. Enhanced by contemporary information and communication technologies in particular, the culture of efficiency as currently manifested emphasizes 24/7, always-on connectivity, productivity, and multitasking. In practice, efficiency becomes the prime standard of success; in other words, doing more with less—be that less time, less money, fewer people, or less of some other resource.

Michel Foucault's notion of Discourses (with an uppercase D) is relevant here: Discourses are the "standardized ways of referring to/constituting a certain type of phenomenon" formed in and from the conversations, cultural assumptions, and everyday realities of particular socioeconomic and historical locations (Alvesson & Kärreman, 2000, p. 1134). Capitalist Discourses of efficiency, productivity, instrumentality, and economics remain privileged in the culture of efficiency. Work and leisure (or nonwork) are often discursively constructed as diametrically opposed, as opposites. Work is often privileged over leisure or nonwork in terms of time spent, even though leisure is something desirable to be attained. Tips and strategies for quick ways to save time, be more productive, and accomplish more abound in contemporary

culture, such as how to fit in short workouts, take mini-vacations, and do business during commutes. Companies market productivity software in an effort to make sure you "use every minute" (Palm, Inc., 2008) and "help you make time behave" (Microsoft Corporation, 2008).

How we talk about things shapes our perceptions of them and our behaviors. In the culture of efficiency, both work and leisure are often discussed instrumentally, in other words, as means to an end. Work is a means to achieve a certain standard of living or goal. Paradoxically, proponents of leisure now sometimes argue not for the inherent value of leisure but for its contribution to overall productivity, often as a means to cope with work-related stress. For example, a Web site describing the InShape Indiana program touts that "healthy people perform better and save money for themselves, their employers and the state" (Indiana State Government, 2008). In addition, as argued by Daniel Cohen (1994), psychology author and news director, adult play, particularly in U.S. culture, has become something we work at, quantify, and measure. Intentional and unintentional proponents of the culture of efficiency privilege productivity and efficiency above alternate values or Discourses. This does not mean that there are not other ways to talk about work and leisure but rather that the culture of efficiency provides one predominant way.

This chapter focuses on how people use spiritual Discourses to both resist and exploit technology, including those technologies implicated in the creation of the culture of efficiency. Although new technologies do not necessitate the development of the culture of efficiency, the culture of efficiency is enabled by many contemporary technologies. Globalizing pressures for just-in-time delivery and cost- and time-efficient processes, along with ever-evolving information and communication technologies, allow for continuous connection and the corresponding pressure to be continuously connected or, at the very least, to multitask. In particular, mobile devices, such as iPhones and BlackBerries, facilitate ongoing communication, collaboration, and multitasking even as work "spills over" into leisure and family time (Chesley, 2005).

Ironically, as I write this chapter on my laptop computer in a local Starbucks coffee shop connected to the Internet on a Sunday during my summer "break," I am trying to temporarily forget four projects due in the next few weeks—a 75-page collaborative book chapter, another book chapter, a final report related to a funded research project, and comprehensive exams, which are weeks of written tests followed by an oral exam required of doctoral students to assess readiness for independent research and teaching—amidst an onslaught of e-mails for various opportunities and responsibilities, including numerous family and community events. And now I'm ignoring my ringing cell phone, too.

A disclaimer: despite its prevalence (and prominence in my personal life), the culture of efficiency is not an everywhere, everyone phenomenon. Certain cultures and certain types of jobs are more likely to be engaged in the culture of efficiency. As well, the culture of efficiency is not necessarily the only culture being enacted within a particular society. Time pressure, a central component of the culture of efficiency, is the dis-ease particularly of what have typically been called developed or industrialized countries, which now often include information economies. Although predominant in Western cultures, and the U.S. in particular, the culture of efficiency (and its effects) is not a distinctly Western phenomenon. For example, in 1987 the Japanese Health Department recognized *karoshi* (also spelled *karoushi*), death by overwork or job-related exhaustion (Tubbs, 1993), with recent cases making international headlines (e.g., Associated Press, 2008b; Lewis, 2006; Okamura, 2008; Pesek, 2009; see also Maynard, chapter 3, for a description of fast-paced Japanese culture).

Second, there are collective exceptions to mainstream senses of time pressure and always-on work environments within industrialized, information societies. For example, throughout the world, the Plain People, which include Old Order Amish and Mennonites, offer a counterpoint to dominant cultural practices as evidenced by their deliberate and contemplative technology adoption and usage. For example, prior to adoption or following a trial period, the Old Order Amish examine the possible impact of technologies on the community and its values. This evaluation includes examining the impact of a particular technology, such as the telephone, on silence and the interruption of rhythms (Cooper, 2006). In the case of the telephone, it was initially adopted because of its value in contacting doctors and veterinarians, ordering supplies, and connecting with others, particularly during crises such as fires. The telephone was eventually banished to barns or booths, or borrowed from neighbors, because of its "amplification of gossip, worldly contact, and disruption of family rhythms" (Cooper, 2006, p. 144).

Even though groups such as the Old Order Amish may not experience all of the lauded benefits, however defined, of so-called developed information societies, in terms of connection, convenience, accessibility, efficiency, and so forth, they seem to have something that some people in larger time-pressured communities desire. For example, proponents of the loosely coupled voluntary simplicity movement work to reflect some of the principles of the Plain People lifestyle, rejecting the pressures of consumerism and careerism, but do so typically without joining a church (Grigsby, 2004). Journalists in particular publicly criticize this and the related Slow Food movement for its elitism (see Glover, 2007), since most people cannot afford the wholesale rejection of contemporary work practice or can only do so after years of working diligently (see Houy, chapter 2, for more about the Slow Food movement).

The related Slow movement focuses on combating time famine by putting "the brakes on people's high-velocity lifestyles" with a fundamental emphasis on sustaining resources of time, energy, and the environment (Blake, n.d).

Freedom from Technology: Co-opting Spiritual Practices

More recently, some people are co-opting particular spiritual practices to resist pressures imposed by technology, rather than engaging in wholesale simplicity movements. Specifically, they are taking media or Internet fasts and technology Sabbaths. Although there are individuals who eschew e-mail and the Web completely, Internet fasts and technology Sabbaths are part of a grassroots movement to switch off technology and refrain from work typically for at least one day a week—and sometimes longer—but not permanently (Glaser, 2008; Serjeant, 2008). Feelings on this? healthy? possible?

Fasting traditionally involves abstaining from food, drink, or both for religious or nonreligious reasons. In some ancient religions, including the Greek and Roman mystery religions (Meyer, 1999) and the Druids (Macculloch, 2005), as well as Native American religions (Irwin, 1994), followers often fasted in preparation to receive divine teachings or visions or to perform magic. Adherents of most major religions often engage in fasting for reflection, remembering, refocusing, discernment, self-discipline, or purification, often with the central focus of being mindful of God. For example, the Jews fast during the Day of Atonement, Protestants and Catholics often fast during Lent, and Muslims fast from sunrise to sunset each day for the entire month of Ramadan. Others fast to accomplish political or social purposes. Gandhi is a notable example of someone who fasted as a spiritual discipline and also often refused to eat until demands for social reform were met. During one political fast, Gandhi (2008) opposed discrimination of the untouchables, a caste, or hereditary social class, whose members were the economically, socially, and politically oppressed outcasts of Indian society. His fast helped persuade officials to offer more political representation for the untouchables in India. Additionally, beyond religious or political reasons, people fast for more instrumental reasons. Fasting may be required before surgery or as a precursor to medical tests to ensure accurate results, as in the case of some blood tests for cholesterol or blood sugar levels.

Despite its traditional associations with abstinence from food, more recently evangelicals and Catholics fast not simply from specific food groups, but also from attitudes and behaviors, such as watching television (Winner, 2003), speaking negatively of others, or, in the case of one middle-schooler

I know, chapstick. According to Lauren Winner (2003), a visiting fellow at the Princeton Center for the Study of Religion and former agnostic turned practicing Jew turned Christian, these "non-gastronomic fasts" find their roots in ancient religious practices such as the *tzom shitikah,* the fast of silence of the Jewish mystics.

Like fasting, the Sabbath is also associated with abstinence; however, one abstains from work or the act of creating rather than from food. Although conceptualizations of the Sabbath find their origins in Jewish notions of Shabbat, rooted in the Hebrew word for rest, inactivity, or ceasing, "Sabbath" is often used synonymously with any weekly holy day set aside for worship or religious purposes (Simpson & Weiner, 1989). Sunday or the "Lord's Day" for Protestants and Friday, *Jama'ah* or *Jum'ah,* the day of gathering for Muslims are Sabbath-like in the sense that they are holy days set apart from other days. For Jews, on the Sabbath individuals must not create anything, since the Sabbath is "a serene period during which one strives to have minimal impact on the world and to leave the world unchanged" (Woodruff, Augustin, & Foucault, 2007, p. 529). By surrendering control, renouncing autonomy, and affirming God's dominion, one is able to focus and reflect on larger issues (Woodruff et al., 2007), or, as eighteenth-century Christian pietist Johann Friedrich Starck argued, the Sabbath allows man to "disentangle his mind from worldly cares and troubles" (Erb, 1983, p. 181).

Following the injunction that "the Sabbath was made for man, not man for the Sabbath," Christians redefined notions of Sabbath. In commemoration of Christ's resurrection, Christianity redefined the Jewish notion of Sabbath, moving it from Saturday to Sunday when Emperor Constantine declared Sunday as a "day without work" in the fourth century. But it was not until the Reformation that the notion of Sunday as Christian Sabbath became popularized (Simpson & Weiner, 1989), typically involving a day of gathering for religious sermons, prayer, and/or singing, and mandated rest from work.

Islam's weekly holy day, *Jama'ah,* is not actually a day of rest; however, the book of Islam's sacred writings, the *Koran* or *Qur'an,* calls people to prayer (*athan* or *adhan*) in congregation, away from work, at noon. The person leading the prayer, the *Imam* or the *khatib,* usually provides religious oration, or *khutbah.* According to Islam, Muslims may go back to work after prayer (*salat*) as long as business is closed during prayers, but in many Muslim countries, including Qatar, Saudi Arabia, and Kuwait, Friday is equivalent to Sunday in Western countries, with the workweek typically extending from Saturday to Wednesday, in contrast with a Monday to Friday workweek typical of Western industrialized nations.

Both fasting and Sabbath keeping, by which I mean observing a day of rest, prayer, reflection, and/or worship, tend to focus on withholding or absti-

nence practices, from food or from work and creation, in order to focus on something other than the immediate material situation (typically on God), whether that be for an entire day, as in Judaism and Christianity, or for a period during the day, as in Islam. Although only three world religions are presented here, there are also Sabbaths or weekly holy days in other religions. Additionally, though the weekly Sabbath or holy day is described here, there are also sabbatical years. For example, within Judaism, in Mosaic law, every seventh year was the sabbatical year during which the land was to lay fallow, slaves freed, and debtors forgiven. Outside of religion, within academia and now in other professions and companies as well, a sabbatical involves a period of leave from duty for study, travel, or simply rest or absence from duties; in academia, faculty are typically eligible for a sabbatical every seven years (Simpson & Weiner, 1989).

Media fasts and technology Sabbaths refocus abstinence on the use of and creation with information and communication technologies, rather than on abstinence from food or work per se. One could argue that information and communication technologies are intimately intertwined with work in contemporary information economies, such that technology Sabbaths are in significant part, although not exclusively, about abstinence from work, since these technologies are also an increasing part of people's nonwork lives. National Public Radio journalist Mark Glaser (2008) argues that the "concept of a 'Technology Sabbath' is becoming more widespread, both in religious circles and among bloggers and media people who are overwhelmed with the always-on nature of the broadband Internet and smartphones." Some technology Sabbaths are simply extensions of religious practices, as articulated by Kevin A. Miller in his 2004 book, *Surviving Information Overload*:

> The Sabbath.... had two purposes: rest and remembrance of God. An info-tech Sabbath, as I dub it, has the same goals: rest for our minds and overstimulated senses and remembrance that life is bigger than the news stories, stock quotes, and sport scores. It's bigger than ourselves. There is in fact a God and we're not it. (p. 157)

But not all technology Sabbath and media fast practices have religious overtones, aside from the Sabbath label. For example, in addition to the "Soul Tech" workshops that are nonreligious "sustainable technology" workshops, mainstream media, including the *New York Times*, *ABC World News*, and *The Today Show*, have all recently covered the concept of "secular Sabbaths," in some cases highlighting author Ariel Meadow Stallings (2008) and her blog, *Unplugged*, in which, ironically, she chronicles her experience of abstaining from the Internet, her cell phone, and television every Tuesday evening for a year. Taking an academic perspective, American University communi-

cations professor Donna Walker (2007) required her students to abstain from television, computers, iPods, radio, video games, CD players, records, cell phones, landlines, and the like for 24 hours and to reflect on the influence of information technology and media in contemporary society.

It is the co-optation of religious practices and language by individuals not associated with religious organizations that makes these secular versions of Sabbath and fasting fascinating. Motivations for these fasts and Sabbaths appear to be imposed rest, opportunity for reflection, and freedom from technology addictions, and sometimes include arguments for increased productivity. Despite more and more examples in the popular press of technology fasts and secular Sabbaths, there is a paucity of academic research on these phenomena.

Embracing Technology for Religious Fulfillment

Not everyone seeks respite from contemporary technologies. Some religious groups are embracing and developing information and other technologies to better fulfill religious commitments. Religion is defined here using Emile Durkheim's (1912/1995) neutral stance that deemphasizes whether religious beliefs are true or false, instead focusing on social practices and religious communities. Research on religious groups' spiritualizing of the Internet (Campbell, 2005) and techno-spiritual practices suggests "increasingly visible intersections of spiritual practice and technological development world wide" (Bell, 2006, p. 141). Although recent research describes how people are using technology to support religious practice (for example, Bell, 2006; Woodruff et al., 2007), the use of technology to support religious practices is not a new phenomenon. For example, Muslims applied the technologies of compasses and telescopes to support a central practice in Islam: the five daily Islamic prayers, or *salat,* which require facing east toward Mecca (Wyche, Caine, Davison, Arteaga, & Grinter, 2008).

Contemporary examples from Jewish, Christian, and Muslim religious practices provide compelling evidence of technologies as potential tools for religious practice. Mobile devices, and smart phones in particular (sardonically called electronic tethers and crackberries), remain popular targets of time pressure critics and key elements of the culture of efficiency. Muslims and Jews employ religiously oriented smart phones and/or software to maintain religious commitments and rhythms. For example, the ilkone is marketed in the Middle East and Europe as "the world's first mobile phone with unique Islamic applications" (AME Info, 2004) and in East Asia as "a mobile phone that connects you to your beliefs where you are" (ilkone Asia, 2004). Its global positioning system (GPS) and other features allow users to find the direction of Mecca from anywhere, hear the call to prayer in a live voice

> Using ~~modern~~ technology for religion- effective or just a facade?

(*athan* or *adhan*), and read the Koran in Arabic and English. The phone automatically disables during times when one would be at the mosque or in prayer (Bell, 2006). The ilkone was not marketed in the U.S. in part due to the lack of compatible cell phone technology, since the predominant type of network in the U.S., where there is no mobile phone system standard, is different and incompatible with the networks typically used in Europe and the rest of the world. But designers in the U.S. recently developed cellular software to provide *salat* (prayer) reminders in a culture where the low density of mosques does not allow individuals to hear the Imam's call throughout the day (Wyche et al., 2008).

In the UK, many Jews also employ religiously compatible, or kosher, phones. Something is considered kosher if it is prepared according to Jewish ritual and religious law, and this typically involves certification by a rabbinate council. On start-up, kosher phones display the seal of the rabbinate council. They do not send text messages or connect to the Internet and cost only a penny a minute, except on the Sabbath when a minute costs £1.50 as a religious penalty, currently equivalent to about US$2.70 (Drainey, 2007). There is also a kosher version of the Internet for ultra-orthodox Jews that blocks access to a range of Web sites, including more easily apparent concerns such as sexually explicit or pornographic Web sites as well as sites that are not required for legitimate business use. The kosher Internet can also identify ultra-orthodox individuals who do not use the kosher Internet option. The primary goal is to allow ultra-orthodox Jews to use the Internet for business without risking exposure to educational and spiritual damage resulting from exposure to the world outside of their tightly knit communities (British Broadcasting Corporation, 2007).

Christians also use technology for religious purposes, including mobile phone software designed to reach current generations. For example, the Bible Society in Australia (n.d.) has translated the entire Bible into SMS format: "4 God so luvd da world."

Groups are using more than just information and communication technologies to meet religious needs. Other technologies are being leveraged as well. There are kosher vending machines that distribute kosher food (Severson, 2007), with Hot Nosh 24/6 providing kosher hot dogs in places such as Fenway Park in Boston (Associated Press, 2008a). Kosher technology entrepreneurs have developed pens with ink that disappears within a few days, which avoids prohibitions against permanent writing on the Sabbath, as well as sound systems and kosher wheelchairs that work through indirect action, or *gramma,* a Jewish legal concept that offers a means of using appliances while still observing Sabbath laws (Levin, 2008). There are also smart homes: fully automated domestic environments designed to anticipate and meet occupants' needs, whose very name conjures up scenarios popularized in

science fiction, in the early 1960s animated sitcom *The Jetsons,* and by Bill Gates.

Despite futuristic allusions, smart homes have existed within Jewish families for decades, and they offer compelling examples of technology serving religious goals (Woodruff et al., 2007). A recent qualitative study of 20 Orthodox Jewish smart homes in the U.S. demonstrated how technology took over mundane activities so occupants could focus on their relationship with God and surrender control over quotidian activities as they reflect on larger issues (Woodruff et al., 2007). Without apparent prompting from the interviewers, participants spontaneously discussed the conflict between technology and rest, and associated technology with stress, worry, and family disconnection although these same participants intentionally employ technology to accomplish Sabbath goals of rest and spiritual reflection (Woodruff et al., 2007). In many communities, these daily activities are also sometimes accomplished by a *Shabbos Goy,* non-Jew willing to do certain tasks on Sabbath that observant Jews cannot do, including turning on the air conditioner when it is hot or the furnace when it is cold, or rushing pregnant women to the hospital. Whether the development of new smart technologies and corresponding rabbinical law will replace the need for the *Shabbos Goy* remains unstudied by academics. Although ostensibly teaching Jewish religious and cultural concepts, debates about technology, the *Shabbos Goy,* and Sabbath keeping are explored in *Shabot6000,* a comic strip about a robot purchased to perform the duties of a *Shabbos Goy* who decides he is Jewish and therefore cannot fulfill his duties on the Sabbath (see http://www.shabot6000.com/).

Woodruff and colleagues (2007) acknowledge that skeptics might argue that the presence of automation technology to make technology (that is, lights, appliances, and other domestic technologies) more hidden is hypocritical subterfuge or self-deception. As rabbinical debates continue about the appropriateness of technological automation in accomplishing Sabbath commandments to refrain from any act of creation or work, the emphasis by the participants and the researchers focuses on the fundamental purpose of Shabbat: reflection on God and surrender of control over mundane activities (Woodruff et al., 2007). As such, automation is typically considered by the study participants to be an external process that cannot be controlled in the moment, providing value in its "inability to control," and is consistent with other Sabbath practices: one can prepare food before the Sabbath, so too can one prepare, that is to say automate, the lights and heat in the residence.

These paradoxes, the use of technology to provide the illusion of less technology (Woodruff et al., 2007) and automation or control as a means of demonstrating lack of control, suggest a more complex interplay between technology

and spiritual practices. Technology can enhance or detract from spiritual practices. Some religious individuals want both more and less technology to accomplish their goals of Sabbath keeping. Technology offers control that enables spiritual practice while spiritual practices offer freedom from technology that is controlling. In contrast to secular Sabbaths addressed in popular literature, which in addition to imposed rest, suggest a goal of regaining individual control (from, for example, technology addiction), Jewish Sabbath keeping focuses on the relinquishment of control. However, both seem to recognize the illusion of control offered by technology, and members of both groups suggest that technology, rather than the individuals themselves, is in control of everyday life outside of religious or secular Sabbaths.

So why do some people co-opt spiritual practices to resist the pressures seemingly imposed by technology while others exploit technology to meet their religious commitments? Although the intersection of religious practices and technology provides a useful example of how technology does not determine particular social outcomes, the intersection of the secular (technology) and the sacred (religion) suggests something more.

Time and Rhythm in Contemporary Society

Contemporary secular societies, that is, societies without a religious mandate or religious governance, typically lack the religiously imposed rhythms that regularize and control the rhythm of social life (Durkheim, 1912/1995). According to Durkheim, rhythm is essential to social functioning. Although "society cannot revitalize the awareness it has of itself unless it assembles.... it cannot remain continuously in session" (p. 353). Religious rhythms express the rhythm of social life. This is consistent with Judaism, the source of many contemporary ideas about Sabbath practices. Renowned Jewish scholar Abraham Joshua Heschel (1975) asserts that

> Judaism is a religion of time aiming at the sanctification of time.... Jewish ritual may be characterized as architecture of time. Most of its observances—the Sabbath, the New Moon, the festivals, the Sabbatical and the Jubilee year—depend on a certain hour of the day or season of the year. It is, for example, the evening, morning, or afternoon that brings with it the call to prayer. (p. 8)

So too with Islam's *adhan* and *salat*, in which the daily call to prayer orients Muslims by time of day and space (facing east), Friday is the day of gathering, and Ramadan is determined by the lunar calendar. Catholics and Protestants have Lent, Easter, Christmas, and mass or Sunday services, with Easter and Lent also determined by the lunar rather than the Gregorian calendar. There are periods of gratitude and gathering, abstinence, and self-examination. Every religion divides the calendar into sacred rhythms in

contrast or discord with other secular rhythms of semesters, sports seasons, and fiscal quarters.

Prior to globalization in the mid- to late twentieth century, individual religions tended to have a greater influence on cultural practices in secular societies, including imposing temporal rhythms in terms of defining workweeks and national or organizational holidays. Holidays and the calendar associated with Christianity remain predominant in much of the Western world, including the U.S., and those associated with Islam remain predominant in large parts of the Middle East. However, in countries where pluralistic tolerance for various religious practices or nonpractices has emerged and/or where international companies and work are desired, some of the architecture of time or temporal rhythms of work and life have been eliminated. For example, in many Islamic countries the typical workweek ranges from Saturday to Wednesday, with weekends falling on Thursday and Friday. For organizations and individuals that conduct business internationally, this only allows three workdays' overlap of "regular office hours" with Western organizations that typically have a Monday to Friday workweek.

Our notions of days for work, for rest, and holidays emerge from religious and cultural assumptions. Starting in colonial times, blue laws, which prohibited commercial activity on Sundays in countries such as the U.S. and Canada, provided an architecture of time that forced the religious and non-religious to observe sacred rhythms together. In the 1960s, most blue laws in the U.S. were repealed, with the exception of some laws that continue to ban the sale of alcohol. Contemporary movements toward religious tolerance and acceptance encourage more flexibility in holiday schedules, religious days off, and even floating holidays, which offer individuals the choice of when and for what purpose to take a day off work. Floating holidays allow organizations to limit the number of designated holidays offered to all workers, but provide the flexibility for a range of religious and otherwise motivated holidays for employees. Although clearly in countries like the U.S., the influence of Judeo-Christian religious holidays tends to predominate in work calendars, in particular with Christmas holidays; other countries, such as Oman, Kuwait, and the United Arab Emirates, base work or national holidays on the Islamic calendar events, including Eid al-Fitr, the feast celebrating the end of Ramadan, and Eid al-Adha, the feast of sacrifice that celebrates Abraham's obedience to Allah.

Religious structures are not the only factors influencing cultural rhythms and notions of time. Different economic systems also influence social rhythms. For example, an agrarian economy, like that which was typical during colonial periods of U.S. society and is still evident within small rural farming communities, tends to follow the seasons and the associated planting and harvesting cycles, whereas an industrialized society, as manifested in manu-

facturing centers like Detroit at the height of the Industrial Revolution, would be more inclined to follow the patterns of shift work in which groups of employees rotate into factories throughout the day to allow for 24-hour production. In both situations a combination of economy and religion constructed periods of work and nonwork by weeks, months, and seasons.

It is important to remember that time is a social construct, not an absolute, even though the structure of days, hours, minutes, and seconds makes it appear to be an objective reality (see Anton, chapter 5). Time is not something that necessarily is the way it is understood. The clock and our notion of time is as much a social construction as the rhythm of religious calendars. Different types of clocks (for example, water clocks, candle clocks, sundials) were invented or used by religious orders such as the Benedictine monks as a means of maintaining the rhythm of daily religious activities (Dohrn-van Rossum, 1996). Standardized time was imposed by the railroads as a means of encouraging efficient and accurate transportation.

Before the 1850s, the time of day was determined locally (Bartky, 2000). People would check the clock in the local church steeple, which in turn was set based on local solar time. It was difficult for trains to travel from one location to another safely given lack of standardization, and following some large train accidents, the enforcement of standardized times was encouraged. Time zones were not accepted until 1884 at the International Prime Meridian Conference, with the 24-hour standard time encouraged by Sir Sandford Fleming who became interested in the topic in 1876 when he missed his train because of a misprint of p.m., instead of a.m., on his ticket (Bartky, 2000).

My intent is not to encourage a return to a singular religious (or other) calendar and its rhythms or to argue that one rhythm is better than another. Rather, I am suggesting that in contemporary society, many people are searching for an architecture of time in a space that lacks one, or at least lacks one that is recognizable. The mid-twentieth-century movements in some countries toward greater pluralistic tolerance and acceptance of religions and beliefs, as well as toward an information economy like that of the U.S. and other industrialized countries, do not, either independently or together, provide a clear, broadly understood rhythm for work and nonwork or leisure. (I hesitate to use the terms "work" and "life" in opposition because of the inherent implication that work is therefore not life, but we currently lack a viable alternative.) In noninformation economies like Mexico and South Africa, and in some occupations, like manufacturing, construction, and agriculture, work still occurs in a physical place and physical manner, creating a tangible demarcation between work and nonwork. But a lot of work in an information economy occurs in our heads and on computers and cell phones. Work

No Punctuation

[handwritten note: Possible to ever stop working in an info economy?]

comes with us wherever we go, no longer clearly separated in space or time from nonwork.

This perhaps is the appeal of secular Sabbaths and media fasts: people desire an architecture of time with its intervals of self-examination, rest, and reflection, and a clear distinction between work and nonwork. Globalization and the information economy, along with the technologies that underlie them, have changed our notions of time. This is not a new realization. In an era of 24/7, always-connected technologies, there seems to be no punctuation. There seems to be no recognizable rhythm. However, it may not simply be that there is not a clear rhythm to work and nonwork or leisure, but that separation between work and leisure (nonwork) is not as objective or inherent a division as we articulate and seem to believe.

More Than a Turn of Phrase: Implications of Secular Sabbaths and Internet Fasts

Are the adoptions and/or co-optations of spiritual practices through secular Sabbaths and Internet fasts simply linguistic (or incidental or marketing) turns of phrase, or do more fundamental motivations and implications underlie these terms and practices? What do these engagements, disengagements, and intersections of information technology and religious practices say about our rhythms of work and leisure today? Here are some preliminary thoughts.

First, the intersections between spirituality and technology discussed in this chapter offer useful vantage points from which we can explore contemporary Discourses of technology and Discourses of work and leisure. Examining how and why individuals employ religious language and practices to resist technology can help us to better understand the complicated architectures of time in contemporary society and how these impact human behavior and meaning in everyday life.

How does the seeming co-optation of religious language and practices as forms of resistance affect notions and meanings of work and nonwork, if at all? Are people using language and practices to maintain the received social order of past generations? Or, are they (re)creating an architecture of time more suitable than the one offered (or not offered) by the culture of efficiency, or one more suitable to the demands of the culture of efficiency? Are they simply attempting to demarcate different human activities such as work or nonwork? Are they resisting or adapting to the culture of efficiency? How do spiritual Discourses affect meaning(s) of work and life in the culture of efficiency, including our connections and disconnections with one another? How might interpolations and intersections between spirituality

and technology like those discussed here alter dominant notions of technology (as instrumental), work (as oriented toward efficient production), and leisure (as reward or instrumental means of accomplishing production)?

Examining the relationship between religion and technology might offer insight into ways people are resisting or co-opting aspects of the culture of efficiency symbolized or enacted in its particular equipment: either repurposing its fundamental information and communication technology tools to accomplish unique ends, such as devices like GPS-enabled cell phones to enable periods of prayer and reflection, or as in the case of the Old Order Amish, resisting technology use that disrupts community connection and rhythms with the values and pressures of the culture of efficiency, or perhaps by limiting use periodically, as in the case of secular Sabbaths and Internet fasts.

Conclusion

An intriguing cultural shift is taking place, and we seem to lack language to describe it. In the language of software design, a mash-up involves the combination of data and/or applications from two different or even competing Web sites or software to create something new. It is, according to *The Oxford English Dictionary,* "the mixture or fusion of disparate elements" (Simpson & Weiner, 1989). In the culture of efficiency, where boundaries between work and nonwork become blurred, a mash-up of religion and technology has developed. Acts of technology resistance like secular Sabbaths and technology fasts might offer insights into the explicit nature of this phenomenon as well as how it is influenced by and influences dominant Discourses and underlying ideas about work, leisure, time, and technology within and outside of a culture of efficiency. We need a new way of talking about work, leisure, nonwork, technology, and time so we can understand and make good decisions for sustainable and meaningful (in every sense of the word) lives. Exploring the motivations and processes behind the mash-up of religion and technology may provide a way.

References

Alvesson, M., & Kärreman, D. (2000). Varieties of discourse: On the study of organizations through discourse analysis. *Human Relations,* 53, 1125–1149.

AME Info. (2004, August 16). ilkone launches first fully Islamic mobile phone. *AME Info.* Retrieved November 9, 2008, from http://www.ameinfo.com/43982.html.

Associated Press. (2008a, April 1). Kosher franks coming to Fenway. *The Boston Globe.* Retrieved September 14, 2008, from http://www.boston.com/sports/baseball/articles/2008/04/01/kosher_franks_coming_to_fenway/.

Associated Press. (2008b, July 9). Ruling finds Japanese man died from overwork. *CNN. com*. Retrieved July 10, 2008, from http://www.cnn.com/2008/WORLD/asiapcf/07/09/japan.overwork.death.ap/index.html.

Bartky, I. R. (2000). *Selling the true time: Nineteenth-century timekeeping in America*. Stanford, CA: Stanford University Press.

Bell, G. (2006). No more SMS from Jesus: Ubicomp, religion, and techno-spiritual practices. *Proceedings of the International Conference of Ubiquitous Computing*.

Bible Society in Australia. (n.d.). *SMS Bible*. Retrieved November 8, 2008, from http://www.biblesociety.com.au/smsbible/.

Blake, J. (n.d.). "Slow movement" wants you to ease up, chill out. *CNN.com*. Retrieved July 9, 2008, from http://www.cnn.com/2008/LIVING/worklife/06/06/balance.slow.movement/.

British Broadcasting Corporation (BBC). (2007, May 27). Israel: Ultra-orthodox group launches "kosher Internet." *BBC Monitoring World Media*.

Campbell, H. (2005). Considering spiritual dimensions within computer-mediated communication studies. *New Media & Society, 7*, 110–134.

Chansanchai, A. (2008, January 22). Tech-stressed people from balance. *Seattlepi.com*. Retrieved July 14, 2008, from http://seattlepi.nwsource.com/lifestyle/347939_soultech22.html.

Chesley, N. (2005). Blurring boundaries? Linking technology use, spillover, individual distress, and family satisfaction. *Journal of Marriage and Family, 67*, 1237–1248.

Cohen, D. (1994). *The development of play* (2nd ed.). London: Routledge.

Cooper, T. W. (2006). Of scripts and scriptures: Why Plain People perpetuate a media fast. *The Journal of American Culture, 29*, 139–153.

Dohrn-van Rossum, G. (1996). *History of the hour: Clocks and modern temporal orders* (T. Dunlop, Trans.). Chicago: University of Chicago Press. (Original work published in 1992)

Drainey, N. (2007, November 4). Nick Drainey's world view: Kosher phones let religious call in good faith. *Scotland on Sunday*, p. 22.

Durkheim, E. (1912/1995). *Elementary forms of the religious life* (K. E. Fields, Trans.). New York: Free Press.

Erb, P. C. (1983). *Pietists: Selected writings*. Mahwah, NJ: Paulist Press.

Gandhi, R. (2008). *Gandhi: The man, his people, and the empire*. Berkeley: University of California Press.

Glaser, M. (2008, June 5). "Technology Sabbath" offers one day to unplug. *Mediashift*. Retrieved July 10, 2008, from http://www.pbs.org/mediashift/2008/06/digging_deep-ertechnology_sabba.html.

Glover, R. (2007, April 14). The trouble about these boomer philosophies is the one-size-fits-all template. *Sydney Morning Herald*, p. 20.

Grigsby, M. (2004). *Buying time and getting by*. Albany: State University of New York Press.

Heschel, A. J. (1975). *The Sabbath: Its meaning for modern man*. New York: Farrar, Straus and Giroux.

ilkone Asia. (2004). *ilkone. for you. for life*. Retrieved September 15, 2008, from http://www.ilkoneasia.com/.

Indiana State Government. (2008). *InShape Indiana*. Retrieved July 14, 2008 from http://www.in.gov/rde/xchg/in_core/hs.xsl/faqs.htm?faq_id=621.

Irwin, L. (1994). *The dream seekers: Native American visionary traditions of the Great Plains*. Norman: University of Oklahoma Press.

Kleinman, S. (2007, November). *In a New York nanosecond: Multitasking and time poverty in 21st century American culture*. Paper presented at the National Communication Association Annual Conference, Chicago, IL.

Levin, D. (2008, September 1). Entrepreneurs find ways to make technology work with Jewish Sabbath. *New York Times*. Retrieved September 5, 2008, from http://www.nytimes.com/2008/09/02/business/worldbusiness/02kosher.html?_r=1&ei=5070&emc=eta1&oref=slogin.

Lewis, L. (2006, May 18). Downside of Japanese recovery is death by overwork. *Times London*, p. 69.

Macculloch, J. A. (2005). *The Celtic and Scandinavian religions*. New York: Cosimo.

Meyer, M. W. (1999). *The ancient mysteries*. Philadelphia: University of Pennsylvania Press.

Microsoft Corporation. (2008). *Office: Mac2008*. Retrieved September 13, 2008, from http://www.microsoft.com/mac/products/Office2008/default.mspx.

Miller, K. A. (2004). *Surviving information overload: The clear, practical guide to help you stay on top of what you need to know*. Grand Rapids, MI: Zondervan.

Okamura, N. (2008, September 5). Suicide letters spell out risk of overwork. *Reuters*. Retrieved February 28, 2009, from http://www.reuters.com/article/lifestyleMolt/idUST13950520080905.

Palm, Inc. (2008). *Productivity: Software*. Retrieved July 14, 2008, from http://www.palm.com/us/software/productivity.html.

Pesek, W. (2009, February 4). Candle-burning culture in for killer year. *New Zealand Herald*. Retrieved March 1, 2009, from http://www.nzherald.co.nz/business/news/article.cfm?c_id=3&objectid=10554990.

Serjeant, J. (2008, April 22). Even tech geeks need to unplug: Internet addicts and BlackBerry fanatics are taking back control of their lives by switching off completely for a day a week. *The Globe and Mail*, p. L5.

Severson, K. (2007, August 15). For kosher emergencies, manna from a machine. *New York Times*, p. F5.

Simpson, J. A., & Weiner, E. S. C. (1989). *The Oxford English dictionary*. New York: Oxford University Press. Retrieved November 3, 2008, from http://encompass.library.cornell.edu/cgi-bin/checkIP.cgi?access=gateway%5Fstandard%26url=http://etext.library.cornell.edu/oed.

SparkNW. (2008). *Services: Sustainable technology*. Retrieved July 14, 2008, from http://sparknw.com/soultechseattle.html.

Stallings, A. M. (2008). *Unplugged*. Retrieved July 4, 2008, from http://electrolicious.com/category/unplugged.

Stein, J. G. (2002). *The cult of efficiency: The Massey lectures series*. Toronto: House of Anansi Press.

Taylor, F. W. (1911). *The principles of scientific management*. Norwood, MA: Plimpton Press.

Tubbs, W. (1993). Karoushi: Stress-death and the meaning of work. *Journal of Business Ethics, 12,* 869–877.

Walker, D. (2007, August 5). The longest day. *Washington Post Magazine,* p. W20.

Winner, L. (2003). *Mudhouse sabbath.* Brewster, MA: Paraclete Press.

Woodruff, A., Augustin, S., & Foucault, B. (2007). Sabbath day home automation: "It's like mixing technology and religion." *Proceedings of the Computer Human Interaction Conference.*

Wyche, S. P., Caine, K. E., Davison, B., Arteaga, M., & Grinter, R. E. (2008). Sun dial: Exploring techno-spiritual design through a mobile Islamic call to prayer application. *Proceedings of the Computer Human Interaction Conference.*

CHAPTER 7

Varieties of Efficiency

How Automatic Asset Tracking Changes the Way Businesses Work

▶ MICKEY BRAZEAL

The pursuit of efficiency produces a continuous pressure for innovation in basic business processes. Opportunities created by an evolving technology move quickly from idea to small-scale proof-of-concept tests to process replacement. Applications that can provide a competitive advantage migrate in two ways. They are emulated by direct competitors. And they jump to quite different industries that have a similar problem or an analogous problem. This makes it useful to think about the problems solved by an emerging technology as categories of problems or categories of solutions.

Radio Frequency Identification (RFID) has matured as a technology. Global standards are in place. Early implementation glitches have been figured out. It is breeding new business models and changing old processes in many different businesses. So many processes are changing so profoundly that it makes sense to survey the field and classify the new opportunities. RFID is a technique for automatic identification. A small, inexpensive transponder, or tag, is attached to an object—an object as big as a steel shipping

container or as small as a bottle cap. When the tagged item passes within range of an RFID reader, that reader gets a wireless notification, saying in effect, "here I am" at a particular moment in time. The notification includes the individual identity of the item.

The tag might be a chip as small as the letters *RF* in this typeface. Add some room for a flat ribbon of antenna in circles around the chip. Now, the whole thing might be a little bit bigger than a postage stamp and almost as thin—thin enough to embed in a credit card without a bulge. That's a convenient size for many applications, though there are tags as big as a deck of cards, and tags as small as a grain of sand. Simple tags cost about ten cents each if you're willing to buy a million at a time. Tag costs have fallen steadily and the industry is focused on reducing their cost still further. There are predictions of one-cent tags, but this would require some breakthroughs (Lee, 2008).

Most are passive tags, which work by picking up a signal sent out by the reader, changing it slightly, and bouncing it back. Active tags, with battery power, may be used for long distances or additional functions. Even small tags can contain a little data-processing power, a little memory, and sensors—devices that measure temperature, or acceleration, or heart rate, or radiation, or chemical changes, or hundreds of other things. The reader can be wall mounted or handheld. You could have one in your cell phone.

To understand the power of this idea of automatic identification, think about online search engines. Search engines like Google have transformed the process of finding information. Before the advent of search engines, there were lots of things people needed or wanted to know but had no easy way to find out. Lots of tasks were done the hard way because it was difficult to find out about easier approaches. How people live, work, and make things happen has changed dramatically because search engines offer a quick and inexpensive way to find things out. But search engines can only be used to find information—information that is stored online and has been made available by its owner.

In essence, RFID creates a search engine for objects in the physical world. It can find individual things and report their location and condition. It can know which other things are nearby. And it can report other kinds of context, like how a sensor reading changes when a thing moves from one place to another.

RFID is a giant step beyond bar codes, the previous high point in automatic identification. Bar codes need to be seen in order to communicate. Radio waves don't. So the tagged item can be facing away from the reader, or under a stack of other products, or inside a case, or covered with mud, or in the dark. Bar codes have to be oriented, that is, held in front of the reader at a particular angle. In practice, this means someone has to pick the item

up and align it, as at a supermarket checkout counter. Bar codes identify a category: this is a Gillette Mach3 Razor. RFID tags identify a specific instance: this is the twenty-third Mach3 Razor in the case that was shipped to receiver X on Y date at Z time. Bar codes cannot be changed once they have been deployed in the world. RFID tags can be locked, or they can be changeable, "written to" wirelessly from a distance. Finally, RFID tags can be designed to be turned off or "killed" if the owner no longer wants them to be read.

RFID is often used to track products as they move through the supply chain. If companies can know exactly where things are on the long trek from materials supplier to component supplier to subassembler to assembler to wholesaler to warehouse to retailer, they can keep from running out of something on the retail shelf. That's desperately important. When a product is out of stock on the shelf, customers may feel they have wasted a trip. Often, they go away without buying. The most conservative study says this happens 38 percent of the time (Zinn & Liu, 2001). Brand marketers who have advertised and perhaps launched promotions to bring the buyer to that shelf have wasted their money. And when customers choose a competitive product to replace one that was out of stock, they will often continue to buy that product (Gruen, Corsten, & Bharadwaj, 2002). In early tests, reducing out-of-stocks with RFID tracking increases retail sales by about 7 percent (Simchi-Levi, 2005).

Retailers keep billions of dollars worth of inventory at various points in the supply chain to keep from running out—an investment without a return. Procter & Gamble alone, before RFID, kept 65-plus days of inventory in the supply chain, at a cost of three billion dollars (Hughes, 2005). Once retailers can know in real time where everything is, they can do "responsive replenishing" and cut back safety inventory.

Businesses are only beginning to understand the tremendous advantages of asset tracking outside the supply chain. When you can know, in real time, where things are, without sending somebody to find them, you can do things that you could not do before. You may be able to get the job done with fewer assets or less costly assets. And you may be able to do things remotely and automatically that would otherwise require management intervention or workers on location.

To understand the new efficiencies, let's look at ten of the fastest growing categories, each with an example or two.

Remote Administration

If you have tags and a reader at the critical spot, you might not need to have a manager on the spot.

Zipcar is a shared car club in which a car can be rented inexpensively and by the hour. The cost includes insurance, maintenance, and even gasoline; a gas card tucked inside the driver's side visor of each car enables free fueling. Cars can be scattered strategically across a city—just parked in parking lots with "Reserved for Zipcar" signs. The renter has a membership card that contains an RFID tag. A phone call or Web site visit allows the renter to choose a car to reserve, based on its proximity to the trip origin. If the nearest car is unavailable, the site says where the next closest available car is located, showing the distance in one-tenth of a mile increments. Once a reservation has been made, the customer's membership card gets empowered to access the car. An RFID reader inside the windshield reads the card and unlocks the door. A pin number on the car adds another layer of security. The keys remain in the car at all times and are on a retractable cord next to the steering column. The customer benefits include a lower rental cost, a shorter trip to pick up the car, and the option to rent for just an hour or two.

Price comparison is complicated, because car rental companies change prices frequently. (And car clubs have an upfront membership fee, so the customer won't save money on the first rental.) But, in a same-day, same-city comparison, pricing the smallest car available for the shortest time available, before taxes, three major car rental companies come in at $43.99, $46.99, and $63.27. A car club right in my neighborhood charges $9.85 per hour. The national chains are exploring responses, some launching their own RFID systems. Enterprise has conducted a pilot test. Hertz has announced it will offer car sharing soon (Jones, 2008).

But consider the new efficiencies. Rather than leasing or constructing a giant centralized facility in a high-cost, downtown location where every renter must go and stand in line and interact with one or two employees, the car club needs only some scattered parking places, and someone at an inexpensive office to answer the phone and authorize the rentals.

The *New York Times* reports a study by the U.S. Institutes of Medicine, the prestigious national organization that serves as advisor to the nation's healthcare providers, that delivers some shocking numbers about hospital errors (Harris, 2006). Looking at the administration of medications to hospital patients in the U.S. in a single year, the study found that preventable drug administration errors in U.S. hospitals cause 770,000 "adverse events" per year. Of these, 98,000 were deaths—more, according to the *Times*, than the number caused by drunk drivers and breast cancer put together during the same time span. An Associated Press report of a similar study cited still worse numbers: one error per patient per day, on average (2006). In-person supervision of the nurse administering medications is not practical. But one error per patient per day is not practical either.

A pilot project designed to address this dangerous situation used bar codes (Zebra Technologies, 2006). There were bar codes on the medications, bar codes on patient wristbands, and bar codes worn by the individual nurse. The nurse would scan the three bar codes before giving the medication. Whenever the bar code on the medication and the bar code on the patient's wristband indicated a mismatch, the technology issued a discreet warning to the nurse. Out of 6.2 million doses, across 118 different hospitals, there were 192,000 warnings of a potential error. In approximately 152,000 of those cases, 2 percent of the total doses, the error would have been harmful to the patient.

Remember that RFID works better than bar codes. An RFID tag does not need to be oriented, so the nurse doesn't have to twist the patient's wrist around to align the patient's bar code with the reader. The RFID tag is readable in the dark. Most important, the reading is automatic: quick, easy, and impossible to skip. The nurse has only to look at a miniature, handheld screen to see that the patient tag, the bottle tag, and the nurse tag match. One error per patient, per day—cured.

The sheep stations of Australia need to manage large numbers of sheep with the smallest possible number of people (Laursen, 2006). RFID creates an automated process that checks up on every sheep every day. Each animal is RFID tagged with its date of birth, sex, owner information, and an identification number. A fence is built around the watering point. To get through the fence to the water, the sheep have to cross a small bridge each day. (Sheep form habits. After they've figured it out the first time, they do it every day.) The bridge is narrow enough to make the sheep pass through it one by one. As they cross the bridge, each sheep is automatically weighed, and the weight is associated with the tag's identification number in a database. Underweight animals can be diverted through a different gate for supplemental feeding. Ultrasound scanners check for pregnancy and twins: ewes carrying twin lambs get extra food. A facial recognition camera system checks for chin worms, a common problem. All the data go in the animal's database. The ear tags can automatically open a gate. Untagged wild goats and feral pigs can be shunted away from the herd. (Australia has 23 million feral pigs. They compete for food and eat lambs.) All this can be done with little or no human intervention. Alerts generated by the system can be addressed at the convenience of the shepherd.

Biosensors in a tag on a wristband can alert a distant manager if an employee's heart starts racing (Swedberg, 2007). In convenience stores, this might send a silent alarm to security providers. In a casino, it might cause a camera to be turned toward the employee to detect a possible problem.

Efficient Sharing

If you can track high-cost assets in real time, they can be shared among people who do not communicate with one another.

There are lots of high-cost assets that hospitals must shift from place to place to be used for different patients: electrocardiogram machines, respiratory therapy equipment, infusion pumps, defibrillators, pulse oximeters, even wheelchairs. It is possible for a hospital to be unable to locate millions of dollars worth of equipment that is within its walls (Zebra Technologies, 2006). This situation causes overbuying. One study puts over-procurement of moveable assets by U.S. hospitals at 20 to 30 percent (McGuinness & Rideout, 2007). Searching for equipment uses up expensive employee time. A report on asset tracking says hospital technicians spend a remarkable 40 percent of their time looking for things (McCoy, n.d.). When assets are routinely hard to find, departments may begin to hide and hoard them, making the problem larger still. Employees stow equipment they expect to need in uniform lockers, above ceiling tiles, or wherever it will be quickly available and not in use by others.

Hospitals recover their costs by associating the use of particular equipment and procedures with particular patients. If they fail to record usage, they lose revenue and must charge more for services that were correctly recorded. But time-pressured healthcare technicians might not make billing records a priority. A hospital investigation of infusion pump usage showed that procedures were recorded so that they could be billed to the patient about 50 percent of the time (McCoy, n.d.). These pumps are used to administer fluids, medication, and nutrients into patients' circulatory systems. RFID can automatically create a record of usage.

Like retailers, hospitals have problems with unauthorized removal of assets. An industry rule of thumb is $4,000 to $5,000 worth of shrink (losses and theft) per bed per year. Most of it is equipment (McCoy, n.d.). RFID tags can address all these problems. Tagged items can be seen in real time on nurse's station monitors, which show a map and the location of each tagged asset. There are asset-tracking start-ups in which key assets went from shortage to surplus (McGuinness & Rideout, 2007).

The global economy took a giant step forward with standardized shipping units: standard-sized steel containers, pallets, shipping crates, and bins. But items sent to a stranger halfway around the planet can be difficult to track and retrieve. In the world's great ports, hundred-acre lots are stuffed with empty steel containers stacked nine high, their painted identification numbers readable only with field glasses. Records of their location may be sketchy and inaccurate. Those won't be coming home in a hurry.

Now, pooling companies have formed, renting containers to shippers, tracking them around a continent or around the world, and offering them to a different customer at each destination (Bacheldor, 2007b). Wooden pallets were an ecologically unfortunate disposable, a cost of doing business whose fragments scattered across the warehouse. Today, unbreakable, cleanable, plastic pallets with embedded RFID tags track shipments around the world, rented by the day, checked in and out automatically. Customers get back their deposit as they pass them along. Steel containers with big active RFID tags don't lose their identity. And, shared among multiple users, they no longer spend most of their life sitting empty. One European pool shares 88 million RFID-tagged reusable crates (Bacheldor, 2007b). Tagged, shared, reusable containers have removed a small piece of friction from global trade.

Blood services businesses must manage a product that is urgently needed, irregularly supplied, and highly perishable. Blood and plasma products donated for transfusion expire in 5 to 42 days (Greengard, 2007). Multiple types must be held in multiple locations. Demand is unpredictable. Products that are almost right are wrong. It is possible (and not unusual before RFID) for product to expire though needed right now, because newer products were sent out before older products. Where product expires so quickly, there is no way to take inventory often enough. RFID tags on every container of blood or plasma automatically create a continuous picture of what is currently available and when it will expire. Sensors issue an alert on temperature problems before damage can occur. The system saves and uses significant amounts of donated blood products that would otherwise have been wasted. And that's a lifesaver.

Security Made Convenient

In commercial air travel, security needs and convenience needs are in deep conflict. Passengers are summoned to arrive two hours early for a one-hour flight. They shuffle through endless lines, taking off shoes and putting on shoes. They deal with changing rules: last time you couldn't have a nail clipper, next time you can't have a regular-sized toothpaste, the time after that you can't carry a water bottle. And the rules in Omaha are not the rules in Frankfurt. It is not clear to the passenger that all this hassle is averting imminent catastrophe. A more efficient process would win some friends.

At Dubai International Airport, which serves the largest city of the United Arab Emirates, contactless smart cards eliminate line standing for some travelers ("Dubai Airport," 2006). Very frequent flyers can register in advance, go through a security screening, and get a card that contains a biometric ID. The card matches that biometric record with physical characteristics of the

traveler for verified identification. It opens a special door that provides a shortcut to departure gates. A guard makes certain that no uncarded person goes through the door with a cardholder, but this adds no time to the process. For the prescreened population included in the program, it provides a higher level of actual security than all the U.S. line standing, and some of the wasted time has been removed.

Seven million steel shipping containers arrive at U.S. ports each year (Luedtke, 2003). Some are inspected when they arrive in the U.S. Some are inspected before they are sent, though this does not address the issue of tampering at sea. Most are not inspected rigorously or not inspected at all. It is too much work, too much money. Yet it is hard to imagine a simpler scenario for large-scale terrorism than the delivery of a nuclear weapon in a shipping container. Today, some containers carry RFID tags with sensors—for radiation and certain chemicals, and light-sensors that can tell where and when a container was opened en route. Some containers have seals with RFID tags that send an alert at the moment the container is opened. This portion of the "Container Security Initiative" provides an affordable way to reduce the threat ("Container Security," n.d.; Luedtke, 2003).

Remote Querying

There are 38 million telephone poles and 88 million utility poles in the U.S. (Nobel, 2006). Some simply hold up cables. But millions of others hang a transformer or a compressor or switching equipment or other electronics or machinery. What precisely is on a particular pole? When was it serviced last? Why isn't it working now? In the past, you had to climb the pole to get the answer. But if you put an RFID tag with a couple of sensors on the equipment on top of the pole, the sensors can deliver their message to a handheld reader in the serviceperson's pocket. Sometimes the worker will still need to climb the pole. But every time service personnel can learn what they need to know with a tag and a reader without even getting out of the truck, labor is saved, costs are cut, and the customer's problem is solved faster.

If you could get the concrete in big construction projects to cure (harden) faster, many millions of dollars could be saved (O'Connor, 2006). Highways could be unblocked sooner. Crews and equipment waiting to start the next step could be used more efficiently. Engineers use test samples poured at the same time as the big slab. When they think the slab might be ready, they crush one of the samples to see how much force it will withstand. If the sample is strong enough, they assume that the big slab is strong enough. But what if the big slab cures faster than its test samples? Some firms have started embedding RFID tags with temperature sensors in curing concrete slabs. They have an algorithm that deduces from the time since pouring and cur-

rent internal temperature how much force the slab can stand, the same thing measured by crushing small samples. It is inherently more accurate to measure the slab itself rather than the samples. Sometimes these measurements indicate that the next step can begin in four days instead of fourteen. Checking the temperature inside the concrete from outside the concrete is saving weeks in some long-term projects.

Medtronic has a pacemaker with an interesting extra feature. An RFID tag and sensor in the pacemaker can track heart rhythms and notice the onset of an arrhythmia (Prahalad & Ramaswamy, 2004). At the end of the day, wearers touch readers to their chests to collect data. The readers send this information to doctors or hospitals via the Internet. The effect is a daily checkup, unaffordable if it happened any other way. Patients can collect and send in data every day at a regular time in just a minute or two. In addition, data can be sent immediately, if a patient fears a problem is occurring.

Removing Bottlenecks

The most expensive moment in the working life of a passenger aircraft is the time it spends on the ground. There are many manual procedures that must be performed, as fast as possible, before a plane can take off again. Life jackets must be counted. Meals on board must be counted. The presence and expiration of oxygen generators must be checked. These and other manual procedures can be accomplished instantly with RFID tags and handheld readers. A Cambridge study picked out automatic ID as one of the key enablers for high-speed turnaround (Wessel, 2007).

It is also a race against time for an airline to get your baggage on the right plane. Here, if the airline loses, you lose too. Lately, they have been losing a lot. Each mishandled bag costs the airline about $100, plus the impact on relationships. In the U.S. alone, these losses add up to $400 million a year (Wasserman, 2007). Tags that use bar codes to track your wheelie bag must be oriented by hand, one by one, to be read. They can't be read if they're under a stack of bags, smudged, or facing the wrong way. The result is the classic bottleneck: a pile of bags that has to be hand sorted at the last minute, if there is time. Bar codes leave 10 to 20 percent of bags in that last-minute crisis pile. RFID tags shrink the pile to 1 or 2 percent. It's a costly fix, but far more costly not to fix. And airlines expect that RFID-tag costs will fall. The International Air Travel Association says that if RFID tags get down to 10 cents apiece, airlines worldwide could save $760 million in lost baggage costs (McCartney, 2007). Nearly a dozen large-scale tests are underway. The first airline that stops losing bags will have a competitive advantage worth talking about.

The technology of termite control has not advanced very far in the past few thousand years. But here is a small step forward. In the termite belt of the southeastern U.S., a standard control method uses a ring of conical termite traps sunk into the lawn around the protected building. Each has a dose of bait that termites can carry back to their nest. Traps are checked frequently to see where termites are coming from. Most of the traps are empty. The traps that contain termites direct the search for a nest. This is labor intensive and therefore expensive. The exterminator has to go to each trap, kneel down and open it up, to check for bugs. This takes 20 minutes per building if the worker is really hustling. As you might imagine, an RFID solution is emerging (Edwards, 2007). Inside the trap, a sort of fuse, tasty to termites, triggers a short-range RFID tag when it is eaten. The exterminator can walk the trap line with a handheld reader and only has to get down on hands and knees at the traps that contain termites. Result: a six-minute visit, almost twice as many job sites per worker per day, and a substantially lower cost. This will seem like a small thing only to those who don't have termites.

Empowering Collaboration

More and more, the future of business is delivering value to the end customer through the combined efforts of two or several different firms. The more that managers focus on their company's core competency, the more they depend on others to supply the rest of the competencies required. But companies are organized to control their own employees and not much else. Even the manufacturer-to-wholesaler-to-retailer supply chain must work hard to work together. Collaboration requires constant communication. When communication between firms becomes a ceaseless, event-driven, automatic process, new efficiencies occur.

Consider the marketing promotion of fast-moving consumer goods. The most common consumer promotion is the combination of mass media consumer advertising, a strong promotional offer, and a special product display at retail locations. Success requires that the message be compelling enough, the offer generous enough, and the product conspicuous enough at the point of sale. Breakdowns typically happen at the third step. The special promotional display is absolutely critical to the success of the promotion. But the supermarket that stocks 30,000 to 50,000 different types of items is constantly receiving prepackaged displays of one kind or another from many different manufacturers with many different timetables. Sometimes the display makes it out of the backroom to the selling floor during the brief period of a promotional campaign; sometimes it doesn't. If the product display isn't there, advertising is wasted. Consumer demand that has been created by the

advertising is frustrated and may be captured by a competitive brand. And the product's marketers will not know if the display was stuck in the backroom until it is too late. Kimberly-Clark found that about 56 percent of its promotional displays were getting onto the selling floor on time (Weier, 2008). The later they are, the less they add to sales.

If you put an RFID tag on promotional displays, a reader at the store's backdoor, and a reader at the door between the backroom and the selling floor, you can know what is happening to your display in time to do something about it. You can know if it was received on time and if it arrived at the selling floor on time. You can alert the stores that didn't get the job done. Absent RFID tags, it is hard to know how to solve this problem, or even to know that you have a problem until it is too late. Gillette says on-time deployment of promotional displays creates a 48 percent increase in the sales generated by a promotion (OATSystems, 2008). More than 50 major marketers adopted this model within a few months of its first deployment (OATSystems, 2008).

Managing the inventory of medications in a hospital can be expensive and problematic. There are temperature-control issues: some medicines no longer work if the cold chain of continuous refrigeration is broken, even for a short time. There are theft issues, as well. And workers who withdraw controlled substances must be identified. Costly medications can expire, and this might not be detected until it is too late to use them up. The consequences of inventory out-of-stocks are severe: from the extra cost of last-minute procurement, to missing a scheduled dose, to endangering a hospital's ability to respond to a patient emergency. Managing the drug inventory is a job that can benefit from the attention of a specialist, but it might not be a big enough job for a full-time person.

An emerging solution is management by a vendor (Bacheldor, 2007a). One of the firms that sells medicines to the hospital takes responsibility for keeping a cabinet stocked, aided by smart-shelf technology: readers on the shelf and tags on the products allow the system to know what's on the shelf and respond to inventory changes according to pre-set business rules. Individual bottles in a refrigerated cabinet are tagged for ID and expiration date. A reader switches on whenever the door is opened. This means the system will know if a medication was removed from refrigeration and how long it stayed out. Cold-chain compliance can be documented and proved. Moreover, with RFID-tagged product, the hospital gets a guaranteed e-pedigree—protection from counterfeit medications, because the product is tracked by its tag all the way from the manufacturer to the hospital. RFID-bearing badges on personnel can associate the product removed with the person who removed it. The smart-shelf software can notify a manager when individual medicines are approaching expiration and must be moved to the front of the cabinet

for quicker usage. And when the vendor manages the process, drugs can be provided on consignment, so the hospital does not have to pay for them until they are used. All of this can be accomplished automatically—without a full-time person on the spot—but only if the product is RFID tagged.

The shelf life of consumer products has to be carefully managed to protect the final customer, the retailer, and the producer. Producers protect their retailers from receiving a product just before it expires. They watch for and try to prevent situations in which shipping conditions will reduce shelf life. But, when a product in inventory is approaching the end of its shelf life, both producer and retailer will look for places where it can be used immediately, while it is still at its best.

Lots more opportunities open up when the condition of products in motion can be measured from moment to moment. Sometimes it is possible to calculate how shelf life will be changed by conditions on the road. If a trailer full of fresh seafood loses its cold environment for a couple of hours, it is not ruined, but its shelf life is shortened. It might then make sense to sell it locally rather than to use up more of its life in shipping. If a cargo of pharmaceuticals was held at an inappropriate temperature, its use-by date is changed. Perhaps it should be rerouted from a low-volume destination to a place where it is likely to be used immediately. One RFID-label maker has a credit card-sized tag that logs data on the intensity and duration of exposure to light, temperature, and humidity. When the tags are read, the middleware adjusts the shelf life and notifies the sender (Wessel, 2006).

An additional advantage is that this is information from a neutral source, which cannot be altered by the shipper, distributor, manufacturer, or receiver. Moreover, this technology would permit pricing by condition: repricing a product whose shelf life has changed, for example, so that some of its original value can be recovered without being unfair to the retailer.

Matching up Elements in Complex Systems

We have all had to learn to connect the right cable to the right port to get the keyboard and the mouse and the headset and the printer and whatever else to interact with our computers. But imagine a system that is so big that you cannot just make one port green and another one salmon. Imagine a system with 15,000 or 20,000 ports and cables, a system in which ports get their names changed frequently and are labeled only inside the computer. Imagine a system in which there are damaging consequences if you accidentally touch a cable to the wrong port. Now you need tags and readers. A reader at the port with an extremely short read-range can light up when the tag on your cable gets close, so that you quickly find the right one. If a cable

comes loose, it stops a radio signal, and this creates an alert that lets you know which one came unplugged and where it is (O'Connor, 2007).

Next step: the home network. Maybe you should not have to plug in all of those peripherals. The wireless router in your home office gets a reader, and every other piece of computer equipment in the house is RFID tagged (Smith, 2007a). Proximity creates the connection. Tagged devices do not need to be turned on to be connected. They turn themselves on when you access them from your own computer. The rat's nest of wires under the desk goes away forever. Office networks could connect your laptop to a projector automatically, when you carry it into the conference room. The efficiency comes from taking back some of the time that computers have stolen from daily life.

Efficient Environmentalism

Research tells the same story over and over: people will choose green products and processes if they are cheap and easy, but not if they are expensive or inconvenient (Athavaley, 2007). Maybe we can change those priorities. In the meantime, you're not green if you're not efficient.

One billion empty water bottles were collected in 2007 in California residential garbage (Smith, 2007b). That's a lot of landfill. It won't biodegrade, and it will get bigger every year. One attempt to do something about it involves oversized vending machines installed in supermarket parking lots by a start-up corporation, SBC Global. It sells five-gallon jugs of water with RFID tags attached. The machines accept payment by credit card and deposit money back into customers' accounts when the jugs are returned. Because the check-in of jugs and the payment for recycling is done automatically, the price per gallon stays low. And the jugs stay out of the landfill. A model like this may solve the problems of paint makers, whose product is even harder on the human habitat. Dropped into landfill, paint puts chemicals into the water supply that municipal treatment systems cannot remove ("Paint Disposal," 2003).

A start-up called RecycleBank uses RFID to reward consumers for recycling ("RecycleBank," 2008). A second garbage bin at each home is filled with recyclables. An RFID tag on the bin associates it with a particular house. When garbage trucks empty the bin, it is weighed, and the amount of recycling is credited to the home. Commercial sponsors—Kraft Foods is one early leader—deliver coupons and similar rewards based on the amount recycled. RecycleBank gets paid by the city, by the pound, for materials it keeps out of the landfill. Automatic RFID makes it economically feasible. The program has established the recycling habit in places where it did not

exist before. And inputs to landfill have been reduced by as much as 40 percent.

One problem with recycling plastics is that different kinds are incompatible. If you mix recycled plastics and melt them down, you get a nearly useless lump, good for making park benches and parking lot bumpers, and not much else. But it is not cost-effective for humans to sort the different kinds of plastic in garbage. However, recent engineering trials have shown that different kinds of plastics can be separated quickly and efficiently if they carry RFID tags. The result is a bunch of batches of identical plastics, each of which can be melted down to produce a pure stream of a particular polymer that is equal in quality to the raw material from which the plastic was originally made. This sounds simple, but it is in fact revolutionary. It is garbage into goods. It conserves energy and petrochemicals, diminishes landfill, and replaces a largely symbolic form of recycling with one that can have planetary impact (Schoenherr, Reichman, & Baloun, 2008).

Customized Products

Mass customization is the idea that products can be manufactured in a process that captures some of the efficiencies of mass production, but with individual variations that meet the needs of a specific customer. A critical step in mass customization is keeping track of which variant belongs to which customer. RFID tags make it easy to pick out which product among thousands belongs to a particular customer.

A basic part of medical treatment is the laboratory test in which a specimen is collected from an individual patient and sent to a laboratory for analysis. A report of the analysis is returned to the patient's physician. The laboratory itself may be within a hospital or at some remote location. Such tests are useless if a laboratory specimen cannot be associated with a particular patient with 100 percent accuracy. Fast-moving professionals attach handwritten tags to thousands of identical specimen containers. Mistakes happen. The solution includes RFID-tagged test tubes, vials, and specimen collectors, as well as patient wristbands. The patient ID is wirelessly "written to" the specimen ID as the sample is collected. The tags are designed to withstand shock, refrigeration, even centrifuge. For patient security, the tags are encrypted and have a very short read-range. This system can identify an individual specimen quickly and with the necessary accuracy (Moher & Wilson, 2005).

Efficient Compliance

The Sarbanes Oxley Act of 2002, known as SOX or SarbOx, is a U.S. law that regulates corporate accounting and financial reporting practices for public companies or companies in the process of becoming public ("Sarbanes Oxley," 2002). Passed in the aftermath of a group of corporate frauds and failures, its requirements are far more intrusive than previous U.S. law. Compliance is difficult and expensive. CEOs must personally certify, under threat of criminal penalty, information about financial records and physical assets at a level of detail that many would not have attempted to know before. Responses to regulators are in some cases required within 24 hours, and some businesses now routinely budget for SOX fines, figuring that there is no way they could find that quickly information that could legally be required. Compliance consultants say that RFID systems may create at least the possibility of timely compliance, and may eventually reduce the cost of complying with the law, which is well over a million dollars annually for a large corporation (Dunlop, 2007). RFID systems for document management can associate the precise physical location of a file with its location in a database, so that it can be tracked in massive file rooms, and in applications where files move around within an office. And RFID in the supply chain permits for the first time a real-time view of the exact amount and location of assets, which SarbOx assumes that companies have.

Conclusion

Some have worried that the use of RFID makes it impossible to protect individual privacy. Their concerns are many and important. There is concern that tags might associate a user with a product without the user's knowledge, that tags might be read from a distance without the user's knowledge, that the government might improperly collect personal data, that burglars or nosy people might be able to "see" what is inside peoples' homes, and that hackers might be able to alter the information carried on tags. Most of these issues are addressable with encryption, tag killing, database security, or other proven techniques. Without addressing either the technical remedies available or the laws that govern the behavior of tag users and readers, it should be noted that all but one of the applications described in this chapter do not collect individual data. The exception is the attachment of personal identification to hospital laboratory samples. This is data that would be collected by the hospital anyway, as a necessary part of medical treatment. In the U.S., that data is protected by extremely specific and rigorous law under the Health Insurance Portability and Accountability Act (HIPAA). The specific data in this application is secured by powerful encryption and by read-range limits

Varieties of Efficiency

that would require a data snatcher to come within a few centimeters of the vial or test tube. At that range, a person could read a printed label as well. The point is this: there are many, many applications that can bring new efficiency to all kinds of business processes without endangering in any way the privacy of the individual.

The real impact of RFID on privacy may be a reduction in the privacy with which corporations operate, as incredibly detailed real-time data about corporate assets and their location and condition are automatically collected. Both the citizen and the shareholder may have cause to welcome this.

Finally, here is a comment about the categories used in this chapter. They were gleaned from interviews, conversations at industry conclaves, seminars, manufacturers' Web sites, and blogs. Some of the examples could have been described in terms of several different categories. Frequently mentioned categories that would not fit in this discussion, or were included as part of a broader category, include alerts and reminders, event-driven management, payment systems, authentication, pricing by usage, and loss prevention. What does appear to be universal is the way in which the contagion of efficiency operates. Planners, implementers, dreamers, and searchers for new sources of advantage think not in terms of principles or specifications but in terms of stories, examples, and categories.

References

Associated Press. (2006, July 15). *Drug errors injure more than 1.5 million a year.* Retrieved September 21, 2008, from http://www.msnbc.msn.com/id/13954142/.

Athavaley, A. (2007, October 29). What price green: For many Americans, pretty much any price is too high. *Wall Street Journal,* pp. R6, R29.

Bacheldor, B. (2007a). ASD Healthcare deploys RFID refrigerated drug cabinets. *RFID Journal.* Retrieved July 21, 2008, from http://www.rfidjournal.com/article/articleview/3632/.

Bacheldor, B. (2007b). Euro pool system tags reusable crates. *RFID Journal.* Retrieved July 21, 2008, from http://www.rfidjournal.com/article/articleview/3501/.

Container security initiative. (n.d.). Retrieved July 21, 2008, from http://www.globalsecurity.org/security/ops/csi.htm.

Dubai Airport expedites travel with contactless cards. (2006, November 13). *Contactless News.* Retrieved July 21, 2008, from http://www.contactlessnews.com/news/2006/11/13/dubai-airport-expedites-travel-with-contactless-cards/.

Dunlop, G. (2007). Radio frequency identification and fixed asset management. *White paper.* Retrieved July 21, 2008, from http://www.rfidinfo.jp/whitgepaper/384.pdf.

Edwards, J. (2007, May 2). Most innovative uses of RFID: Getting the bugs out. *RFID Journal.* Retrieved July 21, 2008, from http://www.rfidjournal.com/article/articleview/3376/1/1/.

Greengard, S. (2007, August 7). Mississippi blood services banks on RFID. *RFID Journal*. Retrieved July 21, 2008, from http://www.rfidjournal.com/article/articleview/2472/.

Gruen, T. W., Corsten, D. S., & Bharadwaj, S. (2002, April 18). Retail out of stocks: A worldwide examination of extent, causes and consumer responses. *Goizueta Paper Series*. Retrieved July 21, 2008, from http://gbspapers.library.emory.edu/archive/00000035/.

Harris, G. (2006, July 21). Report finds a heavy toll from medication errors. *New York Times*. Retrieved July 21, 2008, from http://www.nytimes.com/2006/07/21/health/21drugerrors.html.

Hughes, S. (2005). P&G: RFID and privacy in the supply chain. In S. Garfinkel & B. Rosenberg (Eds.), *RFID: Applications, security and privacy* (pp. 397–412). Boston, MA: Addison-Wesley.

Jones, J. (2008, July 12). Getting people into cars despite $4 gas. *New York Times*. Retrieved July 21, 2008, from http://www.nytimes.com/2008/07/12/business/12interview-web.html.

Laursen, W. (2006, February). Managing the mega flock. *IEEE Review*, 52(2), 38–42.

Lee, S. (2008). *Printed electronics: The future of RFID?* IDTechEx, Inc. Retrieved July 21, 2008, at http://www.idtechex.com/products/en/articles/00000811.asp?rsstopicid=3.

Luedtke, J. (2003, July). Toward pervasive computing. *DM Review*. Retrieved September 21, 2008, from http://www.dmreview.com/news/7096–1.html.

McCartney, S. (2007, February 28). Radio-tagged luggage system may be implemented globally. *Wall Street Journal*. Retrieved July 21, 2008, from http://www.volweb.cz/horvitz/os-info/news-feb07–028.html.

McCoy, J. (n.d.). Spot by Innerwireless: A rational solution for healthcare asset tracking. *White paper*. Innerwireless. Retrieved July 21, 2008, from http://www.antennason-line.com/images/Whitepapers/Innerwireless.pdf.

McGuinness, M., & Rideout, J. (2007, February 16). Optimizing a wireless LAN for location. *RFID Journal*. Retrieved July 21, 2008 from http://www.rfidjournal.com/article/articleview/2672/1/128/.

Moher, R., & Wilson, K. (2005). Labeling and tracking: Preventing errors in the lab. *Patient Safety and Quality Healthcare*. Retrieved July 21, 2008, from http://www.psqh.com/sepoct05/barcodingrfid4.html.

Nobel, C. (2006, February 13). Symbol considers RFID options. *eWEEK*, 23(7), p. 35.

OATSystems. (2008). Real-time promotion execution. White paper. Retrieved July 21, 2008, from http://www.oatsystems.com/content-library/library_content/Real-timePromotionExecution.pdf.

O'Connor, M. C. (2006, October 30). RFID cures concrete. *RFID Journal*. Retrieved September 21, 2008, from http://www.rfidjournal.com/article/articleview/2673/1/3/.

O'Connor, M. C. (2007, February 1). IT cabling company offering RFID value-add. *RFID Journal*. Retrieved July 21, 2008, from http://rfidjournal.com/article/articleview/3047.

Paint disposal. (2003, November). *Colorado Recycles Reports*. Retrieved July 21, 2008, from http://www.colorado-recycles.org/referencelibrary/recyclingtips/paintrevised.htm.

Prahalad, C. K., & Ramaswamy, V. (2004). *The future of competition*. Boston, MA: Harvard Business School Press.

RecycleBank. (2008). Retrieved November 8, 2008, from http://recyclebank.com/how-it-works.

Sarbanes Oxley Act of 2002. Pub.L. 107–204, 116 Stat. 745, enacted 2002–07–30.

Schoenherr, J. I., Reichman, M., & Baloun, T. A. (2008, March). RFID-based waste recycling. *RFID Journal*. Retrieved September 21, 2008, from http://www.rfidjournal.com/whitepapers/1.

Simchi-Levi, D. (2005). The impact of RFID on supply chain efficiency. In C. Heinrich (Ed.), *RFID and beyond* (pp. 209–220). Indianapolis, IN: Wiley.

Smith, W. (2007a, March 9). Apple patent uses RFID for home networking. *RFID Update*. Retrieved July 21, 2008, from www.rfidupdate.com/articles/index.php?id=1314.

Smith, W. (2007b). RFID enables innovation in water jug distribution. *RFID Update*. Retrieved July 21, 2008, from http://www.rfidupdate.com/news/08242007.html.

Swedberg, C. (2007). New RFID system takes security to heart. *RFID Journal*. Retrieved July 21, 2008, from http://www.rfidjournal.com/article/articleview/3170/1/1/.

Wasserman, E. (2007). RFID takes off in the aerospace industry. *RFID Journal*. Retrieved July 21, 2008, from http://www.rfidjournal.com/magazine/article/3244.

Weier, M. H. (2008). RFID: Hold the revolution, pass the incremental change. *Electronics Supply and Manufacturing*. Retrieved July 21, 2008, from http://www.my-esm.com/manufacturingchain/showArticle.jhtml?articleID=198701659.

Wessel, R. (2006). Pharma label maker to test tags that record temps. *RFID Journal*. Retrieved July 21, 2008, from http://www.rfidjournal.com/article/view/2675/.

Wessel, R. (2007). Group studies RFID's potential to help speed aircraft turnarounds. *RFID Journal*. Retrieved September 21, 2008, from http://www.rfidjournal.com/article/view/3430/.

Zebra Technologies. (2006, December 1). *Patient safety applications of bar code and RFID technologies*. Retrieved July 21, 2008, from http://www.rfidproductnews.com/whitepapers/files/Zebra_Application_BarCode_RFID.pdf.

Zinn, W., & Liu, P. C. (2001). Consumer responses to retail stockouts. *Journal of Business Logistics, 22*(1), 49–71.

CHAPTER 8

Profiling the Likelihood of Success of Electronic Medical Records

▶ J. DAVID JOHNSON

> Across the political spectrum—from Hillary Clinton to Newt Gingrich—computer fans perceive the electronic medical record (EMR) as a painless solution to the most vexing health policy questions, allowing expansions in coverage, quality improvement, and cost control. (Himmelstein & Woolhandler, 2005, p. 1121)

As more and more of the U.S. Gross National Product is devoted to healthcare, with increases in spending far outstripping other inflationary indices, government budgets and corporate competitiveness (Friedman, 2005) are progressively more threatened (Bodenheimer, 2005a), and leaders are growing desperate for solutions, especially related to Medicare and Medicaid spending. Concomitantly, there are growing concerns about healthcare quality and the responsiveness of the public healthcare system to emergencies, as well as mounting concerns about whether services are provided in ways that allow us to learn from past practices and continuously improve. Recently, considerable excitement has surrounded the widespread adoption of elec-

tronic medical records (EMR) as a potential solution to these and other challenges.

Profiling Electronic Medical Records

In this chapter, I analyze electronic medical records by profiling their attributes as an innovation qua innovation, detailing the a priori likelihood that they will have sufficiently widespread adoption to reach the critical mass needed to secure many of their professed benefits. As I will detail, the likelihood of resistance is high, particularly at the local level (because of changes in work flow, status relationships among healthcare providers), which by and large bears the costs for system-level benefits (research on best practices, monitoring disease outbreaks, cost management).

Successful implementation of an innovation can be conceived of as the routinization, incorporation, and stabilization of the innovation into ongoing work activity. Lawrence Mohr (1969) has suggested that the primary motivation for public health organizations to innovate is the quest for prestige (see also Becker, 1970) rather than issues of internal effectiveness and efficiency. Similarly, Donald Brenner and Robert Logan (1980) argued, based on their analysis of the diffusion of medical information systems, that outside innovation factors were much more important in the diffusion of innovation process than was represented in the prevailing view in the literature. Adoption depends not only on cost considerations but also on quality ones, including the improvement of the implementers' quality of life (McDonald et al., 2005), with some arguing, in the presence of controversy over costs, that quality considerations alone should drive EMR adoption (Goodman, 2005), and that these considerations are often the primary benefit seen by doctors (Gans, Kralewski, Hammons, & Dowd, 2005).

More generally, I have argued that successful implementation of innovations depends on positive weightings of three distinct factors: innovation attributes, innovation environment, and framing. Framing refers to the couching of an innovation in terms of political and strategic imperatives, something particularly important for EMR, which are designed to address our healthcare financing crises. The innovation environment refers to the tactical environment for innovation implementation; for example, the presence of enabling information technologies, standards, technologies, and health information exchanges that maximize EMR benefits by facilitating the transfer of medical records within regions. Neither framing, environment, nor attributes are sufficient by themselves to ensure unequivocal success, although they may lead to partial successes (Johnson, 2000, 2001).

I turn first, then, to profiling the attributes of EMR, which allows me to describe this multifaceted innovation in detail. Following this, I discuss the innovation environment and framing.

Describing the Attributes of Electronic Medical Records

"An *innovation* is an idea, process, or technology that is perceived as being new. An *innovation attribute* is a perceived characteristic of a new idea, process, or technology" (Dearing & Meyer, 1994, p. 47). The Innovation Profile, an instrument that calculates potential adopters' perceptions about an innovation, is a promising predictive tool based on an a priori evaluation of attributes (Dearing & Meyer, 1994). James Dearing and Gary Meyer's (1994) finding that reliability (riskiness), applicability (adaptability), and effectiveness (one component of relative advantage) are central to innovation adoption processes has been supported in other research (Johnson, 2005). Focusing on innovation attributes may provide managers with a pragmatic Innovation Profile that they can use to develop specific, tailored strategies to insure the successful implementation of particular innovations (Dearing & Meyer, 1994). Managers who assess organizational members' perceptions of innovation attributes can employ this information as a diagnostic tool to evaluate the fit of an innovation, to anticipate problems arising as a result of an innovation, and to modify an innovation to reflect the changes that stakeholders deem necessary. A focus on innovation attributes allows us to explore the nuances of contrasting innovations. There should be a conscious weighing of the attributes before implementing innovations. With knowledge of innovation attributes, innovators can develop appropriate communication strategies to facilitate implementation. For example, innovations that are seen as more risky may require higher volumes of persuasive communication in the implementation stage (Fidler & Johnson, 1984).

Attributes of Electronic Medical Records

Innovation implies bringing something perceived as new into use (Rogers, 2003). Innovation can be related to: (1) a product or service; (2) a production process; (3) organizational structure; (4) people; and (5) policy (Zaltman, Duncan, & Holbek, 1973). One problematic aspect of EMR is that all of these classes of innovation may be implicated. In its simplest expression, EMR constitutes a health information technology that captures information about a patient's treatment in a particular context. In solo or small group practices, this can include transcription of treatment encounters, problem lists, medication lists, laboratory results retrieval, decision support (for exam-

ple, computer prompts suggesting possible diagnoses), e-prescribing (for example, information technology to handle prescription ordering), medical literature access, tracking of bills for services, patient scheduling, and reminders about screenings or treatment of chronic illnesses (Bates, Ebell, Gotlieb, Zapp, & Mullins, 2003; Hersh, 2002).

EMR can reduce the currently unacceptable number of medical errors in three ways: through enhanced decision support; by more rapid response to adverse events, including overdoses and incompatible medications; and by tracking things like accumulated dosages and providing feedback on contraindicated treatments (Bates & Gawande, 2003). In group practices, it has been estimated that the implementation of such systems might decrease physician income by 10 percent (Gans et al., 2005). It is estimated that 21 to 43 billion dollars are needed in the U.S. over a 10-year period to insure adoption in small- and medium-sized practices (Rosenfeld, Bernasek, & Mendelson, 2005).

Historically, researchers have described innovations in terms of their attributes, or perceived characteristics, which play a significant role in the diffusion of innovations. In some ways, these attributes become the content of messages that can be disseminated about an innovation. Early on, Elihu Katz (1963) saw the adoption of an innovation as being contingent upon its compatibility, or the degree to which the attributes of an innovation matched the attributes of potential adopters. Everett M. Rogers (2003) developed the most commonly recognized scheme for examining differing properties of innovations. He identified five perceived attributes of an innovation: relative advantage, compatibility, trialability, observability, and complexity.

Attributes of innovations are often the most immediate, objective indicators of success. A compelling research project by Harry Boer and Willem During (2001) suggests some notable biases in a company's a priori perceptions of attributes with readily apparent parallels to EMR. Relative advantage, particularly in terms of profitability, was often substantially overestimated. Complexity, particularly in terms of reinvention issues, was often underestimated in this Danish research focusing on product, process, and managerial innovations with fixation on just one aspect of an innovation. This feeds into, or maybe is a result of, the general pro-innovation bias in the U.S. and in other Western countries, and it creates a volatile mix that may, in part, explain the high rate of innovation failure. For a variety of reasons, such as compelling needs and groupthink processes, people are often overly optimistic about a proposed innovation's likely success, downplaying barriers to implementation. It is well known, partly because of the persuasive processes involved, that initial project proposals are overly optimistic in order to insure the attainment of resource commitments (Dornblaser, Lin, & Van de Ven, 2000).

Relative Advantage

Relative advantage refers to the degree to which an innovation is perceived as being better than the idea with which it competes or that it supersedes. The current combination of paper-based and diffuse, horizontal file systems for maintaining medical records has many problems, including: availability to only one user at a time, illegibility of heathcare providers' handwriting, lack of remote access, unwieldy and bulky folders, storage challenges, and so on (Bates, Ebell et al., 2003).

According to Rogers (2003), relative advantage can be divided into two types: economic and social advantage. Economic advantage can be equated with profitability, while social aspects reflect prestige or status afforded to the adopter of any particular innovation. James Dearing, Gary Meyer, and Jeff Kazmierczak (1994) isolated three aspects of relative advantage: "economic advantage," "effectiveness," and "reliability." Effectiveness is the degree to which an innovation is communicated as being relatively more capable in achieving an ideal end-state. Reliability is the degree to which an innovation is communicated as being consistent in its results. Dearing and colleagues' (1994) study of hazardous waste remediation indicated that more than two-thirds of comments related to relative advantage were noneconomic. The noneconomic indicators relate to quality and reputational standing in the medical community, with quality not necessarily rewarded in our current medical system (Hackbarth & Milgate, 2005).

EMR offers a number of compelling advantages:

- Increased accountability for the quality of care (Harris & Associates, 2005; Thompson & Brailer, 2004);
- Reduced medical errors, which in the current system lead to between 50,000 and 100,000 deaths a year in the U.S. (Brailer, 2005; Harris & Associates, 2005), with 777,000 people injured from adverse drug events in U.S. hospitals (Thompson & Brailer, 2004);
- Currently, 16 percent of the U.S. Gross Domestic Product is spent on healthcare. Lower estimates suggest that EMR would save $112 billion a year in the U.S.—7.5 percent of healthcare spending—with the higher estimates ranging to 30 percent (Lewin Group, 2005; Thompson & Brailer, 2004);
- Increased consumer involvement in choice of medical care through the development of associated personal health records and system-wide information costs and benefits (Brailer, 2005; Harris & Associates, 2005; Thompson & Brailer, 2004);
- Improved management of chronic diseases, such as diabetes, through coaching and home monitoring (Harris & Associates, 2005);

- Increased likelihood that physicians will prescribe generic drugs, with resulting cost savings (Harris & Associates, 2005); and
- Strengthened privacy and data protection (Thompson & Brailer, 2004).

Compatibility

Compatibility is the degree to which an innovation is perceived to be consistent with existing values, past experiences, and adopters' needs. Compatibility is the most important innovation attribute for cancer control research (McKinney, Barnsley, & Kaluzny, 1992), and has also been found to be critical for information technology innovations (Leonard-Barton & Sinha, 1993). The current medical record system is often difficult to access, residing in incompatible, geographically dispersed islands of data that use different nomenclatures for a variety of systems, for example, billing, pharmacy, laboratory, and so forth (McDonald, 1997). The more compatible that an innovation is, the more likely it will be adopted (Rogers, 2003) and effectively implemented (Klein & Sorra, 1996). EMR is often perceived to be incompatible with healthcare professionals' work flow, and, perhaps more important, with physician status relationships with others in most medical settings. Interference with physician's traditional work flow, which is complex and time pressured (Walker, 2005), that adversely affects doctor-patient relationships, because physician attention is more focused on data entry, is a major stumbling block to physician acceptance (Lapointe & Rivard, 2005; McDonald, 1997; Shortliffe, 1999, 2005; Thompson & Brailer, 2004).

Trialability

Trialability, or the degree to which an innovation may be experimented with on a limited basis, has generally been considered to be positively related to innovation adoption (Rogers, 2003). One characteristic of information technology innovations, especially communication-related ones, is that they are difficult to test because they often require a critical mass of users. Some components of this bundle of EMR innovations are imminently trialable, although like many other health information technology innovations, some of the higher-end benefits depend on widespread adoption, in this case in highly collaborative health information exchanges. It is estimated that over 100 communities in the U.S. are creating health information exchanges (Halamka et al., 2005), which will potentially enhance EMR observability.

Observability

Observability, or the degree to which the effects of an innovation are visible, is generally thought to have a positive impact on innovation adoption (Rogers, 2003). There might, however, be proprietary interests that could limit the observability of some of these systems, and, as always, the dissemi-

nation of information on best practices is problematic because of factors such as tacit knowledge and the not-invented-here syndrome, for example.

Adaptability

Adaptability can be conceptualized as the degree to which an innovation can be modified to fit local needs. However, to achieve the most important system-level benefits, some common standards are needed for EMR systems to be maximally effective in health information exchanges. Thus, the demands for interoperability on a system-wide basis limit this attribute at a local level.

Complexity

Complexity is generally viewed as the degree to which an innovation is perceived as relatively difficult to understand and to use (Rogers, 2003). Alternatively, complexity can be conceptualized as the number of dimensions along which an innovation can be evaluated by a potential receiver. An innovation that has a larger number of components to consider is one that involves more uncertainty for the potential adopter, because uncertainty is in part a function of the number of alternative ideas contained in an innovation (Fidler & Johnson, 1984).

The degree to which organizational members perceive new interventions to be risky ventures may have a significant impact on whether the innovations are accepted. The very novelty of an innovation entails some risk (Rogers & Adhikayra, 1979). In essence, the greater the uncertainty of the outcome regarding an innovation, the greater the degree of perceived risk in implementing it (Fidler & Johnson, 1984).

As Joe Bohlen (1971) has noted: "Other factors equated, the more complex an idea is, the more slowly it tends to be adopted" (p. 807), and the greater the resistance to it (Perry & Kraemer, 1978; Zaltman & Duncan, 1977). In part, because in its highest form, with the most benefits, EMR represents the bundling of a number of innovations, it is exceedingly complex. There is also a complex array of potential actors, especially in the formative stages, but also in the implementation and operational stages. In the U.S., over 30 federal agencies are involved in EMR implementation efforts (Brailer, 2005; Thompson & Brailer, 2004). It is hard to conceive of a more complex innovation than EMR, at least in versions that offer the most comprehensive benefits.

Profiling Attributes

> If we required it (health IT), we would have a 70 percent failure rate. It's got to be something in the end that somebody wants to do, and our job is to help

increase the benefits and lower the barriers so that the people who want to do this can do it. (Brailer, qtd. in Cunningham, 2005, p. 1152)

An initial rough profiling of EMR would suggest that it is a trialable system, at least in a limited sense; its advocates also suggest it has a high relative advantage, in part because there are so many problems with our existing healthcare system (Bates, Ebell et al., 2003). This suggests one strategy for adoption that the U.S. government is already pursuing, running highly observable pilot projects that would hopefully demonstrate compelling advantages to doubters. EMR is adaptable to local circumstances, but this may impede the interoperability that would lead to larger system advantages. Alternatively, it is, especially when discussed as a bundle, extremely complex and potentially highly risky, and might be incompatible with traditional medical practice patterns and work flow.

Robert Miller and his colleagues (2005) conducted extensive case studies of 14 primary care practices, the setting in which more than two-thirds of U.S. physicians work. They estimated that the initial implementation costs, that is, training, installation, hardware, software, staffing, and so on, per provider averaged $44,000 per year, with ongoing EMR system costs of $8,500 per year (Miller, West, Brown, Sim, & Ganchoff, 2005). It took approximately two and a half years for practices to recover the initial costs. After that, they had the potential for substantial profits as a result of efficiency savings, reduced transcription costs, fewer medical record support staff needed, error reduction, more accurate coding of services, and so on. But there have also been cases of dismal failures (Miller et al., 2005). There were clear increases in hours worked by physicians and other healthcare professionals during implementation, with quality of life only improving for some healthcare providers thereafter (Miller et al., 2005). Moreover, only 2 of the 14 practices studied used their systems to extensively improve chronic and preventive care (Miller et al., 2005).

All of this suggests that an immense amount of resources, especially those related to communication, may be needed for the widespread adoption and successful implementation. The centrality of communication becomes even more pronounced when innovation occurs in the operation of consortia, such as those needed to insure interoperability among various healthcare providers within regions.

Let me now turn to the larger environment in which EMR operates in individual institutions.

Innovation Environment

Generally, several innovation environment factors can potentially determine the success of individual innovations, including the interdependence

of components of the system; their diversity in varying regions; the nature of the formal management system; external conditions, such as government regulations (Galbraith, 1973); types of power and influence used to secure involvement (Fidler & Johnson, 1984); climate in terms of human resources (Johnson, Meyer, Berkowitz, Ethington, & Miller, 1997); cultural norms toward innovation (Deal & Kennedy, 1982); and the openness of a system (Rogers, 2003). To use EMR, even in small practices, strong leadership, strategic planning, reengineering, and reinvention are necessary, and, above all, the EMR system must match and support the desired work flow (Lee, Cain, Young, Chockley, & Burstin, 2005). The larger the small practice, and the greater its linkage to a larger institutional environment, such as a Preferred Provider Organization, the higher the likelihood that EMR will be adopted (Burt & Sisk, 2005).

Here I view EMR in the broadest possible sense to include linkage in interoperable networks. So, I am not only looking at implementation in an individual physician's office, which may be problematic enough (Miller et al., 2005), but implementation in regions of health information exchanges, which also implies standard setting (developing common vocabularies for various medical conditions), itself an immensely complicated innovation (Halamka et al., 2005; Hammond, 2005). So, to achieve their maximum benefit, the bundling of a number of interrelated innovations is necessary (Hillestad et al., 2005; Taylor et al., 2005).

Perhaps most important, the benefits of EMR for research and for response to emergencies accrue at the system level, while costs, which can be quite high, are primarily incurred at the local level (Lewin Group, 2005; Middleton, 2005; Shortliffe, 2005; Taylor et al., 2005). Thus, there is often a mismatch of motivations, with a lack of compelling ones for those who must implement the system. However, various groups have decided that the benefits of these systems outweigh their risks and costs, although the real benefits may take five to ten years of diligent application to realize (Lewin Group, 2005).

The most significant application and potential benefit of EMR, perhaps, is that it can be efficiently used for conducting research on a large number of pooled medical records. For example, the Indianapolis Regenstief Institute's system has a database on the treatment of over 3 million patients with 300 million online coded results (Brailer, 2005; McDonald, 1997; McDonald et al., 2005). This database allows for large clinical studies focused on improving the quality of care for common medical conditions. Large databases can also be used as an early warning system for the emergence of diseases, promoting public health and preparedness (Thompson & Brailer, 2004), accelerating diffusion of knowledge, enhancing best practices (Thompson & Brailer, 2004), as well as potentially improving cost management by reduc-

ing the likelihood of unnecessary surgeries, waste, fraud, and abuse. While moving to health information exchanges considerably enhances the benefits of EMR, it vastly increases the complexity and challenges.

Framing

> We see policy positions as resting on underlying structures of belief, perception, and appreciation, which we call "frames." The frames that shape policy positions and underlie controversy are usually tacit, which means they are exempt from conscious attention and reasoning. (Schon & Rein, 1994, p. 23)

The concept of frames is most commonly used to indicate a way of viewing the world and interpreting it, acting as a sense-making device that establishes the parameters of a problem (Johnson, 1997a, 1997b, 1998). Here the focus is on how innovations are framed in terms of the expectations of key external stakeholders (Mitchell, Agle, & Wood, 1997). Satisfying these external stakeholders is critical to the flow of resources in large public sector organizations, where new investments often depend on the matching of agency efforts with new political initiatives. Often environmental "jolts" associated with organizational stakeholders are necessary to stimulate innovations (Marcus & Weber, 1989).

A report from RAND, a nonprofit global policy think tank, has estimated that widespread improvements in health information technology, which includes adoption of EMR, would result in yearly U.S. savings of $81–162 billion, with concomitant gains in safety, chronic disease care, and improved patient outcomes increasing saving to $142–371 billion (Hillestad et al., 2005). The adoption costs for such systems are estimated to be less than $10 billion (Taylor et al., 2005). More broadly, others have estimated that fully implementing a National Health Information Network in the U.S. would cost $156 billion in capital investment over a five-year period, with likely investments of only $24 billion if current trends continue (Kaushal et al., 2005). David Brailer (2005), who has led this effort at the federal level, estimates that 5 percent of healthcare costs could be saved by improved interoperability of EMR systems. Moreover, others estimate that nearly 30 percent of U.S. healthcare spending annually—$30 billion—is expended on unneeded or duplicative care (Harris & Associates, 2005) and that the widespread implementation of EMR could partially mitigate this situation. On a policy level, this issue has become important enough that President George W. Bush signed an Executive Order in 2004, setting a goal that the majority of Americans would have interoperable EMR within ten years.

However, one person's waste is another's revenue stream, resulting in a core of resistance to this bundle of innovations. Currently, only about 10 to 16 percent of physicians use EMR in their offices (Lee et al., 2005), with 49

percent of physicians in a Massachusetts survey indicating they had no intention of using it (Lewin Group, 2005), and little increase in penetration has occurred in recent years (Burt & Sisk, 2005; Noblis, 2008; Roenker, 2008). Small- and medium-sized practices, where 80 percent of medicine is practiced (Harris & Associates, 2005; Lee et al., 2005), are often the most resistant to EMR. Acceptance is only slightly better in hospital outpatient departments (29 percent adoption rates) and hospital emergency rooms (31 percent) (Burt & Sisk, 2005). The U.S. is significantly lagging other industrialized countries in this regard (Harris & Associates, 2005), while it clearly outspends them for healthcare (Bates, Ebell et al., 2003; Bodenheimer, 2005a). For example, a recent series of articles in the *Financial Times* found U.S. spending per capita on healthcare nearly three times that of Germany, Australia, and the UK (Timmins & Cookson, 2008). Thus, issues of costs and quality drive much of this discussion at a policy level and create the impetus for investments at a national level.

Change often depends on creating a vision of an attractive future pattern that politicians can articulate (Brailer, 2005; Mongiardo, 2005). Here demonstration projects that establish that success is possible can often be important for establishing the efficacy of an innovation. The leading case study for this is the largest integrated health system in the U.S., the Veterans Administration (VA). It has become the model for EMR implementation (Perlin, Kolodner, & Roswell, 2004; Thompson & Brailer, 2004). Up until the mid-1990s, the VA was widely seen as a vast, unwieldy, heavily politicized failure in delivering healthcare services (Gaul, 2005; Perlin et al., 2004). However, under innovative leadership it heavily invested in health information technology, became more patient-centric, and developed a renewed interest in the measurement and accountability of quality (Gaul, 2005; Perlin et al., 2004). In accomplishing these changes, the VA cared for more patients, with proportionally fewer resources, with higher quality (Gaul, 2005; Perlin et al., 2004).

Likelihood of Success

Resistance often occurs in asymmetrical relationships and can be countered by the classic influence of strategies of persuasion, authority, and rewards. Resistance to change has been a popular topic in the management literature for decades, although recently it has been cast in terms of often legitimate objections to inherent problems in change itself (Dent & Goldberg, 1999). In the case of EMR, an innovation that has been tried repeatedly for a generation (Brenner & Logan, 1980; McDonald, 1997; Shortliffe, 2005) with little return on investment, increases in medical errors due to poor training and resistance, and little gain in knowledge, there is reason for skepticism

in the current overhyped environment because of the possibility of failure on a truly massive scale (Himmelstein & Woolhandler, 2005).

Among physicians, there are many sources of resistance to EMR, including concerns about wasting time and money, harm to patient relationships, and doctors' roles becoming more like clerks' or nurses' because of the way that orders are entered into the computer (Lapointe & Rivard, 2005). Most dramatic, physicians have been involved in incidents ranging from passive resistance to refusal to enter prescriptions to refusal to admit patients to surgery, as detailed in fascinating case studies (Lapointe & Rivard, 2005). It has been estimated that sabotage rates of hospital information systems run as high as 35 percent (Lee et al., 2005). Information technology in healthcare settings has lagged behind other sectors of the U.S. economy (Burt & Sisk, 2005). Ironically, other technologically driven changes in healthcare, for example, cardiac catheterization, are key drivers of rapidly increasing costs (Bodenheimer, 2005b). Yet resistance is not necessarily a bad thing because it can stimulate dialogue that leads to a more effective implementation.

The success of an innovation implementation effort is often difficult to determine because the innovation can mean differing things, at differing levels, to different constituencies (Connolly, Conlon, & Deutsch, 1980). It is especially hard to predict a priori which efforts will be successful (Watts, 2003). I have developed an approach to evaluating the likelihood of success of an innovation by combining the levels (Johnson, 2000, 2001). By evaluating the nominal conditions of innovation attributes (that is, pros and cons), internal innovation environment, and framing, I have classified eight possible conditions of success (Johnson, 2000, 2001).

It is unlikely that EMR will be an unequivocal success given the complexity and shifting state of many factors. What is more likely is that it will fall between a squeezed success and a mandated failure. The squeezed success condition represents a highly efficacious innovation that is valued by stakeholders and has visionary leaders, overcoming a bad innovation environment, such as competition in local regions. Mandated failures are all too common in public service organizations where questionable innovations that lack appropriate support structures are mandated by external stakeholders such as politicians.

The classic diffusion of innovation paradigm assumes that the purpose of innovation is adoption of a more effective practice that will improve institutional efficiency (Rogers, 2003), but often the primary purpose of participating in innovation is symbolic—a demonstration that one is forward looking and modern, willing to jump on whatever bandwagon may be rolling by (Abrahamson, 1991; Abrahamson & Rosenkopf, 1993). Mandated failures tend to further contribute to the decline in morale of organizational mem-

bers who come to view themselves as pawns. They also result in considerable opportunity costs when scarce resources are devoted to costly failures. Even more damaging is when partial failures result in show projects that can be publicly trumpeted as successes, even when their unintended consequences result in substantially larger failures (Johnson, 2000, 2001).

As Rosabeth Moss Kanter (1983) has established, there is considerable reluctance to labeling an innovation a failure because of the taboo of mentioning failure, the threatening nature of failure for future risky ventures, the multiple goals of many projects that prevent them from being cast as outright failures, and the strategies by which clever innovators convert failures into minor successes. Indeed, managers use multiple, diverse, and idiosyncratic performance criteria for differing innovations even in the same organizational context, with the criteria used by resource controllers being the most critical (Dornblaser et al., 2000).

In spite of often rosy predictions, the impacts of information processing technologies on organizational productivity and profitability have been a matter of some controversy (Hoffman, 1994). While the focus of substantial investments, information technology has had problematic relationships to profitability specifically and to organizational performance more generally (Melville, Kraemer, & Gurbaxani, 2004). It has become widely recognized in the literature that most approaches to innovation have a pro-innovation bias (Rogers, 2003), partly because of underlying cultural beliefs in progress through technology. All of us, especially in our personal technological purchases, increasingly realize that early adoption can be risky (think of Sony's Betamax videocassette recorders) and, at the very least, it is sometimes cheaper to wait to adopt innovations (consider personal computers, for example). There are also real organizational costs to innovations: wasting resources on inappropriate technology, constant uncertainty resulting from perpetual change, and lowered morale from unsuccessful adoption efforts, to name but a few.

Conclusion

Electronic medical records do not possess many of the conventional success factors commonly applied to new information and communication technologies (Paisley, 1993), except that they meet an important need in terms of reforming our healthcare system. They require a lot of effort, especially in implementation; they are expensive; they may not be intrinsically gratifying to users in terms of data entry; they require a high level of technological literacy; they are not yet idiot-proof; they can be de-statusing for physicians and other healthcare professionals; and they can inhibit human contact. Given all this, to achieve even a modicum of success, they will need an enor-

mous investment of political will and resources by stakeholders to be implemented.

Acknowledgment

I thank Dr. James Andrews for suggesting some key informatics articles relating to electronic medical records.

References

Abrahamson, E. (1991). Managerial fads and fashions: The diffusion and rejection of innovations. *Academy of Management Review, 16*, 586–612.

Abrahamson, E., & Rosenkopf, L. (1993). Institutional and competitive bandwagons: Using mathematical modeling as a tool to explore innovation diffusion. *Academy of Management Journal, 18*, 487–517.

Bates, D. W., Ebell, M., Gotlieb, E., Zapp, J., & Mullins, H. C. (2003). A proposal for electronic medical records in U.S. primary care. *Journal of the American Medical Informatics Association, 10*, 1–10.

Bates, D. W., & Gawande, A. A. (2003). Improving safety with information technology. *New England Journal of Medicine, 348*, 2526–2534.

Becker, M. H. (1970). Factors affecting diffusion of innovations among health professionals. *American Journal of Public Health, 60*, 294–304.

Bodenheimer, T. (2005a). High and rising health care costs. Part 1: Seeking an explanation. *Annals of Internal Medicine, 142*, 847–854.

Bodenheimer, T. (2005b). High and rising health care costs. Part 2: Technologic innovation. *Annals of Internal Medicine, 142*, 932–937.

Boer, H., & During, W. E. (2001). Innovation, what innovation? A comparison between product, process and organizational innovation. *International Journal of Technology Management, 22*, 83–107.

Bohlen, J. M. (1971). Research needed on adoption models. In W. Schramm & D. F. Roberts (Eds.), *The process and effects of mass communication* (pp. 798–815). Urbana: University of Illinois Press.

Brailer, D. (2005, March). *Presentation to national governor's association conference.* Retrieved March 26, 2005, from http://www.kyhie.org/library.htm.

Brenner, D. J., & Logan, R. (1980). Some considerations in the diffusion of medical technologies: Medical information systems. In D. Nimmo (Ed.), *Communication yearbook 4* (pp. 609–624). New Brunswick, NJ: Transaction Books.

Burt, C. W., & Sisk, J. E. (2005). Which physicians and practices are using electronic medical records. *Health Affairs, 24*, 1334–1343.

Connolly, T., Conlon, E. J., & Deutsch, S. J. (1980). Organizational effectiveness: A multiple constituency approach. *Academy of Management Review, 5*, 211–217.

Cunningham, R. (2005). Action through collaboration: A conversation with David Brailer. *Health Affairs, 24*, 1150–1157.

Deal, T. E., & Kennedy, A. A. (1982). *Corporate cultures: The rites and rituals of corporate life.* Reading, MA: Addison-Wesley.

Dearing, J. W., & Meyer, G. (1994). An exploratory tool for predicting adoption decisions. *Science Communication, 16,* 43–57.

Dearing, J. W., Meyer, G., & Kazmierczak, J. (1994). Portraying the new: Communication between university innovators and potential users. *Science Communication, 16,* 11–42.

Dent, E. B., & Goldberg, S. G. (1999). Challenging "resistance to change." *Journal of Applied Behavioral Science, 35,* 25–41.

Dornblaser, B. M., Lin, T., & Van de Ven, A. H. (2000). Innovation outcomes, learning, and action loops. In A. H. Van de Ven, H. L. Angle, & M. S. Poole (Eds.), *Research on the management of innovation: The Minnesota studies* (pp. 193–217). New York: Oxford University Press.

Fidler, L. A., & Johnson, J. D. (1984). Communication and innovation implementation. *Academy of Management Review, 9,* 704-711.

Friedman, T. L. (2005). *The world is flat: A brief history of the twenty-first century.* New York: Farrar, Straus and Giroux.

Galbraith, J. R. (1973). *Designing complex organizations.* Reading, MA: Addison-Wesley.

Gans, D., Kralewski, J., Hammons, T., & Dowd, B. (2005). Medical groups' adoption of electronic health records and information systems. *Health Affairs, 24,* 1323–1333.

Gaul, G. M. (2005, August 22). Revamped veterans' health care now a model. *Washington Post,* p. A01.

Goodman, C. (2005). Savings in electronic medical record systems? Do it for the quality. *Health Affairs, 24,* 1124–1126.

Hackbarth, G., & Milgate, K. (2005). Using quality incentives to drive physician adoption of health information technology. *Health Affairs, 24,* 1147–1149.

Halamka, J., Overhage, J. M., Ricciardi, L., Rishel, W., Shirky, C., & Diamond, C. (2005). Exchanging health information: Local distribution, national coordination. *Health Affairs, 24,* 1170–1179.

Hammond, W. E. (2005). The making and adoption of health data standards. *Health Affairs, 24,* 1205–1213.

Harris, L., & Associates. (2005, April 1). *At a tipping point: Transforming medicine with health information technology: A guide for consumers.* Retrieved September 14, 2006, from http://www.lharris.com.

Hersh, W. R. (2002). Medical informatics: Improving health care through information. *Journal of the American Medical Association, 288,* 1955–1958.

Hillestad, R., Bigelow, J., Bower, A., Girosi, F., Meili, R., Scoville, R., et al. (2005). Can electronic medical record systems transform health care? Potential health benefits, savings, and costs. *Health Affairs, 24,* 1103–1117.

Himmelstein, D. U., & Woolhandler, S. (2005). Hope and hype: Predicting the impact of electronic medical records. *Health Affairs, 24,* 1121–1123.

Hoffman, G. M. (1994). *The technology payoff: How to profit with empowered workers in the information age.* New York: Irwin.

Johnson, J. D. (1997a). A framework for interaction (FINT) scale: Extensions and refinement in an industrial setting. *Communication Studies, 48,* 127–141.

Johnson, J. D. (1997b). Review of the books *The art of framing: Managing the language of leadership* and *Frame reflection: Toward the resolution of intractable policy controversies*. *Quarterly Journal of Speech, 83,* 397–398.

Johnson, J. D. (1998). Frameworks for interaction and disbandments: A case study. *Journal of Educational Thought, 32,* 5–20.

Johnson, J. D. (2000). Levels of success in implementing information technologies. *Innovative Higher Education, 25,* 59–76.

Johnson, J. D. (2001). Success in innovation implementation. *Journal of Communication Management, 5,* 341–59.

Johnson, J. D. (2005). *Innovation and knowledge management: The Cancer Information Science Research Consortium.* Cheltenham, England: Edward Elgar.

Johnson, J. D., Meyer, M., Berkowitz, J., Ethington, C., & Miller, V. (1997). Testing two contrasting models of innovativeness in a contractual network. *Human Communication Research, 24,* 320–348.

Kanter, R. M. (1983). *The change masters: Innovation and entrepreneurship in the American corporation.* New York: Simon and Schuster.

Katz, E. (1963, August). *The characteristics of innovations and the concept of compatibility.* Paper presented at the Rehovoth Conference on Comprehensive Planning of Agriculture in Developing Countries, Rehovoth, Israel.

Kaushal, R., Blumenthal, D., Poon, E. G., Jha, A. K., Franz, C., Middleton, B., et al. (2005). The costs of a National Health Information Network. *Annals of Internal Medicine, 143,* 165–173.

Klein, K. J., & Sorra, J. S. (1996). The challenge of innovation implementation. *Academy of Management Review, 21,* 1055–1080.

Lapointe, L., & Rivard, S. (2005). A multilevel model of resistance to information technology implementation. *MIS Quarterly, 29,* 461–491.

Lee, J., Cain, C., Young, S., Chockley, N., & Burstin, H. (2005). The adoption gap: Health information technology in small group physician practices. *Health Affairs, 24,* 1364–1366.

Leonard-Barton, D., & Sinha, D. K. (1993). Developer-user interaction and user satisfaction in internal technology transfer. *Academy of Management Journal, 36,* 1125–1139.

Lewin Group. (2005). *Health information technology leadership panel: Final report.* Falls Church, VA: Lewin Group.

Marcus, A. A., & Weber, M. J. (1989). Externally-induced innovation. In A. H. Van de Ven, H. L. Angle, & M. S. Poole (Eds.), *Research on the Management of Innovation* (pp. 537–559). New York: Oxford University Press.

McDonald, C. J. (1997). The barriers to electronic medical record systems and how to overcome them. *Journal of the American Medical Informatics Association, 4,* 213–221.

McDonald, C. J., Overhage, J. M., Barnes, M. Schadow, G., Blevins, L., Dexter, P. R., et al. (2005). The Indiana network for patient care: A working local health information infrastructure. *Health Affairs, 24,* 1214–1220.

McKinney, M. M., Barnsley, J. M., & Kaluzny, A. D. (1992). Organizing for cancer control: The diffusion of a dynamic innovation in a community cancer network. *International Journal of Technology Assessment in Health Care, 8,* 268–288.

Melville, N., Kraemer, K., & Gurbaxani, V. (2004). Information technology and organizational performance: An integrative model of IT business value. *MIS Quarterly, 28,* 283–322.

Middleton, B. (2005). Achieving U.S. health information technology adoption: The need for a third hand. *Health Affairs, 24,* 1269–1272.

Miller, R. H., West, C., Brown, T. M., Sim, I., & Ganchoff, C. (2005). The value of electronic health records in solo or small group practices. *Health Affairs, 24,* 1127–1137.

Mitchell, R. K., Agle, B. R., & Wood, D. J. (1997). Toward a theory of stakeholder identification and salience: Defining the principle of who and what really counts. *Academy of Management Review, 22,* 853–886.

Mohr, L. B. (1969). Determinants of innovations in organizations. *American Political Science Review, 63,* 111–26.

Mongiardo, D. (2005, February 25). Health bill could cure a lot of ills. *Herald-Leader,* p. A13.

Noblis. (2008, May 20). *LouHIE business plan.* Retrieved July 8, 2008, from htp://www.louhie.org/Downloads/LouHIE%20Biz%20Plan%20Approved%205-21-08.pdf.

Paisley, W. (1993). Knowledge utilization: The role of new communication technologies. *Journal of American Society for Information Science, 44,* 222–234.

Perlin, J. B., Kolodner, R. M., & Roswell, R. H. (2004). The veterans health administration: Quality, value, accountability, and information transforming strategies for patient-centered care. *American Journal of Managed Care, 10,* 828–836.

Perry, J. L., & Kraemer, K. L. (1978). Innovation attributes, policy intervention, and the diffusion of computer applications among local governments. *Policy Sciences, 9,* 179–205.

Roenker, R. (2008, January). Starting to click. *Lane Report,* 38–40.

Rogers, E. M. (2003). *Diffusion of innovations* (5th ed.). New York: Free Press.

Rogers, E. M., & Adhikayra, R. (1979). Diffusion of innovations: An up-to-date review and commentary. In D. Nimmo (Ed.), *Communication yearbook 3* (pp. 67–81). New Brunswick, NJ: Transaction Books.

Rosenfeld, S., Bernasek, C., & Mendelson, D. (2005). Medicare's next voyage: Encouraging physicians to adopt health information technology. *Health Affairs, 24,* 1138–1146.

Schon, D. A., & Rein, M. (1994). *Frame reflection: Toward the resolution of intractable policy controversies.* New York: Basic Books.

Shortliffe, E. H. (1999). The evolution of electronic medical records. *Academic Medicine, 74,* 414–419.

Shortliffe, E. H. (2005). Strategic action in health information technology: Why the obvious has taken so long? *Health Affairs, 24,* 1222–1233.

Taylor, R., Bower, A., Girosi, F., Bigelow, J., Fonkych, K., & Hillestad, R. (2005). Promoting health information technology: Is there a case for more-aggressive government action? *Health Affairs, 24,* 1234–1245.

Thompson, T. G., & Brailer, D. J. (2004, July 21). *The decade of health information technology: Delivering consumer-centric and information-rich health care: Framework for strategic action.* Washington, DC: National Coordinator for Health Information Technology.

Timmins, N., & Cookson, C. (2008, July 1). Sense of crisis prevails as money fails to revive an ailing system. *Financial Times*, p. 4.

Walker, J. M. (2005). Electronic medical records and health care transformation. *Health Affairs, 24,* 1118–1120.

Watts, D. J. (2003). *Six degrees: The science of the connected age.* New York: W. W. Norton.

Zaltman, G., & Duncan, R. (1977). *Strategies for planned change.* New York: Wiley.

Zaltman, G., Duncan, R., & Holbek, J. (1973). *Innovation and organizations.* New York: Wiley.

CHAPTER 9

The Multitasking of Entertainment

▶ DANIEL G. MCDONALD & JINGBO MENG

Recent technological changes in the entertainment industries have resulted in increased attention to the idea that entertainment activities such as listening to music, watching television, surfing the Internet, or reading may be becoming more commonly a situation in which audience members consume multiple media more or less simultaneously. This phenomenon is known by a variety of names, especially media multitasking and simultaneous multiple media use, but little is known about the extent to which it occurs or the extent to which it is a new phenomenon. Much communication research, and many other studies of the use of time, focus on time as a fixed quantity (24 hours in a day) that is allocated to specific activities or media. If multitasking is a common aspect of media use, there are important ramifications for our thinking about the audience experience, the process of media consumption, and any effects that may result from media use.

Media multitasking—a way of sharing a fixed period of time among different media—may be on the rise at the same time that media technologies

are enabling audience members to shift times and location for media consumption. Personal media devices, such as MP3 players like the iconic iPod, personal video players, digital video recorders, and wireless technologies of various sorts, are enabling users to shift times and locations for scheduled activities and events. Popular belief suggests that we are in a situation in which more flexible access to media is increasing concurrently with less time being dedicated to the use of a specific medium. If so, less attention is being paid exclusively to one medium, even though the technologies could allow more exclusive time.

This chapter explores the known history of multitasking entertainment activities by examining the literature dating back to Pitirim Sorokin and Clarence Berger's (1939) classic, *Time-Budgets of Human Behavior*. We will also cover the early studies of the use of media in U.S. homes and other relevant historical and current materials concerning the use of multiple mass media. The historical materials will provide an overview of what we know about media multitasking throughout media history to enable us to better understand media multitasking today.

Clarifying Terms and Concepts: Media Use and Multitasking

In current studies, "media multitasking" is defined in a variety of ways and may refer to very different activities. For example, Yahoo! & Carat Interactive (2003) refer to multitasking as the use of multiple media at the same time (in particular, the Internet in combination with other media). Ulla G. Foehr (2005) described multitasking as using a single medium while engaging in other non-media activities, and media multitasking refers to using multiple media simultaneously. Amy Jordan and colleagues (2005) defined "multiple media use" as combining one medium with another medium, and multitasking as combining use of one medium with a non-media activity.

The distinction between the two different ideas may not be necessary in many cases. In studying the use of a particular medium and the effects of that use, for example, it may not matter whether someone is performing a household chore or engaging in the use of other media, because the interest may be in the decrement of attention paid toward that one particular medium under study. Any use of a different medium in that situation could simply fall within a classification that helps a researcher decide whether or not multitasking has occurred.

Alternatively, if interest is in the psychological processes that occur during interaction with media content, the simultaneous use of another medium implies a complication of those psychological processes and a switching

between the mental states for each medium. Such a switching requires some sort of alternating distancing and engagement process that, to our knowledge, has never been described in the literature. A great deal of theoretical work is needed to even begin an outline of the processes involved in switching between mental states occupied by two different media, although we see the value of such a contribution.

This chapter will consider media multitasking and simultaneous multiple media use as two distinct phenomena because of the rich potential for later theory and research. Because this is an overview chapter, we will simplify the conceptual definitions by focusing on media use as the defining factor. Any time two or more different media are used at the same time, we will consider it simultaneous media use. Any time one or more non-media tasks or activities are combined with any one media activity, we will refer to it as media multitasking. In this way, using one medium and participating in two non-media activities is still media multitasking, but using two media with any number of additional tasks will be considered simultaneous media use. For example, we might have the use of three media at the same time: television viewing, surfing the Internet, and reading a book. This would still fall under the idea of simultaneous media use, as would television viewing, listening to a digital audio player, and preparing dinner.

We will confine ourselves to the typical quasi-social mass media of communication—newspapers, motion pictures, radio, television, and the Internet—and consider traditionally interpersonal communication opportunities, such as face-to-face, telephone calls, and some uses of the Internet, as tasks to be performed. For brevity, we shall sidestep the issues involved in distinguishing between channels, medium, and content that may allow someone to engage in simultaneous media use while only using one medium (for example, simultaneously using the Internet for instant messaging and watching a movie online).

A History of Media Multitasking and Multiple Media Use

The term "multitasking" is historically associated with the popularity of computers in the 1950s and 1960s, but multitasking has been a part of life since complex life forms began. Essentially, multitasking is the allocation of attention or information-processing power to more than one object, event, or activity, whether that attention is a computer's or a teenager's. Multiple media use, a special form of multitasking, probably began when it became possible to engage with two media in the same physical space, although certain media require specific environmental conditions that set limitations on which media

The Multitasking of Entertainment

can be used concurrently. Early parlor entertainment in the nineteenth century, such as three-dimensional image stereoscopes, which used available light, might be passed around from one family member to another while the newspaper was being read, but other forms of parlor entertainment, such as magic lantern slide shows, which required a darkened room for projection purposes, would have prevented reading at the same time. Clearly, though, some members of the family may have multitasked during magic lantern shows by playing piano or organ music to accompany the slides. This type of activity would have predated silent film pianists by decades.

One of the earliest systematic studies of how people distribute their time was conducted by Sorokin and Berger (1939); their data were collected in 1935. They relied on their participants to fill out time budget sheets related to what they did during the day. While the authors were quite thorough in their analyses, they did not allow for more than one task at a time. Multitasking and simultaneous media use are evident in their results in a number of ways, however. Sorokin and Berger provide a list of the activities that people indicated in open-ended responses. A glance at the list indicates that a number of these instances were multitasking: cards and talk, cards and smoke, dance and talk, rest and talk, eat and smoke, meal and talk, play and talk; others took on aspects of media multitasking: radio and auto repair, read and rest, reading and study groups; and still others indicate simultaneous media use, especially radio and reading. Because Sorokin and Berger's interests were in how people allocated their time, more than in what specific activities were completed during a given day, they only considered one activity even though more than one was indicated. They do not indicate how they resolved this issue, so their book only provides a brief glimpse of data that could have provided much more information on the notions of multitasking and simultaneous media use.

By the mid-1930s, though, we were beginning to see fairly clear evidence of multitasking and simultaneous media use from the communication literature. Hadley Cantril and Gordon Allport (1935) noted that

> the ease of tuning in, together with the lack of obligation to listen, has created a new type of auditory background for life within the home. The housewife performs her household duties to the accompaniment of music, advice and advertising: in the afternoon she may sew, read or play bridge with the same background of sound; in the evening, if she is not exhausted, the radio may provide a setting against which dinner is served and guests are entertained.... Students often prepare their assignments to the muted tune of a jazz orchestra. (p. 25)

In their data analysis, Cantril and Allport (1935) noted that two-thirds of the people in their sample are involved in some other activity while listening to radio music, but for people under 30, the proportion was three-quarters. Conversely, when educational talks were the radio content, more gave

their undivided attention. Interestingly, when the non-radio task was the main task, three-quarters indicated that listening to radio programs involving talk distracted too much attention from the primary task.

Cantril and Allport (1935) also had data related to students in college at this time. These data indicated that 68 percent studied while listening to the radio, with 44 percent of their sample indicating that they "frequently" or "always" listened to the radio while studying. Forty-seven percent of those in the Cantril and Allport college student study indicated that, while studying, the radio volume was either at a loud or medium level. These students indicated a variety of different types of programs to listen to while studying, but nearly all neglected to mention talk programs (99 percent), which 40 percent of the sample indicated were a hindrance to studying. Fifteen years after Cantril and Allport, A. L. Chapman (1950) found that about half of the college students he studied listened to the radio while studying.

In asking whether multitasking and multiple media use had a cumulative effect on attention and concentration, Cantril and Allport (1935) posed a question that continues today in both popular press and academic research. As they note, selection between competing stimuli can be made only at the cost of mental effort. They suggest that attention waxes and wanes between stimuli, and shifts from one focus to another, with one particular stimulus seldom inhibited for more than a few minutes at a time.

By 1950, as Angus Campbell and Charles Metzner (1950) note, some people had their radios on almost continually. They question, however, how much attentive listening is done by those with radios on more than six hours per day (13 percent of their sample): "we may even question whether they really listen at all" (p. 4). They further note that those who read a number of books listen to as much radio as those who read few books and indicate that a number of people read and listen to the radio at the same time. The structural differences accounting for differing media multitasking are also highlighted, as Campbell and Metzner (1950) note that "movie going, unlike much radio listening, competes for time which might be devoted to reading" (p. 8).

The radio had become a background to much of daily life, but television was beginning to make inroads in U.S. homes by the early 1950s. Early predictions were that television would not be used much in multitasking or simultaneous media use situations. It was thought that the visual element in combination with audio would demand too much attention for viewers to engage in other tasks (Peterson, 1938, as reported in Bogart, 1956). Eldridge Peterson suggested that television would demand concentrated attention and thus would not take the same background place in life as radio had accomplished. There is some evidence that that did occur early on: a number of

studies of the early 1950s indicate changes in sleep patterns and other activities to accommodate television schedules (see Bogart, 1956, for a review).

However, by the time of Leo Bogart's (1956) study, many viewers had found ways to multitask with television. Bogart also reports a study by Melvin Goldberg (1949) indicating that 8 percent of families had changed their dinnertime to correspond with television programming, and another 11 percent of families had begun to multitask: eating in front of the television set rather than at the dinner table. A study by Raymond Stewart (1952) reported that 97 percent of families had kept the dinner hour the same, but 44 percent of families were eating within viewing distance of the set. In Stewart's study, 57 percent of the sample indicated that they sometimes listened to television without paying attention to the images, and that 90 percent of the time that they were watching television they were also doing something else, typically household chores. Bogart (1956) also reports a study by John Fine and Eleanor Maccoby (1952) that indicated that 25 percent of upper-income families reported multitasking while viewing television. A series of studies of the "distraction possibilities" of television indicated that multitasking with television reduced awareness of the program content, but did not distract from the speed or efficiency of household chores such as washing dishes (University of Oklahoma, 1950).

A 1955 study by Mike Ripley indicated that during every time period in the day, a substantial proportion (about a third) of women "viewers" were not even in the same room as the television; another third were in the room but multitasking or using simultaneous media. The picture that emerged from Ripley's data was one in which the women wandered in and out of the area in a physical analog to the mental wandering described in our definitional section of this chapter.

At the same time as the Ripley study, Bogart (1956) reports that the *Chicago Tribune* conducted a similar study of the Chicago area but concentrated on prime-time viewing. The *Tribune* study found that 63 percent of women and 73 percent of men were not multitasking or using simultaneous media when the phone rang for the survey. Five percent of the women and 8 percent of the men were reading; about 5 percent of both genders were eating. Among women, about 3 percent were sewing. The rest were participating in other activities.

During the 1950s, the conflict between radio and television for viewers spilled over into a specialization for multitasking and simultaneous media use. Alfred Politz Research, Inc. (1953) indicated that during the daytime, most radio listeners were multitasking (preparing food, chores, eating, or driving), while in the evening, only 37 percent were multitasking. In the evening, 9 percent were engaging in reading at the same time as radio listening. By the mid-1950s, though, a study by William McPhee (1956) indicated that

radio's main advantage was that it permitted multitasking and simultaneous media use. McPhee went on to extrapolate from his data to suggest specific types of programs that would be suitable for multitasking, suggesting that the attention demanded of the best television program is self-defeating in terms of the limitations it puts on multitasking. Indeed, a number of studies of the mid-1950s indicate that television diffusion led to a decline in book reading, in part because of the conflict inherent in the use of the visual channel for both media.

By the late 1970s, though, television had become integrated in the lives of U.S. families in a way that radio had probably never been. A study by Elliott Medrich (1979) found that over one-third of inner-city families had the television set on nearly all the waking hours, forming a constant backdrop to all family activities.

The picture that emerges in the historical literature, then, suggests that media or other activities all require some degree of mental effort. A person can alleviate some of the boredom and drudgery of household chores or other activities by allocating a small portion of their processing power to monitoring an entertainment medium. It would appear to be most effective and efficient when that medium provides much (if not all) of the information through a channel that is not required by the other task. In that way, the medium can be monitored effectively with only minor shifts in the attentional focus.

This is what we see with the development of radio as a medium, and its evolution as a background environment for the home through the 1940s and into the 1950s, and continuing today, primarily in work and shopping environments. In the case of radio, most household tasks, such as washing dishes, cleaning, and so forth, did not require audio for efficiency; people had plenty of processing room to monitor a radio program, stopping and listening whenever the program required it for comprehension, or whenever the monitoring suggested a particularly pleasurable or an especially important piece of information.

With the growth of television, the early literature suggested that the visual aspect of programs required more attention, so television as a background to daily life was not as prevalent for a number of years. The literature suggested a need for people to move in and out of the viewing range of the television to maintain the appropriate level of processing attention. Whether it was a change in the structure of television content, an adaptation of the audience to television conventions, or a combination of the two, by the late 1970s, television had become a background to daily life much as radio had been 30 years earlier. In both of these cases, it would appear that simultaneous media use and multitasking are most efficient when the secondary media use does not require much interaction with the medium—no

The Multitasking of Entertainment

page turning or channel switching required, except sporadically, so television and radio were both excellent possibilities for backgrounds for other tasks. They did not demand much attention for operation and, unlike the phonograph (early record player), they did not require much interaction for continual use.

As long as there was one dominant medium in the home that could provide that kind of streaming entertainment without distraction, multitasking and simultaneous media use did not attract much academic attention. With the development of miniature and personal media such as the Walkman, which Sony released internationally in 1979, the notion of dividing attention among more than one medium or between a medium and a non-media task, began to gather interest. As personal media proliferated in the 1990s and the first decade of the twenty-first century, more popular press and academic articles began to appear, alongside a confusion in terminology. More personal media made it easier for people to use more than one medium at a time, or engage in other chores or activities while using a particular medium. However, television viewing became more complicated. Remote control devices have been combined with peripheral devices and so changed from simple channel switching and volume control to handsets that are able to control multiple video inputs, pause or replay programming, and more. The complication in television technology makes it easier to stop processing or to reprocess content in the sense that content can be paused, rewound, or restarted. However, decisions such as pausing, rewinding, or restarting content all require a level of thinking about the content that is probably less compatible with multitasking than is "background" multitasking of previous media that allowed primary attention to one medium, with a background medium to which the person could pay varying levels of attention. It seems likely that the determinant of how much attention was paid to the secondary medium was based on what was required by the primary medium.

The complication for today's television use suggests to us that, consistent with what we have learned from the historical literature, television may now be less subject to multitasking than in previous decades. The plethora of new devices and the historical patterns among older media suggest that media are better suited in specific combinations: audio may work best with visual media, while media requiring complex or frequent interactions, such as instant messaging, are most likely complementary to streaming media, such as radio or a personal MP3 player, and potentially less of a fit with today's television viewing.

However, the flexibility of television programming still allows for simpler viewing—something like the streaming effect, which was referred to as inertia in the early radio and television literature. That is, technological changes for television in the past two decades have made it possible to inter-

act with television in a much more dynamic fashion, but they do not require it; viewers can still turn on the television and leave it on without changing channels or altering the volume all day.

Prevalence of Multitasking and Simultaneous Media Use Today

Despite hints in the literature just described that media multitasking and simultaneous media use are quite common in the history of media audiences, there has been little theory to guide investigations in recent years. Rather, most recent efforts are focused on field studies examining either the extent to which it exists or experimental studies of attention allocation. Much of this work is directed toward children or young adults. Despite the currency of the topic and the potential importance of these activities for media research and theory, surprisingly few studies have been undertaken to determine current patterns or the implications of those patterns for the audience effects.

Most recent research efforts on media multitasking and multiple media use have been driven by the advertising industry and are rarely published in academic journals. A few studies have been conducted and are available through organizational Web sites or other means. In general, these studies are not particularly clear or predictive of the future. For example, BIG Research conducted "The Simultaneous Media Usage Survey" in 2003 and reported that 70 percent of consumers indicated using two or more forms of media at once (Media Center at American Press Institute, 2004). Harris Interactive (2003, cited by Jordan et al., 2005) concluded that 68 percent of young people from 13 to 24 years old listen to MP3s, and 45 percent of them listen to the radio while surfing on the Internet. Such findings are not surprising given the historical literature we have just reviewed.

As we noted, many previous multitasking and simultaneous media use studies are concerned with young children or youth. Donald F. Roberts, Ulla G. Foehr, Victoria Rideout, and Mollyann Brodie (1999) conducted a survey for the Kaiser Family Foundation and found that 42 percent of the sample (18- to 24-year-olds) reported the television was on "most of the time," with 58 percent reporting that it was on during meals, a figure similar to that reported by Bogart (1956) at the dawn of television. Another Kaiser Family Foundation diary study reported that the amount of time 8- to 18-year-olds spend media multitasking has increased from 16 to 26 percent of total media use time (Graham & Kingsley, 2005).

Some data support the notion that television may be less compatible with interactive multitasking than in previous decades. In a recent Kaiser Family Foundation project, Foehr (2005) sampled 694 8- to 18-year-olds for a sev-

en-day media use diary study and found that young people are most likely to use multiple media when they are surfing the Internet; they are least likely to do so when watching television (17 percent of the total time with multiple media use). Foehr also found that when it is a young person's primary activity, television is least likely to be used simultaneously with other media, while reading and computer activities such as looking at Web sites (two visually oriented media) are the most multitasked. Foehr found that 55 percent of the time spent watching television as a primary activity these teens are doing nothing else.

A survey of 1,800 Web users 13 to 17 years old asked about their Internet use outside of school (BurstMedia, 2006). About half (48.9 percent) say they are doing offline homework while online. Other offline activities going along with online activities include television or movies (33.8 percent), radio (21.4 percent), music videos on television (21.2 percent), sending mobile phone text messages (20.1 percent), talking on a phone (35 percent), or watching sports on television (18 percent).

Jordan and colleagues (2005) investigated how much time high school and college students spend multitasking and in simultaneous media use. The result showed that of the 37 hours of total media use per week, approximately 6 hours were spent using multiple media (16 percent of total media use). In contrast, 28 hours were spent multitasking (76 percent). When multitasking, non-media activities (such as grooming and hanging out with friends) were more likely to be the primary activity, with the television and eating combination as an exception. The Internet is more likely to be the primary medium when listening to music (77 percent of the simultaneous media use time spent listening to music). With regard to media use patterns, there were two major multiple media combinations: Internet and music (59 percent of total time spent using multiple media) and Internet and television (24 percent of total time spent using multiple media). By comparison, there are extensive possibilities of multitasking (for example, television and eating, and music and grooming), but none of them accounted for more than 10 percent of total multitasking time.

Similarly, recruiting U.S. college students, Naomi Baron (2008) finds increased multitasking through phones, e-mail, instant messaging, and mobile phones. Ninety-eight percent of students using instant messaging were involved in at least one other activity, including an average of 2.7 ongoing instant messaging conversations (synchronous and asynchronous). Other online activities included Web-based activities (70.3 percent), computer-based media players (47.5 percent), and word processing (38.6 percent). Offline activities included face-to-face conversation (41.1 percent), eating/drinking (36.7 percent), television (28.5 percent), and telephone (21.5 percent).

When asked why they multitasked, the students indicated that the task may require multiple activities to complete; there was a particular need to accommodate time demands, and multitasking allows more activities to be completed in a given day; they became bored or impatient with the primary task; or that the multitasking was unintentional, such as receiving a phone call while doing another activity (Baron, 2008).

A few researchers have turned their attention to media multitasking among adults. A Middletown Media Multitasking study was conducted in Muncie, Indiana, and surrounding Delaware County in 2004 (Papper, Holmes, & Popovich, 2004). Unlike the studies already mentioned, this project recruited a much more diverse sample in terms of age groups. The researchers tried to identify the relative merit of differing techniques in measuring media use and the extent to which people can recognize, recall, and identify their own media use behaviors. A telephone survey was conducted, and a diary study was followed up with a comprehensive daily log of media usage.

The diary keepers noted simultaneous multiple media use 12.4 percent of their total media use time, but observational data revealed that during a quarter of total media use, people use at least two media at the same time. There appeared to be much more reading coupled with other media use than the authors had anticipated. Specifically, based on each observation, in "all reading" (including books, newspapers, and magazines), 73.4 percent of readers also engaged in another media activity at least some of the time; 57.5 percent of the time spent reading involved watching television or a DVD, or listening to the radio or a CD (Papper et al., 2004).

In the case of watching television and reading, there was actually less multiple media use than people appeared to think. Although 44.6 percent of television viewers read something at least some of the time while watching television, the two activities multitask only 7.8 percent of the time, supporting the separation of channels we described previously. Participants focusing on television tended not to read at the same time, but participants focused on reading could have the television on, most likely in a streaming manner (Papper et al., 2004).

In addition, both telephone survey and observation data found that about 39.1 percent of television viewers multitask with the computer, although they do so only 11.6 percent of the time. However, in the diary study, only 8.7 percent of television viewers reported also being on the computer, for just 2.1 percent of the time. Diary keepers listed the most common media used with television as the telephone, newspaper, and then computer. In sum, the study suggests that when people are using a computer primarily, they are also using other forms of media; however, when people are primarily watching television, they are seldom on the computer (Papper et al., 2004).

A number of studies have focused on multitasking with media. Se-Hoon Jeong and colleagues (2005) found that the most popular type of multitasking involves the use of television with homework, eating, grooming, and social interaction. The study also suggested that audiences are more likely to multitask with broadcast such as television and online media rather than print media. Foehr (2005) reported that when watching television, a person is not usually using other media at the same time, but when a person is using multiple media there is likely television involved. In other words, when television is the primary medium, multiple media use will be less likely to happen and secondary activities are more likely to be non-media related. In contrast, a computer is a hub for multiple media use.

Some Industry Data

The Cable & Telecommunications Association for Marketing (CTAM) supplied the authors with some illustrative data from a diary survey conducted in 2004. In this case, the diary data were concerned with "viewing instances" rather than specific time points. Any time a person began to watch television, the viewing instance began; when they stopped watching television, it was over. Participants recorded the other activities they engaged in during that viewing instance (thus the percentages do not sum to 100 percent), and if no other activity was listed, that was coded as well. In Figure 1, we provide an illustration summarizing these diary data for different age groups.

As is evident in the figure, general household chores are undertaken in about 20 percent of viewing instances, regardless of age group, but all other activities differ widely by age group. Doing nothing else shows a linear increase with age, while surfing the Internet shows a linear decrease. Reading shows increasing occurrences with age. Leaving the room and talking on the phone begin at about 35 percent of viewing instances for the youngest age group, and show similar patterns of a flattening out at around age 35, so that anyone 35 or older still engages in that activity at about 18 percent and 25 percent, respectively.

Despite much of the popular belief that multitasking and simultaneous media use occur primarily among younger people, the figure suggests that between 70 and 80 percent of viewing instances involve some form of multitasking or simultaneous media use, even for the oldest age group studied (55 and older). That is, we see a slight difference for younger people (which was present even in the historical radio and television literature), but all age groups are within about 10 percent of one another in terms of multitasking or simultaneous media use instances. The activities differ for different age groups. This appears to indicate that some of the differences observed in the literature depend to some extent on how multitasking or simultaneous media

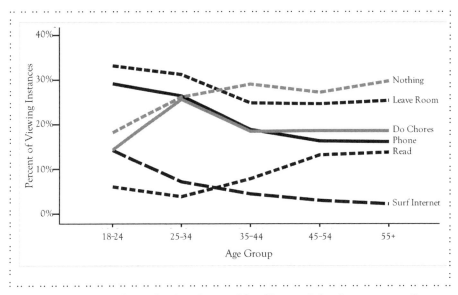

Figure 1. Diary data (CTAM) related to multitasking and simultaneous media use.

use is conceptualized and measured. If MP3 players, television, and certain types of chores are asked about, a different picture would emerge than would be obtained through open-ended responses.

Conclusion

Our historical review suggests that media multitasking and simultaneous media use have been important parts of the audience experience at least since radio entered the home. The streaming nature of the content of radio and network television resulted in what media researchers of the day called inertia, the tendency to stay on a channel or station for a fairly lengthy period. Skilled audience members found ways to monitor that content while using other media or performing other tasks. Eventually, radio, and later television, began to be part of the social environment of the home—a relatively innocuous, constant background to daily life. Within the context of the first eight decades of the twentieth century, it was clear that to engage in multiple activities simultaneously meant that an audience member had to allocate and withdraw attention as necessary to accommodate the content being consumed, while also continuing to monitor the medium or activity that was not primary at the moment. In other words, an audience member can read a book and listen to the radio at the same time. If the radio content is music, it can be monitored with fairly low effort, and attention can be allocated to the music during a soft or exciting passage, as necessary, and reading can be resumed when the audience member does not need to pay that much

attention. If the radio content involves talking, though, both radio and reading involve decoding language, and so monitoring the radio content will be more difficult. A number of the historical studies suggest that audience members, especially college students, understood that inherently. Similarly, listening to music and listening to a talk show would create more difficulties because both involve an audio component.

Given these suggestions from the literature, it should not be surprising that new media, new communication devices, and outgrowths of old media are leading to different configurations for multitasking and simultaneous media use. Recent data do not suggest a tremendous increase in the occurrence of multitasking or simultaneous media use, however. If anything, the increasing complexity in television technologies may have led to two different uses for television: the older, streaming experience, which was highly compatible with multitasking; and the newer, more interactive experience, which tends to discourage multitasking.

Multitasking and simultaneous media use make it difficult to conceive of time as a fixed quantity, as is often done in communication research. This suggests to us a need for audience researchers to refocus communication concepts on attentional processes that are very difficult to measure, such as attention switching and background monitoring, rather than global concepts such as the amount of attention, which have characterized too much communication research in the past. If anything, multitasking and simultaneous media use indicate some extent of the complexity of audience behavior. It is not surprising to us that these phenomena are beginning to get increased research attention. What is surprising is that, after eight decades, we know so little about these processes.

Acknowledgment

Some of the data reported in this chapter were supplied by the Cable and Telecommunications Association for Marketing (CTAM). The authors thank CTAM for the data and take full responsibility for any errors in interpretation or the analyses of these data.

References

Alfred Politz Research, Inc. (1953). *The importance of radio in television areas today.* New York: Henry I. Christal.

Baron, N. (2008). Adjusting the volume: Technology and multitasking in discourse control. In J. E. Katz (Ed.), *Handbook for Mobile Communication Studies* (pp. 344–381). Cambridge, MA: MIT Press.

Bogart, L. (1956). *The age of television.* New York: Frederick Ungar.

BurstMedia. (2006). *Divided attention: Teens multi-task when online.* Retrieved July 14, 2008, from http://www.burstmedia.com/assets/newsletter/items/2006_05_01.pdf.

Campbell, A., & Metzner, C. A. (1950). *Public use of the library and other sources of information.* Ann Arbor: University of Michigan Institute for Social Research.

Cantril, H., & Allport, G. W. (1935). *The psychology of radio.* New York: Harper & Brothers.

Chapman, A. L. (1950). *College-level students and radio listening.* Austin: University of Texas Press.

Foehr, U. G. (2005). *The teen media juggling act: The implications of media multitasking among American youth.* Kaiser Family Foundation. Retrieved November 7, 2008, from http://www.kff.org/entmedia/entmedia121206pkg.cfm.

Goldberg, M. A. (1949). *Politics and television.* Unpublished master's thesis, Columbia University, New York.

Graham, R., & Kingsley, S. W. (2005). *"Media multi-tasking": Changing the amount and nature of young people's media use.* Kaiser Family Foundation. Retrieved November 7, 2008, from http://www.kff.org/entmedia/entmedia030905nr.cfm.

Harris Interactive. (2003). A brave new media world. In K. Bagnaschi and J. Geraci (Eds.), *Trends & Tudes, 2*(10). Retrieved July 12, 2008, from http://www.harrisinteractive.com/news/newsletters/k12news/HI_TrendsTudes_2003_v02_i10.pdf.

Jeong, S. H., Zhang, W., Davis, E., Fishbein, M., Jordan, A., Hennessy, M., et al. (2005, May). *Multitasking and multiple media use among youth.* Paper presented at the annual International Communication Association Conference, New York.

Jordan, A., Fishbein, M., Zhang, W., Jeong, S., Hennessy, M., Martin, S., et al. (2005, May). *Multiple media use and multitasking with media among high school and college students.* Paper presented at the annual International Communication Association Conference, New York.

McPhee, W. N. (1956). Broadcast evolution: From radio to radio. *Broadcasting-Telecasting,* 78–80.

Media Center at the American Press Institute. (2004). *Simultaneous media usage survey.* Reston, VA: The Media Center. Retrieved July 1, 2008, from http://www.mediacenter.org/mediamorphosis/bigresearch/.

Medrich, E. A. (1979). Constant television: A background to daily life. *Journal of Communication, 29*(3), 171–176.

Papper, R. A., Holmes, M. E., & Popovich, M. N. (2004). Middletown media studies: Media multitasking...and how much people really use the media. *The International Digital Media and Arts Association Journal, 1*(1), 5–50.

Ripley, J. M. (1955). *Levels of attention of women listeners to daytime and evening television programs in Columbus, Ohio.* Columbus: Ohio State University Department of Speech.

Roberts, D. F., Foehr, U., Rideout, V., & Brodie, M. (1999). *Kids and media @ the new Millennium.* Kaiser Family Foundation. Retrieved November 7, 2008, from http://www.kff.org/entmedia/1535-index.cfm.

Sorokin, P. A., & Berger, C. Q. (1939). *Time-budgets of human behavior.* Cambridge, MA: Harvard University Press.

Stewart, R. F. (1952). *The social impact of television on Atlanta households.* Atlanta, GA: Emory University Division of Journalism.

University of Oklahoma. (1950). *When TV moves in: Report of a series of studies of changes in living habits in homes when television sets are purchased.* Norman: Oklahoma University Broadcasting Studies, nos. 41, 42, 45, 46, 54, 55.

Yahoo, & Carat Interactive. (2003). *Born to be wired: The role of new media for a digital generation.* Retrieved July 12, 2008, from http://us.yimg.com/i/adv/btbw_execsum.pdf.

CHAPTER 10

Rethinking Access

Why Technology Isn't the Only Answer

▶ DOMINIKA BEDNARSKA

An Inadvertent Story of Progress

In the past few decades, technology and computer networks have radically altered the ways in which people communicate and interact in regard to both work and leisure, and people with disabilities are no different in this respect. It seems impossible to discuss the impact of computers and technology on people with disabilities without reverting to a narrative of progress. In a study on the advantages of and barriers to computer use for the visually impaired, Elaine Gerber (2003) highlights the tremendous advantages that the Internet has provided for workers with visual impairments. Respondents cited geographical flexibility, proofreading assistance, and independence from needing the aid of sighted people in general as key factors that allowed them to improve and maintain their job efficiency and work performance. Major benefits of assistive technology are the ability for individuals to read for themselves and also store and read back their own writing. Her findings were consistent with earlier findings in a Harris poll that people with disabilities

are more likely to use computers to connect with other people than people without disabilities (Taylor, 2000). Another major benefit of technology was increased access to information during leisure time as well as the ability to form additional social networks through online communities.

Similarly, we can look at the role of Internet and cell phone technologies in the deaf community and see multiple ways that these technologies improve quality of life. They allow deaf people to communicate more easily and independently with hearing people through e-mail, instant messaging, and text messaging (Harkins & Bakke, 2003). Also, video communication technologies are being used for sign language communication. News media coverage demonstrates that the needs of deaf customers are now becoming a market for telecommunications services such as GoAmerica and T-Mobile. In China, the needs of deaf customers are being used as a justification for the Consumer Foundation's demand that telecommunications services cut their rates ("CF Wants," 2007). The Cleveland police in England are introducing services for the deaf, hard of hearing, and speech impaired that allow deaf users to text the report of a crime or ask for assistance ("Text Messaging," 2008). Along the same wavelength, a taxi company in Middlesborough, England, began providing services for deaf people to book a taxi through texting (McKenzie, 2007). The deaf community has been able to have its needs for teletypewriters (TTY) supplemented, if not entirely supplanted in some cases, by these technologies (Circelli, 2002; Harkins & Bakke, 2003). Research In Motion (RIM) executive Robert Crow boasts that "if we give thought to the broadest possibility of uses for our devices, it works for the deaf community just like it works for everyone else" (Carson, 2006, p. 6).

In contrast, within the blind community assistive technology requires attention to the needs of visually impaired users that are not shared by their sighted counterparts. Training materials are often not available in Braille or in readily accessible electronic formats, and gaining access to computer programs often requires navigating Web sites that were designed with the perceptual abilities of sighted people in mind. The law has yet to catch up with this issue, and companies providing assistive technology are not required to provide additional training or documentation in accessible formats. Some blind users turn for assistance not to vendors but, rather, to other blind people who have already learned the technology (Gerber, 2003).

Though the cost of private training often prohibits many visually impaired people from taking advantage of all that the Internet and assistive technologies have to offer, this is not to suggest that barriers do not exist for deaf people trying to access these technologies. For instance, individuals must use a teletypewriter phone to access 911, and only a few carriers have begun to offer relay services and text-only plans. Overall, the general consensus seems to echo the praise that Short Message Service (SMS) and text tech-

nology are "an answer to deaf people's prayers" (Power & Power, 2004, p. 334).

Of course, the benefits that these technologies provide cannot be enjoyed as easily by those without a cell phone or Internet access. There seems to be a clear correlation between employment and access to this technology and, according to the National Telecommunications and Information Administration (NTIA), people with limited sight or hearing are employed at more significant rates than people with other disabilities (NTIA, 2002). Further evidence suggesting that not all people with disabilities benefit equally from technological advancements can be found in a study by Corrine Kirchner and associates (1988) that notes that gender, ethnicity, and multiple impairments all seem to play a role in the employability of the visually impaired. Several studies also show that multiple impairments significantly decrease an individual's access and ability to use the Internet and computer technology (Gerber, 2003; Gerber & Kirchner, 2001).

The expansion of Internet technology has led to an expansion of congressional efforts to increase their accessibility. In the U.S., closed captioning for the deaf and hearing impaired on television programs is a federal mandate. The Federal Communications Commission (FCC) ruled in 2007 that Internet phone services must be compatible with hearing aids and relay services, as are services provided by traditional phone companies (Hart, 2008). Five years ago, they also ruled that video description be offered for people with visual impairments by video operators, but that ruling was overturned. Neither the Americans with Disabilities Act (ADA) Restoration Act (ADA Amendment Act, 2008), passed by the House of Representatives, nor the latest draft of the ADA regulations proposed by the Department of Justice (American Foundation for the Blind, 2008) address Internet accessibility. The Twenty-first Century Communication and Video Accessibility Act (2008), proposed by Representative Edward J. Markey, would require captions on everything from digital audio (MP3) players to cell phones. It would also require that the devices provide video description and that the on-screen menus be usable by people with visual impairments (Hart, 2008). Whether or not the bill passes, it is clear that technology has altered the ways in which we think about accessibility and equal access.

The Limits of Technology, Technology as Limiting

A greater emphasis on technology can often overlook the drawbacks of technological reliance. Machines often fail to work properly or break down. A focus on these technologies as primary or exclusive means for solving accessibility issues also makes prior accommodations and accessibility modifications less available. A disabled writer, Sally French (1994), explains:

> A visually impaired person may, for example, be given a special piece of equipment like a computer. This may enable them to do the job but also has the effect of others assuming all the problems are now solved. The computer was very expensive so this person must now be equal and they must be normal. They must ask for nothing more. Technology is often used as a substitute for human help, although for many disabled people it is the quick and flexible assistance of colleagues which is the most useful. We are not supposed to query the benefits of such technology or suggest that, however much it cost, there are still difficulties for us at work. (p. 155)

Questioning the utility of technological solutions to access issues is not a popular viewpoint. The alternative to technology is help from other people, which French describes as preferable in some cases. She hypothesizes that the intrusion into other people's lives is one of the reasons that technology is so vehemently advocated. In describing electric signposts that were being installed in her university, presumably to aid other people with visual impairments as well as herself, she says:

> These signposts might satisfy the creative talents of their inventors, they certainly don't satisfy my needs. What I need, of course, are pavements and corridors which are free of obstacles, and people with the time and patience to show me around (and do so more than once). (French, 1994, p. 156)

At the University of California at Berkeley, my own university, the disabled students program decided that it would no longer provide any funds for researchers or typists because of voice recognition technology and the accessibility of some materials on the Internet. Although funding for these services is still available, staff members at the disabled students program discourage students from applying for it, and students must prove that they cannot use technological solutions to meet their needs.

Probing the Issue of Cost: What Is Really Cheaper?

Part of the issue is the question of cost. Many people assume that assistive technology will be cheaper, if not more effective, than the solution of human assistance. However, the question of cost becomes difficult to address since people's needs vary so dramatically from individual to individual. For instance, a blind colleague of mine estimates that in order to effectively use assistive technology for work he spends approximately eight to ten thousand dollars a year for various software and computer upgrades. Additionally, government organizations oriented toward getting disabled people to work will pay for expensive technological solutions but will not fund human assistance. In states that provide funding for attendant care (and not all of them do), this money is designated for specific tasks of daily living, which do not include work-related tasks. One of the reasons technology can often be such an

expensive solution is that it leaves some needs unaddressed or, as we will see in the example of the accessible currency lawsuit, addresses them poorly or impractically (*American Council of the Blind*, 2008). Providing support for such assistance could be seen as an opportunity for economic growth, rather than economic expenditure, especially when we consider the long-term social, cultural, and economic costs of excluding people with disabilities from traditional work environments. I do not, however, mean to suggest that people with disabilities do not make meaningful contributions both within and outside these structures, only that these contributions could only become stronger if more opportunities were available for them to become sustainably involved in paid work. If costs were considered in relation to these factors, perhaps accessibility could be addressed as the multifaceted problem that it is.

Technology Instead of Access

I raise these points not to deny the tremendously useful impact that various technologies have had for some people but only to further amplify the point that these technologies do not universally serve everyone's needs. Their availability further influences, either through direct regulation or through the perception that technological solutions erase impairment, the availability of other forms of assistance, especially the assistance of other people. One salient example is the lawsuit by the American Council of the Blind (ACB) that sought to make currency more accessible to the blind and those with low vision. The ACB sued the U.S. Department of Treasury in 2007, and in 2008 the department was found to be in violation of the Rehabilitation Act of 1973, which prohibits discrimination on the basis of disability in federal programs. One of the major counterarguments to the ACB's claim was that currency-reading devices are available for the blind. These devices work by announcing denomination when currency is inserted one bill at a time. The ACB refuted this solution based on the cost (several hundred dollars out of pocket), ineffectiveness, and general impracticality of such readers: the readers don't work with worn, dirty, or crinkled money; it is time consuming to check one bill at a time; the devices may become less effective with new currency upgrades; and, as is the general concern with all technology, the machines can break down (Al-Mohamed, 2006). The ACB also raises the concern that these readers force blind people to openly identify their monetary values in public, which makes them more vulnerable to robbery, especially in urban settings.

The ACB claims that the U.S. Treasury is using this device as a substitute for accessible currency rather than as a means of achieving greater accessibility (Al-Mohamed, 2006). This distinction is critical in that the

existence of assistive technology can also be used as a rationale to justify not making additional access modifications or to justify not having assistance provided by other people. The assumption that all accessibility issues can best be solved with expensive gadgets is one that needs to be challenged more vehemently in the culture at large.

Taking Longer, Time as an Access Issue

Treating technology as an all-purpose access equalizer also ignores the issue of time. In Gerber's (2003) study on visual impairment, she mentions briefly in her conclusion that using technology can become increasingly time consuming and frustrating for people with visual impairments. Perhaps this issue is downplayed because the goal of her study is to improve the access and availability of technology to people with visual impairments, and the perception that technology is too time consuming to be useful to them would detract from the overall goal. Or perhaps the understanding that, even with technological solutions, the time it takes for people with disabilities, visually impaired or otherwise, to complete certain tasks remains longer than for people without disabilities is so commonplace and commonsensical that it only requires a peripheral mention to the audience she is addressing. French (1994) also discusses time as a major issue in workplace accommodation:

> A blind colleague who has all the special equipment on offer told me that he works 60 hours a week in order to hold down his job. Imagine the outcry if any other group of people worked almost twice as long as their colleagues for no extra reward!...I have never calculated the exact hours that I work, perhaps if I did I would have to acknowledge how little time there is left for me beyond my employment. (p. 158)

Disabled people's frequently slower pace begs a consideration of disability and temporality. What altered relationship to time do the variety of disabilities and disabled bodies have?

Moreover, how is this relationship complicated by the increasing speed and time compression of life in industrialized societies? This issue becomes further exacerbated when we consider the impact that stress and the lack of time to sleep, eat, or exercise have on many people's physical health and its potential to cause physical disability or illness. Idis Sabelis (2007), an organizational anthropologist, found that among the social science faculty at the Vrije Universiteit in Amsterdam more than 55 percent reported that they were too tired after a day of work to do the things they wanted, and 60 percent reported suffering from health problems they attributed to an increased workload as a result of a greater reliance on the Internet and e-mail for scheduling and communication. The relationship between time pressure and the

development of disability suggests that the impact of work can further diminish leisure time through its toll on the mind and body.

For Karl Marx (1887), leisure time is a natural gift that is robbed from workers because of the need for surplus labor; laborers are prevented from using leisure time for their own productive use. But this presupposes that any time spent not laboring becomes leisure time. More than a century later, Ben Agger (2007) describes the way in which not only work time but leisure time become increasingly structured with capitalist and consumerist concerns. The administration of time, all types of time, leads to what he describes as time robbery. In his critique of the capitalistic administration of time, time effectively takes the role of individual property that can, therefore, be stolen. According to Agger, time robbery also breeds time rebels who can live off the clock by disabling their electronic devices and throwing away their planners. Furthermore, time robbery is critiqued on the basis that it fails to afford individuals their ability to function productively. While Agger's critique of the negative effects of time robbery is compelling, what time rebels are fighting against is framed in terms that still hold out for an a priori notion of a productive able body and a normative relationship between time, productivity, and bodily function. In other words, it is true that people need downtime, rest, and sleep to be effective, and that these factors often do increase productivity. But the fact that productivity remains the goal, even of these rebellious acts, further marginalizes certain people with disabilities who, even prior to these technological advancements, are viewed as unable to be productive. Until the focus is shifted from productivity as a measure of effective time management or time rebellion, we will never move away from the notion that people's bodies should function, produce, and contribute according to certain ideals. Illness and other impairments often cause much time to be absorbed in rest, pain, weakness, and recovery, although this is obviously not true for all people dealing with illness and disability.

Crip Time as Queer Time

It is useful to consider the ways in which experiences of disability and illness can construct an alternate sense of temporality. A concept that is particularly useful is one articulated by Judith Halberstam (2005) in *In a Queer Time & Place* where she defines queer time as "a term for those specific models of temporality that emerge within postmodernism once one leaves the temporal frames of bourgeoisie reproduction and family, longevity, risk/safety, and inheritance" (p. 6). For different reasons all of these issues have particular resonance in relation to experiences of a disability temporality as well as a queer temporality, because people with disabilities' access to these various registers of normative temporality is often compromised or altered.

For instance, an Australian study found that the lifespan of people with disabilities was often much shorter than that of those without (Australian Institute, 2006). When we consider the lack of access to healthcare among people with disabilities in the U.S., it is likely that this would be the case in the U.S. as well (Dhont, Beatty, & Neri, 2000; "Global Health," 2008; Lishner, Richardson, Levine, & Patrick, 2008; Neri & Kroll, 2003). To echo Cathy Cohen's (1999) ideas in *The Boundaries of Blackness: AIDS and the Breakdown of Black Politics,* (upon which Halberstam also draws), ill and otherwise marginalized bodies are treated as expendable.

People with disabilities face many obstacles as well, such as regulations that prevent those who receive government benefits from marrying without losing their benefits if they marry someone with another source of income (Public Health and Welfare Act, 2006). Also, laws in some states prevent state-funded attendants from providing childcare. In Michigan, state officials threatened to take away a child from disabled parents while at the same time the parents, who were unable to afford childcare, could not utilize their state-funded attendants for this purpose without breaking the law (Shapiro, 1993).

This case is but one example of how people with disabilities are often forced to weigh risk versus safety. Individuals often weigh the risk of certain activities or the degree to which they consume time and energy—which is often in a more limited supply for people with disabilities than for those without—against the risk of a particular activity they want to participate in during the temporal present. The disabled body often has an uncertain economic future: the gap between employment among people with disabilities and people without continues to widen in the U.S. (Center for an Accessible Society, 2007) despite the passing of the ADA and the Vocational Rehabilitation Act of 1973, both of which prohibit employment discrimination based on disability. Also, disability benefits, including state health insurance, have legal limits that prohibit people with disabilities from accumulating substantial savings that could be used as future generations' inheritance or investment for the future.

People with disabilities must consider the impact of their present actions on their future bodies in a way that nondisabled people often do not. For example, people with energy limitations must often choose between doing an activity in the present or being productive the next day. Thinking about accessibility often requires advance planning with regard to accessible transportation, the accessibility of the venue itself, the availability of accessible restrooms, and what accessibility means to people with different types or degrees of impairments varies considerably. Simultaneously, the disabled body exists as one that lives, as Halberstam (2005) puts it, "outside the logic

of capitalist accumulation" but also as a body that must consider the future and therefore often compromise spontaneity (p. 10).

In addition, it is a body that often creates discomfort for others as a result of its associations with an imagined future, the consequences of aging, and the lack of security that such a future potentially holds for anyone. Disability historian Paul Longmore (1997) articulates the apprehension that disability provokes in relation to American identity:

> People with disabilities provoke anxiety and revulsion because they are defined as literally embodying that which Americans individually and collectively fear most: limitation and dependency, failure and incapacity, loss of control, loss of autonomy, at its deepest level, finitude, confinement within the human condition, subjection to fate. (p. 154)

In some cases, disability is seen as a worse fate than death itself. In a recent national survey commissioned by Disaboom, an online community for people dealing with disability, 52 percent of the respondents reported that they would rather die than live with a permanent disability ("Disaboom Survey," 2008). These findings demonstrate the severity of public misperception about living life with a disability. Moreover, despite the increasing availability of assistive technology and the Internet, there is still a prevailing view that life with a disability is inferior and expendable.

Conclusion

Technology has provided entirely different modes of functioning for people with disabilities that have completely changed how we work, socialize, and interact with the world at large. These advancements have occurred as a result of our own advocacy, increased legal awareness about and protection of accessibility, as well as the degree to which we are able to take advantage of innovations that were made without us in mind at all. But the increased movement toward technological solutions to accessibility issues has the potential to make other modes of assistance increasingly more difficult to access. Time constraints, increased expectations of productivity, and the ways in which disability increases the amount of time required to complete various tasks cannot be fixed. These issues are often exacerbated by a sole reliance on technological advancements to solve issues of access and accommodation, as in the examples of electric signposts and currency readers discussed earlier. Taken together, these different problems point to the ways in which accommodating disability poses fundamental challenges to current ideologies of work and notions of what it means to use time and life productively.

Acknowledgment

I acknowledge the invaluable assistance of Pratik Patel in the writing of this chapter.

References

Agger, B. (2007). Time robbers, time rebels: Limits to fast capital. In R. Hassan & R. Purser (Eds.), *24/7: Time and temporality in the network society* (pp. 219–234). Stanford, CA: Stanford University Press.

Al-Mohamed, D. (2006). *Accessible currency myth vs. fact*. Washington Connection Legislative Update. Retrieved September 16, 2008, from http://www.acb.org/washington/wc070105.html.

American Council of the Blind (ACB). (2008, May 20). ACB Press Release. Washington, DC: American Council of the Blind.

American Council of the Blind et al. v. Henry M. Paulson Jr., Secretary of the Treasury, No. 07–5063. (2008). Retrieved September 16, 2008, from http://www.acb.org/resources/currency-decision-may2008.doc.

American Foundation for the Blind. (2008). *Justice department proposes sweeping revisions to ADA regulations*. Retrieved March 3, 2009, from http://www.afb.org/Section.asp?SectionID=3&TopicID=32&SubTopicID=123&DocumentID=4202.

Americans with Disabilities Act Amendment Act of 2008, H.R. 3195, 110th Congress. (2008). Retrieved September 4, 2008, from http://www.thomas.gov/cgi-bin/query/z?c110:H.R.3195.

Australian Institute of Health and Welfare (AIHW). (2006). *Life expectancy and disability in Australia 1988 to 2003. Disability Series*. Cat. no. DIS 47. Canberra: AIHW.

Carson, P. (2006, November 13). Wireless messaging critical for deaf community: Devices figured in recent, successful student protests. *RCR Wireless News*, p. 6.

Center for an Accessible Society. (2007). *Employment gap between working-age people with and without disabilities continues*. Retrieved September 4, 2008, from http://www.accessiblesociety.org/topics/economics-employment/empgap1107.html.

CF wants telecom firms to cut text messaging rates. (2007, April 25). *China Post*. Retrieved February 26, 2009, from https://www.lexisnexis.com/us/lnacademic/results/docview/docview.do?docLinkInd=true&risb=21_T5894204042&format=GNBFI&sort=RELEVANCE&startDocNo=1&resultsUrlKey=29_T5894204049&cisb=22_T58942044047&treeMax=true&treeWidth=0&csi=227171&docNo=2.

Circelli, D. (2002, December 1). An easier way to communicate: Text messaging with cellphones and pagers has become a boon. *Palm Beach Post*, p. 1F.

Cohen, C. J. (1999). *The boundaries of blackness: AIDS and the breakdown of black politics*. Chicago: University of Chicago Press.

Dhont, K. R., Beatty, P. W., & Neri, M. T. (2000). *Access to health care services among people with disabilities in managed care and traditional fee-for-service health plans*. Abstracts of the Academy of Health Services Research and Health Policy Meeting 2000, 17. Retrieved November 7, 2008, from http://gateway.nlm.nih.gov/MeetingAbstracts/ma?f=102272510.html.

Disaboom survey reveals 52 percent of Americans would rather be dead than disabled. (2008). Retrieved September 4, 2008, from http://www.prweb.com/printer.php?prid=1082094.

French, S. (1994). Equal opportunities...yes, please. In L. Keith (Ed.), *Mustn't grumble: Writing by disabled women* (pp. 154–160). London: Women's Press.

Gerber, E. (2003). The benefits of and barriers to computer use for individuals who are visually impaired. *Journal of Visual Impairment & Blindness,* 97(9), 536–550.

Gerber, E., & Kirchner, C. (2001). Who's surfing? Internet access and computer use by visually impaired youths and adults. *Journal of Visual Impairment & Blindness,* 95, 176–181.

Global health: Addressing the world's health challenges. (2008). Retrieved September 15, 2008, from http://science.america.gov/science/health/disease.html.

Halberstam, J. (2005). *In a queer time & place: Transgender bodies, subcultural lives.* New York: New York University Press.

Harkins, J., & Bakke, M. (2003). Technologies for communication: Status and trends. In M. Marschark & P. E. Spencer (Eds.), *Oxford handbook of deaf studies, language and education* (pp. 406–419). New York: Oxford University Press.

Hart, K. (2008, June 19). Access denied: The blind or deaf can feel left behind as the tools of technology advance. *Washington Post,* p. D1.

Kirchner, C., & Associates. (1988). *Data on blindness and visual impairment in the United States* (2nd ed.). New York: American Foundation for the Blind.

Lishner, D., Richardson, M., Levine, P., & Patrick, D. (2008). Access to primary health care among persons with disabilities in rural areas: A summary of the literature. *The Journal of Rural Health,* 12(1), 45–53.

Longmore, P. K. (1997). Conspicuous contribution and American cultural dilemmas: Telethon rituals of cleansing and renewal. In D. Mitchell & S. Snyder (Eds.), *The body and physical difference: Discourses of disability* (pp. 134–160). Ann Arbor: University of Michigan Press.

Marx, K. (1887). *Capital, volume one: The process of production of capital.* London: Penguin.

McKenzie, S. (2007, September 7). Taxis by text: Special mobile service gets deaf passengers on the move. *Evening Gazette,* p. 10.

National Telecommunications and Information Administration (NTIA). (2002). Chapter 7: Computer and Internet use among people with disabilities. *A nation online: How Americans are expanding their use of the Internet.* Retrieved September 4, 2008, from http://www.ntia.doc.gov/ntiahome/dn/html/chapter7.htm.

Neri, M., & Kroll, T. (2003). Understanding the consequences of access barriers to health care: Experiences of adults with disabilities. *Disability and Rehabilitation,* 25(2), 85–96.

Power, M., & Power, D. (2004). Everyone here speaks TXT: Deaf people using SMS in Australia and the rest of the world. *The Journal of Deaf Studies and Deaf Education,* 9, 333–343.

Public Health and Welfare Act. (2006). 42 U.S.C. §1382c (f)(1).

Sabelis, I. (2007). The clock-time paradox: Time regimes in the network society. In R. Hassan & R. Purser (Eds.), *24/7: Time and temporality in the network society* (pp. 255–278). Stanford, CA: Stanford University Press.

Shapiro, J. (1993). *No pity.* New York: Three Rivers Press.

Taylor, H. (2000). How the Internet is improving the lives of Americans with disabilities. *The Harris Poll, 34*. Los Angeles: Creators Syndicate.

Text messaging service for deaf community introduced by Cleveland police. (2008). *Telecomworldwire*. Retrieved October 6, 2008, from http://findarticles.com/p/articles/mi-m0ecz/is-2008-may-2/ai-n25386454.

Twenty-first Century Communication and Video Accessibility Act of 2008, H.R. 6320, 110th Cong. (2008). Retrieved September 4, 2008, from http://thomas.loc.gov/cgi-bin/bdquery/z?d110:h.r.06320.

PART

3

Speed
Multitask
Displace

CHAPTER 11

E-tymology of Inefficiency

How the Business World Colonized Academe

▶ MICHAEL BUGEJA

At the start of my academic career at my first convocation, in 1979, an administrator advised the professoriate that we should embrace the business world because it was more efficient than the academic one. The business world got rid of "dead wood" through performance reviews, whereas the academic world petrified that wood through tenure. Parents paid tuition because they believed that a college degree guaranteed their children a better job and a brighter future. We should make that our priority. We should engage students the way that managers engage clientele, requesting regular feedback so that we could improve our classroom performance. Professors should treat students as "customers" who paid our salaries and funded our facilities, he said. I remember thinking, "If students were customers, did that make us sales managers?" In a way, it did. We were selling the future the way that brokers sold commodities.

Why would any university introduce into education a model designed for short-term profit rather than for lifelong learning? Of course, I understood

why my first academic administrator had been promoting business. He assumed that corporate executives respected their customers, believing they were "always right," but that didn't make sense, either. Students were wrong as often as right, which was why we tested them. A recent article, aptly titled "Learning to Leisure? Failure, Flame, Blame, Shame, Homophobia, and Other Everyday Practices in Online Education," supports that view:

> The knowledge of teachers and that of students are not equivalent. Teachers know more. They write and read expansively. They write and interpret curriculum. They set assignments. They moderate and examine. They study, think and translate complex ideas into the stepping stones of lesson plans. Students can perform none of these tasks. (Eve & Brabazon, 2008, p. 53)

Such insight was practically nonexistent in 1979, which was not an especially productive year for U.S. business. Annual inflation was 11.22 percent. First-year students would see inflation rise 41 percent by the time they became seniors. Also, we were in the midst of an oil shortage with long lines at the pump. Nevertheless, Jimmy Carter had begun his 1979 State of the Union speech by praising business: "Real per capita income and real business profits have risen substantially in the last two years." Carter's answer to inflation and recession sounded eerily similar to that of George W. Bush in his 2008 State of the Union address: "America has the greatest economic system in the world. Let's reduce government interference and give it a chance to work."

Carter's speech that year totaled 3,258 words. Halfway through it, he had used the word "effective" five times. He probably avoided the word "efficient" because, at the time, "fuel efficiency" was on everyone's lips in America but not in everyone's garage. This was the age of the land cruiser—the Lincoln Continental, the Chevy Impala, the Cadillac Eldorado, the Chrysler New Yorker, and the Olds Ninety-Eight. Nonetheless, the government passed a "Gas Guzzler Tax," adding $7,700 to the sticker price of a passenger car averaging less than 12.5 miles per gallon. Americans who wanted fuel-efficient cars in the 1970s bought what were arguably some of the worst automobiles ever built in this country, yet another triumph for U.S. business: the Ford Pinto, the Chevy Vega, and the AMC Gremlin. In 1979, Americans discovered Honda, Toyota, and Datsun. Despite this, we were supposed to treat students like "customers."

Looking back, what is so striking about 1979 is how the issues then are so like our own three decades later, with some noteworthy differences. Even though fuel costs were responsible for inflation in 1979 as they are today, politicians claim that the current annual inflation rate is significantly lower than it was back then—about 4 percent. We really cannot compare inflation then and now because of "hedonic pricing," which breaks down the various

components of a product or service that influence its market value. Such pricing works when assessing the value of a house, from its lot size and construction features to its neighborhood and area schools; but it is less reliable when a product or service keeps evolving, such as technology. A house bought 10 years ago is comparable with new houses on the market; but a computer purchased today cannot be compared to one bought a decade earlier, and it is upon this that problems arise when hedonic pricing adjusts for inflation in the technology sector. The Federal Reserve under Chairman Alan Greenspan used hedonic pricing based on "Moore's Law," the idea that microprocessor speed presumably doubles every two years. Shouldn't it follow, then, Greenspan argued, if consumers pay about the same price for better processors, the increase in computing power represents a decrease in tech-sector inflation? This logic has allowed the Bureau of Labor Statistics to report inflation "at about 0.8 percent to 1 percent less than it otherwise would have been in every year since 1995," writes investment banker Martin Hutchinson (2008). Like education, the government acknowledges only the upside of the technology sector based on Moore's Law rather than Murphy's (if something can go wrong, it will). An article in *Communication Education* tells of a professor who begins every course by saying, "I guarantee computing will fail us, and anyone who uses computers understands that will happen" (Shedletsky & Aitken, 2001, p. 207). In 1979, we could substitute "cars" for "computing" with the same understanding. Ironically, it was Apple CEO Steve Jobs who noted once that his company's market share was greater than that of luxury cars in the automotive market, stating, "What's wrong with being BMW or Mercedes?" (Snell, 2004). *What's wrong?* I'll tell you: the inflated price tag, frequent unreliability, and infuriating inefficiency—the same problems we associate now with technology and the U.S. economy. Hutchinson makes this point, recounting the negative hedonic effects of computing that are responsible for the so-called tech boom of the late 1990s and the apparent one today—"even though neither really seemed to make consumers any richer" (2008).

Indeed, technology booms typically have made college students and their parents poorer. Hedonic pricing hasn't applied to higher education, even though academe has invested heavily in technology since 1995, funding proliferation with easy student loans, higher tuition, and all manner of technology-related fees. Tuition increases on average are twice the purported rate of inflation, or about 8 percent annually ("Tuition Inflation," 2008). The rise in college costs today rivals the 41 percent inflation rate over four typical college years in the 1970s. Now, as then, the U.S. is dealing with an oil crisis and the land cruiser in the form of the sport utility vehicle (SUV), with one of the top models even bearing that name: Toyota's Land Cruiser. According to *Consumer Reports*, eight of the nine best fuel-efficient SUVs

of 2008 (averaging 21–24 miles per gallon overall) were Japanese, whereas five of the eight worst SUVs (averaging 13 miles per gallon) were made by U.S. manufacturers: Dodge Durango Limited, Ford Expedition Eddie Bauer, Cadillac Escalade, Jeep Commander Limited, and Lincoln Navigator Ultimate ("Best and Worst," 2008). This was yet another benchmark of U.S. business in the twenty-first century. Even as Detroit-based carmakers reported record losses, with plant closings and layoffs, CEO salaries continued to skyrocket. Ford Motors, which lost $2.7 billion in 2007—an improvement from $12.6 billion the previous year—paid its top five executives more than $35 million in salaries and perks, with CEO Alan Mulally netting $21.6 million ("Ford's Top Bosses," 2008). With the U.S. economy in crisis, Bush, like Carter before him, was optimistic about business in his 2008 State of the Union address. Although he did concede that the economy was slowing down, Bush noted that "Americans can be confident about our economic growth." In explaining how to resolve economic and other issues facing the country, Bush used the word "effective" three times. He also mentioned the need for "energy-*efficient* technology," the only time he used that word.

This chapter evaluates e-tymology, or the technical data associated with "efficiency," which is defined by *The American Heritage Science Dictionary* as "the ratio of the energy delivered (or work done) by a machine to the energy needed (or work required) in operating the machine" (Efficiency, n.d.). By that standard we can demonstrate the inefficiency of technology, which has, at long last, fulfilled my first administrator's wish: we now run entire academic institutions as if they were businesses.

Nobody really knows what business model is effective anymore after scandals of the caliber of Enron, subprime, and student loan, and (at this writing) $120-barrel oil with speculation that prices will soar again beyond the record-breaking rates of 2008. In the past, those working in academia were reluctant to admit that we were attempting to run our institutions like businesses; but now that has changed, as we often refer to business models—not to tout efficiency or service but to justify inflated costs. Business has indoctrinated us well. In a *Des Moines Register* article documenting a huge spike in student fees at Iowa universities, the headline only disclosed a snippet of the actual story: "Universities' Student Fees Jump 341% in a Decade" (Rossi, 2008). Justifying the price rise, University of Iowa spokesperson Steve Parrott observed that students "go where the colleges have the kind of services they want. It's a competitive business, and to a certain degree, you have to treat your students as customers."

This reflects exactly the inefficiency of running academic institutions as businesses. Parrott makes the assumption that students have a supply of cash for services, and to a degree, they did, thanks to the student loan scandal of 2007, which involved conflicts of interest in financial partnerships

and resulted in huge settlements by such providers as Sallie Mae (Baskin & Field, 2007). Parrott's statement mirrors the notion of charging more for services rather than serving customers because they come first. Factored into the 341 percent spike in fees is a figure of $226 in annual fees for Iowa State University, which "supports such services as specialized lab and instructional software, departmental computing facilities, student lab monitors, public computing labs, campus course management system, and classroom presentation systems" (Rossi, 2008). However, that $226 figure only represents what the university collects by way of mandated fees. Other fees are passed directly to the vendor, often a technology company whose business model is pegged to enrollments, requiring students to register a device or an application online, with the potential to datamine a user's name, address, and other demographic data.

The most pernicious of such deals at my university involved audience response systems, or clickers, probably the most inefficient and antiquated technology introduced recently into higher education. Prototypes for these systems were developed in Hollywood in the 1960s to rate unreleased movies and television shows. In tracking hidden fees I learned that my institution went from 0 to 14,000 clickers in the space of a few years because of a ploy by publishers to make textbooks (literally dead wood) more interactive for the multitasking student. For those unfamiliar with clickers, teachers solicit replies from students who text their answers on a remote control-like device that funnels data to a receiver hooked into the teacher's laptop containing proprietary software that in turn funnels results through presentation software such as PowerPoint into a liquid crystal display projector and onto a large screen. In the past, students just raised their hands.

The case of clickers shows how business earns profit from inefficiency. For starters, anyone who has ever tried to program a television remote control understands how inefficient this technology actually is. Customers keep purchasing "universal" remotes only to lose or forget various proprietary codes needed to enable the remote to communicate with the television, DVD player, satellite box, audio device, and other components manufactured by different companies. The result is incompatibility with one or more parts of the system. With clickers, however, the entire system fails when the receiver, laptop, software, or hardware is updated, rendering student handsets useless until someone divines a fix. If that isn't bad enough, publishers at first flooded higher education with grossly inefficient infrared clickers that required students to point with sharpshooter precision at one of several receivers in the auditorium. Each clicker only worked with a certain textbook so that students in the infrared days of 2004–2006 were lugging four or five different handsets at a time in their backpacks. In a few cases those clickers were touted as "free," even though their cost may have been factored into the text-

book price. One vendor at Iowa State University for a time not only required registration but also had access to student records through its product, requiring our legal department to craft a document making the company liable for any breach of the Family Educational Rights and Privacy Act. At a 2005 meeting to discuss these and other issues related to clickers, a facilitator was asked about a universal radio-frequency model that required students to pay a onetime $15 fee. He noted this was the business model of the company desiring "steady cash flow from enrollments" ("Computer Consulting," 2005).

Moreover, with this and other models, businesses selling clickers didn't have to advertise their handsets or train clients how to use them or maintain equipment when it failed. Teaching excellence centers gladly promoted the product in e-mail blasts, posters, and other venues, in addition to conducting workshops on how to use corporate products, while information technology personnel purchased and maintained the various hardware components needed to make the clicker system work, from installing multiple receivers to fixing glitches when component upgrades resulted in incompatibility. In the past, vendors had to cover these costs for installation, maintenance, service, and promotion.

Business never had it so good.

Of course, students used credit cards to pay clicker fees online, allowing the datamining of students' personal information and the selling of these data to third parties. In a confidential interview of a publishing house executive for a major company, conducted for an article in *The Chronicle of Higher Education* (Bugeja, 2008), I asked the executive to respond to allegations that "free" clickers were factored into the price of the textbook, with institutions providing free installation while companies assessed fees to students, datamined them, and then re-sold that information, "probably to credit card companies." While not acknowledging that his company actually did this, the executive replied, "This sounds about right."

In part because of credit cards, student debt at my institution exceeds $30,000 per graduate, on average. A recent national survey of 40 institutions, including Iowa State University, disclosed alarming data, some of it involving technology and credit card use (U.S. PIRG, 2008). More than half of undergraduate students, or 55 percent, used credit cards to pay for books and supplies. Almost one-fourth, 24 percent, used those cards to pay tuition. Students' use of credit cards today is reminiscent of how some of their parents relied on variable-rate or second and third mortgages, related to the subprime scandal, to maintain their lifestyle or to keep up with cost-of-living increases. Rampant overdependence on credit is part of the reason why the U.S. economy has faltered and why university presidents will have to lower rather than raise tuition in future years. Sooner or later the loan bubble will

E-tymology of Inefficiency 179

burst on students and parents when financial institutions are forced to say no to credit and require students and/or their cosigners to pay up.

As a journalism director, I am privy to what business executives expect from graduates and what they are willing to pay new hires in starting salaries. Recently we asked owners of midwestern communication agencies what they looked for in recent graduates and what recommendations, if any, they might have for us. An advertising agency owner wrote:

> I look for well-rounded and balanced knowledge about the various communications media. Teach people about digital communications vehicles, tools, uses, etc. (which may mean they need to hire different or new teachers for these courses since the older generation isn't knowledgeable about this yet!). Next, I look for kids with at least some live ammo experience. Expose kids to more real-world examples and experiences. Bring private industry speakers and lecturers into the classrooms. Take field trips to real businesses. Even create one- or two-week apprenticeship programs to get them into businesses. Encourage more use of internships for course credit. Lastly, I look for people that know how to learn. Teach kids more critical thinking skills and less rote memorization. Test for creative problem-solving not what was written verbatim in a marketing or public relations text book. Require communication students to take more math and science. That's what teaches people how to use creative thinking to solve problems. (Personal communication, April 2008)

Just as his counterparts were during the 1970s, this agency owner is out of touch with the realities of higher education. On the one hand, he demands technological training without understanding the cost of technology; on the other, he wants critical thinking and believes more experienced professors who can provide that should be replaced because they do not embrace new media. Ironically, computers standardized rote memorization because they can grade multiple choice exams. Clicker aficionados teaching those large classes must ask questions answerable on keypads. But there's more: this agency head requests that academic advisers remind students that "while advertising and communications is indeed a rewarding and challenging career, students shouldn't expect to be making $40K in their first job. I'm not sure how this phenomenon started, but kids these days have a warped sense of reality when they declare their salary expectations" (personal communication, April 2008).

Iowa State journalism and advertising majors graduating with a $30,000 debt will have to repay $500 per month over five years to satisfy their lenders. Those students have starting salaries of $20,000 to $28,000, with the high end providing a monthly income of $1,633 after federal, state, and social security taxes. Deduct from that $700 for apartment rent; another $150 for utilities; another $200 for cell phone, cable, Internet access, and other home communication technologies; and $400 for food and entertainment. That leaves $183 for fuel and clothing. The most that an advertising graduate can

hope to repay on such a loan is about $50 per month, just enough to cover the interest without subtracting anything from the principal. This is how many students deal with credit card debt, too, paying the minimum allowable monthly installment, ensuring that the debt accumulates for years.

In the end, it is not unreasonable for students with $30,000 of education loan debt to anticipate a starting salary of $40,000 a year. That would provide a reasonable lifestyle level, one comparable to the level that the agency owner probably enjoyed after paying much lower tuition and fees, on an inflation-adjusted basis, to his alma mater. Starting salaries have risen modestly in my industry, as opposed to the cost of a college degree. In Iowa, at our public universities, tuition rose 107 percent in the past decade, whereas prices for goods in the U.S. increased by 32 percent (Rossi, 2008). In journalism and communication, beginning salaries averaged $23,000 in 1997 (Colamosca, 1999) and have risen only 21.7 percent since then. Some journalism schools are candid about starting salaries, noting that newspaper reporters can anticipate annual salaries between $25,000 and $30,000, and advertising and public relations practitioners, $28,000 to $32,000. Broadcasters can anticipate $20,000 or less ("Majors and Careers," 2008).

In the past, journalists knew that their lifestyles would be modest because the industry relied on cheap labor from individuals with a "calling" to the profession. They had zeal. They would work weekends and holidays and even pay for their own mileage in tracking down sources or traveling to spot news. Now debt due to technology is killing zeal, with students worried about how to repay loans rather than how to ensure the public good. This is why I have been documenting the inefficiencies of consumer technologies used as learning platforms in higher education. In response, I have advocated for disengagement, abandoning corporate practices that pick the pockets of our students. For the record, I am not discussing the symptoms of psychological disengagement, associated with the drinking culture on many campuses. Donald W. Harward (2008), president emeritus of Bates College, notes that over 40 percent of Millennials—members of the cohort born between 1980 and 1994, also known as Generation Y—self report episodes of depression that disrupt their academic work, typically without faculty awareness of the crises that students endure. In part, faculty members' unawareness may stem from students' having decreased interpersonal access to professors, especially during advising, relying on interfaces of e-mail and Web-based course management systems like Web CT and Blackboard to provide lesson plans rather than life lessons, face-to-face. Moreover, the inefficiency and high cost of a technical education may have something to do with student stress. Another former college president, Richard H. Hersh (2007), who codirects the Collegiate Learning Assessment Project, writes about root causes of such stress, resulting in withdrawal rather than engagement at high-tech residen-

tial campuses. Hersh believes that students are immersed in what he calls "a national culture of neglect that has asked them more than ever before to rely on themselves and their peers for nurturing and wisdom" (p. 31). Students, he states, are informed more by one another and by media and technology than by "the wisdom of parents, teachers, and other caring, mentoring adults" (p. 31). He reminds us that cell phoning and e-mailing are less effective than face-to-face interaction when attempting to address student crises and concerns.

That point is also being emphasized nationwide, recently in Phi Beta Kappa's magazine, *The Key Reporter*. In an article titled "How Can Liberal Education Engage 'Things That Matter'?" educators worry that the emphasis on technology undermines the quest for wisdom and that overly technical education "fails to make knowledge meaningful" (McEnnerney, 2008, p. 7). In their 2008 study assessing shortcomings of technology—"Learning to Leisure?"—Juliet Eve and Tara Brabazon remind us that higher education is not about peer learning; it is about transformation, which technology cannot provide. They write, "We have gone too far in valuing the student 'experience' over scholarly responsibilities to knowledge" (p. 58).

Educators continue to mistakenly think that Millennials want to learn through the same platforms that distract and amuse them socially. These technologies are programmed for revenue consumption. Introduce them into the classroom, and students cease being learners inasmuch as they are addressed by teachers and technologies as "customers." We discovered this in my own journalism school, administering an exploratory survey on the use of technology in our wireless environs. We were curious about activities that we suspected were distracting rather than engaging our students. About 75 percent of the 218 students responding had taken or made a cell phone call during a lecture or checked, read, or sent e-mail during class time. We had anticipated that. Between 45 and 60 percent had instant messaged, checked social networking Web sites, and browsed the Internet, among other non-class-assigned activities. Again, we had anticipated that. For extra credit we slyly asked whether students were responding to the survey during class, with 25 percent stating yes! Alas, we also had anticipated that. What captured our attention, though, was another activity that had been occurring in classes: some 18 percent had made purchases online during lecture, using credit cards.

The introduction of credit cards doubling as student identification cards is another lamentable outcome of inviting the business world into the academy. Companies routinely take advantage of students' on-demand impulses. Before 1996, it was difficult to sell students anything. First, businesses never knew where students were from one moment to another. Sure, students listed their residence in a hall or off-campus housing, but they were never there.

Second, if you found them, you couldn't sell them much of anything because any income was being used for rent, food, and other living expenses. Third, students had weird consumer habits, such as eating peanut butter for a month in order to afford a car stereo. But the 18- to 24-year-old bracket was still important to business because students made brand decisions during college that could last a lifetime, purchasing Colgate toothpaste rather than Crest, as their parents had. In this way, students expressed their independence. So using the controlled circulation method of old media, marketers flooded places with publications where students might show up eventually, such as residence hall lobbies and student unions.

All that changed with the introduction of global positioning satellite software found in every student's cell phone. Students could be located at all hours of the day, with business appealing to their lifestyle statistics, datamined through credit cards, clickers, social networking Web sites, and corporate e-mail accounts from Google to Yahoo. Now that marketers knew where students actually were, the next step was to lobby the federal government to outsource student loans under the so-called efficiency model of business. Outsourcing provided easy money for students with credit cards, financing the proliferation of the same gadgets at school that students had at home and blurring lines between education and entertainment. Typical college students in the U.S. own cell phones, iPods, and laptop computers that can be programmed for revenue generation. Marketers learned that students loved their mobile technology, willing to purchase the latest versions, justifying them as educational expenses. Then students paid again to accessorize their devices, to provide access for them, to purchase products and services through them, amassing debt because of them. In one decade, business progressed from not being able to sell students much of anything to students buying practically everything online, while educators were attempting to engage them in wireless classrooms datamined by vendors.

Students often complain about being inundated through campus e-mail with spam, especially from credit card companies in collusion with universities. Some 80 percent of college students are solicited regularly across media platforms, from telephones to the Internet, with the average credit card company typically contacting students nearly five times per month (U.S. PIRG, 2008). Some students reported receiving hundreds of solicitations, beginning while they were in high school, arriving with invitations from college admissions offices to apply to academic programs. Credit card solicitation and campus admission invitations are designed similarly so that they align one with the other in prospective students' minds. Inevitably, students come to accept marketing as a cultural norm, which says much about what we have become in academe because of the business model. What students who

have become desensitized to advertising and marketing often fail to realize is how much data on them exists and how it is used.

Credit card companies routinely know:

- Which students transfer money to cards from their own bank accounts;
- Which rely on parental transfers. How many. How much. How often;
- Which buy the most online or in local stores, including what they buy; and
- Which pay $35 overdraft fees because they use cards instead of cash for small purchases at Starbucks or library cafes (U.S. PIRG, 2008).

Banks want to know about those overdrafts, especially on coffee, because these students are ideal targets for excessive fees. One student at Portland State University used his student ID as a debit card to buy a few cups of coffee and exceeded his credit limit. The bank partnering with Portland State charged him about $150 in fees (Chu, 2008). (And you thought a $5 latte at the library was expensive!) Credit card use is embedded so stealthily in the student body that it has come to represent that body, literally and figuratively, in the university-issued ID card that functions now as a debit card that takes its user via wireless systems to the bank that mines data with every swipe. In 2007, 127 schools partnered with banks to issue ID cards that double as debit cards, a whopping 144 percent rise from 2002 (Chu, 2008).

Technology developed by the U.S. military and enhanced by industry does two things efficiently: it surveils and it sells, sometimes simultaneously, with Student Affairs trolling Facebook while students pay $1 a pop for virtual gifts, using credit cards. This sorry state of consumer affairs was perhaps predictable. French-Maltese philosopher Jacques Ellul (1912–1994) saw technology as an autonomous system that alters everything it touches, without its changing much at all. Ellul (2003) correctly foresaw that such systems could not substitute for interpersonal human needs, which higher education used to supplement, not only through knowledge for liberal learning but also through access to scholars who introduced young adults to the life of the mind rather than to the hottest new gizmo. Ellul understood this; he saw technology as an inhuman, self-determining organism, "an end in itself," whose autonomy transformed centuries' old systems "while being scarcely modified in its own features" (p. 386).

To illustrate this, he referenced business economics:

> Like political authority, an economic system that challenges the technological imperative is doomed. It is not economic law that imposes itself on the technological phenomenon; it is the law of technology which orders and ordains, orients and modifies the economy. Economics is a necessary agent. It is neither the determining factor nor the principle of orientation. Technology obeys its own determination; it realizes itself. (Ellul, 2003, p. 392)

In other words, introduce technology into the economy, and the economy henceforth is about technology. Introduce it to journalism, and journalism also is about technology. Introduce it to education, and education showcases technology. Better still, technology is independent of everything and so cannot be blamed for anything.

An enlightening essay on that concept, published in the *Bulletin of Science, Technology & Society,* explores how Ellul's work on propaganda relates to modern-day marketing:

> Technology tempts and seduces us with its promise and provision of comfort, convenience, and efficiency. Above all, technology tempts and seduces us with power: power over nature and over human beings. Naively and paradoxically, we believe we have power over technology, even though it actually has power over us. Our immersion in a sea of temptation and seduction, of constant and total propaganda may seem inescapable; however, to criticize and challenge the primacy of technology is to reassert our freedom. (Van der Laan, 2004, p. 509)

Reasserting freedom from technology will be difficult because technology companies are embedded now in our networks. Ethicist Christine Rosen, senior editor of *New Atlantis: A Journal of Technology and Society,* observes,

> It is intriguing to see how insidiously and effectively computer and software companies have colonized academia. A culture that prides itself on research and rigorous inquiry in all other areas—and with an abiding skepticism about the conventional wisdom—is in this area uncritically enthusiastic, judging by the amount of money administrators are spending on technology on campus. (Personal communication, May 19, 2008)

Rosen believes that technology has attained mythic status and, as such, a symbol for a college's or university's status in the modern world:

> Administrators seem to be operating under the assumption that all of this technology is akin to having a successful sports team that draws alumni and student participation (and dollars) to the school, but without first considering whether this is, in fact, the case. (Personal communication, May 19, 2008)

Rosen challenges administrators to "carefully consider where the school's money—and their students' time—are going when they invest in new technologies" (Personal communication, May 19, 2008). Otherwise the colonization of academia will continue unabated.

At some universities, corporations even underwrite classes. At Hunter College of the City University of New York, a Faculty Senate committee investigated a course sponsored by the International Anticounterfeiting Coalition, a group that protects brand names such as Chanel, Harley-Davidson, Levi Strauss, and Reebok. Those companies want the public to know about cheap goods purporting to be the real deal. In an article titled "This Course Brought to You by," *Inside Higher Ed* reports that the university allowed the coalition to sponsor a course in which students "would create a fake Web site to tell the story of a fictional student experiencing trauma because of fake consumer goods" (Jaschik, 2008). Note the use of digital media in this pedagogy. It is not there by accident. Fooling consumers in this manner is a component of so-called guerilla marketing, initially conceived as a low-budget promotion tactic (Levinson, 1984), but which has come more recently to symbolize unconventional, aggressive publicity strategies. No doubt that students learned about an important topic—counterfeit merchandise. But in the process they also reportedly heard only one side of an issue while mastering a controversial marketing method and then hoaxed other students via the Internet. What better way for a company to get across its message, sponsoring a course to influence the lesson plan so as to engage students in a paid commercial—paid, that is, by tuition?

For decades, we were told to adopt the business model so that academe could operate more efficiently. We adopted that model and U.S. business did what it does best: it saw higher education as a new market to exploit to meet the earnings expectations of stockholders and CEOs. Rather than teaching us efficiency, this model taught us about our own willingness to sell out in return for appearing innovative and engaging. Computers were supposed to democratize rather than corporatize learning. Administrators, especially at science-oriented institutions like my own Iowa State University, where the first digital computer was invented by John Vincent Atanasoff, tend to view computers as objective tools utilized in the exploration of scientific discovery. We forget that computers can be programmed to take advantage of people and their subjective impulses, which is why we seek approval for surveys and projects from institutional research boards. Technology is touted as a means to make instruction easier; but early adopters often overlook the fact that technology requires more effort than "on-ground instruction," with professors having to learn new software or upgrades as many as three times per year (Shedletsky & Aitken, 2001, p. 209). As such, technology can be grossly inefficient when factoring its high cost, complicated learning curves, and classroom adaptation, including reassignment of roles so that teachers are mentors and students, apprentices (Shedletsky & Aitken, 2001, p. 212).

We used to view higher education as a journey of the mind. We used to embrace transformation and commitment as primary learning objectives. Increasingly, those concepts are not extolled anymore, even by teaching excellence centers consumed with engagement via technological innovation. Transformation requires exploration in real rather than virtual domains. Learners need time to observe and analyze phenomena, especially in the sciences. Technology has undoubtedly supported Millennial multitaskers who can succeed at jobs requiring this skill, from air traffic controllers to emergency room physicians. But how will they fare at tasks requiring contemplation, critical judgment and, more important, creativity? These elements ensure liberty, civil rights, and freedoms in the Bill of Rights. In an insightful article, "The Technology Paradox, Efficiency versus Creativity," S. M. Edwards (2001) concludes that "the need to be efficient seems to foster an environment that retards creativity by limiting exploration" (p. 223).

Exploration is an interpersonal rather than Web browser experience. Rather than fostering an environment conducive to exploration, technology has distracted our learners to such degree that institutions finally are pulling the Internet plug in classrooms. Engagement is particularly important in law because the U.S. judicial system allows defendants to face their accusers. Saul Levmore, dean of the University of Chicago Law School, was among the first to remove wireless access from his classrooms. "As soon as we discovered that we had the capacity to turn off Internet access during class time, we felt that we ought to move in that direction," he writes ("University of Chicago," 2008). "Our goal is to provide the best legal educational experience in the country, with students and faculty focused on the exchange of ideas in a thorough, engaging manner"—and that is, face-to-face.

My own work *Interpersonal Divide: The Search for Community in a Technological Age* predicted this outcome (2005). My research also suggests that there may be a simpler reason for the level of distraction in our wireless classrooms. Too many professors rely on technology to do the difficult work of teaching mastery—research. Too many of us are wasting time previously reserved for course preparations and enhancements, learning each new technical toy, application, or platform. Class time has always been precious, but now it is even more so, because of spikes in tuition and fees. Do we really want to spend a day in a teaching excellence workshop learning how to make an avatar run up and down pixilated stairs and then dedicate one day of our lesson plans teaching avatars of students to do the same?

Adopting this inefficient pedagogy, we are sending out our learners unprepared for the real world with a debt load that will disenfranchise them as soon as they graduate and have to repay loans precisely when datamines of their alma maters explode digitally, taking a parting shot at what balances remain in their bank accounts. A college education is still valuable, with col-

lege graduates earning on average nearly $300,000 more than high school counterparts over a 40-year career, after deducting tuition, room and board, and income lost while attending college (Meyers, 2006). But beginning in 2001 and in every subsequent year since, college graduates started losing ground to high school graduates because of debt. Meanwhile, community college enrollment has been burgeoning because tuition is lower at these schools than at public and private universities. All these data correlate with increasing investment in digital technologies.

Students have to accept responsibility as well. Too many now are addicted to their devices. A Stanford medical study states 1 in 8 Americans are addicted to the Internet (Stanford University, 2006), whereas 1 in 13 are addicted to alcohol (National Institute on Alcohol Abuse and Alcoholism, 2006)—a sobering thought. So is this: marketers rely on gratification theory to sell to students. The more they click, text, or chat, the greater the reward…and the debt. Students have to delay gratification, or technology will delay graduation. Debt is rapidly becoming the chief cause of attrition in colleges nationwide. In a national survey by the American College Testing program (ACT), students blame inadequate financial resources for ending their education, second only to lack of motivation; and while the ACT report proposes several recommendations to raise retention, it overlooks decreasing tuition and fees (Habley & McClanahan, 2004, p. 6).

Conclusion

The most effective rather than efficient mode of education is to transform our learners intellectually rather than to engage them digitally. The goal is to inspire students to make education a lifelong experience and experience a lifelong education. Machines calibrate, calculate, and simulate. But they do not transform. *Teachers do.* Teachers also have a moral obligation to instill in learners a sense of commitment rather than engagement, because they will need commitment to meet the challenges of the warring, starving, thirsting, and suffering developing countries that do not require the "One Laptop per Child" program of Nicholas Negroponte, lost in his own technostalgia; they need One Net per Child to prevent malaria. In a few years, Americans, too, will undergo social change on a level not seen before in modern times. There is only so much time before the abundance that has allowed our amusements will deplete, along with oil, food, fuel, and water. The more we focus on engagement, the more we delude ourselves about the state of the world and the global economy.

This is why I am challenging the educators reading this text to set the standard for higher education: I am asking you to disengage digitally, overhaul your curricula to facilitate critical thinking, and temper your use of

technology so that your efforts over time result in reductions in tuition and fees. I am asking you to endorse the pedagogy of commitment, rather than the cottage industry of engagement, so as to prepare learners for the challenges that they will encounter. I am asking you to double your efforts at cost containment so that college enrollment rises in inverse proportion to the tuition base.

The irony of technological disengagement is a reduction in workload precisely because our pre-Internet standards were more effective as well as efficient. Educators who recommit to them will also regain time spent frittering with inefficient technology. They can refocus coursework and enjoy more time to do research, mastering their disciplines, updating lesson plans, and advising and engaging students in their offices rather than online. They can assess technology empirically to ascertain which systems actually enhance our educational missions rather than investing in the latest technical toy and learning, in the end, that it could not deliver what promoters promised. Finally, I hope that I and other authors in this book have proved that the written word still can engage the mind, whose journey is sparked more by the breadth of interpersonal actions than by the bandwidth of interactive ones, and by the content of our character more than by the pixels of our avatars.

References

Baskin, P., & Field, K. (2007, April 20). Student-loan investigation sweeps up more colleges. *Chronicle of Higher Education, 53*(33), p. A1.

Best and worst in fuel economy. (April 2008). *Consumer Reports.* Retrieved May 14, 2008, from http://www.consumerreports.org/cro/cars/new-cars/buying-advice/2008-best-worst-cars-review-4–08/best-worst-in-fuel-economy-4–07/overview/0704_best-worst-in-fuel-economy_ov.htm.

Bugeja, M. (2005). *Interpersonal divide: The search for community in a technological age.* New York: Oxford University Press.

Bugeja, M. (2008, December 5). Classroom clickers and the cost of technology. *Chronicle of Higher Education,* pp. A31–A32.

Bush, G. W. (2008, January 28). *State of the Union Address, 2008.* White House Web site. Retrieved May 14, 2008, from http://www.whitehouse.gov/news/releases/2008/01/20080128–13.html.

Carter, J. (1979, January 25). *State of the Union Address, 1979.* Jimmy Carter Library. Retrieved May 14, 2008, from http://www.jimmycarterlibrary.org/documents/speeches/su79jec.phtml.

Chu, K. (March 16, 2008). College debit-ID card deals draw scrutiny. *USA Today.* Retrieved May 14, 2008, from http://www.usatoday.com/money/industries/banking/2008–03–16-cover-college-debit_N.htm.

Colamosca, A. (1999, July/August). Pay for journalists is going up. *Columbia Journalism Review*. Retrieved May 14, 2008, from http://findarticles.com/p/articles/mi_qa3613/is_199907/ai_n8867298.

Computer consulting and support group meeting notes. (2005). Retrieved May 14, 2008, from http://www.it.iastate.edu/ccsg/notes/2005–05.html.

Edwards, S. M. (2001). The technology paradox: Efficiency versus creativity. *Creativity Research Journal, 13*(2), 221–228.

Efficiency definition. (2008). *The American heritage science dictionary*. Retrieved May 14, 2008, from http://dictionary.reference.com/browse/efficiency.

Ellul, J. (2003). The "autonomy" of the technological phenomenon. In R. C. Scharff & V. Dusek, (Eds.), *Philosophy of technology: The technological condition* (pp. 386–397). Malden, MA: Blackwell.

Eve, J., & Brabazon, T. (2008). Learning to leisure? Failure, flame, blame, shame, homophobia, and other everyday practices in online education. *Journal of Literacy and Technology, 9*(1), 36–61.

Ford's top bosses net $35m payday. (2008). *Motor Trader*. Retrieved May 14, 2008, from http://www.motortrader.com/27033/Fords-top-bosses-net-35m-payda.ehtml.

Habley, W. R., & McClanahan, R. (2004). *What works in student retention? Research and policy issues*. American College Testing. Retrieved May 14, 2008, from http://www.act.org/research/policymakers/reports/retain.html.

Harward, D. W. (2008, April 14). A different way to fight student disengagement. *Inside Higher Ed*. Retrieved April 15, 2008, from http://www.insidehighered.com/views/2008/04/15/harward.

Hersh, R. H. (2007). Terms of engagement. *Peer Review, 9*(3), 30–31.

Hutchinson, M. (2008, January 24). Three ways to profit in the face of surging inflation. Money Morning. Retrieved May 14, 2008, from http://www.moneymorning.com/2008/01/24/three-ways-to-profit-in-the-face-of-surging-inflation/.

Jaschik, S. (2008, March 3). This course brought to you by. *Inside Higher Ed*. Retrieved May 14, 2008, from http://www.insidehighered.com/news/2008/03/03/hunter.

Levinson, J. C. (1984). *Guerilla marketing: Secrets for making big profits from your small business*. Boston, MA: Houghton Mifflin.

Majors and careers. (2008). Indiana University. Retrieved May 14, 2008, from http://www.indiana.edu/~udiv/majors/majorinfo.cgi/69.

McEnnerney, D. (2008, Spring). How can liberal education engage "things that matter"? *The Key Reporter*, 7.

Meyers, M. (2006, June 21). College degree still worth investment, economists say. *Minneapolis Star Tribune*. Retrieved June 1, 2008, from http://seattlepi.nwsource.com/business/274669_degreevalue21.html.

National Institute on Alcohol Abuse and Alcoholism. (2006). *Are specific groups of people more likely to have problems?* Retrieved November 26, 2006, from http://www.niaaa.nih.gov/FAQs/General-English/.

Rossi, L. (June 8, 2008). Universities' student fees jump 341% in a decade. *Des Moines Register*. Retrieved June 8, 2008, from http://www.desmoinesregister.com/apps/pbcs.dll/article?AID=/20080608/NEWS02/806080326.

Shedletsky, L. J., & Aitken, J. E. (2001). The paradoxes of online academic work. *Communication Education, 50*(3), 206–217.

Snell, J. (2004, February 2). Steve Jobs on the Mac's 20th Anniversary. *MacWorld*. Retrieved May 14, 2008, from http://www.macworld.com/article/29181/2004/02/themacturns20jobs.html.

Stanford University. (2006, October 17). *Internet addiction: Stanford study seeks to define whether it's a problem*. Retrieved November 23, 2006, from http://mednews.stanford.edu/releases/2006/october/internet.html.

Tuition inflation. (2008). *FinAid*. Retrieved May 14, 2008, from http://www.finaid.org/savings/tuition-inflation.phtml.

University of Chicago Law School eliminates Internet access in some classrooms. (2008, April 11). University of Chicago. Retrieved June 8, 2008, from http://news.uchicago.edu/news.php?asset_id=1329.

U.S. PIRG. (2008). *U.S. PIRG's campus credit card trap: Highlights of major findings*. Truth about Credit Web site. Retrieved May 14, 2008, from http://www.truthabout-credit.org/campus-credit-card-trap.

Van der Laan, J. M. (2004). Temptation and seduction in the technological milieu. *Bulletin of Science, Technology & Society, 24*(6), 509–514.

CHAPTER 12

Mobile Learning in the Digital Age

A Clash of Cultures?

▶ LETIZIA CARONIA & ANDRÉ H. CARON

Myths Underlying the Mobile Turn in Education

Contemporary enthusiasm about emerging mobile learning technologies is deeply rooted in what some scholars have described as the American common images of technology. These images "highlight its rational, ordered, controlled aspects and strongly associate technology with notions of efficiency and progress" (Kerr, 2004, p. 113). Education is certainly one of the fields in which Western societies have long assumed that technology is the solution to increase order, productivity, and efficiency (Caron, 2008; Kerr, 2004). These assumptions have applied to the computer, the Internet, e-books, and, most recently, to mobile digital audiovisual players. It is on the basis of such a shared positive bias and commonsensical assumptions that several North American universities, including Duke University, the University of Michigan, and the University of California at Berkeley, have promptly launched programs involving podcasting and the use of mobile digital media players

as new learning devices (Bélanger, 2005; California State University, 2006).

The reasons commonly advanced for the adoption of mobile teaching and learning devices in education are often economical, political, and educational. A number of educational institutions extol the unique advantages provided by these technologies: together with e-learning programs (a term that refers to the use of new technologies for the purpose of teaching), and distance education (academic courses accessed without having to be physically present on campus), mobile learning devices are put forth as a solution for coping with budget constraints. They could lower the costs for the institution by increasing the student to teacher ratio and reducing the need for larger classroom spaces. Nonetheless, economic factors are not the only ones at play. The adoption of these devices is sometimes justified by political reasons. They would open new educational opportunities for students who could not be physically present in the classroom, including working students, students living far from universities, and young people living in rural areas (Beldarrain, 2006; Lee & Chan, 2007). In this context, mobile teaching and learning devices are viewed as a means to overcome economic, spatial, and temporal constraints and consequently contribute to a more effective democratic diffusion of education and to the recruitment of university students.

The educational reasons supporting the adoption of such devices seem to be even more persuasive: in the so-called knowledge society, mobile learning is supposedly valuable per se. Mobile learning, however, is a fuzzy concept whose core trait is a reference to learning as a context-free activity less and less dependent on face-to-face interaction (Kukulska-Hulme & Traxler, 2005; Sharples, Taylor, & Vavoula, 2007; Wali, Winters, & Oliver, 2008). The basic idea in mobile learning is that efficient learning would reach its optimum level when students may learn at their own pace, where and when they want, and if they control their own learning process.

As knowledge is conceived as an unfocused set of information, diffused and distributed in a vague anywhere, knowing becomes a trans-contextual activity. Consequently, traditional distinctions such as formal and informal education, education versus socialization, and intentional and non-intentional education lose their meaning. If provided with tools giving them access to this knowledge society, individuals are expected to learn anywhere and at any time. Mobile digital audiovisual players seem to fit perfectly this context-free model of learning. Freeing learning and teaching from temporal and spatial constraints, this technology would help transform every moment and place into a *learning environment* (Gao & Shen, 2008). Content and information conceived and formatted in podcasts by teachers could be consumed by students anywhere and at any time. Students could also seek content and information autonomously, evaluate its relevance, download it on

their mobile audiovisual player, and bring it to the classroom to share with classmates and teachers. Time-shifting and flexible contexts of learning are the leitmotiv in most discourses promoting the integration of these technologies in schools.

The educational advantages and opportunities that these technologies offer thus appear to be unique. A kind of mechanistic enthusiasm seems to underlie this shared reliance on technology as a means to increase order, efficiency, and productivity from organizational as well as educational standpoints. This "technology is better" belief relies on a reductionist and still deterministic view of technological innovation, the educational process, and the actors involved. Although the specific functions and utilities provided by the technology, the cost-benefit ratio, and the advantages expected from maximizing the learning output are important factors in planning educational policies, they do not entirely account for the process of appropriation. A crucial—although underestimated—factor is at stake, one that makes a huge difference: the adopters' specific worldview.

The Cultural Side of Innovation: The Neglected Dimension of Research in Technology and Education

Mainstream research in educational technology is largely product-oriented. The focus "has usually been on what is perceived to be the outcome of these approaches on what is thought of as their principal target: learning by pupils" (Kerr, 2004, p. 114). Generally, there have been few attempts to adopt a cultural perspective in analyzing the cultural dimension involved in the process of adoption. The same product-oriented perspective seems to underlie contemporary educational research on podcasting and on the use of mobile digital media players as learning tools. Recent studies focus predominantly on the hypothetical benefits of this technology on learning (Chan & Lee, 2005; Luckin et al., 2005), the conditions for successful use of educational podcasting (Bongey, Cizadlo, & Kalnbach, 2006; Frydenberg, 2006), the educational output of podcasting measured in terms of students' performance (Lazzari, 2007), and the best or most effective features of educational podcasts (Corbeil & Valdes-Corbeil, 2007; Lazzari & Betella, 2007). Contemporary research on the efficacy of podcasting and of the associated technologies generally considers the interplay of three main factors: the possibilities offered by the technology itself, the cognitive processes involved in its use, and teachers' attitudes toward technological innovation (Pandolfi, 2007). Although these components have a significant impact on the successful use of the technology, they are often presumed to operate in a cultural vacuum.

On the contrary, an educational context has its own specific inner operational cultures. These sets of implicit and explicit rules, values, principles, and behavioral models that organize everyday life in the context may affect the innovation process. Indeed, an educational setting is far from being a culturally homogenous milieu. Rather, it is a social context where different and often conflicting operational cultures—teachers' professional culture and students' peer culture—converge. The inner cultural complexity of an educational setting is crucial. Attitudes toward technological innovations in education are always related to systems of beliefs, implicit ideas, assumptions, and theories about education. Thus, the appropriation of a technology for educational purposes is always a culturally mediated process through which a technological tool becomes a cultural object. Technologies are more than mere objects or tools: they are designed for predetermined uses and offer specific possibilities, but they are appropriated by people in ways and for purposes that depend on individuals' cultural frames of reference. Technologies embody these practices and, more important, they represent symbolic systems. As technologies carry the users' world of meanings and ways of life, their transfer from one context to another is not a matter of simply transferring technological functions and utilities. Rather, it entails a work of cultural reframing.

Adopting a phenomenological theoretical approach to social life and events, we conceive this work as accomplished by "intentional" human beings. The notion of intentionality (Husserl, 1970/1913) as the human competence in making sense of reality and in creating the crucial dimensions of people's life-world (Schütz, 1966, 1967/1932) is a key concept for understanding why technologies are not inert sets of mere utilities.

From a phenomenological point of view (Bertolini, 2001; Caronia, 1997; Giorgi, 1985; 1990; Säljö, 1991, 1992), the adoption of mobile learning technologies in schools cannot be explained solely by the technology's performance, the individual's attitudes toward innovation, and the cognitive processes involved. The advantages and disadvantages of a mobile learning technology must be related to the cultural definitions of learning at stake in the educational setting, to the representations of knowledge, and to the interpretation of the technology through which participants make sense of the innovation.

Institutions, administrators, teachers, and students do not necessarily share the same cultural frameworks and systems of beliefs, nor do they belong to the same "community of practices" (Lave & Wenger, 1991). We contend that this cultural diversity needs to be taken into account because it is pivotal to understanding differences in how people manage, exploit, and resist technological innovation in education. The theoretical shift toward culture and intentionality makes it possible to highlight the importance of individual

worldviews in interpreting technologies and their crucial role in making sense of technological innovation in education. The main theoretical implication of considering individuals as cultural actors or intentional subjects is that this perspective accounts for the degree of indeterminacy in the ways educational technologies affect the learning process.

The Contemporary Culture of Education: Professional Systems of Beliefs Underlying the Adoption of Mobile Teaching and Learning Devices and Podcasting

Any formal education context is characterized by some professional systems of beliefs which are sets of assumptions, ideas, and theories that are often implicit but largely shared by the members of this professional community. Anchored in scientific notions, theories on human development, larger theoretical conceptions of learning, as well as in everyday understanding and common sense, this background knowledge about education becomes the unquestioned basis for decision making and orients working styles of education practitioners (Dann, 1990). The efficiency-oriented culture of education of the institutions promoting mobile learning relies on and is often justified by two main professional systems of beliefs.

The first system of beliefs affecting attitudes toward mobile teaching and learning devices concerns the intrinsic value of continuity and contiguity in education (Kalkbrenner & Dietrich, 2008): the more an educational activity is able to connect with the students' specific social and cultural worlds, the more efficient it is. Indubitably, young people live in and through a technologically mediated environment and are constant consumers and producers of a "moving culture" and mobile social networks (Caron & Caronia, 2007). The transfer of mobile digital players and podcasting content from peer culture to school culture is strongly anchored in the belief that educational practices should reach students where they are, and on the idea that educational tools should be ecological, which means consistent with students' everyday culture and life out of school.

The second system of beliefs concerns the very definition of education. Particularly, the definition at stake is derived from and consistent with the socio-constructivist theoretical approach to the learning/teaching process (Bruner, 1986, 1996; Rogoff, 1990; Wells, 2000; Wenger, 1998), whereby knowledge is conceived as situated and distributed (Wertsch, 1985). Enacted by different actors and embodied in different semiotic artifacts (Pontecorvo, 1993; Resnick, Pontecorvo, & Säljö, 1997), knowledge is not a ready-made product to be delivered; rather, it is the partially undetermined result of

social praxis. Consequently, the educational process is conceived as a knowledge-building joint activity. In such a strong interactive context, teachers are supposed to guide newcomers in cultural apprenticeships (Lave, 1996; Rogoff, 1990, 1995), to act as resource people who orient students in the knowledge-building process. As a corollary of this view, students are defined as seekers of knowledge (Caron, 2008). They are expected to actively participate in the educational process by bringing their cognitive and cultural world into the community of learners to which they belong. Participation and activity are central notions: members are supposed to learn by doing and by interacting with other people. Mobile technologies seem to be perfectly compatible with this conception of learning.

The inherent link between these sets of cultural beliefs and the adoption of podcasting and related technologies in universities opens up a specific field of inquiry on the cultural dimensions involved in the adoption process. Notably, do the different actors involved in the educational process share the same operational culture and systems of beliefs? If the presumed educational advantages of this technology are consistent with the continuity pattern and the socio-constructivist cultural model of education, is this culture of education relevant in the students' community of practices?

Investigating the Cultural Dimension of the Mobile Turn in Education: A Case Study

Our study investigated the role of the actors' intentionality, cultures, and worldviews in technological innovation in education. We were particularly interested in discerning and analyzing the different cultures of education that condition the adoption of mobile teaching and learning devices and particularly podcasting. We designed a quasi-experimental study that was primarily intended to provide accurate "thick descriptions" (Geertz, 1973) of the students' practices related to this innovation in education. The study involved 123 students in three different faculties—Arts and Sciences, Pharmacology, and Architecture Design—and five professors who agreed to participate in the study and to adopt mobile teaching and learning devices (such as the iPod by Apple or the Zen Vision by Creative and their accessories) as tools in their courses.

Professors were asked to prepare podcasts based on their own pedagogical criteria and needs: content, format, length, and degree of thematic coherence to the course were determined by each teacher.

The experimental design was differentiated from that of current empirical studies on educational podcasting on at least one level: students were not obliged to use their mobile digital players for academic purposes, nor

were they requested to use them in predefined ways, times, or contexts. This optional nature of listening to podcasts would free students from any formal obligation and allow them to decide whether or not they wanted to use academic podcasts. There was one exception, an industrial design class whose weekly two-hour lectures were mostly delivered through podcasting. Obviously, students needed to consume podcasts but not necessarily on their mobile devices.

Thus students were simply asked to use their mobile device in their everyday activities as they usually would, and to report what they had done with it, if anything. In essence, they were provided with technological and educational conditions to learn in a more mobile way and to consume podcasts prepared by the teacher. They were also given the opportunity to create their own educational podcasts, which they could then upload and share with the teacher and classmates through a common Web site. By deliberately introducing this uncontrollable variable and by following the daily activities of these students over a three-month period, we gained access to their ways of interpreting, exploiting, and even resisting the mobile turn in education.

After a pre-experience survey, students were asked to make entries in an online individual logbook early and then later on in the semester, every day for two one-week periods. Afterward, they participated in a post-experience focus group. Data from the survey and the logbooks were quantitatively analyzed to gain an overview of the practices related to mobile digital player use in students' everyday life (content, locations, and times). Discursive data coming from open-ended questions in logbooks and focus groups were qualitatively analyzed to investigate the interpretive repertoires (Potter & Wetherell, 1987) through which the students make sense of the everyday practices related to the use of the "iPod." As we will see, most of the participants in our research used the commercial label "iPod" to designate their mobile devices whether they were the Apple brand or not. We therefore adopted this same naming strategy.

The specific aim of the analysis was to elucidate students' procedural definitions of learning, knowledge, education, and the iPod. By "procedural definitions" we mean those that are inscribed in the practices and that organize discursive accounts of the practices. Usually unstated but always operating, procedural definitions of reality often differ from declarative ones, that is to say, from the explicit opinions that individuals are ready to provide upon request. Not surprisingly, students' declarative definitions and opinions on the use of mobile players in education were not consistent with those enacted in their practices.

The purpose of the study was not to evaluate the educational value of podcasting per se but, rather, to investigate mobile consumption of educational podcasts on a platform specifically designed for mobile consumption

of content. In so doing, we attempted to grasp students' perception of learning as a context-free activity and of mobile technologies as new tools for efficient learning in the so-called age of the digital knowledge society. The second objective of our study was to evaluate the interest of students in freely participating in the construction of academic knowledge through podcasts. In other words, we were interested in seeing to what extent students shared the socio-constructivist cultural model of education that many believe lies at the core of the adoption of mobile teaching and learning devices.

Academic versus Entertainment Uses: Quantitative Data

More than half of the students in our study already owned some type of mobile digital player. The average age of the students who participated in the research was 23. The quantitative analysis of data from the logbooks indicated that after the initial warm-up period in which students mastered the technological aspects of the technology and were attracted by the novelty, only a marginal amount of their mobile player use was academic: 9 percent.

We classified the following uses as academic:

- Consulting academic podcasts made available by the teacher;
- Consulting podcasts considered educational by the students;
- Recording courses for personal future listening or for classmates that were absent;
- Listening to courses recorded by classmates;
- Loading readings, texts, and recorded courses on the mobile device and using the machine like a USB memory data storage device; and
- Creating personal educational podcasts.

Ninety-one percent of students' iPod usage was related to leisure and social networking. This usage category included:

- Downloading and/or listening to music or radio programs;
- Downloading and/or showing photos or film trailers; and
- Showing their personal music or video collections or making movies.

Music listening overwhelmingly remains the greatest use of the technology, 2 hours and 48 minutes out of the total usage time of 3 hours and 40 minutes, as Figure 1 indicates.

Differences between academic and social uses are also striking with respect to place and co-occurring activities, as Figure 2 illustrates.

Two out of three academic uses of the mobile player occur at home (44 percent) or school (24 percent), and mostly with the support of the computer, onto which academic and educational podcasts are downloaded for consumption. These uses are mainly static and context bound and do not overlap with other activities. Social or entertainment uses of this technology, in contrast, occur almost everywhere: at home, evidently (21 percent), but more frequently on the bus or subway or in the car (29 percent), or walking down the street (22 percent). Social and entertainment uses are not context specific; they overlap with other activities, creating multitask behaviors. Moreover, they are moving uses that occur in "nowhere places" and "no-when times" that characterize young people's mobile culture (Caron & Caronia, 2007).

Students' Accounts: Why They Resist Mobile Learning

These striking differences between academic and social uses surprised both us and the professors involved. Why didn't students use their iPods more for educational purposes? Why did they avail themselves of the technological opportunity for mobile learning everywhere and anytime so infrequently?

The descriptions and explanations provided by students either in the individual logbook or in focus groups provide interesting and intriguing insight into this partial resistance to innovation.

The context of use is one of the most recurrent arguments through which students account for not using their iPods more for mobile learning. The mobile consumption of academic and educational podcasts is far from being

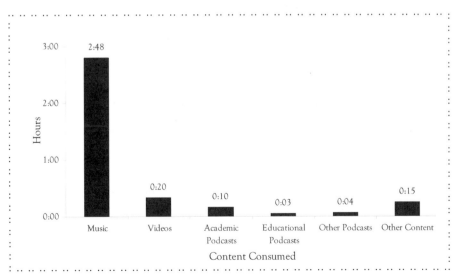

Figure 1. Students' daily average iPod usage by content consumed.

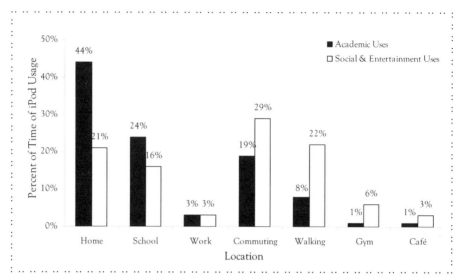

Figure 2. Percent of students' iPod usage by type of use and location.

considered invariably positive by students. Here are examples from the focus groups of this largely shared and recurrent discursive pattern:

> At first, I found it great to be able to move, it seemed like freedom to me. Finally I realized that I did not absorb the content, not really as much as when I was sitting with pen and paper while listening. (Design student)

> Frankly, I think it's a little useless because when you walk with it and try to watch it without knowing where you are going it's dangerous. When I bring it with me, I am going to study in the library and I sit down to watch the video podcast of the courses. I watch the videos on my laptop instead of watching it on the small screen; therefore, I really find this function useless. (Pharmacy student)

> I tried. I put them on my iPod and I listened to them in the morning on the bus. But, as I said earlier, the video gave me motion sickness and honestly, the pharmaceutical podcasts, their content are not something that I will listen to by myself, for fun, on the bus. (Pharmacy student)

The multitasking opportunity offered by the iPod is strongly appreciated by students. However, this appreciation concerns mostly its use in social contexts and for leisure purposes. When the core activity is learning, multitasking becomes a more complex factor. Coping with co-occurring sounds, with people moving around, and with all the characteristics found in most social spaces becomes problematic and more challenging when learning is the goal.

Mobile Learning in the Digital Age 201

> With the noise all around, and you know, there is always something happening, for me it's not the ideal place…if I need to really stay focused…I work at home or at the library, otherwise if there is whatever noise or a friend coming it will distract me, I'll go and have a coffee.…I need to take notes while I'm listening because [Interviewer: Notes on your print copy?] I take notes as if I was in the classroom, on a small notebook. I have to take notes otherwise I am not able to stay focused. (Design student)

The mobile context of consuming academic knowledge created and provided by the technology does not appear consistent with the students' implicit definition of what an educational setting should be. Cognition, understanding, focusing, and processing information seem to require a stable context where the person is not involved in doing something else other than being quiet. Attention needs to be focused on the visual part of the text, whether written or iconic, and even an oral text like an audio-recorded lesson appears to need to be consumed in a more closed environment. The portable quality of the iPod also entails a small screen size: the consumption of academic content needs bigger screens covering a wider part of the visual field. If mobility is the main distinguishing feature of the iPod, this feature is exactly what makes the iPod difficult to work with as a learning technology, at least from the students' point of view.

The second cluster of reasons for the few academic uses of the mobile device pertains to the design features of the course podcasts (format, visual cues, sounds, lengths, inner dynamics). With few exceptions, students considered inappropriate the way some professors had planned and produced their podcasts. We find occurrences of this discursive pattern in both logbooks and focus group discussions. Here are examples from the logbooks:

> The visual podcasts are too small because of black lines at the top and the bottom of the picture.…So it is not very user-friendly to listen to them with the iPod. (Communication student)

> Sound problem with some educational podcasts: need to put the volume up to more than 15. (Communication student)

Here are related examples from focus groups:

> After listening and watching a few podcasts, all seemed increasingly boring. I mean, even if the content is interesting, the fact that we only hear the voice [of the professor] without associating it with his physical presence makes the experience less exciting. (Pharmacy student)

> It was not visually exciting.…A PowerPoint is boring in general. Seeing it again and again but in a smaller format is even worse.…It has many small silences and small sound breaks, which could be eliminated with proper editing. And so it could have been more dynamic. (Pharmacy student)

> I could watch the slides, but at the same time, it was not that great to watch them all the time, to fix one's gaze on the iPod and watch the slides. Also, if you want to read it properly you have to put it on high brightness, and occasionally, the battery is not strong enough to keep it bright enough. (Design student)

Many of the podcasts did not meet the basic design features of a "good enough" podcast (short, dynamic, audiovisual, and narrative). They were mostly audio *or* visual files such as entire formal lectures, interviews, conferences, or PowerPoint slides. Arguably, the less frequent use of academic podcasts by students was linked mainly to their inappropriate format. This appears to be a major reason but perhaps not the main one.

The formatting issue overlaps with issues related to the nature of the academic content. As previously mentioned, the consumption of content delivered through podcasts was deliberately specified as voluntary. Podcasts' content mainly complemented, elaborated on, or consisted of alternative presentations of topics and revisions of previous lessons meant to anchor new and unknown information. If, from the teachers' point of view, this type of content was extremely relevant for pedagogical purposes, the majority of students treated it as peripheral, unfocused, and, in some cases, useless. Here are three typical occurrences of such discursive patterns from the focus groups:

> In my case perhaps because they were like optional…and she [the teacher] did not speak about them [the podcasts] and did not go over them in class. We rarely talked about it.…I had no motivation because of that, and I did not even listen to them, the stories. (Italian-language student)
>
> I don't know, perhaps if they forced people to watch these…because you know some will watch them and others won't.…Like if they were giving us, like, lecture notes, I'm sure that everyone would have to read them…but content like this, you are not sure if you have to do it or not. (Pharmacy student)
>
> I did not listen to the podcasts. But in the context of a course where it would be compulsory for the course and where you have to print the notes in advance, or you have to go to see the podcast before, or if it summarizes what you do in the classroom and it could be a tool to study your exam, I would find it useful if I can watch it on my computer or to listen to it on my iPod in the library.…But since I am a student, it is not obligatory; I won't do it. (Pharmacy student)

As we can see, the formal features of podcasts (too long, not dynamic, and not visually engaging) were not the only reasons explaining the marginal role they played in students' academic work. Another major reason appeared to be that consuming academic podcast content was a voluntary activity. Students evaluate the appropriateness of academic podcasts in terms of their specific culture and identity. As a student clearly stated: "since I am a student, it is not obligatory; I won't do it." From the students' point of view, less

is better and what is not obligatory, specially focused on the curriculum, or established by the teacher as highly relevant, subject to evaluation, or related to getting good grades, is viewed as useless: consuming non-obligatory academic and educational podcasts is considered a waste of time.

Where the Story Unfolds: Mobile Consumption of Popular Culture and the Social Uses of the iPod

If listening to academic podcasts represents only 9 percent of the daily uses, what about the other 91 percent? These uses center on social networking and entertainment, along with the mobile consumption of popular culture. They are everywhere, anytime, context-free uses that strongly benefit from the mobile nature of the technology. Here are a few examples from the logbooks and the focus groups that illustrate the main features of students' cultural appropriation of the iPod:

> I really enjoyed having my iPod when I had to clear the snow off of my car during a snowstorm! (English-language student)

> I did not take public transportation today. Therefore I did not need my iPod. (Design student)

> At school and at all the parties, as well as at home, I show my pictures, those that I bring with me. I have hundreds on my iPod and I showed them to my friends and family instead of sending them by e-mail. (Italian-language student)

> I create my own music, my own product and I need to sell my products if I want to earn a living. With this device, it's interesting because I can take a walk and suddenly…I speak with someone about music: you make music…it must be good! In fact, I have my new music video with me….I take it from my handbag and show him. (Italian-language student)

In light of these comments, it appears that students' iPod culture is a moving culture basically centered on music consumption and on the social sharing of one's own universe of cultural references. Totally integrated into young people's daily routine, the iPod allows multitasking, mobile consumption, and social sharing of popular culture content. From the students' point of view, it is a means to make sense of otherwise meaningless spaces and time in everyday life. Yet this domestication concerns leisure, entertainment, and the social life inside the community of peers. This cultural interpretation of the iPod by young people defines it first and foremost as a leisure and social technology.

Between Educational and Social Uses: Recording Lectures and Sharing Content

Among what we classified as academic uses, the one considered the most relevant by students was recording lectures for asynchronous listening. Students invested considerable time in discussing and evaluating the usefulness of iPods as a simple recording tool, as a means of transferring files, as well as a USB-like device to download the recorded lessons on their personal computer. Here are discussions of this from the focus groups:

> But there are courses where teachers speak so fast that we record them and after we can write notes....Sometimes you are tired in the afternoon and you know you wouldn't listen...so you record. (Pharmacy student)

> For example there was a course review and the teacher told us what he would ask during the exam. So I listened to it three or four times. (Pharmacy student)

> When I do not have my notes...and when teachers do not give them out and you don't feel like taking notes...then you record the course and you listen to it. You supplement your notes like that. (Pharmacy student)

Two elements could explain the use of the iPod as a recording device: (1) recording lectures is a typical activity in the students' community of practices; and (2) the microphones on the mobile devices were of good technical quality.

Recording lectures is an activity that is strongly rooted in the students' specific culture: they record lessons for themselves for subsequent attentive listening and note taking, and they record lessons for their classmates. The iPod has been immediately incorporated into these routines typical of students' academic life.

Aside from the personal use, the recording-transferring function makes the iPod a powerful tool for social circulation and sharing of academic content, as one pharmacy student noted in the logbook: "I recorded my courses to give them to my friends, to transfer on a CD." In a focus group, another pharmacy student remarked similarly: "I found it useful for...you know... sometimes when you record courses for your friends who did not come to class. And I transferred the file after to them. They could just listen and take notes like that as an alternative to giving them my written notes."

As a recording device, the iPod fits perfectly into the social practices through which students construct their peer community. The iPod has been interpreted as a powerful tool for sharing academic content, helping classmates, and coping with course attendance obligations. Through these academic uses of iPods, students construct and confirm the social links that define them as members of a community. Rather than as a tool for mobile

consumption of academic-related content, the iPod has been adopted by students primarily as a tool for building the social dimension of their academic life.

Our data confirm the findings of other researchers: students' academic uses of iPods do not necessarily follow the logic inscribed in the technology. The supposedly peripheral uses of the iPod (recording and transferring files) become core utilities with respect to students' academic life and work. Conversely, what supposedly differentiates the iPod from other educational technologies (providing mobile learning defined as consumption of educational podcasts anywhere, anytime) is nothing more than a peripheral utility.

Knowledge Construction: Untapped Potential of Podcasts

The students were offered the option of producing their own educational podcasts that they considered relevant for the course. Such content would be uploaded on the Web site where it might be shared by other participants and the professor. It was hypothesized that the students would use the iPod as an empowerment tool, a technological device that would facilitate their active contribution to the construction of knowledge. In this case, the teacher would act as a resource person by evaluating the quality and relevance of podcasts with the other members of the classroom community.

We recorded very few occurrences of such uses. In effect, the students involved did not use the iPod to create podcasts or to seek, make available, or share content and information that would supposedly be useful for the classroom community. Despite the suggestions provided by their professors and the research team, students did not exploit the technological opportunities (the iPod and a dedicated Web site) to participate in a joint construction of a collective corpus of knowledge. This omission is meaningful. Some technical difficulties that students encountered at the beginning of the experience do not entirely explain why they did not even try to participate in joint construction of knowledge. It was as if overcoming these difficulties, spending time making podcasts, or sharing them via the Web site were not considered useful for academic purposes.

The Efficiency of Mobile Learning: Which Culture of Education Prevails?

Contemporary discourse supporting the adoption of audiovisual players as mobile learning devices is deeply rooted in and consistent with cultural assumptions about the nature of knowledge (that is, a rhizomatic, distributed, and diffused set of information) and with professional beliefs about

the nature of the learning process (that is, a knowledge-building joint activity connected with students' sociocultural world). It is mainly on the basis of such assumptions that educational institutions define efficient ways of learning in the digital age of contemporary knowledge societies. Yet when culture frames practices, differences often surface.

Why did hyper-technological students not act as mobile learners even if all the necessary and sufficient conditions were supposedly there? Why did they not seize the technological opportunities to engage in a new, flexible, context-free, co-constructed, and technologically mediated form of mobile learning? Why did they resist the new trend in the delocalization of the learning process and setting? The reasons lie in the invisible dimension of the students' culture and intentionality.

As we have seen, the cultural frames through which students make sense of both the learning process and the technology are not totally consistent with those of the institutions and practitioners. This cultural gap notably concerns the socio-constructivist model of learning and the continuity-contiguity of education with respect to students' sociocultural world.

Students' everyday academic practices appear to be organized according to a pragmatic approach to the learning process whereby "efficiency" acquires a culture-specific meaning. In students' cultural community, performing in an efficient way and acting as a "good enough" student entails learning what the professor has defined as relevant, necessary, and, moreover, sufficient information to pass the course; nothing less, nothing more. Certain declarative statements aside, students in this study do not appear to be inclined to act as active learners, to engage in a learning by doing or discovering process, or to contribute to the construction of distributed and rhizomatic knowledge. This pragmatic approach to learning contrasts with some of the basic principles of the socio-constructivist approach to learning and teaching. One of the main arguments justifying the adoption of digital mobile learning devices seems, then, to make very little sense in students' specific culture.

Similarly, concerning the postmodern idea of learning as a context-free activity, our research reveals that "mobile learning" is an oxymoron, at least in terms of the students' specific culture. Learning appears to require specific spatial and temporal boundary markers and settings. Reading, taking notes, understanding, remembering, and preparing for exams are "unmoving" cognitive activities that preferably occur at home, in the library, and in front of the personal computer equipped with a large screen—or at least a screen larger than that on an iPod.

Another cultural frame of reference that explains the students' resistance to this mobile turn in learning and teaching concerns the way they have interpreted the iPod: it is mainly perceived and used as mobile entertainment technology strongly associated with personal leisure and social life.

The mobile consumption of music, the social sharing of videos, photos, and digitized moments of social events, and the carrying of one's own universe of cultural references are all iPod practices that punctuate young people's everyday life. Our study reveals that students are moving consumers of culture, although the culture they consume in context-free ways is not academic. When students use the iPod in learning activities and contexts, they reverse the figure/ground logic of the iPod utilities: mobile consumption of academic podcasts is the exception, whereas recording, loading, and transferring files are common and regular patterns of activity for which the iPod technology in itself is not required. The use of this technology symbolically sets a clear boundary between everyday culture and academic culture, between social life and academic life. This trait of the students' specific culture strongly contrasts with the continuity pattern in education. Once again, one of the main educational arguments supporting the adoption of mobile teaching and learning devices seems not to be part of students' specific culture.

Conclusion

From the students' point of view, efficient learning does not imply transforming every single moment and place into a learning environment, nor does it imply demolishing the boundaries between formal and informal education. Rather, efficient learning implies differentiating the ways and the contexts where popular culture and academic culture are consumed. What may be and actually is relevant for an efficient social life, multitasking, mobile consumption of culture, mobile networking, and even the use of the iPod are not necessarily relevant for efficient academic life, and vice versa. These differences are not ontological, nor do they represent permanent and essential traits of academic and social life. Rather, they operate on a symbolic level: they are the differences that make the difference and thus give order and organization to everyday life. Although local and symbolic, this way of differentiating and defining which processes and technologies belong to which contexts and activities is part of students' culture, and differs from the basic assumptions of the mainstream culture of education.

Elucidating these cultural differences is not an argument for or against the integration of mobile devices into the teaching and learning process. The cultural frames of reference and the interpretive repertoires that are at stake in an educational context may change over time, and technological innovation contributes to such change. Yet these frames of reference and interpretive repertoires remain relevant factors in the process of technology adoption in education.

By subverting the logic inscribed in the technology, by defining the learning process and environment according to their specific worldview, the stu-

dents involved in our study diverted the educational project from the trajectory anticipated by the professors and even by the research team. In so doing they revealed the crucial, albeit often unnoticed, role of culture and of human intentionality in the appropriation of a technology. This finding has both theoretical and practical implications. From a theoretical point of view, it leads us inexorably away from any deterministic or functionalistic approach to technological innovation in education. This process—like any educational process—has an unavoidable degree of indeterminacy as it depends on the unique ways people interpret technologies and make sense of the learning process. Taking into account human agency and individuals' intentionality thus becomes imperative for understanding and even foreseeing technological innovation in education.

From a practical point of view, our results underscore the risks of innovating without knowing. Before launching extensive and expensive programs promoting the adoption of mobile devices, institutions, leaders, policy makers, and professors need to take into account the different operational cultures that prevail in their educational context. Also, they should not presume that a technology is a mere tool endowed with functions and utilities. As we have seen, technologies also carry praxis and have symbolic functions and meanings. Their use, and even definition, is always cultural, that is to say it is mediated by the cultural frames of reference the users live by. The efficiency-oriented culture of contemporary educational institutions and the students' specific culture are not necessarily the same. It is perhaps this cultural clash that could illuminate the reasons for different perceptions related to managing, exploiting, and even resisting the contemporary mobile turn in education.

References

Bélanger, Y. (2005). *Duke University iPod first year experience: Final evaluation report*. Retrieved May 14, 2008, from http://cit.duke.edu/pdf/reports/iPod_initiative_04_05.pdf.

Beldarrain, Y. (2006). Distance education trends: Integrating new technologies to foster student interaction and collaboration. *Distance Education, 27*(2), 139–153.

Bertolini, P. (2001). *Pedagogia fenomenologica, Genesi, sviluppo e orizzonti*. Firenze, Italy: La Nuova Italia.

Bongey, B., Cizadlo, S., & Kalnbach, G. (2006). Exploration in course-casting: Podcasts in higher education. *Campus-wide Information Systems, 23*(5), 350–367.

Bruner, J. (1986). *Actual minds, possible worlds*. Cambridge, MA: Harvard University Press.

Bruner, J. (1996). *The culture of education*. Cambridge, MA: Harvard University Press.

California State University. (2006). *California State University adopts podcasts learning*. Retrieved May 14, 2008, from http://calstate.edu/PA/news/2006/pod.shtml.

Caron, A. H. (2008). Globalisation and new technology: The challenge for teachers to become "translators" and children, knowledge seekers. In P. C. Rivoltella (Ed.), *Digital literacy: Tools and methodologies for information society* (pp. 277–291). Hershey, PA: IGI Publishing.

Caron, A. H., & Caronia, L. (2007). *Moving cultures: Mobile communication in everyday life*. Montreal: McGill-Queen's University Press.

Caronia, L. (1997). *Costruire la conoscenza: Interazione e interpretazione nella ricerca in campo educativo*. Firenze, Italy: La Nuova Italia.

Chan, A., & Lee, M. J. W. (2005). An MP3 a day keeps the worries away: Exploring the use of podcasting to address preconceptions and alleviate pre-class anxiety amongst undergraduate information technology students. In D. H. R. Spennemann & L. Burr (Eds.), *Good Practice in Practice: Proceedings of the Student Experience Conference* (pp. 58–70). Wagga Wagga, North South Wales: Charles Sturt University.

Corbeil, J. R., & Valdes-Corbeil, M. E. (2007). Are you ready for mobile learning? *Educause Quarterly, 30*(2), 51–60.

Dann, H. D. (1990). Subjective theories: A new approach to psychological research and educational practice. In G. R. Semin & K. J. Gergen (Eds.), *Everyday understanding: Social and scientific implications* (pp. 227–243). London: Sage.

Frydenberg, M. (2006). Principles and pedagogy: The two p's of podcasting in the information technology classroom. *Proceedings of the 23rd Annual Conference for Information Systems Educators ISECON 2006, 1*–10.

Gao, W., & Shen, R. (2008). Learning anytime, anywhere: Using mobile learning in a large blended classroom. *IADIS International Conference Mobile Learning 2008*, Algarve, Portugal, 164–168.

Geertz, C. (1973). *The interpretation of cultures*. New York: Basic Books.

Giorgi, A. (Ed.). (1985). *Phenomenology and psychological research*. Pittsburgh, PA: Duquesne University Press.

Giorgi, A. (1990). Phenomenology, psychological science and common sense. In G. R. Semin & K. J. Gergen (Eds.), *Everyday understanding: Social and scientific implications* (pp. 64–82). London: Sage.

Husserl, E. (1970/1913). *Logical investigations* (J. N. Findlay, Trans.). London: Routledge and Kegan Paul.

Kalkbrenner, G., & Dietrich, L. (2008). School goes mobile with Moodle: Dimensions of mobility in a showcase introduction of mobile learning in secondary schools. *IADIS International Conference Mobile Learning 2008*, Algarve, Portugal, 253–256.

Kerr, S. T. (2004). Toward a sociology of educational technology. In D. H. Jonassen (Ed.), *Handbook of research on educational communication and technology* (pp. 113–142). Mahwah, NJ: Erlbaum.

Kukulska-Hulme, A., & Traxler, J. (2005). Mobile teaching and learning. In A. Kukulska-Hulme & J. Traxler (Eds.), *Mobile learning: A handbook for educators and trainers* (pp. 76–83). London: Routledge.

Lave, J. (1996). Teaching, as learning, in practice. *Mind, Culture and Activity, 3*(3), 149–156.

Lave J., & Wenger, E. (1991). *Situated learning: Legitimate peripheral participation*. New York: Cambridge University Press.

Lazzari, M. (2007). *Podcasting in the classroom: Involving students in creating podcasted lessons*. Paper presented at the Conference HCI Educators 2007, Creativity3: Experiencing to educate and design, Aveiro, Portugal.

Lazzari, M., & Betella, A. (2007). Towards guidelines on educational podcasting quality: Problems arising from a real world experience. In M. J. Smith & G. Salvendy (Eds.), *Human interface and the management of information: Interacting in information environments* (pp. 404–412). Berlin: Springer.

Lee, M. J. W., & Chan, A. (2007). Reducing the effects of isolation and promoting inclusivity for distance learners through podcasting. *Turkish Online Journal of Distance Education*, 8(1), 85–104.

Luckin, R., Du Boulay, B., Smith, H., Underwood, J., Fitzpatrick, G., Holmberg, J., et al. (2005). Using mobile technology to create flexible learning contexts. *Journal of Interactive Media in Education*, 22, 1–21.

Pandolfi, G. (2007). But you don't play with the mobile information and communication technologies you already have: An instructional technologist's view of teaching with technology in higher education. In S. Kleinman (Ed.), *Displacing place: Mobile communication in the twenty-first century* (pp. 207–214). New York: Peter Lang.

Pontecorvo, C. (1993). Forms of discourse and shared thinking. *Cognition and Instruction*, 11(3/4), 189–196.

Potter, J., & Wetherell, M. (1987). *Discourse and social psychology: Beyond attitudes and behaviour*. London: Sage.

Resnick, L. B., Pontecorvo, C., & Säljö, R. (1997). Discourse, tools and reasoning. In L. B. Resnick, C. Pontecorvo, R. Säljö, & B. Burge (Eds.), *Discourse, tools and reasoning: Essays on situated cognition* (pp. 1–20). Berlin: Springer-Verlag.

Rogoff, B. (1990). *Apprenticeship in thinking: Cognitive development in social context*. New York: Oxford University Press.

Rogoff, B. (1995). Observing sociocultural activity on three planes: Participatory appropriation, guided participation, and apprenticeship. In J. V. Wertsch, P. del Rio, & A. Alvarez (Eds.), *Sociocultural studies of mind* (pp. 139–164). New York: Cambridge University Press.

Säljö, R. (1991). Introduction: Culture and learning. *Learning and Instruction*, 1, 179–185.

Säljö, R. (1992). Human growth and the complex society: Notes on the monocultural bias of theories of learning. *Cultural Dynamics*, 5(1), 43–56.

Schütz, A. (1966). *Collected papers: Tome III. Studies in phenomenological philosophy*. The Hague, Netherlands: Martinus Nijhoff.

Schütz, A. (1967/1932). *The phenomenology of social world*. Evanston, IL: Northwestern University Press.

Sharples, M., Taylor, J., &Vavoula, G. N. (2007). A theory of learning for the mobile age. In D. R. Andrews & C. Haythornthwaite (Eds.), *The Sage handbook of e-learning research* (pp. 221–247). London: Sage.

Wali, E., Winters, N., & Oliver, M. (2008). Maintaining, changing and crossing contexts: An activity theoretic reinterpretation of mobile learning. *Association for Learning Technology Journal*, 16(1), 41–57.

Wells, G. (2000). Dialogic inquiry in the classroom: Building on the legacy of Vygotsky. In C. D. Lee & O. Smagorinsky (Eds.), *Vygotskian perspectives on literacy research* (pp. 51–85). New York: Cambridge University Press.

Wenger, E. (1998). *Communities of practice: Learning, meaning, and identity.* New York: Cambridge University Press.

Wertsch, J. V. (1985). *Culture, communication, and cognition: Vygotskian perspectives.* New York: Cambridge University Press.

CHAPTER 13

Procrustean Pedagogy

The Architecture of Efficiency in a New Medium

▶ JULIAN KILKER

This chapter examines the perils of relying on simplistic notions of efficiency in the transition between traditional face-to-face environments used for education (schools) and environments that use computer network technologies (online learning management systems). Proponents of these online environments claim more efficient education that benefits students, instructors, and learning institutions. Because these systems have been adopted by a large number of schools and training organizations, it is likely that their design shapes current and future educational experiences of many people. Despite their rapid adoption, commercial learning management systems do not leverage best practices from the design of other new media and physical architectural environments.

Research about online pedagogy largely neglects the extensive literature about user interface and architectural design that is clearly relevant. Yet as learning management systems have become increasingly standardized and widely adopted, relatively minor software design decisions have a great poten-

tial to influence the inherently interactional nature of teaching and learning. I use the phrase "Procrustean pedagogy" to emphasize that typical learning management systems offer standardized and not easily adaptable environments in contrast with the notion, supported by both social constructivism in education and research in architectural and technology design, that interactive environments should adapt to and reflect their users' experiences. In Greek mythology, the bodies of Procrustes' unfortunate guests were stretched or shortened to make them fit their host's guest bed. This is analogous to students and instructors who must unlearn their experiences with teaching, learning, and information technologies in order to fit the limited standards of commercial learning management systems.

My main argument in this chapter—that perceptions of efficiency are highly contextual and differ based on the specialized experiences of the various people involved in any project—is applicable to general contexts besides learning management systems in which technologies are being developed, adopted, and optimized. Interpretations of what constitutes successful operation influence the development and implementation of technologies during their critical early stages (Pinch, 1993). Fundamentally, simplistic notions of efficiency can be embedded in new technologies such as learning management systems because the technology is opaque, in different ways, to the multiple social groups that it connects.

The Context: Online Learning Environments

This chapter focuses on contemporary undergraduate teaching environments in the U.S. rather than on the overall appropriateness of distance education. With the many well-known challenges facing undergraduate education in the U.S.—large class sizes, inconsistent preparation of students, and ballooning costs—it is no wonder that technologies that appear efficient are deployed in educational contexts. In its various forms, distance education does offer efficiencies that include a flexible schedule for participants, greater interaction among students, increased economies of scale, easier access to classes, and decreased transportation costs. At the same time, the overall effectiveness of online systems is unclear for reasons that include the time-consuming nature of interaction for both students and instructors (Cole, 2000), shifting loci of control from instructors and students to nonteaching administrators (Noble, 2002), digital divide barriers (Van Dijk, 2004), and the novelty effect, which leads to unrealistic initial impressions of the technology (Institute for Higher Education Policy, 1999).

Typically, a Web-based learning management system serves as the primary, if not only, point of interactive contact between an instructor, students, and academic administration for the duration of a course or a degree pro-

gram. These systems use information technologies to manage interactions between students, instructors, and academic resources. The technology controls and monitors access to course content such as readings and multimedia presentations (the online equivalent of classroom lectures); it enables participants to interact using tools such as discussion boards, e-mail, and chat functions (the online equivalent to classroom discussion, office hours, and question and answer sessions); and it facilitates the management of course modules, tests, and evaluations (the online equivalent of syllabus development, grade book, and exams).

During the original analysis in 2006, the dominant Web-based systems were Blackboard Inc.'s Blackboard Learning System and WebCT's Campus Edition. A recent merger between the two companies has led to an ongoing integration of features from these systems. Both Blackboard and WebCT have roots in academic information technology settings: Blackboard was developed in 1997 as a collaboration between two education consultants and a Cornell University online education project, and WebCT was initially developed at the University of British Columbia's Computer Science Department in 1995. Each of these commercial learning management systems had been through multiple large-scale revisions as well as incremental updates, which makes their interface shortcomings all the more noteworthy.

Usability in the Classroom and Online

The importance of usability is apparent from the traditional in-person classroom. In such environments, instructors often make relatively minor adjustments to improve their teaching environments. For example, instructors shape discussion patterns by rearranging students' chairs in a circle or by moving aside lecterns that separate instructors from their students to create a less formal setting. Instructors also encounter classroom characteristics that impede learning but over which they have very limited control; these include poor lighting, noisy air conditioning, and awkward presentation facilities, such as a projection screen that blocks the view of a blackboard. Overall, Mark Dudek (2000) argues, the design of pedagogical architecture is tightly intertwined with pedagogical philosophy, and teachers should become spatially aware and communicate with school designers about their complex roles and their experience with school environments.

Similarly, our experiences with physical classroom architecture suggest that instructors using online environments should be actively involved not only in creating content and standardized templates but also in shaping the more fundamental features of the interactive environment. If the computer interface is "where the action is" (Dourish, 2001), then a close analysis of the efficiency of these interfaces is crucial. In user interface design litera-

ture, user control is regarded as important. According to a wide range of respected usability references over the past two decades (Apple Computer, 1993; Dix, Finlay, Abowd, & Beale, 1993; Shneiderman, 1987, to name just a few), interactive systems that aim to be "usable" should be predictable and consistent, support an "internal locus of control," provide shortcuts for experienced users, incorporate aesthetic integrity, and be accessible to those with various disabilities.

Officially, commercial learning management systems often receive positive usability reviews (for example, Copas, Witherspoon, & Reynolds, 2004), and industry coverage material is typically uncritical (for example, Business Wire, 2004). But a large number of comments from students, instructors, and instructional designers suggest broad and consistent areas of concern. People who use WebCT and Blackboard have contributed to many gripe Web sites and discussion threads on professional and personal sites, including *Why WebCT Sucks, All 44 Blackboard Patent Claims Invalidated (Slashdot)*, and multiple Facebook groups with titles such as *Blackboard Sucks, Blackboard Ruins Lives*, and *Blackboard Deserves to Be Slaughtered Because It Ruined My Life*. A sample quote from *Why WebCT Sucks* reads:

> I am teaching an upper-division distance class with this product [WebCT] now, and it is riddled with code errors, usability problems, limitations, and quirks. The incorporation of the JAVA code is particularly troublesome. This has doubled my workload and stressed out many students—all for no reason! This is a classic example of institutional dysfunction and gullibility to a slick sales pitch. (2006)

The pedagogical interfaces of Web-based environments are limited by Web standards, which constrain forms of interaction online in comparison with other computer software. For example, common tasks using Web-based tools are typically divided into a series of incremental Web page by Web page steps. In addition, learning management systems may be limited by their need to address a wide range of pedagogical contexts and resources: Blackboard emphasizes that its software and services are used by clients including "primary and secondary schools, higher education, corporation and government markets as well as textbook publishers and student-focused merchants" (Blackboard, Inc., 2008b), and the company's more recent efforts involve student billing and campus messaging systems.

Architecture, both physical and online, is influenced by many design decisions, constraints, and goals. Take the example of the international dining hall and dormitory built in the early 1960s at Pomona College in Claremont, California. The intention in constructing this hall was to extend the "usual concept of a 'language house' and to build a unique coeducational residence hall which would serve as a language and international relations center for the entire college" (Lyon, 1977, p. 538). As with any construction, the result-

ing form reflected the context in which it was designed and built. The original building, which was designed to encourage cultural immersion, also segregated the sexes in distant wings. While this example might appear dated, my point here is that parallel manifest and latent rationales exist with present-day online pedagogical systems. Now divided into multiple coeducational language dormitories, the building has not aged well. In a 2003 report assessing the building's role in the school and its potential reconstruction, a faculty panel noted:

> The physical design of the facility hinders the ease of human interaction needed to maintain an effective foreign language or cultural experience. Lounges are too small and awkwardly placed; single rooms opening onto narrow dark corridors hinder social interaction; and the lack of recognizable boundaries between sections results in ill-defined section identities. (Faculty Report, 2003, p. 10)

Because the construction used "efficient" concrete blocks, the facility could not be easily modified to reflect changing social conditions or pedagogical goals. One outside reviewer noted that the "architectural characteristics and layout must be part of the discussion [of renovating the facility]. The design of the rooms does not lend itself to a language immersion environment. Students are isolated from each other and from the native-speaker/mentor" (Faculty Report, 2003, p. 12). These comments identify a problem common with physical architecture: that the building cannot effectively "learn" (Brand, 1995), and that its form does not allow it to be shaped through use to reflect shifts in function as well as shifts in people's expectations. In its present state, the physical architecture hinders pedagogical goals. While it meets official accessibility guidelines—including building codes and handicapped access—the facility does not meet a broader notion of pedagogically appropriate usability.

A wide variety of factors in the physical environment of instructional settings have been empirically shown to influence students, teachers (Martin, 2002), and the overall learning experience (Gump, 1987; McGuffey, 1982; Weinstein, 1979). In general, researchers have found that students' academic outcomes are associated with factors such as the educational facilities' air quality, comfort, lighting, and acoustics (Schneider, 2002). The University of Wisconsin's School Design Research Studio summarizes solutions in its 33 *Principles of Educational Design* (Lackney, 2003).

In contrast to architectural debates about school construction, literature addressing the structural design of learning management systems is limited. Despite thoughtful early research about computer-based learning (for example, Papert, 1980), only the rare article examines online pedagogical environments from a student-centered design perspective (for example, Gillani, 2000), and instructor-centered perspectives that focus on educational work

flows are even rarer. The major focus of user interface discussion and critique in learning management systems uses the relatively narrow view of "accessibility" from the federal government's Section 508 of the Rehabilitation Act (U.S. Government, 1998), which is designed to accommodate various disabilities, including visual and motor skills (Blackboard, Inc., 2008a). A growing number of scholars have moved beyond this limited notion of accessibility to include "digital divide" (Van Dijk, 2004) and "media literacy" (Kellner, 2002) factors that influence access to digital content. Overall, outcomes when using learning management systems are difficult to evaluate and may be strongly influenced by the novelty effect, in which differences are largely attributable to the newness of the context rather than its characteristics (Institute for Higher Education Policy, 1999).

Task-based Analysis of Learning Management System Inefficiencies

A traditional usability analysis examines specific characteristics but typically does not analyze naturalistic task flows, such as the series of tasks used to accomplish a typical teaching goal under normal conditions. While quantitative survey design and usability techniques are appropriate in mature technological contexts in which evaluation factors are standardized, for recent technologies such as learning management systems more open-ended case study techniques are appropriate for evaluation and revision. In fact, one could argue that a rush to develop discrete usability benchmarks is an attempt to prematurely influence how the success of such systems will be measured (Pinch, 1993).

The case study examined in this chapter used a variation of the standard talk aloud procedure to identify problems in the pedagogical environments. First, I recorded my observations while preparing and teaching an online course using the Blackboard Learning System (release 6.1.5). Then, I videotaped an advanced student participating in and commenting on multiple courses at another university using the same learning management system. Later, I summarized my analyses for two instructional technologists experienced with WebCT at a third institution to compare the issues I identified with their experiences and to incorporate their perspectives. Tellingly, both staff members requested anonymity because their participation in a project that critically analyzes commercial learning management systems that their institution had invested heavily in might jeopardize their employment. Such requests highlight the political sensitivity of information technology funding and administration on university campuses, and they suggest why in-depth analyses of these systems are rare. Finally, I gathered additional

information from student, developer, and instructor comments online and in a WebCT marketing presentation.

While the examples I provide are from Blackboard, similar usability issues were present in concurrent versions of WebCT. I focus on three types of usability challenges found during simple but common instructor tasks such as creating a course announcement, deleting a course file, and responding to a student's query about submitting homework.

Challenges of Feedback, Status, and Flow: "Where Am I?"

Architects and usability designers have identified navigation and environmental feedback as key factors needed to ensure that people can function efficiently in a new environment. An example of feedback is standardized airport signage, which is designed to assist in "wayfinding" by making information accessible to new arrivals from multiple cultural backgrounds. Similar usability guidelines specify techniques for communicating feedback to people using technology so that they can rapidly understand the context and their options. Basic usability guidelines, however, appear to be neglected in Blackboard.

A common task for instructors is writing announcements for an entire class. (In a physical classroom, these could be verbal announcements or handouts.) The Blackboard learning management system provides a multistep method that has usability limitations typical of many simple Web sites. (Because Blackboard is a Web application, it generates Web pages on the fly; these pages are subject to similar design concerns, constraints, and analyses as those of a typical Web site.) First, instructors compose messages in a very small editing window that restricts them from viewing the complete message; they can preview the message in a larger window that displays (but does not allow editing of) the entire message. The preview window does not display the message title, which would be useful to compare with the message body. If, as is typical, several corrections and clarifications need to be made to messages, instructors must cycle between these edit and preview modes several times.

The overall problems here are feedback and flow: preparing and reviewing a message are considered two distinct (modal) operations that are not appropriately intertwined in this interface. A complicating factor due to the Web-based environment is that the window titles are confusing. Blackboard uses generic window titles ("Blackboard Learning System" and "Preview") rather than unique names associated with each message. When people work with multiple software applications and windows simultaneously, as is common, the windows are difficult to distinguish from each other. Learning management system users often multitask—there are ample opportunities

to do so while waiting for the system to respond, while transferring information from a word processor to the learning management system, or while attempting to modify several items in parallel. In such cases, people can easily forget the task's steps and their current position within each task because of the multiple steps and the limited feedback cues from Blackboard.

Interface cues about the context should be clear, especially during critical activities such as deleting information. Yet in the version of Blackboard that I examined, important cues can be ambiguous and options for common tasks are often insufficiently precise. For example, when an item is deleted from a list of files, a pop-up window warns, "Are you sure that you want to remove this item?" without specifying which file will be deleted. Similarly, course designers have the ability to color-code material—all of the optional links can be a specific green and exam links a prominent red, for example— yet the "ColorPicker" tool, which displays a pop-up window containing 216 unlabeled subtle color variations, neither indicates the current color setting nor allows colors to be labeled for consistent use.

Challenge of Conceptual Models: "How Does This Work?"

Usability researchers such as Don Norman (1988) argue that people can operate technology more efficiently when they can easily develop a conceptual model based on their interactions with the technology. The ad hoc model then informs their understanding of the technology and their ability to predict the consequences of interactions with it. This challenge is often addressed by system designers carefully researching the context in which the system will be used and then deliberately planning interface metaphors, terminology, and feedback cues. For this reason, professional production tools such as Avid (for video editing) and Aperture (for digital image management) are based on common work flows from the video and photography professions that experienced users can rapidly understand.

Planning consistent, reasonable metaphors and terminology is essential when creating a virtual environment, especially when the metaphors and terms pertain to actions that might result in the loss of data. For example, a controversial design decision made in the early Apple Macintosh was to have dragging an icon to the trash bin icon represent both throwing away (deleting) a file and discarding (ejecting) a disk. These were similar actions metaphorically from the designers' perspectives, but not for users, who feared the loss of entire disks of their valuable data. (Later, Apple redesigned its software to display an eject icon instead of a trash bin when selecting a disk.)

Similar shortcomings in the design of the Blackboard environment demonstrate the importance of consistent cues in the design models. When

instructors create course announcements, they are usually posted on the main page of the course Web site in reverse chronological order, with the newest posting at the top. But instructors can force older announcements to remain at the top, presumably because of the importance of the announcements. This breaks the expected chronological model, and if users are not aware of this subtlety, they are likely to overlook new postings because they are out of the expected order.

In learning management system environments, the moving, copying, and deleting of course materials is common when instructors organize and fine tune their courses. Rather than using the click and drag technique that is second nature for most computer users in which icons representing files and folders are moved, duplicated, and thrown away, the Blackboard interface requires an instructor to follow a laborious sequence of steps to move content. Confusingly, the same command is used for both the copy and move functions, but the difference between them is indicated by different terminology in the final question on the page: "Delete item after copy?" (answering "yes" makes this a move, answering "no" makes this a copy").

These examples demonstrate that the environment is inconsistent in both its models of operation and its terminology. Compensating for these inconsistencies presents a particular challenge for users who are inexperienced with computers: not only are they encountering new course content and must understand simple computer operation, but they must also identify, comprehend, and compensate for subtle inconsistencies within the learning management system interface as well as inconsistencies between this system interface and that of the computer.

Challenge of Scaffolding: "Are My Experiences Transferable?"

"Scaffolding" (Vygotsky, 1978) is the notion that knowledge is built on previous, solid foundations, and it suggests that experiences are more valuable—and ultimately more efficient because people benefit from time invested in learning them—if they are transferable to and from the learning management system. One might expect an interface designed to support educational contexts to thoroughly incorporate pedagogical considerations. Usability research suggests that interfaces should be forgiving and thus encourage exploration without serious consequences. Yet when people make mistakes in the Blackboard environment, they cannot turn to a consistent "undo" command like that typically found in other software. While the "removing an item" warning indicates the designers' concern about verifying important choices, these warnings are pointless unless users are aware of their implications. If users cannot understand the choices, they should be able to explore

them—but if their selections cannot be undone, users cannot backtrack to make different ones.

Using Web pages as the main interface requires that common tasks be broken down into a series of simple incremental steps, making it difficult to keep track of each step within the larger task. For example, if instructors want to redesign a four-month course for a two-month intensive session, they might need to repeatedly merge and rename groups of readings and assignments. Similarly, instructors managing multiple courses might want to develop personal shortcuts for common actions, and document their progress in completing the lengthy tasks. There are accepted techniques for accomplishing this with other computer interfaces: at the basic level, most computer users are familiar with selecting groups of items and moving (or deleting) them; advanced users are more familiar with creating scripts or macros that automate repetitious tasks in spreadsheet and image editing applications. In the version of Blackboard I examined, however, common groups of actions cannot be saved for future use or to document that they have been implemented. A "content receipt" is created as feedback to confirm a successful operation. But it is very limited. One example read in its entirety, "Content receipt. Course link copied: All syllabus files," followed by a time stamp. Such a receipt does not indicate details about the action it is confirming, nor does it maintain a log to assist in documenting or troubleshooting a larger task, nor does it allow actions to be saved or annotated for future use. An example of a better solution is the "history" function in Adobe Photoshop, which maintains a list of task steps that can be viewed, saved, and modified.

From a pedagogical perspective, mistakes are learning opportunities, and providing supportive and timely assistance in response to mistakes is an important goal for teachers. Similarly, a learning management system should reduce opportunities for error, give feedback that facilitates intended actions, and provide contextual information about errors. Within the Blackboard interface, however, there is no consistent help feature such as a clickable question mark that, on demand, provides a contextual explanation, examples, and cautions. An advanced version of this feature would solicit suggestions and annotations by users. Tracking these help requests would provide valuable feedback to designers about which areas of the interface are problematic for which types of users. Informing users of their shaping role would give them a sense of participation in their educational environment—a key aspect of constructivism.

During the course of this data collection, I attempted to view the homework "Dropbox" in Blackboard from the perspective of a student in order to respond to a question about submitting an assignment. The result was, "Error:

The action you attempted did not succeed. With a course role of Instructor, you must enter Dropbox from the Control Panel."

This message raises questions such as: How do I accomplish the task that I'm obviously trying to do? (if the interface can tell me how I should act, why not do or link to the action?); Why is this an error? (it seems a reasonable operation); and Why can't I experience the student perspective?" (as I can when I walk to the back of a classroom to verify the readability of my presentation materials projected up front). In this version of Blackboard, I am prevented from taking on the student identity—a serious problem when trying to test, explain, or check the process of submitting homework.

A similar problem existed in the concurrent version of WebCT, in which user and designer "views" could not be easily switched, and which, according to one information technology designer, is "critical when you're designing…you want to be able to see how it's going to work or not" (Personal communication, October 20, 2005).

Each of these challenges—the feedback, status, and flow challenges; the inconsistent conceptual models; and the nonscaffolding interface—demonstrates the extent to which a dominant commercial learning management system has not been designed with pedagogical goals in mind; that is, to be easily explored (there are repercussions for mistakes, and there is no undo), to be easily learned by students and instructors (poor feedback, conceptual model, logging, and help features), or to facilitate modification and improvement (no ongoing design feedback process or scripting).

The Challenge of Current Pedagogical Environments

There are two common responses that supporters of online teaching have to this type of usability analysis. The first is that such problems will be addressed in the next version of the environment. This growing pains argument is sometimes the case, although in practice fixes tend to introduce new problems, particularly when the original conceptual model was poorly conceived. And even though many of the issues listed have been addressed in subsequent versions of Blackboard and WebCT, it is surprising that they existed in the first place.

The second response, more serious from usability and efficiency perspectives, is that an often obscure feature or technique addresses the problem, and that the instructor, student, or educational designer should learn about it. This work-around approach expects people to modify their normal work flows to accommodate the technology, rather than reshaping the technology to accommodate common instructional approaches. Technical tricks

usually do not help people develop a solid conceptual model of the underlying learning management system, nor do they have long-term usefulness because the problems addressed are likely to change with new versions of the technology. The very notion of a work-around solution contradicts standard usability and pedagogical goals.

The growing pains and work-around responses ignore a subtler conclusion: that the array of interface problems indicates that a pedagogically focused conceptual model is not driving the design. The commercial learning management system model appears to emphasize technological features over usability characteristics; indeed, marketing for the more recent WebCT Vista system claims that it has been rewritten to take advantage of a new underlying relational database technology.

The design of commercial learning management systems often conflicts with usability goals that are influential in interactive technology design. Pedagogical technology developers should follow established knowledge acquisition theories in their tool design and development. For example, Lev Vygotsky (1978) argues that new information should be just beyond the learner's current conceptual grasp when learning new skills; he calls this the learner's "Zone of Proximal Development." Vygotsky's perspective is similar to Stephen Krashen's (1981) "Theory of Second Language Acquisition," which holds that learning takes place when "comprehensible input" is at one stage beyond the learner's current stage. (I am indebted to Yvonne Houy for introducing me to Vygotsky's and Krashen's work.) In online pedagogical environments, learning includes both content area acquisition and computer literacy, and thus both the learning management system environment and the course content should provide comprehensible input. These theories suggest that short term efficiency goals often used to justify the adoption of learning management systems are not necessarily the most pedagogically productive over the long term.

Peoples' experiences with computers differ subtly (Van Dijk, 2004), and content, context, and experiential differences have important implications for the design of Web-based pedagogical environments. These interface problems highlight the fundamental challenge: how do we design interfaces that are usable and efficient for multiple groups and for diverse skill levels within these groups? Without deeply understanding specific pedagogical contexts and the many groups of people associated with them, developers cannot create environments that are appropriately flexible to meet this challenge.

Design and Efficiency

The Web-based environment is the point at which pedagogical decisions are made real; the decisions include not only the pedagogical characteristics but

to what extent and how easily such characteristics may be changed, if necessary. The overall design of school architecture, Dudek (2000) argues, is tightly intertwined with pedagogical philosophy; school architects are repeatedly faced with the challenge of balancing multiple design priorities, knowing that their design decisions are figuratively and literally set in concrete. For example, pedagogical philosophies that are student centered might reasonably involve open-plan schools, and philosophies emphasizing rote learning might involve a grid of fixed desks facing a lecture podium.

Dudek (2000) suggests that teachers become spatially aware and communicate with school designers about their complex roles and their experiences with school architecture, a practice that can be adapted for the design of specialized educational software as well. While researching specific contexts and tasks can be challenging, instructors do this continually as they shift and change their teaching approaches, course goals, and lesson plans in response to their students' evolving learning needs. This research is often informal, but it is useful for creating effective learning environments. When the flexibility of the human instructor is mirrored in a pedagogical environment, the instructor can create the optimal conditions for learning. Properly designed, such environments can allow interactivity characteristics to be shaped by their users in ways not possible with physical architecture.

Because specific learning contexts demand specialized instruction, and individual students have specialized needs, developers cannot sufficiently anticipate the multitude of learning needs. If developers want to realize student-centered learning in online environments, students and their instructors should be able to shape those environments according to their course and individual learning needs and wishes. People should be considered codevelopers of the technology from the early stages of a pedagogical environment's development and use. This challenge is not new: people exploring technology and shaping it to meet their own needs contributed to the success of earlier information technologies, such as the personal computer (Bardini & Horvath, 1995) and networked e-mail (Kilker, 2002). Like a building that continues to be shaped as its changing occupants dwell within and around it, so too do online pedagogical environments need to be shapeable by student and instructor occupants as they change and grow. Environments that do not learn—that is, whose forms do not allow dynamic shaping by instructors and students so that they reflect their experiences—will be as ineffective, frustrating, and short-lived as their physical counterparts (Brand, 1995).

More specifically, educational technology designers should focus on techniques developed in the user interface world. They should examine and adapt Web interfaces that are acknowledged leaders: Amazon.com's Web site

for searching, identifying similar content, and exchanging comments; Google's tools for searching and clean, informative interface; major news sites for well-designed structuring of content; and the interactive click-and-drag updating used by Google Maps and Netflix. Designers should pay close attention to the interface philosophies and guidelines that inform computer interfaces: Apple Computer (1993) and Microsoft Corporation (2007) publish interface guidelines that are particularly useful. There is no shortage of excellent user interface design books (Johnson, 2000; Krug, 2005). Nor is there a shortage of works that discuss the larger philosophical concerns of social aspects of architecture, both in how architecture can shape social interactions and how social concerns can be embedded in architecture (for example, Alexander, Ishikawa, & Silverstein, 1977; Brand, 1995; Dudek, 2000). Overlooking relevant literature and best practices is not uncommon in the rushed development of new technologies, but this situation can be remedied.

It is worth examining and comparing the design strategies, ideals, and influences for commercial and open-source learning management systems. Key questions include: who are the major social groups and how do they interpret the technology and one another? Students and instructors are usually portrayed as key users of the technology, but my interviews suggest that instructional designers, information technology specialists, and school administrators, many of whom have had limited experiences in traditional face-to-face and/or online classroom environments, are influential social groups as well. An instructional designer I interviewed found that pedagogical perspectives were largely overlooked at the professional meetings she attended:

> I was at an Educause conference...there were few instructional designers. The IT [information technology] folks were just adamant that [teachers] did not know what they needed,...there's a real disconnect, I think, at times [between] IT and faculty or instructional designers, or people who are concerned with the pedagogy or interaction or the interface. (Personal communication, October 20, 2005)

A related topic concerns how people shape the software they use: how is formal user feedback collected, analyzed, prioritized, and implemented? For example, while WebCT has an extensive advising board, the depth and breadth of its members' pedagogical experience is unclear, and its technology seems to lack a coherent pedagogical philosophy. In contrast, Moodle, an open-source system explicitly designed to support a constructivist pedagogical philosophy, is evaluated favorably in comparison with Blackboard in several small studies (Machado & Tao, 2007). Because Moodle is license free and is updated with contributions from active user groups at sites in

many countries, it offers a different set of efficiencies than commercial systems (see Jurgenson and Ritzer, chapter 4, for more about the effectiveness of open-source applications). The Sakai project, begun with funding from the Mellon Foundation, is another popular open-source system. Like Moodle, it has active user participation in design and development of the technology. There is an ongoing and lively debate about the benefits and challenges of open-source projects in general, but as mentioned earlier, Bardini & Horvath (1995) and Kilker (2002) provide useful perspectives on people actively developing their own tools. As with any infrastructure that involves an extensive investment in resources, institutional factors influence who evaluates new technologies, and how technologies are adopted. Contexts do vary considerably, but the instructional designer noted she had seen a "real reluctance… in academia, to use open source [such as Moodle]. Individuals like to use open source, but if you take an IT [information technology] group…no. They want a well-known [thing]" (Personal communication, October 20, 2005).

As demonstrated in the critical evaluation of the Pomona College language hall and the architectural resources described earlier in this chapter, educators are familiar with the challenges of negotiating the design of physical academic resources such as buildings, libraries, and student facilities. But the processes for negotiating parallel characteristics of online pedagogical environments are still in their infancy, and design and adoption decisions are too often driven by marketing, technical, and administrative considerations rather than by relevant pedagogical and design experiences.

Conclusion

Although online pedagogical environments have the potential to be more flexible and efficient than their physical precedents, this potential has yet to be realized in what appears to be thus far a surprisingly Procrustean approach to teaching and learning.

This case study indicates that (1) the design of the major commercial learning management systems limits their efficient use in practice; (2) these limitations, while in many cases technically minor, can in aggregate shape how people use the system; and, ultimately, (3) that such limitations result from simplistic understandings of efficiency that privilege specific perspectives—in particular, technical and administrative—among the multiple groups of people that the technology connects. These notions of efficiency are less apparent than with existing physical environments because learning management systems are conceptually opaque ("black boxes") to users, like many consumer technologies (Kilker, 2003). People who do not understand

a technology do not appreciate how it can be modified or further optimized; the converse is true, too (Kilker, 2007).

Learning management systems shape educational interactions, and their designs have important implications for how people understand education and structure teaching situations. When analyzing what makes an environment for education efficient, we must ask, "efficient for whom?" and incorporate experiences from related contexts (for example, architecture and usability design) as well as encourage spirited discussion among the groups of people who will use the technology, much as the public design charrette is used in urban planning to incorporate perspectives from multiple stakeholders.

References

Alexander, C., Ishikawa, S., & Silverstein, M. (1977). *A pattern language: Towns, buildings, construction*. Oxford: Oxford University Press.

Apple Computer. (1993). *Macintosh human interface guidelines*. New York: Addison-Wesley.

Bardini, T., & Horvath, A. (1995). The social construction of the personal computer user. *Journal of Communication*, 45(3), 40–65.

Blackboard, Inc. (2008a). *Accessibility and the Blackboard Academic Suite*. Retrieved July 13, 2008, from http://www.blackboard.com/company/accessibility.aspx.

Blackboard, Inc. (2008b). *Elevating education*. Retrieved July 13, 2008, from http://www.blackboard.com/company.

Brand, S. (1995). *How buildings learn: What happens after they're built*. New York: Penguin.

Business Wire. (2004, July 14). *WebCT user survey shows significant increase in enterprise-wide implementations, usage and user satisfaction*. Retrieved July 13, 2008, from http://findarticles.com/p/articles/mi_m0EIN/is_2004_July_14/ai_n6105613.

Cole, R. A. (2000). Introduction. In R. A. Cole (Ed.), *Issues in web-based pedagogy: A critical primer* (pp. ix-xii). Westport, CT: Greenwood.

Copas, G. M., Witherspoon, T. L., & Reynolds, K. V. (2004). Blackboard gets a global review. *Usability News*, 6(2). Retrieved July 13, 2008, from http://psychology.wichita.edu/surl/usabilitynews/62/blackboard.htm.

Dix, A., Finlay, J., Abowd, G., & Beale, R. (1993). *Human-computer interaction*. New York: Prentice Hall.

Dourish, P. (2001). *Where the action is: The foundations of embodied interaction*. Cambridge, MA: MIT Press.

Dudek, M. (2000). *Architecture of schools: The new learning environments*. Oxford: Architectural Press.

Gillani, B. B. (2000). Use the web to create student-centered curriculum. In R. A. Cole (Ed.), *Issues in web-based pedagogy: A critical primer* (pp. 161–181). Westport, CT: Greenwood.

Gump, P. (1987). School and classroom environments. In I. Altman & J. F. Wohlwill (Eds.), *Handbook of environmental psychology* (pp. 131–174). New York: Plenum Press.

Institute for Higher Education Policy. (1999). *What's the difference?* Washington, DC: Institute for Higher Education Policy.

Johnson, J. (2000). *GUI bloopers.* San Francisco: Morgan Kaufman.

Kellner, D. (2002). New media and new literacies: Reconstructing education for the new millennium. In L. Lievrouw & S. Livingstone (Eds.), *The handbook of new media* (pp. 90–104). London: Sage.

Kilker, J. (2002). Social and technical interoperability, the construction of users, and "arrested closure": A case study of networked electronic mail development. *Iterations, 1*(1). Retrieved July 13, 2008, from http://www.cbi.umn.edu/iterations/kilker.html.

Kilker, J. (2003). Shaping convergence media: "Meta-control" and the domestication of DVD and web technologies. *Convergence, 9*(3), 20–39.

Kilker, J. (2007). Breaking free: The shaping and resisting of mobility in personal information and communication technologies. In S. Kleinman (Ed.), *Displacing place: Mobile communication in the twenty-first century* (pp. 105–121). New York: Peter Lang.

Krashen, S. D. (1981). *Second language acquisition and second language learning.* New York: Pergamon Press.

Krug, S. (2005). *Don't make me think* (2nd ed.). Berkeley, CA: New Riders Press.

Lackney, J. A. (2003). *33 principles of educational design.* Madison: University of Wisconsin–Madison.

Lyon, E. W. (1977). *The history of Pomona College, 1887–1969.* Claremont, CA: Pomona College.

Machado, M., & Tao, E. (2007, October). Blackboard vs. Moodle: Comparing user experience of learning management systems. *Proceedings of the 37th Annual ASEE/IEEE Frontiers in Education Conference,* 7–12.

Martin, S. H. (2002). The classroom environment and its effects on the practice of teachers. *Journal of Environmental Psychology, 22*(1/2), 139–156.

McGuffey, C. (1982). Facilities. In H. J. Walbert (Ed.), *Improving educational standards and productivity* (pp. 237–288). Berkeley, CA: McCutchan.

Microsoft Corporation. (2007). *User interface design and development.* Retrieved July 13, 2008, from http://msdn.microsoft.com/en-us/library/aa511258.aspx.

Noble, D. F. (2002). *Digital diploma mills: The automation of higher education.* New York: Monthly Review Press.

Norman, D. A. (1988). *The design of everyday things.* New York: Basic Books.

Papert, S. (1980). *Mindstorms: Children, computers, and powerful ideas.* New York: Basic Books.

Pinch, T. (1993). "Testing–one, two, three…testing!": Toward a sociology of testing. *Science, Technology, and Human Values, 18*(1), 25–41.

Schneider, M. (2002). *Do school facilities affect academic outcomes?* Washington, DC: National Clearinghouse for Educational Facilities.

Shneiderman, B. (1987). *Designing the user interface: Strategies for effective human-computer interaction.* Reading, MA: Addison-Wesley.

U.S. Government. (1998). *Section 508 of the Rehabilitation Act (29 U.S.C. 794d), as amended by the Workforce Investment Act of 1998 (P.L. 105–220), August 7, 1998.* Retrieved July 13, 2008, from http://www.section508.gov/index.cfm?FuseAction=Content&ID=14.

Van Dijk, J. (2004). *The deepening divide: Inequality in the information society.* Thousand Oaks, CA: Sage.

Vygotsky, L. S. (1978). *Mind in society: The development of higher psychological processes.* Cambridge, MA: Harvard University Press.

Weinstein, C. (1979). The physical environment of the school: A review of the research. *Review of Educational Research, 49*(4), 577–610.

Why webCT sucks. (2006). Posted June 27, 2006, http://webct.realmtech.net.

CHAPTER 14

Stalking Made Easy

How Information and Communication Technologies Are Influencing the Way People Monitor and Harass One Another

▶ PENNY A. LEISRING

Your phone rings and obscene callers are on the line. Strangers show up repeatedly in the middle of the night at your door wanting to force themselves on you sexually. This is what happened to the victim in the first case prosecuted under California's cyberstalking law. Randi Barber was being cyberstalked by a man from her church, Gary Dellapenta, who was posting things about her on the Internet (Hitchcock, 2002). After Barber rejected Dellapenta's romantic overtures, Dellapenta posed as Barber in Internet chat rooms and announced that she had fantasies about men raping her. He posted her home address and phone number online and urged men to show up at her home in the middle of the night. He even told them how to break into her apartment and bypass her home security system (Hitchcock, 2002). Dellapenta told the men that her refusals were part of her fantasy but that she really wanted the men to force themselves on her. Six men showed up at her home (Hitchcock, 2002). Barber was traumatized. She lost 35 pounds, lost her job, and moved out of her home (Morewitz, 2003). Dellapenta was

sentenced to six years in prison for stalking and for soliciting others to commit rape (Hitchcock, 2002).

This case illustrates one way that people use the Internet to stalk and harass others. Information and communication technologies such as computers, cell phones, and BlackBerry-like devices are making stalkers more efficient. Remarkably, a "stalker's home page" exists on the Internet, containing information and Web links for people interested in stalking others (Roberts, n.d.). Cyberstalking is "easier and less risky" to engage in than more traditional offline forms of stalking (Bocij, 2004, p. 36). Stalking with technology—cyberstalking—is common, especially among college students. Most cyberstalking is perpetrated by someone who knows the victim, and often cyberstalking, like other forms of stalking, is perpetrated by an ex-partner after a romantic relationship ends. Some ex-partners hope to rekindle the relationship. Computer-mediated communication may "promote a false sense of intimacy and misunderstanding of intentions" (Finn & Banach, 2000, p. 248). If a person's messages are responded to, their hope and behavior may persist or increase. According to Brian Spitzberg's (2002) review of offline stalking methods, stalking often lasts for almost two years. Paul Bocij (2004) suggests that cyberstalking typically lasts about four months.

All 50 states in the U.S. have laws against stalking, and the Federal Violence Against Women Act now includes cyberstalking (Spence-Diehl, 2003). Stalkers have used a variety of methods to monitor and harass their victims, including phone calls, in-person contact, and surveillance methods (Sheridan, Blaauw, & Davies, 2003). The Internet has expanded stalking methods, and now people can stalk others anonymously or pseudononymously (Tavani & Grodzinsky, 2002). Cyberstalkers may send repeated e-mails, chat requests, or text messages, or they may make repeated cell phone calls to the victim. Some monitor the victim's activities by reading the victim's e-mails; online "away messages," which sometimes reveal the current location and behavior of the victim; and postings to social networking Web sites, such as MySpace and Facebook. Some perpetrators use global positioning system (GPS) devices to track their target's physical location, and they may even use computer spyware to monitor their victim's Web activity or computer keystrokes. When victims discover these activities, it can lead to tremendous fear and distress, especially for female victims.

This chapter discusses the most common ways in which technology is used for stalking. It examines the characteristics of stalkers and the common effects of stalking on victims. Actions that can reduce the likelihood of being stalked are reviewed and suggestions are provided for future research.

Definitions

Various definitions of stalking are used, some of which are quite subjective. Legal definitions of stalking often require that the contact is both repeated and threatening in nature (Spitzberg & Hoobler, 2002). However, Brian Spitzberg and Alice Veksler (2007) have found that some people label themselves as having been stalked even if they haven't been threatened. Many definitions also require that the victim be fearful (White, Kowalski, Lyndon, & Valentine, 2000), but Angela Amar (2007) has found that many college women consider themselves as having been stalked even if they did not experience fear. The line between stalking and harassment is often a blurry one (Tavani & Grodzinsky, 2002). Furthermore, researchers measure a variety of behaviors that are similar to stalking but that may not meet legal definitions of stalking (Sheridan et al., 2003). Some of these behaviors include: obsessional following, obsessional harassment, obsessional relational intrusion, as well as unwanted pursuit. Rebecca Lee (1998) asserts that in some ways, stalking has paradoxically become part of "normal" romantic pursuit on college campuses.

Types of Stalking with Technology

The ways in which information and communication technologies are being used to stalk and harass others are numerous. Cindy Southworth and Sarah Tucker (2007) have provided an excellent review of many cyberstalking methods. Stalkers may use cell phones to repeatedly call or send text messages to their victims. Fax machines may be used to send messages and the header on faxes may reveal the location of a victim, if she sends a fax to the stalker (Southworth, Finn, Dawson, Fraser, & Tucker, 2007; Southworth & Tucker, 2007). Stalkers may use computers to send e-mail or instant messages to the victim or to post information about the victim on Web pages, bulletin boards, or blogs (Web logs). Spoofing is another technique used by cyberstalkers, which involves impersonating the victim online (Hitchcock, 2002). Some stalkers have used anonymous re-mailers, e-mail forwarding services that mask the originating address of e-mail messages so that the sender cannot be traced (Spence-Diehl, 2003). Others have spammed victims by sending hundreds of e-mail messages to clog up the victim's e-mail inbox (Spence-Diehl, 2003; see also Williams, 2007) or have signed the victim up for numerous online mailing lists so that the victim is flooded each day with e-mail (Ellison, 2001). Some cyberstalkers purposely e-mail the victim files containing computer viruses (Finn & Banach, 2000). Some stalkers send pornography to their victims (Finn, 2004). Some even enlist third parties to stalk their victims, which Paul Bocij (2005) refers to as "stalking by proxy."

The Internet with its search engines and databases is also used to collect information for the purpose of monitoring or tracking victims. Vanessa Bufis, Penny Leisring, and Jessica Brinkmann (2007) found that many college students view the online "away messages" of their ex-partners. In these messages, people often reveal what they are doing and where they are located. Many college students also acknowledged checking their ex-partners' pages on social networking sites for information (Bufis et al., 2007).

Perpetrators who are the former romantic partners of their victims may know their victims' passwords and personal identification numbers, which they could use to gain access to the victims' e-mail and voice mail accounts (Atkinson, Johnson, & Phippen, 2007). One stalker accessed his victim's e-mail account and, impersonating the victim, sent threatening messages to himself that he took to the police (Southworth & Tucker, 2007). Technologies used by deaf individuals such as teletypewriters (TTY) and telecommunication devices for the deaf (TTD) record and save transcripts of all phone conversations, which makes it easy for stalkers to monitor victims' communications if they have access to the victims' devices (Southworth & Tucker, 2007). Such systems have also been used to impersonate victims (Southworth & Tucker, 2007). One perpetrator, pretending to be his victim, made a call to a prosecutor using the victim's TTY (Southworth & Tucker, 2007). The call indicated that the victim would commit suicide if charges against the perpetrator were not dropped. When help arrived it became apparent that the victim had been sleeping and had not made the call.

Stalkers sometimes resort to even more extreme measures, such as installing keystroke loggers or spyware on computers or cell phones belonging to their victims (Southworth & Tucker, 2007). Keystroke loggers require that the perpetrator have physical access to the victim's computer (Southworth & Tucker, 2007). Once installed, all keys pressed on the victim's computer are recorded, giving a perpetrator access to a lot of information, including confidential passwords. Spyware, which can be installed remotely, allows the perpetrator to track Web sites visited and e-mails sent and received by the victim (Southworth & Tucker, 2007). According to Bruce Gross (2006), some spyware allows the user to access all files on the victim's computer and will search for passwords. Spyware is sometimes configured to reinstall itself if it is deleted (Gross, 2006). Small cameras can be remotely installed and activated that would allow the perpetrator to actually see inside the victim's home (Southworth & Tucker, 2007). Mapping sites like Google Earth (Atkinson et al., 2007) and GPS devices (Southworth & Tucker, 2007) are used to track victims' physical locations. In addition, some new Caller Identification (ID) systems show the caller's address as well as phone number (Southworth et al., 2007). Thus, if the victim calls the perpetrator, the victim's address will be revealed.

Prevalence of Stalking

Specific definitions affect the prevalence rates and gender distribution of stalking (Davis & Frieze, 2000). If a definition requires the victim to be fearful, or if police contact is required, then rates are lower overall, and the victims are predominantly female. However, if specific stalking behaviors are assessed without requiring that the victim be fearful, rates increase and similar rates across genders are found (Davis & Frieze, 2000). Most studies examining the prevalence of stalking either have not assessed cyberstalking or they combine behaviors such as receiving unwanted e-mails and unwanted letters in their assessment measures, and both instances make it difficult to tease apart the prevalence of cyberstalking compared to offline stalking (for example, Dye & Davis, 2003; Langhinrichsen-Rohling, Palarea, Cohen, & Rohling, 2000; Roberts, 2005; Sinclair & Frieze, 2000).

A National Violence Against Women (NVAW) survey in the late 1990s did not assess cyberstalking, but it found that 8 percent of women and 2 percent of men were stalked by offline methods (Tjaden & Thoeness, 1998). The stalking definition used in the NVAW survey required a high level of victim fear (Tjaden & Thoeness, 1998). If the definition required that the victims be only somewhat or a little frightened by the behavior, then the stalking rates from that national sample rise considerably to 12 percent for women and 4 percent for men (Tjaden & Thoeness, 1998). According to a review by Lorraine Sheridan and her colleagues (2003), the lifetime prevalence of stalking for women is 12 to 16 percent and for men is 4 to 7 percent. This means that approximately 1 in 6 women and approximately 1 in 14 men will be stalked in their lifetime.

A survey of women in a Dutch anti-stalking federation found that only 2 percent of a support-seeking sample of stalking victims reported having been "stalked via the Internet" (Kamphuis & Emmelkamp, 2001). It is possible, though, that some women in the sample were unaware that they were being monitored online. Also, the use of the word "stalking," instead of asking about specific behaviors such as receiving repeated unwanted e-mails or text messages, may have lowered the number of reports of stalking. Angela Amar (2006) used a 12-item measure of stalking that included one cyberstalking item (receiving unsolicited or harassing e-mails). She found that 25 percent of college students had been stalked in some way, and 19 percent indicated that they had received unsolicited or harassing e-mails. Vanessa Bufis and her colleagues (2007) found that over three quarters of college students look at their ex-partners' "away messages" and over half look at their ex-partners' pages on social networking sites. An examination of reports and requests for assistance from Internet sites for victims of cyberstalking indi-

cates that as many as 76,000 people may be cyberstalked each year (Bocij, 2004).

Studies have found that more women than men are stalked using offline methods (Spitzberg, 2002; Tjaden & Thoeness, 1998), but at least one study has found that cyberstalking may affect more men than women (Alexy, Burgess, Baker, & Smoyak, 2005), and one study by Jerry Finn (2004) assessing cyberstalking/online harassment in a college sample found no gender differences. Finn's data collected in 2002 indicated that 58 percent of his sample had received unwanted pornography via e-mail or instant messenger, and between 10 and 15 percent of the sample reported that they had repeatedly received e-mails or instant messages that threatened, insulted, or harassed. Fourteen percent of the sample received such messages even after they told the sender to stop sending messages (Finn, 2004). Sexual minority students were more likely than heterosexual students to receive repeated threatening, insulting, or harassing e-mails from strangers or people that they barely knew (Finn, 2004). Finn hypothesized that this may be due to the increased harassment faced by gay, lesbian, bisexual, and transgendered individuals in the offline world.

Post-Intimate Stalking and Intimate Partner Violence

Stalking is most often perpetrated by current or former romantic partners (Coleman, 1997; Roberts & Dziegielewski, 1996). In his review, Brian Spitzberg (2002) finds that approximately 50 percent of stalking stems from prior romantic relationships, 25 percent is perpetrated by strangers, and 25 percent is perpetrated by acquaintances. Much stalking occurs after a romantic relationship ends, and the person who was rejected is typically the one to engage in stalking behavior (Davis, Ace, & Andra, 2000). Keith Davis and his colleagues (2000) found that anger and jealousy after a romantic relationship dissolves are associated with post-breakup stalking. They also found that expressions of love are highly correlated with stalking, which supports the assertion that many people stalk their ex-partners in hopes of reuniting. Stalking may be referred to, in this context, as "unwanted pursuit" (Langhinrichsen-Rohling et al., 2000).

Post-intimate relationship stalking seems to be more likely when a relationship has been abusive (Coleman, 1997). T. K. Logan, Carl Leukefeld, and Bob Walker (2000) found that college students who had been stalked had higher rates of physical and emotional abuse within their relationship than students who had not been stalked. Jennifer Becker and Penny Leisring (2005) also found in a college sample that physical abuse within a relation-

ship was associated with post-breakup unwanted pursuit behaviors. Mindy Mechanic, Terri Weaver, and Patricia Resick (2000), in their study of battered women, found that dominance and isolation within a relationship were associated with stalking behaviors perpetrated against women. Jennifer Langhinrichsen-Rohling (2006) found that about 25 percent of sheltered battered women acknowledged engaging in stalking and unwanted pursuit behaviors toward their abusive partners during separations. Most of the stalking was bi-directional in nature. In other words, many of the male partners were also engaging in stalking and unwanted pursuit behaviors.

Partner violence does not necessarily end after a breakup, and stalkers have been known to engage in physical and psychological aggression toward their ex-partners (Spitzberg, 2002). In a study by Karl Roberts (2005), 35 percent of the college women who had been stalked were victims of violence during the stalking. T. K. Logan, Lisa Shannon, and Jennifer Cole (2007) surveyed women who had restraining orders against violent partners or ex-partners and found that the women who had been stalked by their partners or ex-partners experienced more violations of restraining orders and more severe abuse than the victimized women who had not been stalked. Stalking has been characterized as a "severe form of emotional/psychological abuse" (Mechanic et al., 2000, p. 56). Stalking and psychological aggression seem to have similar antecedents, such as a need for control, anxious attachment, and harsh parental discipline (Dye & Davis, 2003).

Characteristics of Stalkers

What do we know about stalkers? Most of the research examining the characteristics of stalkers has focused on those who perpetrate stalking using traditional offline methods, and few studies have focused exclusively on cyberstalkers. However, since many cyberstalkers engage in offline methods of stalking in addition to using technology to stalk their victims, the research examining offline stalkers is likely relevant. Paul Bocij (2004) asserts that almost a third of cyberstalkers use offline stalking methods in addition to using technology.

Domestic violence perpetrators and stalkers seem to share many of the same traits (Douglas & Dutton, 2001). A history of childhood abuse and disrupted attachment are common among stalkers and batterers (Davis & Frieze, 2002). Some stalkers and batterers also appear to have borderline personality disorder traits (Douglas & Dutton, 2001; Roberts & Dziegielewski, 1996; Spitzberg & Veksler, 2007). Borderline personality disorder is characterized by an intense fear of abandonment, impulsivity, emotional instability, and unstable interpersonal relationships (American Psychiatric Association, 2000). Thus, when people with borderline personality disorder traits are

rejected by their intimate partners, they may have extreme difficulty handling the loss, and they may persistently and inappropriately attempt to reconnect and avoid abandonment. This fits in with the beliefs of Keith Davis and Irene Frieze (2000) who assert that many stalkers want to reunite with their romantic partners after the relationships have ended. They also indicate that some stalking occurs in the context of a desired but unreciprocated intimate relationship. Alcohol and drug problems are also commonly found among both stalkers and batterers (Meloy et al., 2000; Melton, 2007; Stuart, Moore, Kahler, & Ramsey, 2003). Substances may disinhibit behavior and increase the likelihood of stalking or violence. Jealousy and a need for control are also characteristics shared by domestic violence perpetrators and stalkers (Davis & Frieze, 2000).

We know very little about the characteristics of cyberstalkers in particular. The gender distribution of cyberstalking may be different than that of offline stalking; equal rates of cyberstalking seem to be found across genders, at least in college populations (Finn, 2004). Cyberstalking can be so easy to perpetrate from the comfort of home that cyberstalkers may have less psychopathology than offline stalkers. This is a hypothesis worthy of study. Paul Bocij (2004) points out that not all cyberstalkers (or offline stalkers) have psychological disorders. Stephen Morewitz (2003) hypothesizes that cyberstalkers may have higher socioeconomic status than offline stalkers, as reflected in their access to the Internet and other means for electronically mediated communication, such as cell phones and BlackBerry-like handheld devices. He points out, however, that this potential difference is likely to diminish as free e-mail and Internet access become even more widespread (Morewitz, 2003).

Information regarding treatment for cyberstalkers is needed. Oliver Howes (2006) discussed a case in which a 32-year-old woman was treated for compulsively sending text messages to her ex-boyfriend after he ended the relationship. She was spending four hours per day sending text messages and was treated with the antidepressant Trazodone and with behavior modification. The behavior modification component of treatment involved monitoring the patient's behavior, using relaxation methods, and scheduling time for sending messages with increased intervals between messages. The patient's compulsive texting gradually ceased. While the improvement for the woman in this case study is encouraging, it should be noted that without a control group we cannot know for certain whether improvement was due to the specific treatment utilized. Controlled trials of treatment for cyberstalkers are clearly warranted.

Effects on Victims

Offline stalking and cyberstalking can have various effects on victims ranging from mild annoyance to severe fear and psychological maladjustment. Symptoms of depression, drug use, and posttraumatic stress disorder have been found among stalking victims (Basile, Arias, Desai, & Thompson, 2004; Davis, Coker, & Sanderson, 2002; Kamphuis & Emmelkamp, 2001; Pimlott-Kubiak & Cortina, 2003). In Michele Pathé and Paul Mullen's (1997) clinical sample, they found that 24 percent of stalking victims experienced suicidal thoughts or attempted suicide. Kathleen Basile and her colleagues (2004) found in a nationally representative sample of the U.S. that stalking was associated with posttraumatic stress symptoms even after controlling for other types of violence perpetrated by the stalker. T. K. Logan and Jennifer Cole (2007) found stalking to be associated with anxiety symptoms over and above other forms of intimate partner violence in their sample of women who had obtained restraining orders against their violent partners. Karen Abrams and Gail Robinson (1998) suggest that women stalked by ex-partners may experience low self-esteem and guilt over their choice of romantic partners. Some victims may turn to substances as a way of coping with their victimization. Sheryl Pimlott-Kubiak and Lilia Cortina (2003) found that men and women who had been stalked had higher levels of prescription and illegal drug use than non-victims. Pathé and Mullen (1997) found that stalking victims reported increased smoking and drinking as a result of their victimization.

In addition to psychological consequences, some stalking victims also receive physical injuries. Women stalked by intimate partners or ex-partners are over four times more likely to be physically injured than women stalked by others (Kohn, Flood, Chase, & McMahon, 2000). Over 80 percent of women who are stalked by an intimate partner have also been physically assaulted by that partner (Tjaden & Thoeness, 1998). Acquaintances, as well as intimate partners, can physically harm their stalking victims. Amy Boyer was shot and killed in 1999 by a cyberstalker, Liam Youens, who was able to locate her work address online (Hitchcock, 2002). Boyer's former schoolmate, Youens had posted his plans to murder her online (Tavani & Grodzinsky, 2002). Youens claimed he had been in love with her for years (Hitchcock, 2002). He committed suicide right after killing her (Hitchcock, 2002).

Many stalking victims report that they have taken precautions and have changed their routines as a result of being stalked (Amar, 2006; Pathé & Mullen, 1997). Some victims move and change jobs (Pathé & Mullen, 1997). Jayne Hitchcock (2002) bought a gun for self-protection after she was cyberstalked and her phone number and address had been posted online by the perpetrator.

Negative consequences of stalking are experienced by both male and female stalking victims (Davis et al., 2002; Pimlott-Kubiak & Cortina, 2003). Some studies indicate, however, that the consequences of stalking seem to be more severe for female victims. Brian Spitzberg and William Cupach (2003) indicate that "even when males experience the same tactics as females, these tactics may not be perceived as threatening" (p. 355).

Research has yet to examine the effects of cyberstalking in isolation. Thus, it is unclear whether the severity of consequences for victims of cyberstalking will match that of offline stalking. Morewitz (2003) asserts that cyberstalking can be traumatic to victims, and Bocij (2004) believes that cyberstalking victims are likely to suffer as much psychological harm as victims of offline stalking. This is a topic for future study.

Preventative Measures and Steps to Take If Cyberstalked

There are various things that can be done to reduce the odds of being a victim of cyberstalking. For example, everyone should periodically conduct an Internet search to see what information about them is available online for all to see. If they find information that they would like removed, they should contact the Web master of the site where the information is located. People should use extreme caution when posting information about themselves, considering the public nature of information on the Internet. Emily Spence-Diehl (2003) argues that people should only post information that they would be comfortable having on the front page of their local newspaper. Thus, college students should utilize privacy functions on social networking Web sites like Facebook and MySpace so that they can control who has access to the material they post. They should think twice about posting any personal information on these sites. If college students do not want their ex-partner to know, for example, that they are now dating someone new, then they should refrain from posting such information or pictures with their new partner on social networking Web sites.

To avoid file corruption due to computer viruses sent by stalkers, backing up files on a scheduled basis is recommended. Computer users should also check for and regularly install updates to their operating systems to maximize security (Bocij, 2004). Computer passwords and personal identification numbers (PINs) should be changed regularly, too (Spence-Diehl, 2003). Bruce Arnold (2006) urges computer users to choose Internet service providers based on professionalism rather than lowest cost. He also recommends that people be cautious about including their cell phone numbers in e-mail signature files.

Once people determine that they are being stalked, there are many concrete steps they can take. Jerry Finn and Mary Banach (2000) and Sharon Miceli, Shannon Santana, and Bonnie Fisher (2001) list numerous resources that provide information and assistance to stalking victims, including the Working to Halt Online Abuse Web site, http://www.haltabuse.org. As soon as a person feels uncomfortable with the behavior of a potential stalker, sending a clear statement to the perpetrator that the behavior is unwanted is crucial (Finn & Banach, 2000). J. Reid Meloy (1997) recommends that a third party, such as an attorney, spouse, or mental health professional, contact the perpetrator once a pattern of behavior has been established. According to Meloy, the third party should alert the perpetrator that the behavior is unwanted and that the police will be contacted if the behavior continues. If a stalker continues to contact the victim after being told to stop, then the offense becomes "aggravated stalking" (Lee, 1998, p. 383). Avoiding further contact with the perpetrator will be critical because contact may serve to reinforce or encourage the stalking behavior (Meloy, 1997).

The victim should retain and print all "cyber-evidence," such as e-mails, facsimiles, instant messages, and Web postings (Meloy, 1997; Spence-Diehl, 2003). If the software being used does not lend itself easily to printing the communication, then a screen capture utility should be used to document the cyberstalking behavior (Bocij, 2004). Cyber-evidence will enable the victim to make a stronger case against the stalker if police and judicial involvement is warranted. However, most stalking police reports do not lead to arrests (Gross, 2006), and restraining orders are not necessarily effective; one review found they were violated 40 percent of the time and that they were thought to have intensified the stalking 20 percent of the time (Spitzberg, 2002). Victims and their advocates should be aware that certain acts by the victim, such as filing a restraining order or threatening to contact authorities, may lead to retaliation or violence by the stalker (Meloy, 1997). Bocij (2004) recommends contacting the police if one receives a threat that they believe someone will act on.

Victims should take steps to privatize any personal information about them on the Internet and should block e-mail and instant messages from perpetrators (Miceli et al., 2001). They should consider contacting the Internet service providers used by their stalkers to request that stalkers' memberships be canceled (Miceli et al., 2001). A complaint to the Internet service provider or re-mailer will often cause e-mail harassment or "e-mail bombing" to stop (Hitchcock, 2002). Victims can also change their usernames, their e-mail and instant messaging addresses, and their e-mail providers (Finn & Banach, 2000). Louise Ellison (2001) suggests that women use a male or a gender neutral username. Victims can also use encryption software so that only intended recipients can read sent messages (Finn & Banach, 2000).

They should also make sure that none of the security codes or accounts that they have (for example, health insurance) use their social security number as the identification number (Finn & Banach, 2000). Antivirus software and a firewall program should be utilized (Hitchcock, 2002). Cindy Southworth, Shawndell Dawson, Cynthia Fraser, and Sarah Tucker's article (2005) includes an informative planning checklist for victims and their advocates.

Conclusion

Actions to stop cyberstalking can also be taken by people online who become aware that someone is being stalked. Reports can be made to the Web masters of the Web sites being used, and/or victims can be alerted. According to Herman Tavani and Frances Grodzinsky (2002), we all have a moral responsibility to warn victims if we know that cyberstalking is occurring. As a psychologist who studies the prevention and reduction of aggressive behavior in adults and children, I wholeheartedly agree.

References

Abrams, K. M., & Robinson, G. E. (1998). Stalking part I: An overview of the problem. *Canadian Journal of Psychiatry, 43,* 473–476.

Alexy, E. M., Burgess, A. W., Baker, T., & Smoyak, S. A. (2005). Perceptions of cyberstalking among college students. *Brief Treatment and Crisis Intervention,* 5(3), 279–289.

Amar, A. F. (2006). College women's experience of stalking: Mental health symptoms and changes in routines. *Archives of Psychiatric Nursing,* 20(3), 108–116.

Amar, A. F. (2007). Behaviors that college women label as stalking or harassment. *Journal of the American Psychiatric Nurses Association,* 13(4), 210–220.

American Psychiatric Association. (2000). *Diagnostic and statistical manual of mental disorders* (4th ed.). Washington, DC: American Psychiatric Association.

Arnold, B. (2006). *Caslon analytics cyberstalking.* Retrieved June 14, 2008, from http://www.caslon.com.au/stalkingnote5.htm.

Atkinson, S., Johnson, C., & Phippen, A. (2007). Improving protection mechanisms by understanding online risk. *Information Management & Computer Security,* 15(5), 382–393.

Basile, K. C., Arias, I., Desai, S., & Thompson, M. P. (2004). The differential association of intimate partner physical, sexual, psychological, and stalking violence and post-traumatic stress symptoms in a nationally representative sample of women. *Journal of Traumatic Stress,* 17(4), 413–421.

Becker, J. M., & Leisring, P. A. (2005, October). *Unwanted pursuit behaviors after the dissolution of a college dating relationship.* Poster presented at the 45th annual meeting of the New England Psychological Association, New Haven, CT.

Bocij, P. (2004). *Cyberstalking: Harassment in the Internet age and how to protect your family.* Westport, CT: Praeger.

Bocij, P. (2005). Reactive stalking: A new perspective on victimisation. *The British Journal of Forensic Practice, 7*(1), 23–34.

Bufis, V. M., Leisring, P. A., & Brinkmann, J. L. (2007, October). *The use of technological advancements in the perpetration of unwanted pursuit behaviors*. Poster presented at the 47th annual meeting of the New England Psychological Association, Danbury, CT.

Coleman, F. L. (1997). Stalking behavior and the cycle of domestic violence. *Journal of Interpersonal Violence, 12*(3), 420–432.

Davis, K. E., Ace, A., & Andra, M. (2000). Stalking perpetrators and psychological maltreatment of partners: Anger-jealousy, attachment insecurity, need for control, and break-up context. *Violence and Victims, 15*(4), 407–425.

Davis, K. E., Coker, A. L., & Sanderson, M. (2002). Physical and mental health effects of being stalked for men and women. *Violence and Victims, 17*(4), 429–443.

Davis, K. E., & Frieze, I. H. (2000). Research on stalking: What do we know and where do we go? *Violence and Victims, 15*(4), 473–487.

Davis, K. E., & Frieze, I. H. (2002). Research on stalking: What do we know and where do we go? In K. E. Davis, I. H. Frieze, & R. D. Maiuro (Eds.), *Stalking: Perspectives on victims and perpetrators* (pp. 353–375). New York: Springer.

Douglas, K. S., & Dutton, D. G. (2001). Assessing the link between stalking and domestic violence. *Aggression and Violent Behavior, 6*, 519–546.

Dye, M. L., & Davis, K. E. (2003). Stalking and psychological abuse: Common factors and relationship-specific characteristics. *Violence and Victims, 18*(2), 163–180.

Ellison, L. (2001). Cyberstalking: Tackling harassment on the Internet. In D. S. Wall (Ed.), *Crime and the Internet* (pp. 141–151). New York: Routledge.

Finn, J. (2004). A survey of online harassment at a university campus. *Journal of Interpersonal Violence, 19*(4), 468–483.

Finn, J., & Banach, M. (2000). Victimization online: The down side of seeking human services for women on the internet. *Cyberpsychology and Behavior, 3*(2), 243–254.

Gross, B. (2006). Tracking stalkers. *Forensic Examiner, 15*(4), 48–53.

Hitchcock, J. A. (2002). *Net crimes & misdemeanors: Outmaneuvering the spammers, swindlers, and stalkers who are targeting you online*. Medford, NJ: Information Today.

Howes, O. D. (2006). Compulsions in depression: Stalking by text message. *American Journal of Psychiatry, 163*(9), 1642.

Kamphuis, J. H., & Emmelkamp, P. M. G. (2001). Traumatic distress among support-seeking female victims of stalking. *The American Journal of Psychiatry, 158*(5), 795–798.

Kohn, M., Flood, H., Chase, J., & McMahon, P. M. (2000). Prevalence and health consequences of stalking—Louisiana, 1998–1999. *Morbidity and Mortality Weekly Report, 49*(29), 653–655.

Langhinrichsen-Rohling, J. (2006). An examination of sheltered battered women's perpetration of stalking and other unwanted pursuit behaviors. *Violence and Victims, 21*(5), 579–595.

Langhinrichsen-Rohling, J., Palarea, R. E., Cohen, J., & Rohling, M. L. (2000). Breaking up is hard to do: Unwanted pursuit behaviors following the dissolution of a romantic relationship. *Violence and Victims, 15*(1), 73–90.

Lee, R. (1998). Romantic and electronic stalking in a college context. *The College of William and Mary Journal of Women and the Law, 4,* 373–409.

Logan, T. K., & Cole, J. (2007). The impact of partner stalking on mental health and protective order outcomes over time. *Violence and Victims, 22*(5), 546–562.

Logan, T. K., Leukefeld, C., & Walker, B. (2000). Stalking as a variant of intimate violence: Implications from a young adult sample. *Violence and Victims, 15*(1), 91–110.

Logan, T. K., Shannon, L., & Cole, J. (2007). Stalking victimization in the context of intimate partner violence. *Violence and Victims, 22*(6), 669–683.

Mechanic, M. B., Weaver, T. L., & Resick, P. A. (2000). Intimate partner violence and stalking behavior: Exploration of patterns and correlates in a sample of acutely battered women. *Violence and Victims, 15*(1), 55–72.

Meloy, J. R. (1997). The clinical risk management of stalking: "Someone is watching over me..." *American Journal of Psychotherapy, 51*(2), 174–184.

Meloy, J. R., Rivers, L., Siegel, L., Gothard, S., Naimark, D., & Nicolini, J. R. (2000). A replication study of obsessional followers and offenders with mental disorders. *Journal of Forensic Science, 45*(1), 147–152.

Melton, H. C. (2007). Predicting the occurrence of stalking in relationships characterized by domestic violence. *Journal of Interpersonal Violence, 22*(1), 3–25.

Miceli, S. L., Santana, S. A., & Fisher, B. S. (2001). Cyberaggression: Safety and security issues for women worldwide. *Security Journal, 14*(2), 11–27.

Morewitz, S. J. (2003). *Stalking and violence: New patterns of trauma and obsession.* New York: Kluwer Academic/Plenum.

Pathé, M., & Mullen, P. E. (1997). The impact of stalkers on their victims. *British Journal of Psychiatry, 170,* 12–17.

Pimlott-Kubiak, S., & Cortina, L. M. (2003). Gender, victimization, and outcomes: Reconceptualizing risk. *Journal of Consulting and Clinical Psychology, 71*(3), 528–539.

Roberts, G. L. (n.d.). *The Stalker's Home Page.* Retrieved June 24, 2008, from http://www.glr.com/stalk.html.

Roberts, K. A. (2005). Women's experience of violence during stalking by former romantic partners: Factors predictive of stalking violence. *Violence Against Women, 11*(1), 89–114.

Roberts, K. A., & Dziegielewski, S. F. (1996). Assessment typology and intervention with the survivors of stalking. *Aggression and Violent Behavior, 1*(4), 359–368.

Sheridan, L. P., Blaauw, E., & Davies, G. M. (2003). Stalking: Knowns and unknowns. *Trauma, Violence, and Abuse, 4*(2), 148–162.

Sinclair, H. C., & Frieze, I. H. (2000). Initial courtship behavior and stalking: How should we draw the line? *Violence and Victims, 15*(1), 23–39.

Southworth, C., Dawson, S., Fraser, C., & Tucker, S. (2005). A high-tech twist on abuse: Technology, intimate partner stalking, and advocacy. *Violence Against Women Online Resources.* Retrieved September 17, 2007, from http://www.mincava.umn.edu/documents/commissioned/stalkingandtech/stalkingandtech.pdf.

Southworth, C., Finn, J., Dawson, S., Fraser, C., & Tucker, S. (2007). Intimate partner violence, technology, and stalking. *Violence Against Women, 13*(8), 842–856.

Southworth, C., & Tucker, S. (2007). Technology, stalking, and domestic violence victims. *Mississippi Law Journal, 76,* 667–676.

Spence-Diehl, E. (2003). Stalking and technology: The double-edged sword. *Journal of Technology in Human Services, 22*(1), 5–18.

Spitzberg, B. H. (2002). The tactical topography of stalking victimization and management. *Trauma, Violence, and Abuse, 3*(4), 261–288.

Spitzberg, B. H., & Cupach, W. R. (2003). What mad pursuit? Obsessive relational intrusion and stalking related phenomena. *Aggression and Violent Behavior, 8,* 345–375.

Spitzberg, B. H., & Hoobler, G. (2002). Cyberstalking and the technologies of interpersonal terrorism. *New Media & Society, 4*(1), 71–92.

Spitzberg, B. H., & Veksler, A. E. (2007). The personality of pursuit: Personality attributions of unwanted pursuers and stalkers. *Violence and Victims, 22*(3), 275–289.

Stuart, G. L., Moore, T. M., Kahler, C. W., & Ramsey, S. E. (2003). Substance abuse and relationship violence among men court-referred to batterers' intervention programs. *Substance Abuse, 24*(2), 107–122.

Tavani, H. T., & Grodzinsky, F. S. (2002). Cyberstalking, personal privacy, and moral responsibility. *Ethics and Information Technology, 4,* 123–132.

Tjaden, P., & Thoeness, N. (1998). *Stalking in America: Findings from the National Violence Against Women Survey.* Washington, DC: National Institute of Justice, U.S. Department of Justice. Retrieved July 5, 2008, from http://www.ncjrs.org/pdffiles/169592.pdf.

White, J., Kowalski, R. M., Lyndon, A., & Valentine, S. (2000). An integrative contextual developmental model of male stalking. *Violence and Victims, 15*(4), 373–388.

Williams, M. (2007). Cyber-crime on the move. In S. Kleinman (Ed.), *Displacing place: Mobile communication in the twenty-first century* (pp. 91–104). New York: Peter Lang.

CHAPTER 15

The Politics of Disaster

Crises, Communication, and Marginalization in the United States

▶ MIKAELA L. MARLOW & HOWARD GILES

Millions of Americans face tragic disasters every year (Federal Emergency Management Agency, 2008). Events like these serve to remind us of the delicacy of human existence. The U.S. has faced major crises like the Chicago fire of 1871, the San Francisco earthquake of 1906, the airplane hijackings of September 11, 2001 (hereafter, referred to as 9/11), and Hurricane Katrina in 2005. Catastrophic events consume and debilitate communication and functional ability among individual, social, economic, and political systems (Raphael, 1986). As such, governmental, organizational, and scholarly inquiry has begun to pay special attention to communication preparedness and response (Noll, 2003).

Risk and crisis communication have been the topic of some inquiry, yet until now, less attention has been devoted to emergency planning for people with unique communication needs (Kailes, 2000; National Council on Disability, 2005). Dan O'Hair (2005) confirmed at a Subcommittee Research Meeting of the U.S. Congressional Hearing that emergency infrastructure

in the U.S. communicatively excludes many who are socially marginalized because of age, class, or minority status.

In the U.S., approximately 50 million individuals (20 percent of the entire population) are disabled (U.S. Census Bureau, 2000). This group includes those with cognitive, emotional, visual, hearing, and mobility limitations. The events of Hurricane Katrina illuminated profound deficiencies in the current emergency infrastructure for people who are blind, deaf, or physically challenged. For example, the National Organization on Disability (2005) confirmed that 76 percent of employers do not consult emergency training experts, 50 percent lack special needs registries, and 58 percent omit public awareness campaigns targeting people with disabilities. Even in situations where emergency plans are in place, the protocol typically relies on the diligence and altruism of others: the Americans with Disabilities Act's (ADA) official "evacuation plan" for people who are blind or using a wheelchair instructs them to proceed to the nearest (sometimes marked) staircase where they should wait for someone to assist them out of the building. Michael Berube (2005) recalled events during Hurricane Katrina and the ways in which race became salient in media coverage, while the struggles of the disabled were often overlooked:

> As we watched the stunning spectacle of people dying of starvation and thirst in the streets of an American city that seemed to have been abandoned by every form of government, I was struck, time and time again that…while race had become "visible," disability had not.…Who among us can forget that iconic image of the dead woman in the wheelchair outside the Superdome, covered only in a blanket? (p. 1)

The Centers for Disease Control and Prevention (CDC) (2004) confirmed that people with distinct communication or evacuation needs include children, the elderly, the physically or cognitively challenged, and non-English speakers. Each of these groups have received minimal consideration in planning, warning, and evacuation. U.S. Congressman Robert C. Scott testified that "Congress has identified discrimination as a problem to be addressed in disaster assistance since Hurricane Camille struck in 1969.…Despite past actions, discrimination in disaster assistance remains a problem to be addressed" (U.S. Federal News, 2006, p. 1).

Thus far, social science inquiry has devoted minimal attention to the communicative efficiency of disaster-based planning and management among minority groups in the U.S. Considering that millions of Americans have diverse needs that directly impact their ability to prepare for such events, this chapter discusses past challenges for individuals with unique communication needs during disasters. Anecdotal evidence is presented to clarify specific instances of communicative inefficiency and exclusion. To conclude, we proffer avenues for theoretical and applied advancement in this area.

Disaster as a Communicative Process

Communication about disasters is typically categorized as either risk or crisis communication. Risk-based messages warn the public about the risks of behaviors like smoking, drinking and driving, or unsafe sexual practices (Witte, 1995). Crisis communication often deals with managing issues associated with disasters and is more oriented toward public relations. For instance, media messages disseminated after 9/11 or Hurricane Katrina would be characterized as crisis messages. The CDC integrates both approaches with the term "crisis and emergency risk communication" (Reynolds, Galdo, & Sokler, 2002), recognizing that both crisis and risk communication management should be standardized and synchronized.

Natural disasters (earthquakes, fires, and tsunamis), industry accidents (product defects, explosions, and spills), and intentional terrorist events mandate specific preparation and management (Seeger, Sellnow, & Ulmer, 2003). Distinctions across disaster situations require that people understand impending threats in addition to the behavior necessary to minimize risk. For example, during a hurricane, people are advised to store food and water, while tornadoes require that people stay inside (Sellnow, Seeger, & Ulmer, 2002).

The channels used to communicate messages are crucially important. For instance, during the West Nile Virus outbreak of 1999 in the U.S., public health organizations initiated media messages and public education campaigns describing the frequency, nature, and infection potential for the disease. Clearly, people must correctly interpret messages about risk situations in order to make lifesaving choices (Mileti, Hutton, & Sorenson, 1981; Turner, Nigg, Paz, & Young, 1981). Colleen Fitzpatrick and Dennis Mileti's (1994) Model of the Theory of Public Risk Communication suggests that crisis communication should be viewed as cognitive, behavioral, and social. Individuals must hear, understand, believe, personalize, and respond to emergency messages in order to protect themselves and others.

Although sirens or auditory messages initially warn the public about hazardous encounters, some members of the population may not be able to attend to such warnings because of hearing loss or an inability to understand English. Moreover, even those who hear a message may not cognitively process it. People may not interpret risk communication based on habitual processing patterns (tuning out television or radio) or selective perception (attending to certain things and omitting others). When people lack sufficient warning, their ability to protect themselves and others is decreased (Bellamy, 1987; Perry & Lindell, 1986; Turner et al., 1981).

Variations in perceptions of terminology may influence impressions of risk and resulting behavior. For instance, some may perceive a flood warn-

ing as indicative of an oncoming sea of water, while others view it as predictive of ankle-high runoff (Fitzpatrick & Mileti, 1994). Moreover, people vary in their tendency to perceive risk warnings as accurate and credible (Mileti, Drabek, & Hass, 1975; Quarantelli, 1980). Many tend to evaluate risk messages based on whether they are relevant to them personally or socially, that is, relevant to a friend or family member. When individuals do not view a warning message as accurate or perceive that the information was not intended for them or for someone they care about, they are less likely to take precautionary actions. However, if people personalize risk, they will be more likely to prepare for an impending disaster.

Fitzpatrick and Mileti's (1994) model accurately notes that people must hear, understand, believe, personalize, and respond to disaster warning messages. This model is valuable for assessing generalized message interpretations and responses. Utilizing their model as a conceptual foundation, we developed the Communication Process Model of Disasters to account for communication and physical differences across ability, language, and cultural groups (see Figure 1).

The first stage begins with the message content and relates to the language, style, and information conveyed. Also, this phase accounts for the communication medium (radio, television, print, the Internet).

The second stage highlights the fact that information must be communicated in a way that is physically and mentally accessible. For example, someone who is deaf will not be able to gather required information when warnings are disseminated through sirens, radio, or non-captioned television. Also, variations in language and cultural orientation will profoundly impact the way in which people process the message. For instance, those who maintain fatalistic views about natural disasters may think they are unable to avoid being harmed and may fail to take necessary precautions.

The third stage accounts for the personal and social factors that influence whether someone will accept a message (Mileti et al., 1975; Quarantelli, 1980). People must perceive that they are personally at risk. Social networks (or the lack thereof) will also determine message acceptance. The actions of friends and neighbors influence individuals' decision making.

The fourth stage accounts for varying levels of physical, social, and community resources. An individual may have the necessary information, but if they are wheelchair-bound, they are likely to be physically dependent on others for evacuation. Similarly, people who are economically challenged may not be able to leave a high risk area, even if they know about an impending disaster. During the events of Hurricane Katrina, access to resources was one factor that influenced evacuation behavior; economic and social factors may assist in explaining why a disproportionate number of poor people perished.

The Politics of Disaster

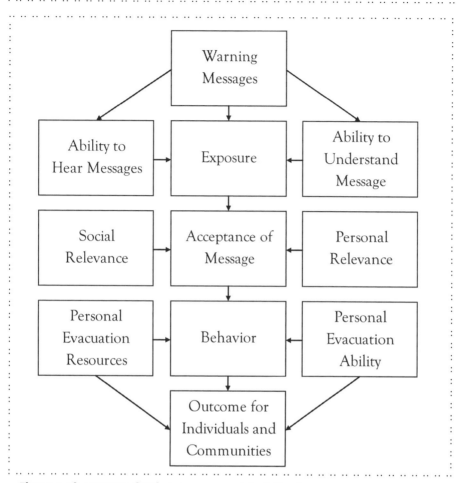

Figure 1. The communication process model of disasters.

The fifth stage represents the individual and community outcomes, based on the culmination of the previous four stages. The Communication Process Model of Disasters suggests that disaster-based planning should specifically account for physical and mental ability, language, and cultural issues that influence message interpretation, acceptance, and behavior.

Ability, Language, and Culture in the United States

Approximately 20 percent of the U.S. population has a physical or cognitive challenge and lives without institutionalization. The 2000 U.S. Census Bureau Report found that 21.2 million people have a condition that impedes physical activity, 9.3 million people are challenged with their sight or hear-

ing, 12.4 million people have emotional or cognitive disabilities, and 18.2 million people are unable to travel because of their condition. The U.S. Government Accountability Office (2006) reported that individuals with disabilities and the elderly have been minimally incorporated during disaster preparedness, response, and recovery. Although crisis-based anecdotes have been elicited from the disabled community and press, minimal work has specifically explored the impact of catastrophic events on individuals with disabilities (Pollander & Rund, 1989; White, 2003).

Disaster preparation and management in the U.S. is oriented toward people who are proficient in English. The U.S. Census Bureau reported that in 2000, 18 percent of the U.S. population (47 million people) spoke a language other than English in the home. Of these people, 55 percent reported speaking English "very well," while 45 percent reported speaking English less than "very well." More than 11 million people reported speaking English "not well" or "not at all." In fact, the U.S. Census Bureau (2000) suggested that millions of people employ languages other than English as their primary language. In order of frequency, these are: Spanish (28 million), Chinese (2 million), French (1.6 million), German (1.4 million), Tagalog (1.2 million), Vietnamese (1 million), Italian (1 million), Korean (900,000), Russian (700,000), and Polish (700,000).

Thirty percent of the U.S. population belong to a minority ethnic or cultural group (Ma, 1999) and often maintain distinct beliefs about health, illness, and treatment. Cultural and language differences enhance communication uncertainty (Gudykunst, 1988). Communication and information uncertainty may be particularly common for those who identify strongly with their ethnic group (Dyal & Dyal, 1981). Variations in perception and acceptance of risk messages are influenced by culture, social status, education, power, and trust (Flynn, Slovic, & Mertz, 1994). Once a disaster has occurred, language barriers or unique values may complicate health assistance by providers who are unable to accommodate diverse linguistic or cultural codes. June Isaacson Kailes (2000) suggested that it would be useful for emergency specialists to designate specific terms for people who have "special needs." In assigning an umbrella term that categorizes all differences with this one term, it is difficult to accurately assess the specific needs among people of diverse languages, cultures, and abilities.

Conceptual Frameworks

Intergroup Communication

The paradigm of intergroup communication explores the ways in which group affiliations influence communication and interactions in a variety of situations (for example, Bourhis, Giles, & Tajfel, 1973; Giles, 1977, 1978). Such research has discussed attitudes toward language (Bradac, Cargile, & Hallett, 2001), bilingualism and multi-lingualism (Marlow & Giles, 2006; Sachdev & Bourhis, 2005), interculturalism (Hecht, Jackson, & Pitts, 2005), gender (Reid, Keerie, & Palomares, 2003), aging (Williams & Nussbaum, 2001), and inter-ability relations (Fox, Giles, Orne, & Bourhis, 2000; Ryan, Bajorek, Beaman, & Anas, 2005).

Intergroup communication occurs when either individual in an interaction defines the self or another person with regard to their group membership. Group membership may be based on "age groups, nationalities, sexual orientations, cultures, religions, academic, sporting, and political groups, to name a few" (Harwood & Giles, 2005, p. 3). However, intergroup communication has only taken place when interactions are guided by perceptions of group affiliation. Often, people are motivated to gain or maintain resources, status, or prestige for the ingroup and/or advantages over outgroups (Hogg & Abrams, 2001).

Foundations of the intergroup approach are based on social identity theory, which addresses the interaction of psychological and sociological processes within intergroup exchanges (Tajfel, 1978; Tajfel & Turner, 1986). The theory suggests that individuals categorize ingroups and outgroups based on motivations to enhance individual or collective self-esteem, reduce uncertainty, and establish a favorable identity (Hogg & Abrams, 1999). Categorization processes may contribute to stereotypes and intergroup discrimination (Hogg, Terry, & White, 1995; Oakes, Haslam, & Turner, 1994; Potter & Wetherell, 1987). The intergroup approach assists in understanding the ways in which human tendencies stimulate social inequity across a variety of contexts, and as such, can be applied toward better understanding the exclusion of some groups during crisis planning and management.

Networks

Jan Van Dijk (2006) suggested that communication takes place across individual, social, technical, and media levels. Individual relations address connections among family members, colleagues, friends, neighbors, and any other type of relationship that manifests based on social interaction. Social networks involve collective ties, while technical networks address roads, dis-

tribution, telecommunication, and computers. Media networks involve radio, print, television, and the Internet.

According to Van Dijk (2006), modern individual relations are supported and enhanced by the emergence of media networks, including telephones (landline and mobile) and the Internet (e-mail, chat rooms). In comparison, group and organizational relations address collectives and group formations that are temporary (group projects) and fixed (organizations). Societal relations involve individuals, groups, and organizations that form the foundation of all subsystems. Also labeled as a network state, internal societal relations link government and public administration collectives at all levels, while external networks link with public institutions or citizen organizations (Castells, 1997; Fountain, 2001; Goldsmith & Eggers, 2004; Guéhenno, 1993). The most encompassing level of network theory is labeled global relations, or the world network of international organizations and societies (Slaughter, 2004; Urry, 2003). Peter Monge and Noshir Contractor (2003) suggested that network perspectives assist in explaining interconnectedness among social infrastructures. During large-scale disasters, the integration of individual, social, technical, and media networks will influence the information people receive, the way in which that information is processed, and resulting behavior.

Uses and Gratifications

The uses and gratifications framework assumes that media consumers seek information to satiate specific gratifications (Rosengren, Wenner, & Palmgreen, 1985). Gratification behavior has been established on an individual level (Blumler, 1985), yet less inquiry has specifically sought to understand the ways in which specific groups seek media to gratify collective needs. Jake Harwood and Abhik Roy (2005) argued that scholarly examination of broader social influences on media gratification interactions has, thus far, been minimal. The uses and gratifications lens has not been applied to further understand motivations and behaviors among people with disabilities, non-English proficiency, and unique cultural backgrounds. Furthermore, research has yet to assess media consumption patterns among dominant groups who desire self-enhancement or the establishment of positive group identity.

Social groups that apply dominant readings to media messages accept the presentation of the phenomena and may not question the disparities that exist among those who survive and those who perish in a crisis. For example, during the events of Hurricane Katrina, a disproportionate amount of African American people perished. Those applying a dominant reading to this situation would be likely to overlook or disregard the racial differences between

those who survived and those who perished. People who negotiate their reading of disaster coverage may assume the dominant ideology yet apply their own understanding to a situation. For instance, negotiators may assume that nonwhite people chose to remain at the location of the impending hurricane rather than questioning the institutional practices that may have failed to include many African Americans in evacuation and rescue. Privilege and agency are inherently involved with marginalization.

Harwood and Roy (2005) suggested that group vitality is an important group-based identity dimension, influencing media ownership and control. Group vitality is the socio-structural strength of a group (objectively assessed or subjectively experienced) that includes the historical status of the group and its communicative practices, numbers of the group and relevant outgroups, and modes of institutional support for the group in the media, business, and schools.

Media typically cater to established groups, while disadvantaging subordinate groups (Giles, Bourhis, & Taylor, 1977; Harwood, Giles, & Palomares, 2005). Power issues also guide the debate about media ownership, as media content often reflects inequity among different groups in social, institutional, and political contexts. Social dominance through media channels manifests as a result of the ethnic homogeneity and concentration among media owners (Jakubowicz, 1995). Alternative media that represent opposing perspectives are often limited by financial resources and minimal audiences (Lull, 1995). As the Federal Communication Commission (FCC) consolidates media in the U.S., advocates for marginalized groups have striven with varying levels of success to continue representation of people with diverse ability, race, and age.

An abundance of research has demonstrated that women, elderly adults, and cultural minority groups are underrepresented in media depictions. A group's objective vitality is symbolized in the amount and quality of media portrayal it receives (Abrams, Eveland, & Giles, 2003; Harwood & Anderson, 2002). Media tend to reflect generalized social trends among groups in society by underrepresenting or misrepresenting those from various minority groups. By projecting an idealized world in which most enjoy relative affluence, opportunity, and success, dominant social groups are able to remain blind to the negative manifestations of intergroup tensions. Media serve a dual function of fulfilling individual and group needs for enhancement, while also reifying perception of hegemony across mass audiences. More specifically, when dominant groups are portrayed in mainstream television and film, their social privilege is both depicted and reified as the norm. This serves a dual function of reinforcing the esteem and privilege of majority groups by marginalizing the interests of less dominant groups in both representation and social consideration. In what follows, we present several

compelling instances of communicative exclusion among people with diverse needs during U.S.-based disasters. Ideally, discussing areas of planning and communication inefficiency will compel broader reflection and reparation toward those who have been marginalized in the past.

Theoretical Interpretation of Disasters

Intergroup Issues

Individuals belonging to minority groups encounter negative social effects in a variety of interactional contexts (Simon, Aufderheide, & Kampmeier, 2001). Distrust, competition, and conflict are more likely to occur when intergroup dynamics are not handled effectively by organizations (Blake & Mouton, 1984; Kramer, 1991). Status, power, and representational inequity may contribute to withdrawal from professional or academic activity. Those in marginalized groups may internalize their own perceived inferiority (Jost & Burgess, 2000; Pfeffer & Sutton, 2000) and experience threatened self-concepts and social identities (Elsbach & Kramer, 1996; Sidanius & Pratto, 1999).

During the events of 9/11, images of devastation were broadcast into millions of homes. Claude Stout, Cheryl Heppner, and Kelby Brick (2004) noted that during disasters, many people with visual or hearing disabilities are unable to hear radios, telephones, sirens, or shouting. In the U.S., 28 million people have an auditory or visual challenge (U.S. Census Bureau, 2000). In the case of an impending emergency, people with sensory challenges face the disproportionate risk of communicative exclusion.

Ingroup favoritism takes place by trait ascription (we are inherently good), allocation of ingroup resources (more resources for our group), and more favorable evaluations of ingroup projects (our work is of higher quality than that of others) (Hinkle & Schopler, 1986; Mullen, Brown, & Smith, 1992; Tajfel & Turner, 1986). The allocation of existing emergency resources and planning is consistent with predictions of the theory, as majority groups are clearly provided with more extensive resources, while low status group needs are primarily overlooked.

High status groups exhibit more of a tendency to discriminate during social and organizational interactions than vice versa (Sachdev & Bourhis, 1984, 1987, 1991; Sidanius & Pratto, 1999). In 2006, U.S. Congressman Bill Honda introduced a bill that would make advocacy services more accessible for those that may be socially marginalized by linguistic or cultural orientation. Such advocacy demonstrates that politicians and government officials are aware of existing gaps in knowledge and emergency access among mar-

ginalized groups in the U.S. Although this is only a beginning, acknowledging inadequacies in emergency infrastructure is the initial step necessary to promote preparedness campaigns for minority collectives.

Network Issues

Social exclusion manifests multidimensionally by decreasing the realization of citizen rights in four institutions: legal and democratic systems, welfare systems, labor markets, and familial or community-based systems (Scharf & Smith, 2004). When compared with people who maintain consistent networks, the socially excluded experience diminished opportunities, resources, and support, over time culminating in decreased life satisfaction. During the events of 9/11, selected television stations employed captions in order to assist people with unique communicative needs, yet not all stations accommodated with captions. For instance, one man in Arlington, Virginia, recalled his uncertainty and fear watching the Pentagon explosion take place on television without captioning: "I was watching the Pentagon go up in flames one block away from my home and since there were no captions on national TV for a while, I didn't have a clue what was happening" (Stout, Heppner, & Brick, 2004, p. 18). Another person wrote:

> Unfortunately, the next day (after the attacks), to my surprise and disappointment, NBC, ABC, and CBS had no live or open captioning. All I could see was pictures of terror, pain, crashes, emergency people carrying bodies....I kept asking my co-workers every two or three minutes, "What is being said? What is that? What is happening?" (Stout et al., 2004, p. 17)

Network infrastructure did not effectively include people with diverse interaction needs. The previous examples also illustrate the ways in which people use existing social networks to enact passive (waiting for information) and active (asking others) information-seeking strategies when coping with information uncertainty. As these examples suggest, the efficiency of closed captioning protocol in the U.S. is still being developed and refined.

In 1993, the FCC required that closed captioning services be provided in the U.S. At this time, the FCC ruled that all analog televisions sold or manufactured in the U.S. have decoder circuitry enabling the display of closed captioning. In 1996, Congress mandated that video programming distributers, such as satellite companies, broadcasters, cable operators, and multichannel video programmers provide closed captioning for television programs. In 2002, the FCC required that all digital television receivers be designed with the capability for closed captioning. Beginning in 2006, FCC requirements mandated that most television broadcast stations comprising the top 25 television markets must provide emergency information in closed captioning (FCC, 2008). Emergency mandates about closed captioning ser-

vices demonstrate that information access issues are increasing in importance among institutional entities.

The National Organization on Disability (2005) verified that during Hurricane Katrina in 2005, only 46 percent of organizations had networked with aging or disability organizations to assist disaster preparedness, while only 50 percent of managers had actually implemented policies and plans for people with disabilities. Prior to Hurricane Katrina, less than 40 percent of organizations had networked with an expert for guidance about effectively serving people with unique communication needs. Following the disaster, 86 percent of advocacy groups reported they did not know how to effectively network with emergency management systems.

Divisions in emergency infrastructure severely impaired functional ability among volunteers, medical staff, and other personnel, ultimately detracting from their ability to provide comprehensive service. One individual who managed a shelter following Hurricane Katrina described the complications involved in trying to locate assisting devices for people with disabilities: "It would have been nice to have 'someone' local provide a list of resources in the area, rather than taking staff hours on phones all day trying to find equipment" (Kailes, 2006, p. 5). People with hearing impairments were unable to hear loudspeaker announcements. Those with vision impairments were unable to see direction signs or were unable to remain in line for the required seven hours because their wheelchairs had been destroyed. Individuals with emotional, cognitive, or physical conditions requiring medication were often unable to understand where to go for medical assistance. In these scenarios, nonexistent networks contributed to practices that were time and cost inefficient and detracted from crisis respondents' abilities to provide sufficiently for disaster victims.

Emergency planning in the U.S. must be standardized and interconnected across community, regional, state, and federal organizations (Stout et al., 2004). Such networks will impart greater consistency among employed and volunteer rescue teams, security protocol, training, and communication techniques. As an example, local or grassroots organizations that specialize in the interests of the disabled and non-English speakers should be in contact with government and private institutions, such as the American Red Cross, that are based in local, regional, state, and national contexts.

In 2006, the American Red Cross announced the establishment of a national agreement for discounted registration rates among American Red Cross chapters with Language Line Services, an interpretation service provider for telephone-based communication. Mori Taheripour, Vice President of Corporate Diversity at the American Red Cross, corroborated the necessity of interpretation services to meet the needs of monolingual populations. He stated, "Being able to communicate with our clients in their own lan-

The Politics of Disaster 257

guages is a critical part of effectively serving our clients" (Graney, 2006, p. 1). Collaboration among government, not-for-profit, and corporate entities may prove to be beneficial, both in meeting the needs of people with unique language needs and in modeling disaster preparation across contexts.

Uses and Gratification Issues

During emergencies, people in the U.S. have traditionally employed television, radio, and telephone technology for information seeking. During 9/11 and its aftermath, Americans utilized e-mail, landline and cellular telephones, and facsimile (fax) machines to socially interact with family and friends, yet employed television and radio for information acquisition purposes (Noll, 2003).

Stout and colleagues (2004) reported that the majority of people with nonauditory disabilities access information through television, yet those who are hard of hearing or deaf remain uninformed when television stations omit captioning. During the events of 9/11, many national network and cable channels posted captions, yet there were also reports of unreliable coverage. This was especially evident with local stations that omitted captioning related to airport closings, security requirements, or other disaster warning messages. Deaf residents of California described their frustration at not being able to access important information: "ABC, CBS, NBC, and MSNBC aren't even bothering to caption their programs now that the initial shock of the event is done. This is leaving many of us in the dark, once again" (Stout et al., 2004, p. 17).

In another incident, KAKE TV, a local ABC affiliate station in Wichita, Kansas, placed their station logo on a blue band across the bottom of the screen during the 9/11 events, blocking captions from visibility. When a deaf viewer sent an e-mail to the news department expressing concern about the lack of captioning, she received a chastising reply from the station's general manager: "TV stations and the networks are doing their best under 'war' conditions. You, of all people, should be understanding. Instead, we see the 'selfish' portion of human nature come forward" (Stout et al., 2004, p. 18).

This example suggests that requests by low status social groups for accommodation of special communication needs may seem unreasonable to some majority group members, who perceive that people with disabilities or non-English speakers should submit quietly to dominant group interests. These anecdotes also verify that media content and the ways that content are conveyed often reflect the primary interests of mainstream groups. Media that fail to accommodate information acquisition needs of diverse groups may actually exclude the marginalized from emergency preparedness, reifying a

system catering to majority interests and minimizing the needs of "the others."

The Internet is becoming increasingly popular among people who are deaf or hard of hearing because of the text-based nature of dialogue. During 9/11 and its aftermath, people who had access to the Internet were informed and able to communicate with family and friends. Although broadcasts were available through Internet streaming, they were not captioned, which prevented many from accessing updated information. Despite such challenges, some progress has been made. For example, AOL initiated CNN coverage of short newscasts at specified times during the day with both streaming video and captioning. People with auditory challenges have found this resource extremely valuable and have requested that other Internet service providers follow suit to assist people with hearing or vision disabilities (Stout et al., 2004).

Research has not yet specifically assessed the ways in which non-English speakers access information during calamities in the U.S. Clearly, this is an important area of further inquiry. Investigation has established that during Hurricane Katrina (and following the event) many non-English speaking individuals encountered great difficulty attempting to access important information and services. On October 3, 2006, U.S. Senator Joseph Lieberman and Senate Chairperson Susan Collins proposed legislation to eliminate language and cultural barriers for assistance and relief among non-English speakers, before, during, and after national emergencies. However, the status of this legislation remains uncertain.

Recent research has suggested that technology is becoming increasingly useful for people with communication and mobility challenges (see Bednarska, chapter 10, for a discussion of helpful technological developments as well as an analysis of "why technology isn't the only answer"). For example, 16 million people in the U.S. admit to having vision problems, even when wearing glasses or contact lenses, according to a *Wall Street Journal* article (Beck, 2008). However, recent advancements are beginning to provide communication assistance for people with vision challenges. Melinda Beck (2008) discussed the hardships faced by a teacher of 31 years who was forced to stop teaching when she developed severe hemorrhaging in her retina. Vision-rehabilitation specialists provided the teacher with telescopic glasses that enabled her to see. Sharing her joy at having her vision back, she stated, "I can see individual leaves and blades of grass....And when I realized I could read music again, I just started crying" (Beck, 2008, p. D1). This example illustrates how collective interests among people with unique needs have inspired the development of vision assisting devices. Technological advancements have been made in the areas of mobility, information access, and computer-based resources. Emergency preparation and management would

be significantly enhanced through the utilization and dissemination of these kinds of devices among people with unique sensory needs.

From a uses and gratifications perspective, it is also important to address the ways that media influence audience members' perceptions of altruism and activism. Social groups that apply dominant readings to disaster media coverage will accept the presentation of the phenomena, often failing to question why gross disparities exist among those who survive and those who perish. Those who negotiate their reading of disaster coverage may acknowledge dominant ideology, yet apply their own understanding to the situation. In crises, it may be that dominant groups consume media coverage about disasters, because passive participation (or donating nominal monetary support) may cause people to feel they are helping to alleviate what appears to be unjust suffering among minority populations. These behaviors may allow people to feel that they are assisting others, regardless of their participation in the current system.

Conclusion

This chapter provides data demonstrating that several million people in the U.S.—and inevitably elsewhere—have been insufficiently prepared for disasters and encounter anxiety, uncertainty, and frustration when they attempt to locate vital information and resources. Current institutional and social practices have not effectively met all of the emergency communication needs among diverse populations in the U.S. This chapter has drawn from intergroup, network, and the uses and gratifications frameworks to assess the communication barriers that minority groups have faced during recent disasters. Scholars and practitioners should continue to evaluate and critique crisis planning for groups with special needs.

Ideally, the topics discussed in this chapter will enhance disaster management planning in the future. Research could intensify inquiry into the antecedent variables predicting emergency information access, processing, and response among people of varying abilities, languages, and cultures. Investigation could explicate the justifications high status groups maintain in accommodating their own emergency preparedness, while overlooking the needs of others. Such avenues of inquiry should be both theoretical and applied in order to clarify the impact of individual tendencies, social norms, and political ideologies during crisis planning and response.

Evidence also reinforces the importance of organizational and social networks in disaster preparedness. Available news and public documents suggest that federal, state, and county governments have only recently begun to pay attention to establishing and maintaining reliable information flow among various levels of emergency services. Frayed networks among com-

munity advocacy organizations and emergency personnel have impeded their ability to effectively serve the needs of the disabled, minorities, and those with language challenges.

Finally, our assessment points to the reality that the people who have been most afflicted during disasters are lower status groups on the margins of society. They often lack the necessary information and resources required to evacuate during emergencies. Although some media are beginning to offer captioning for consumers with unique communicative needs, examples reviewed here suggest that majority group interests are primarily considered, while minority communities are minimally accommodated.

Future research needs to investigate the ways in which individuals from minority groups access important disaster information and with what effects. In what ways do lower status groups assert their communicative and identity interests during mainstream media processes? A more detailed understanding could be developed about the ways that dominant groups justify and attribute the structural inequities described here.

During and after Hurricane Katrina, media audiences were appalled to discover that during the George W. Bush administration, the U.S. government did not have an adequate infrastructure to warn, assist, and evacuate large groups of people, but especially low status groups. The delayed and haphazard response of government and organizations in providing even the most basic needs for minority groups shows that emergency accommodations in the U.S. are primarily intended for those who enjoy relative opportunity, status, and dominance in society—namely, people who are able bodied, English speaking, white, wealthy, and healthy. By comparison, individuals from a variety of other groups are regarded as afterthoughts.

Communication accommodation theory addresses the ways in which social attitudes and distance are maintained among groups through convergence (conforming) or divergence (differentiation) (see Gallois, Ogay, & Giles, 2005, and Giles, 2008, for the history and applications of communication accommodation theory). The theory has been applied to communication in intercultural and bilingual contexts, inter-ability, and inter-aged interactions, but it has not yet been applied to institutional accommodation policies and practices. Assessing tendencies across social and institutional environments may impart knowledge about general processes manifesting during intergroup distinctions and bias. Further research might also identify existing practices of inclusion or exclusion in government, organizational, and community environments, in order to increase awareness of these issues. More broadly, in what ways do national, cultural, or institutional ideologies legitimate accommodating the needs of certain groups, while neglecting others?

Public demonstrations of concern for the disadvantaged during disasters have been evident in certain domains, yet scant attention to the needs of the most destitute testifies to a systemic undercurrent that threatens the egalitarian ethos of U.S. values. The term "civil defense" describes a basic mission and function, namely, the defense of civilians from serious threats. Apparently, some groups in the U.S. may be considered to be more civilian than others. Systemic exclusion must be consistently critiqued and challenged in order to further institutional and social practices that are inclusive, proficient, and thorough in meeting the needs of all citizens.

References

Abrams, J. R., Eveland, W. P., & Giles, H. (2003). The effects of television on group vitality: Can television empower nondominant groups? In P. J. Kalbfleisch (Ed.), *Communication yearbook 27* (pp. 193–219). Mahwah, NJ: Erlbaum.

Beck, M. (2008, September 9). High technology for low vision. *Wall Street Journal,* pp. D1-D2.

Bellamy, L. J. (1987). *Evacuation data.* Paper presented at the European Conference on Emergency Planning for Industrial Hazard, Varese, Italy.

Berube, M. (2005). *Disability and disasters-blog.* Posted by Michael Berube. Retrieved October 15, 2006, from, http://www.michaelberube.com/index.php/weblog/disability_and_disasters/.

Blake, R. R., & Mouton, J. S. (1984*). Solving costly organizational conflicts.* San Francisco: Jossey-Bass.

Blumler, J. G. (1985). The social character of media gratifications. In K. E. Rosengren, L. A. Wenner, & P. Palmgreen (Eds.), *Media gratifications research* (pp. 41–60). Beverly Hills, CA: Sage.

Bourhis, R. Y., Giles, H., & Tajfel, H. (1973). Language as a determinant of Welsh identity. *European Journal of Social Psychology, 3,* 447–460.

Bradac, J. J., Cargile, A. C., & Hallett, J. S. (2001). Language attitudes: Retrospect, conspect, and prospect. In W. P. Robinson & H. Giles (Eds.), *The new handbook of language and social psychology* (pp. 137–155). Chichester, England: Wiley.

Castells, M. (1997). *The information age: Economy, society and culture: The power of identity.* Oxford: Blackwell.

Centers for Disease Control and Prevention. (2004). *Continuation guidance: Crosscutting activities.* Retrieved October 15, 2006, from http://www.bt.cdc.gov.

Dyal, J. A., & Dyal, R. Y. (1981). Acculturation, stress, and coping. *International Journal of Intercultural Relations, 5,* 301–328.

Elsbach, K. D., & Kramer, R. (1996). Members' responses to organizational identity threats: Encountering and countering the business week ratings. *Administrative Science Quarterly, 41,* 442–476.

Federal Communications Commission (FCC). (2008). *Closed captioning: FCC consumer facts.* Retrieved September 14, 2008, from http://www.fcc.gov/cgb/consumerfacts/closedcaption.html.

Federal Emergency Management Agency (FEMA). (2008). *FEMA Mission.* Retrieved September 14, 2008, from http://www.fema.gov/about/index.shtm.

Fitzpatrick, C., & Mileti, D. S. (1994). Public risk communication. In R. R. Dynes & K. J. Tierney (Eds.), *Disasters, collective behavior, and social organization* (pp. 71–84). Cranbury, NJ: Associate University Press.

Flynn, J., Slovic, P., & Mertz, C. K. (1994). Gender, race, and perception of environmental health risks. *Risk Analysis, 14,* 1101–1108.

Fountain, J. (2001). *Building the virtual state: Information technology and institutional change.* Washington, DC: Brookings Institution.

Fox, S., Giles, H., Orne, M., & Bourhis, R. Y. (2000). Interability communication: Theoretical perspectives. In D. Braithwaite & T. Thompson (Eds.), *Handbook of communication and disability* (pp. 192–222). Mahwah, NJ: Erlbaum.

Gallois, C., Ogay, T., & Giles, H. (2005). Communication accommodation theory: A look back and a look ahead. In W. Gudykunst (Ed.), *Theorizing about intercultural communication* (pp. 121–148). Thousand Oaks, CA: Sage.

Giles, H. (Ed.). (1977). *Language, ethnicity and intergroup relations.* London: Academic Press.

Giles, H. (1978). Linguistic differentiation between ethnic groups. In H. Tajfel (Ed.), *Differentiation between social groups* (pp. 361–393). London: Academic Press.

Giles, H. (2008). Accommodating translational research. *Journal of Applied Communication Research, 36,* 121–127.

Giles, H., Bourhis, R. Y., & Taylor, D. M. (1977). Towards a theory of language in ethnic group relations. In H. Giles (Ed.), *Language, ethnicity, and intergroup relations* (pp. 307–348). London: Academic Press.

Goldsmith, S., & Eggers, W. (2004). *Governing by network: The new shape of the public sector.* Washington, DC: Brookings Institution Press.

Graney, M. (2006, June 28). *American Red Cross signs national agreement with Language Line for instant interpreting services.* PR Newswire Association.

Gudykunst, W. B. (1988). Uncertainty and anxiety. In Y. Y. Kim & W. B. Gudykunst (Eds.), *Theory in intercultural communication* (pp. 123–156). Newbury Park, CA: Sage.

Guéhenno, J.-M. (1993). *La fin de la démocratie.* Paris: Flammarion.

Harwood, J., & Anderson, K. (2002). The presence and portrayal of social-groups on prime-time television. *Communication Reports, 15,* 81–98.

Harwood, J., & Giles, H. (Eds.). (2005). *Intergroup communication: Multiple perspectives.* New York: Peter Lang.

Harwood, J., Giles, H., & Palomares, N. (2005). Intergroup theory and communication processes. In J. Harwood & H. Giles (Eds.), *Intergroup communication: Multiple perspectives* (pp. 1–17). New York: Peter Lang.

Harwood, J., & Roy, A. (2005). Social identity theory and mass communication research. In J. Harwood & H. Giles (Eds.), *Intergroup communication: Multiple perspectives* (pp. 189–211). New York: Peter Lang.

Hecht, M. L., Jackson, R. L., & Pitts, M. J. (2005). Culture: Intersections of intergroup and identity theories. In J. Harwood & H. Giles (Eds.), *Intergroup communication: Multiple perspectives* (pp. 21–42). New York: Peter Lang.

Hinkle, S., & Schopler, J. (1986). Bias in the evaluation of in-group and out-group performance. In S. Worchel & W. G. Austin (Eds.), *Psychology of intergroup relations* (pp. 196–212). Chicago: Nelson-Hall.

Hogg, M. A., & Abrams, D. (1999). Social identity and social cognitions: Historical background and current trends. In D. Abrams & M. A. Hogg (Eds.), *Social identity and social cognition* (pp. 1–25). Oxford: Blackwell.

Hogg, M. A., & Abrams, D. (2001). Intergroup relations: An overview. In M. A. Hogg & D. Abrams (Eds.), *Intergroup relations: Essential readings* (pp. 1–14). Ann Arbor, MI: Taylor & Francis.

Hogg, M., Terry, D., & White, K. (1995). A tale of two theories: A critical comparison of identity theory with social identity theory. *Social Psychology Quarterly, 58*, 255–269.

Jakubowicz, A. (1995). Media in multicultural nations: Some comparisons. In J. Downing, A. Mohammadi, & A. Sreberny-Mohammadi (Eds.), *Questioning the media* (pp. 165–183). Thousand Oaks, CA: Sage.

Jost, J. T., & Burgess, D. (2000). Attitudinal ambivalence and the conflict between group and system justification motives in low status groups. *Personality and Social Psychology Bulletin, 26*, 293–305.

Kailes, J. (2000). Creating a disaster-resistant infrastructure for people at risk including people with disabilities. In A. B. Tufana & M. Petal (Eds.), *Trauma treatment professionals training* (pp. 41–63). Ankara, Turkey: Hacettepe University, School of Social Work.

Kailes, J. (2006). *Including people with disabilities and seniors in disaster service*. California Foundation for Independent Living Centers. Retrieved October 15, 2006, from http://www.cfilc.org.

Kramer, R. M. (1991). Intergroup relations and organizational dilemmas: The role of categorization processes. In L. L. Cummings & B. M. Staw (Eds.), *Research in organizational behavior* (pp. 191–228). Greenwich, CT: JAI Press.

Lull, J. (1995). *Media, communication, culture: A global culture*. New York: Columbia University Press.

Ma, G. X. (1999). *The culture of health: Asian communities in the United States*. Westport, CT: Bergin and Garvey.

Marlow, M. L., & Giles, H. (2006). From the roots to the shoots: A Hawaiian case study of language revitalization and modes of communication. *Communication Yearbook, 30*, 343–385.

Mileti, D. S., Drabek, T. E., & Hass, J. E. (1975). *Human systems in extreme environments: A sociological perspective*. Boulder: University of Colorado, Institute of Behavioral Science.

Mileti, D. S., Hutton, J., & Sorenson, J. H. (1981). *Earthquake prediction response and options for public policy*. Boulder: Institute of Behavioral Science, University of Colorado.

Monge, P. R., & Contractor, N. S. (2003). *Theories of communication networks*. New York: Oxford University Press.

Mullen, B., Brown, R. J., & Smith, C. (1992). Ingroup bias as a function of salience, relevance, and status: An integration. *European Journal of Social Psychology, 22*, 103–122.

National Council on Disability. (2005). *Saving lives: Including people with disabilities in emergency planning.* Retrieved October 11, 2006, from http://www.ncd.gov.

National Organization on Disability. (2005). *Report on special needs assessment for Katrina evacuees (SNAKE) project.* Retrieved October 15, 2006, from http://www.ncd.gov.

Noll, A. M. (2003). *Crisis communications: Lessons from September 11.* Oxford: Rowman & Littlefield.

Oakes, P. J., Haslam, S. A., & Turner, J. C. (1994). *Stereotyping and social reality.* Oxford: Blackwell.

O'Hair, D. (2005). *The role of social science research in disaster preparedness and response.* Subcommittee on Research at the 109th United States Congressional Hearing.

Perry, R. W., & Lindell, M. K. (1986). *Twentieth-century volcanicity at Mt. St. Helens: The routinization of life near an active volcano.* Tempe: Arizona State University, School of Public Affairs.

Pfeffer, J., & Sutton, R. I. (2000). *The knowing-doing gap: How smart companies turn knowing into action.* Boston, MA: Harvard Business School Press.

Pollander, G. S., & Rund, D. A. (1989). Disabled persons and earthquake hazards. *Disasters, 13,* 365–369.

Potter, J., & Wetherell, M. (1987). *Social psychology: Beyond attitudes and behaviors.* London: Sage.

Quarantelli, E. L. (1980). Some research emphasis for studies on mass communication systems and disasters. In National Academy of Sciences (Ed.), *Disasters and mass media* (pp. 293–299). Washington, DC: National Academy of Sciences.

Raphael, B. (1986). *When disaster strikes: How individuals and communities cope with catastrophe.* New York: Basic Books.

Reid, S. A., Keerie, N., & Palomares, N. (2003). Language, gender salience, and social influence. *Journal of Language and Social Psychology, 22,* 210–233.

Reynolds, B., Galdo, J., & Sokler, L. (2002). *Crisis and emergency risk communication.* Atlanta, GA: Centers for Disease Control and Prevention.

Rosengren, K. E., Wenner, L. A., & Palmgreen, P. (1985). *Media gratifications research: Current perspectives.* Beverly Hills, CA: Sage.

Ryan, E. B., Bajorek, S., Beaman, A., & Anas, A. P. (2005). "I just want you to know that 'them' is 'me'": Intergroup perspectives on communication and disability. In J. Harwood & H. Giles (Eds.), *Intergroup communication: Multiple perspectives* (pp. 117–137). New York: Peter Lang.

Sachdev, I., & Bourhis, R. Y. (1984). Minimal majorities and minorities. *European Journal of Social Psychology, 32,* 71–103.

Sachdev, I., & Bourhis, R. Y. (1987). Status differentials and intergroup behavior. *European Journal of Social Psychology, 17,* 277–293.

Sachdev, I., & Bourhis, R. Y. (1991). Power and status group differentials in minority and majority group relations. *European Journal of Social Psychology, 21,* 1–24.

Sachdev, I., & Bourhis, R. Y. (2005). Multilingual communication and social identification. In J. Harwood & H. Giles (Eds.), *Intergroup communication: Multiple perspectives* (pp. 65–92). New York: Peter Lang.

Scharf, T., & Smith, A. E. (2004). Older people in urban neighborhoods: Addressing the risk of social exclusion in later life. In C. Phillipson, G. Allan, & D. Morgan (Eds.),

Social networks and social exclusion: Sociological and policy perspectives (pp. 162–179). Aldershot, England: Ashgate.

Seeger, M. W., Sellnow, T. L., & Ulmer, R. R. (2003). *Communication and organizational crisis.* Westport, CT: Quorum Press.

Sellnow, T., Seeger, M., & Ulmer, R. R. (2002). Chaos theory, informational needs and the North Dakota floods. *Journal of Applied Communication Research, 30,* 269–292.

Sidanius, J., & Pratto, F. (1999). *Social dominance.* New York: Cambridge University Press.

Simon, B., Aufderheide, B., & Kampmeier, C. (2001). The social psychology of minority-majority relations. In R. Brown & S. L. Gaertner (Eds.), *Blackwell handbook of social psychology: Intergroup processes* (pp. 303–323). Oxford: Blackwell.

Slaughter, A. M. (2004). *A new world order.* Princeton, NJ: Princeton University Press.

Stout, C., Heppner, C. A., & Brick, K. (2004). *Emergency preparedness and emergency communication access: Lessons learned since 9/11 and recommendations.* Sponsored by the Deaf and Hard of Hearing Consumer Advocacy Network and Northern Virginia Resource Center for Deaf and Hard of Hearing Persons. Retrieved October 15, 2006, from http://tap.gallaudet.edu/EmergencyReports/DHHCANEmergencyReport.pdf.

Tajfel, H. (Ed.) (1978). *Differentiation between social groups: Studies in the social psychology of intergroup relations.* London: Academic Press.

Tajfel, H., & Turner, J. C. (1986). The social psychology of intergroup behavior. In S. Worchel & W. G. Austin (Eds.), *Psychology of intergroup relations* (pp. 7–24). Chicago: Nelson-Hall.

Turner, R. H., Nigg, J. M., Paz, D. H., & Young, B. S. (1981). *Community response to earthquake threats in Southern California.* Los Angeles: University of California Press.

United States Census Bureau. (2000). *Statistical abstract of the United States.* Washington, DC: United States Government.

United States Federal News. (2006). *Rep. Honda introduces bill mitigating language and cultural barriers to disaster relief.* Washington, DC: United States Government.

United States Government Accountability Office. (2006). *Observations on hurricane response.* Washington, DC: United States Government.

Urry, J. (2003). *Global complexity.* Cambridge, England: Polity.

Van Dijk, J. (2006). *The network society* (2nd ed.). London: Sage.

White, G. (2003). *Nobody left behind: Investigating disaster preparedness and response for people with mobility impairments.* Kansas University, Research and Training Center on Independent Living. Retrieved October 15, 2006, from http://rtcil.org/abstract.htm.

Williams, A., & Nussbaum, J. F. (2001). *Intergenerational communication across the lifespan.* Mahwah, NJ: Erlbaum.

Witte, K. (1995). Generating effective risk messages: How scary should your risk communication be? In B. R. Burleson (Ed.), *Communication yearbook* (pp. 229–254). Thousand Oaks, CA: Sage.

CHAPTER 16

Efficiency Techniques in Journalistic Practice, Scientific Rigor, and Religious Rhetoric

▶ GENE BURD

The techniques of journalistic objectivity and scientific research methods have ironically coincided with a cult of communication efficiency with the rhetorical ritual of religion and the snare of social science. Lest journalists forget, the first book printed was the Bible and the first words on the telegraph wondered, "What hath God wrought?" and Stewart Brand, founder of *The Whole Earth Catalogue*, a precursor of the Internet, suggested in 1968 that, "We are as Gods, and we might as well get good at it" (Markoff, 2006, p. 155).

Although journalism has long considered itself to be primarily a secular, separate, and independent mechanical technique, in retrospect, the genealogies of Progressive Era muckrakers, the new Internet technologies, and the new public journalism have often mixed morality with media practice, while journalism and communication have been studied as social science also concerned with facts, evidence, accuracy, proof, and truth. This shared turf has housed a mutual mission woven into precision, prediction, and prophecy

inherent in the efficiency of information control. In this respect, news itself is frequently defined as the breakdown and absence of efficiency in a society where reactive political officials and the press worship "techniques" and "tools" that "work" if there is "access" to "resources" that feed into "the system as the solution"—the current vocabulary, language, and strategy of social action. Means are paramount, and ideology and ends are often denied, downgraded, and replaced with the efficient cant of objective certainty despite a cultural reality full of subjective and inefficient uncertainties.

Technique and technology have nourished a modern theology of communication, while media have facilitated the objective conduit of authoritative sources of control whose gods of human certainty replace the once-secure God of the cosmos. Meanwhile, there is a resurgence of Neo-Luddite resistance and revolt against the objective machinery of news-making and communications efficiency by those who seek truth through experience and intuition rather than depend on mediated techniques. There are many reactions and much resistance against media efficiency: people dehumanized and separated from their own experiences; fears of post-human information robots, quantified nanoseconds, and artificial body transplants; anxiety about scientific assaults on feeling, emotion, opinion, belief, ideology, and subjectivity; concern over the derision and demise of unpredictable and unrestricted liberty; and the fear, threat, and loss of creative chance, risk, spontaneity, serendipity, and the freedom to be incorrect and imprecise—and even inefficient!

Low public esteem for media and journalism thrives amidst communication overload; resistance to TMI (too much information); television turn-offs, computer hacking, media bashing, bloggers, smart-mobs, citizen journalists; and the rise of we, me, and my in public and media spaces and places. Readers, viewers, and listeners are striking back by using, exploiting, and controlling the technology and techniques bombarding them in the culture of efficiency.

Arrogant, top-down "Big Media" have "treated the information and news as a lecture," but "technology has given us a communications toolkit that allows everyone to become a journalist" to produce bottom-up democratic grassroots news by and for "we the media" that "will be more of a conversation or a seminar" (Gillmor, 2004, pp. xii–xiii). That "technology will eventually win" as did the printing press when the "Vatican's monks, who controlled publishing, were helpless with the onslaught of the new technology. After Gutenberg, the Word of God was liberated from the Pope's doctrine" (pp. 236–238).

Historically, the objective, rational, and artificial content in the dominant "mass media has provided the essential link between the individual to the demands of the technological society" (Ellul, 1964, p. 22). Meanwhile, practicing journalists continue to be trained to be efficient information technicians in a setting where "alienated from its natural (humanities) home, journalism education has sought refuge in technique or in science...a science of bureaucracy, of systems, of procedures, of management, and of control" (Carey, 1996, p. 10). Journalism traditions, texts, and practices have focused on internal production techniques, institutional forms and structures, more than on content and substance. Journalism is closer to technology than to sociology and is more about means in geographic places and specific events than about the ends of policies and issues (Burd, 1981).

Journalism is a how-to-do trade, skill, and craft tied to a professional practice whose ideal mechanical operation is efficiency, although not always perfected. It involves adept mechanical abilities and utilities. It is a technical operation that uses physical materials: paper, ink, lead, type, wires, waves, images (fixed and moving)—from the alphabet to the computer, the book, photo, film, telegraph, telephone, typewriter, radio, television, Internet, and new personal mobile technologies.

By their nature, these communications media invariably involve technical efficiency in the quantitative and fixed physical control of time and space. They involve and require speed and schedules in the production of products for readers, viewers, and listeners with precise deadlines, headlines, cutlines, and datelines measured by split seconds, seconds, minutes, hours, days, weeks, months, years, and beyond. Their disconnected parts create a vacuum for efficiency: cuts, cues, tips, bits, bites, and bytes in search of exact and efficient length, depth, width, space, and time. There is also the pressure to be accurate and correct with evidence, verification, and proof of truth while reducing the inefficient and unforgivable errors, surprises, mistakes—and libel—and preventing changes for unpredicted, unanticipated inefficiency. It becomes fatal to miss the big story for the last newscast or final edition or to fail to correctly predict and forecast the future in weather, politics, or sports even before the game or contest ends (or begins). Efficient journalism means certainty and finality on "how many dead tells the story" or that classic assignment for journalism freshmen to write the headline for the hypothetical last story on how "the world ends and the savior returns."

Efficiency and exactness in reporting and scientific research methods are valued as ends in themselves, as the objective journalist and scientist insist that they only report what is, not what should be. They contend that means and methods are their main goals, while ends are for others to define

and decide in the public interest; and the system is responsible for any solution to problems that may arise. Many journalists have long insisted that "there is but one kind of unity possible in a world as diverse as ours. It is unity of method, rather than aim" (Lippmann, 1922, p. 67). Therefore, "like scientific method, journalistic method is validated by consensus. Equally important, the methods themselves are considered objective" (Gans, 1979, p. 183), if "procedures are followed providing for systematic decisions" (Dennis & Merrill, 1991, p. 118).

To justify the ends of efficient and relevant communication yet avoid accusations of being part of a subjective religious cult, journalism technicians are somewhat timidly taught that morality "underlies journalism" (Mencher, 2006, p. 553). It "is basic to the theory and practice of journalism" where there is "belief in the methods of journalism…(and) the conviction that this method will lead to some kind of truth worth sharing" (pp. 562–563). While journalists "shrink at being described as moralists" (p. xi), they consider their work to have a large "moral component" within a "moral framework," with a "moral vision," and "a religious perspective" on the "good" and "communal" life (p. 428).

Such an efficient and pristine objectivity in journalism has been protected and sheltered by its reliance on the validity and reliability of science in "precision journalism" (Meyer, 1979) with which it has shared "an empirical base, that both rely fundamentally on finding evidence for statements before statements are made" (Tankard, 1976, p. 47). Thus, "the journalist has lessons to learn from the behavioral scientist about using theory and hypotheses to direct inquiries, making reliable and valid observations, using quantification to make more precise statements, basing conclusions on adequate samples, and making legitimate causal inferences" (p. 77).

Multiple editions of journalism texts teach "how to do" techniques and methods, more than preach "what is" the nature, meaning, and consequence of the content (Fedler, Bender, Davenport, & Kostyu, 1997, pp. 60–61). Such procedures are expected to represent and reproduce reality, because the "perfect choice" of words "makes a sentence forceful and interesting" while "imprecision creates confusion and misunderstanding" and "audiences derive a different meaning from the one intended" when reporters "fail to express their ideas clearly and precisely" (p. 103). "Media writers" for the twenty-first century are reminded of the "powerful tools" needed "to control the packaging, timing and dissemination of the message, as well as its content" (Whitaker, Ramsey, & Smith, 2000, p. 297). Writers for the mass media are taught how to use techniques and "tools of the trade," "how to be specific, accurate, exact," and "how to use words precisely" and "not waste the read-

er's time" (Stovall, 2006, pp. 3–4). These efficient media techniques have been taught, practiced, and have survived new multimedia ("Multi-Media and Efficiencies," 1995); new communication technologies; and continue to be the skills and training desired by editors using the new technologies for online journalism (Fahmy, 2008).

The efficient marriage of journalism with scientific methodology also finds a home with government bureaucracy, which has stoked the engines of communication efficiency to help manage, control, and explain the complex and powerful machinery of modernity. In this congregational matrix, the new religious mass morphs into mass communication, creating what might be termed "godernity," which combines religious rhetoric and scientific rigor. That combination stretches from Johannes Gutenberg and Martin Luther to the Industrial Revolution, to the intellectual class of the Progressive Movement, to the New Deal and Great Society, and to the current "evangelists in the newsroom" in the more recent public journalism movement (Corrigan, 1999). Social scientists have managed to pledge allegiance to the government's powerful Fourth Branch (the press) to create "heaven on earth" as did Progressives who saw government and the muckraking press as the new "gods," who "hoped to make American government better able to serve the people's needs by making government operations and services more efficient and rational," according to Wikipedia.

Today, the media's "deification of technology" as the "Second God" at the altar of television produces "a kind of religious literature…assuming the form of religious parables…from which a moral or spiritual truth is drawn" and "organized around a consistent theology…which upholds technological sophistication as the pathway to solutions" (Postman, 1982, and Schwartz, 1981, qtd. in Shrader, 1992, p. 150). Mediated techniques and tools are expected to create moral values and solve problems outside of direct personal experience. Knowing and being good have been replaced by skills that do good and thereby change the world instead of the self. Journalists once inclined to enter the ministry and priesthood have used new communication technology like blogging to get inside the media establishment to become insiders who define and distribute "The Word" like scribes inside the temple of truth (Burd, 2008).

When deity declined and was redefined in the Progressive Era, Americans fell in love with "an efficiency craze—a secular Great Wakening, an outpouring of ideas and emotions in which a gospel of efficiency was preached without embarrassment to business-men, workers, doctors, housewives, and teachers, and yes, preached even to preachers" (Haber, 1964, p. ix). Journalism's muckrakers at *McClure's, Saturday Evening Post, Outlook,* and *Ladies Home*

Journal worshipped alongside social scientists in the cult and church of civic optimism. Efficiency and rhetorical catchwords were used by journalists who "combined the accuracy and thoroughness of the research scholars with the qualities of good reporting," resulting in "legislation...to correct the more flagrant abuses of industrial, democratic America" (Callahan, 1962, p. 10).

> Missionary-like muckrakers exposed problems rationally and social efficiency suggested a moral clean-up. It implied that society was in control of its affairs, that the spread of the efficient systems throughout society was not only desirable, it was possible. By 1910, an efficiency craze gripped the country. Efficiency societies, efficiency expositions, efficiency courses, and efficiency lectures were commonplace. Churches set up efficiency committees to increase membership. Feminists put forth the idea that efficient methods of doing housework would free women from subordination. (Gelberg, 1997, p. 16)

The *New Republic* "respected both the non-rational and the rational impulse" and "with one hand (Walter) Lippmann held to science and order, but he stretched to grasp indeterminacy, emotion, imagination and even mysticism" (Haber, 1964, p. 91).

> Science and the scientific method—systematized rational knowledge gleaned from study and observation—came into its own during the years around the turn of the century. It became a driving force conditioning the development of twentieth-century American civilization. It gave us methods of investigation, knowledge, and tangible products of technical innovation. It became viewed as the key to the discovery of truth and efficiency. (Gelberg, 1997, pp. 23–24)

The American Social Science Association, founded in 1865 by ex-abolitionist Frank Sanborn, believed that "doses of simple morality mixed with efficiency could reduce poverty, cure the mentally ill, house the homeless and feed the hungry," and he suggested that "organizational efficiency was replacing cleanliness as the virtue closest to godliness" (Seidelman & Harpham, 1985, p. 49).

This mix of the gospel of scientific efficiency provided the objective expertise of science and journalism for modern government with "a method of scholarly inquiry and social improvement intertwined with efforts to use social research and politics together" through "professional, modern research to technically master both nature and society" (Tevelow, 2000, p. 33). Progressive politics "deferred to science as a de-politicized source of judgment," and efficiency was the key term to change the political system, especially municipal reform by elite experts with specialized knowledge. The nineteenth century of limited government was replaced by the "notion of the public interest produced by the efficiency movement" (p. 39). This was "stimulated by the journalistic muckrakers, whose posed objectivity matched the

ideal of the non-political science and non-partisan government...(and their) idea that social science could be used to cure social ills...was assimilated and attenuated by the metaphor of efficiency," which was a "rhetorical device" in muckraking and urban reform" (pp. 39–40). Despite sensationalism in muckrakers' journalism, "the objective ideal was tied to visions of reform" with a "guise of 'naïve empiricism,'" although to "operate without 'bias'...(the supposed defining characteristic of objectivity) is simply to operate with the unstated assumptions of the current culture" (Harrison, 2000, p. 20). The ends of objectivity were not questioned in journalism, science, and government, so that efficiency of techniques in "the public interest" remained the only issue open for debate.

Today, U.S. federal government officials are again eager to embrace information technology and its techniques to create efficient electronic government for the citizen as customer, client, consumer, and constituent because "the public wants more and better government services, more useful and timely information, and more effective and efficient government" ("Information Technology," 1993, pp. 175, 184). Such a seductive "national information architecture" with "easy, efficient and secure information access" would be "based on the citizen's bottom-up perspective rather than the top-down perspective" (Fosler, 1993, p. 107)—a promise not very different from the prediction of the pluralistic and democratic "we the media" (Gillmor, 2004).

As the traditional religious tone of the mainstream media moved from a consensus toward a pluralistic, multicultural secular society (Olasky, 1991), the tranquil and compartmentalized newspaper religion pages arose (Nordin, 1978) and left behind the early religious roots of American journalism. Journalists became increasingly critical (and perhaps jealous) of the power of religious figures and their claims to efficient certainty. However, the muckrakers themselves were driven by a moral commitment but were considered objective, yet they claimed moral authority on issues of economics, gender, racial inequities, war, and peace. For Progressives, "efficiency meant social harmony and the leadership of the 'competent,'" as methods for commercial efficiency and scientific management were borrowed from the exact sciences and "efficiency and co-operation were bywords of business...interlaced (with) considerations of morality and profit" (Haber, 1964, pp. 11, 72).

The Progressive legacy survives today in the gospel of global warming preached as a moral failure needing environmental repentance for the guilt of consumption, "the problem of evil," and media's responsibility for the global "moral order" (Silverstone, 2007, pp. 7, 56). One argument is that "religion and communication are inseparable" and "pursuit of the religious involves inquiry, exploration, and discovery" but its "real power" is its "medi-

ation" (Longinow, 2004, p. 78). During the Progressive Era, methods, media, government, science, and religion momentarily merged in religious rhetoric, which suggested that "science, which was a more certain form of the true, could also appear as a more rigorous form of the good" with "social gospel ministers and similarly minded sociologists, social workers and publicists, working initially from a broadened concept of Christian charity" (Haber, 1964, pp. 11, 134).

The language of moral strategies has since moved even closer toward efficient methods and means rather than toward goals and ends. The political and press rhetoric of tools, tasks, skills, gaps, fixes, and resources to "get things done" efficiently is bolstered by political and press calls for nonpartisan, bipartisan policies devoid of ideology (and debate), which removes press and politicians (Left and Right) from confronting differences in a technological culture where "technologies are not value neutral" (Oberdiek, 1995, p. 23). However, if "efficiency becomes an end in itself, one that we reify and then allow to dominate us…we turn ourselves into slaves of an efficiency imperative" (Levine, 2004, p. 88).

Although it is heresy to question or criticize journalists as efficient seekers of truth, there has been concern expressed that their techniques are tied too closely to media dependence on commerce; that techniques overshadow content; that scientific methods and new media technologies can ignore personal human communication and separate people from communication techniques; that the ease, speed, and magic of the Internet lead to technological determinism; and that radical post-human evolution and objectivity overwhelm and trump subjectivity.

In academic circles, the insecure scholarship of journalism has been "alienated from its natural home in the humanities" and has "sought refuge in technique or in science" (Carey, 1996, p. 10). "Technique, in the long run, is too thin to justify a home in the university" and science "deeply undercuts the democratic impulse of journalism," so that communication science has occupied journalism schools and "created and fed off a natural hostility between journalism and the arts of social control" (p. 10). The use of scholarly objectivity borrowed from scientific methodology allowed journalism teachers to be accepted by university research scholars, who look down on journalism. At the same time, the objectivity-obsessed working press adopted some of the social science research methods of precision and public journalism taught to journalism school graduates to help the media efficiently reconnect to a declining audience.

Some journalists have resented efficiency experts' time and motion studies to cut newspaper costs by arguing that "editorial staffers are profession-

als whose work can't be timed as though they are machine operators in a macaroni factory" (Holsinger & Black, 1965, pp. 58–59). Also, clustered newspaper operations in geographically adjacent markets (which share resources and news gathering with smaller staffs in economies of scale) have been found to be more efficient, but "gains in efficiency might be offset by reductions in quality," an increase in employee stress, emotional exhaustion, and job turnover (Martin, 2003, p. 17). Editors operating more efficiently with smaller staffs that have heavier workloads "may be forced to compromise quality of coverage in favor of quantity" (p. 17). The "cult of cost efficiency" has also been criticized for destroying credible corporate relations with the media (Crooks, 1996), and excessive prediction efficiency by media pundits is blamed for preempting voters' choices ("Media to Voters," 2008). Broadcast spectrum efficiency has also been criticized because efficiency meant that "public-interest protections have been dismantled to privilege the commercial imperatives of broadcast stakeholders" (Stavitsky & Odell, 2006, p. 693).

Communication technology efficiency was sought by media executives more than news quality. Although such technology would cut costs, bring faster production, more glitz and graphics, better pagination and layout, more collaboration, and repackage more services, it improved technical rather than thinking skills. Technology also forecast a "relentless emphasis on efficiencies" to create its own momentum and bottom-line considerations that overshadow the journalistic mission (McMullen, Fletcher, & Ross, 1994, p. 26). The actions of media buyers and sellers also drive out inefficiency, which has actually benefited consumers and citizens because each new competing media technology "complemented each other because they were relatively equally inefficient in terms of measurability by the advertisers that supported them" (McNulty, 2008, p. 2).

In other countries, imported communication efficiency from Western "media imperialism" and "the mathematical activity of electronic media (media-metrics)" may have "weakened the development of communication concepts of indigenous groups" and "may distort the value systems" of developing countries (Ngwainmbi, 1995, pp. 82, 89).

In the U.S., "McDonaldization" is an "optimum method for getting from one point to another" efficiently by "following the steps in a pre-designed process" (Ritzer, 1993, pp. 12–13, 46; see also Jurgenson and Ritzer, chapter 4). It provides lots of fast food quickly in a standardized Ford-like assembly line, but it is linked to an increase in the pace of life, has spawned "inefficiency, rather than increased efficiency, brought relatively high costs, illusory fun and reality, false friendliness, disenchantment, threats to health

and the environment, homogenization and dehumanization" (Ritzer, 1993, p. 158). These techniques have led to quantity more than quality, and the "replacement of human with non-human technology" (robotic and artificial intelligence) has made "more pliant participants" through "increased control over the uncertainties created by people—especially employees and customers" (p. 132).

The efficiency practices of McDonaldization have extended beyond food into education, sports, politics, tourism—but also into media, where the efficiency and success of the national newspaper *USA Today* reaches busy readers with little time to read news McNuggets of junk journalism in the McPaper. Its short and tightly edited stories, minimum of facts and details, entertaining features, and colorful graphics can be consumed like a fast food drive-through restaurant meal. Some critics of both newspaper and fast food franchises have been concerned about quality and have asked, "Where's the beef?" as the means of efficient speed in delivery became a value in itself.

Perhaps the most prominent and productive critic of technology's techniques was French sociologist and theologian Jacques Ellul (1964), whose critical analysis of *The Technological Society* defined seven of its attributes: rationality, artificiality, automatism, augmentation, monism, universalism, and autonomy. He warned how efficiency eliminates the natural world, facilitates propaganda through media, and creates a sacred religiosity of absolute efficiency. He predicted that "as technique takes hold over the world, efficiency becomes the key determinant of human affairs" (Moore, 1998, p. 132). He cautioned that "efficiency is the only thing that matters in a technological system, so all other considerations are subordinated to efficiency, if not eliminated outright" (Strate, 2004, p. 28). He warned of the "mingling of techniques and politics" and decisions "necessitated by efficiency"; the control of information to maintain efficiency for "keeping the system running smoothly"; and the government being "able to take advantage of the media to improve its efficiency" run by bureaucrats "attuned to the needs of the machine" (Moore, 1998, pp. 137, 136, 138).

Ellul, a Christian, believed that good deeds, and not use of technology, defined the righteous, and he worried that "technique does not eliminate religious tendencies but subordinates them to its purposes (Karim, 2001, p. 121). "In displacing spirituality, he reasoned, technique itself becomes an object of faith. It comes to embody the sense of mystery that was once the province of religion" (p. 121). Today's miraculous Internet magic becomes part of the mystical and sacred devotion to "the power of fact" (Karim, 2001, p. 121) as democracy and propaganda become a religion and promise prog-

ress and paradise for all who plug into the information technology (Ellul, 1964).

The close ties of science, religion, society, and communication techniques flood the works of Ellul and his interpreters. He and they lament the vicarious overstimulation of technology; how the qualitative becomes quantitative; how "know-how" and technology take on an ultimate and fundamental (and unexamined) value and "a quality of divinity in the unconscious" (Shrader, 1992, p. 153). They note how salvation now comes from things and techniques; how scientific method, theories, and data incubate technologies as means to ends; and how technology prediction, control, and manipulation march on with science often unconcerned with values. They remind us that the magic that once helped humans deal with existence has been replaced with the efficiency of techniques and procedures, and "modern society has followed the lead of applied science and technology as medieval society followed that of divine revelation" (p. 153).

While the Greeks separated science and techniques, the Romans were more inclined toward the latter. Early Christians were skeptical of both, but the Reformation and Industrial Revolution modified that, while the Progressives were to excel in their embrace of modernism. The recent movement toward public, citizen, and civic journalism has also been an effort to revive the *head* of the social scientists, the *heart* of the zealous moral journalists, and the *help and heft* of the bureaucratic experts and governmental system. This seems designed and destined to shift the one-directional media and communication assembly line of Fordism to a more democratic populist post-Fordism with bottom-up communication so as to democratize and economize mass media's loss of connection to its consumers.

Coming to a possible rescue, public journalism combines traditional professional objective reporting with the precision journalism (Meyer, 1979) of evangelized social science methods: polls, sampling, surveys, focus groups, field experiments, meetings, deliberative forums, roundtables, solution action teams, pledge cards, study guides, information kits, brochures, lobby voter registration desks, and participant observation; along with an activist, moral, ethical, spiritual, and religious missionary tone to produce a more efficient and virtuous democracy.

It is visualized as "the re-creation of a participant, speaking public, ritually formed for democratic purposes" (Munson & Warren, 1997, p. 338). Both media and its recipients are to be more involved in the process of information efficiency. The public replaces the pope as the new journalism saves and redeems media economics, revives democracy, and stokes the ideological agenda of the secular society. "The god term of journalism—the be-all

and end-all, the term without which the enterprise fails to make sense—is the public" (Carey, 1992, p. 11).

Public journalists seek to reinforce the efficiency of the declining daily dinosaur media by reconnecting them to the civic congregation through their own reformation led by public journalism prophet Jay Rosen (2002), who describes the new civic journalism as "notable because it became a breakaway church against the high church of journalism" (p. 14). These journalistic "protestants" do not abandon their "church" faith (as with Christianity and Luther) but seek to renew and revive it through techniques of "doing journalism" (Charity, 1995; Rosen, 1996, p. 1). Those involve nuts and bolts techniques for hearing citizens; public listening; helping citizens act with democratic skills, with a set of practices; showing how to spot—and spotlight—an evolving public consensus as a fair-minded participant in a community that works. Public (reform) journalism invites people to become a public (like pray directly rather than go to a priest?) through the machinery of journalism, because "even more important than the facts (confession?) they create the establishment of a shared present" (Rosen, 1996, p. 85).

And so, we see that public journalists identify more with John Dewey's (reformation) communication model of a public "conversation" than with Lippmann's emphasis on mediated (papal) information (Haas, 2007). With "more tools and better skills," the public journalist is expected to "restyle the work of the press" with "a style of commitment" to "break out of established routine" in a "disturbance in the hierarchy of influence" in "a kind of construction site" (Rosen, 1999, pp. 4–8). This would "reconnect citizens and politics," change the media's efficiency, which produces "attention as the media's finished product," and persuade journalists "not to produce attention, but to make our attention more productive" so that "commercial success joins public purpose" (pp. 294–297).

Reformation within the parish goes only so far. For example, although the press in the Nixon-Watergate scandal was considered "a righteous institution performing well in an hour of need," public journalists are now told "don't turn 'the people' into gods or assume that their judgment is infallible" (Rosen, 1999, pp. 300, 8).

Public (civic, citizen) journalism is primarily a technique whose means of activist practices and projects are designed to bring about more efficient ends for the objective media it seeks to reform and reinvigorate. Its rationale often resonates with a religious rhetoric of certainty despite claims in postmodernity that both God and objectivity are dead. Its new deification of democratic efficiency as a religious replacement suggests perhaps there is a godernity with remnants of social science methodology in its toolkit of report-

ing techniques. Since both elitist (objective) journalism and public (egalitarian) journalism share similar ends and values, a comparison of their techniques is more fruitful than to "compare the final products of each approach with its self-professed goals—a comparison which is unproductive" rather than "quibbling over elitism and egalitarianism" (Holbert, 2000, p. 65).

Public journalism has been criticized as a cult-like religious movement with zealous, high priest evangelists and prophets whose converts have had epiphanies in moments and places of revelation and discovery, and who require prayer, a mantra, an apostle's creed. It has its own scripture, which believers affirm and preach in their gospel of glad tidings that lead to reconnection and salvation after repentance for the sins of an elitist, detached, uncaring journalism blamed for the decline of civic life (Corrigan, 1999). Intolerant academic scribes are accused of developing scientific jargon to battle dissenters, while eager missionary communitarians spread the "good news" toward global developmental journalism (Corrigan, 1999).

Conclusion

Ironically, the labels of "religious journalism" are quickly, easily, conveniently, exclusively, and typically assigned to media like Mary Baker Eddy's *Christian Science Monitor* in Boston; Brigham Young's *Deseret News* in Salt Lake City, and Reverend Moon's *Washington Times* in Washington, DC. However, they survive as cousins within the family of journalism where the sacred and secular have lived together for a long time, often sharing techniques in the search for certainty through the rigor of science and the ritual of religion in a rather unhappy and unholy marriage, but somehow an arrangement that seems rather permanent.

References

Burd, G. (1981). News in the metropolis: New concepts. *Ecquid Novi, 2*(2), 107–120.
Burd, G. (2008, March). *The blogger as outsider: Technology as a tactic to get inside the media establishment.* Paper presented to The Society for the Interdisciplinary Study of Social Imagery, Colorado Springs, CO.
Callaahan, R. (1962). *Education and the cult of efficiency: A study of the social forces that have shaped the administration of the public schools.* Chicago: University of Chicago Press.
Carey, J. (1992, Winter). The press and the public discourse. *Kettering Review,* p. 11.
Carey, J. (1996). Where journalism education went wrong. *Proceedings from Journalism Education, the First Amendment Imperative, and the Changing Media Marketplace* (pp. 4–10). Murfreesboro: Middle Tennessee State University.
Charity, A. (1995). *Doing public journalism.* New York: Guilford Press.

Christians, C. (1981). *Jacques Ellul: Interpretative essays*. Urbana: University of Illinois Press.

Corrigan, D. H. (1999). *The public journalism movement in America: Evangelists in the newsroom*. Westport, CT: Praeger.

Crooks, R. A. (1996). How the cult of cost efficiency destroys credible communications. *Public Relations Quarterly, 41*(2), 8–13.

Dennis, E., & Merrill, J. C. (1991). *Media debates*. New York: Longman.

Ellul, J. (1964). *The technological society* (J. Wilkinson, Trans.). New York: Knopf. (Original work published in 1964)

Fahmy, S. (2008). How online journalists rank importance of news skills. *Newspaper Research Journal, 29*(2), 23–39.

Fedler, F., Bender, J. K., Davenport, L., & Kostyu, P. (1997). *Reporting for the media* (6th ed.). Fort Worth, TX: Harcourt Brace.

Fosler, R. S. (1993). The information government. *Proceedings of the National Academy of Public Administration: Forum on the Role of Information Management*.

Gans, H. (1979). *Deciding what's news*. New York: Pantheon Books.

Gelberg, D. (1997). *The "business" of reforming American schools*. Albany: State University of New York Press.

Gillmor, D. (2004). *We the media: Grassroots journalism by the people, for the people*. Sebastopol, CA: O'Reilly Media.

Haas, T. (2007). *The pursuit of public journalism*. New York: Routledge.

Haber, S. (1964). *Efficiency and uplift: Scientific management in the progressive era, 1890–1920*. Chicago: University of Chicago Press.

Harrison, M. (2000). Sensationalism, objectivity and reform in turn-of-the-century America. In C. A. Stabile (Ed.), *Turning the century: Essays in media and cultural studies* (pp. 55–74). Boulder, CO: Westview.

Holbert, R. L. (2000). A comparative analysis: Objective & public journalism techniques. *Newspaper Research Journal, 21*(4), 50–67.

Holsinger, R., & Black, B. (1965). When efficiency experts came to a newspaper. *Columbia Journalism Review, 3*(4), pp. 58–60.

Information technology and government efficiency. (1993). Hearing before the U.S. House Committee on Science, Space and Technology.

Karim, K. H. (2001). Cyber-utopia and the myth of paradise: Using Jacques Ellul's work on propaganda to analyse information society rhetoric. *Information, Communication & Society, 4*(1), 113–134.

Levine, A. (2004). *The American ideology: A critique*. New York: Routledge.

Lippmann, W. (1922). *Liberty and the news*. New York: Harcourt, Brace & Howe.

Longinow, M. A. (2004). Book reviews essayists. *Journalism & Mass Communication Educator, 59*(1), 79–80.

Markoff, J. (2006). *What the dormouse said: How the sixties counterculture shaped the personal computer industry*. New York: Penguin.

Martin, H. J. (2003). Clustered newspapers operate more efficiently. *Newspaper Research Journal, 24*(4), 16–21.

McMullen, R., Fletcher, A., & Ross, B. I. (1994, October 31). Survey: Efficiency valued over news quality. *Broadcasting and Cable, 124*(44), 26.

McNulty, E. (2008, May 8). The high cost of media efficiency. *Richer Earth*. Retrieved October 25, 2008, from http://richerearth.blogspot.com/2008/05/high-cost-of-media-efficiency.html.

Media to voters: It's over. (2008, January 8). *Fairness & Accuracy in Reporting (FAIR)*. Retrieved October 15, 2008, from http://www.fair.org/index.php?page=3240.

Mencher, M. (2006). *News reporting and writing* (10th ed.). Boston, MA: McGraw Hill.

Meyer, P. (1979). *Precision journalism: A reporter's introduction to social science methods*. Bloomington: Indiana University Press.

Moore, R. C. (1998). Hegemony, agency and dialectical tension in Ellul's technological society. *Journal of Communication, 48*(3), 129–144.

Multi-media and efficiencies. (1995, September 4). *Mediaweek, 5*(33), 14.

Munson, E. S., & Warren, C. A. (1997). *James Carey: A critical reader*. Minneapolis: University of Minnesota Press.

Ngwainmbi, E. K. (1995). *Communication efficiency and rural development in Africa: The case of Cameroon*. Lanham, MD: University Press of America.

Nordin, K. D. (1978, August). *Non-sectarian religion: An historical interpretation of the shape of religious news in the American daily press*. Paper presented to the Association for Education in Journalism, Seattle, WA.

Oberdiek, H. (1995). *Living in a technological culture: Human tools and human values*. Hoboken, NJ: Taylor & Francis.

Olasky, M. (1991). *Central ideas in the development of American journalism*. Hillsdale, NJ: Erlbaum.

Postman, N. (1982). *The disappearance of childhood*. New York: Delacorte Press.

Postman, N. (1985). *Amusing ourselves to death: Public discourse in the age of show business*. New York: Viking.

Ritzer, G. (1993). *The McDonaldization of society*. Thousand Oaks, CA: Pine Forge.

Rosen, J. (1996). *Getting the connections right*. New York: Twentieth Century Fund.

Rosen, J. (1999). *What are journalists for?* New Haven, CT: Yale University Press.

Rosen, J. (2002, Summer). Moving the needle. *Civic Catalyst, 7*(3), 14.

Schwartz, T. (1981). *Media: The second god*. New York: Random House.

Seidelman, R., & Harpham, E. J. (1985). *Disenchanted realists: Political science and the American crisis*. Albany: State University of New York Press.

Shrader, W. K. (1992). *Media blight and the dehumanizing of America*. New York: Praeger.

Silverstone, R. (2007). *Media and morality*. Malden, MA: Polity.

Stabile, C. A. (Ed.). (2000). *Turning the century: Essays in media and cultural studies*. Boulder, CO: Westview.

Stavitsky, A. G., & Odell, T. (2006). Spectrum efficiency and the public interest. *Journal of Broadcasting and Electronic Media, 50*(4), 692–702.

Stovall, J. G. (2006). *Writing for the mass media* (6th ed.). Boston, MA: Allyn & Bacon.

Strate, L. (2004). Ellul and technology studies. *Communication Research Trends, 23*(2), 28–31.

Tankard, J. (1976). Reporting and scientific method. In M. McCombs, D. Shaw, & D. Grey (Eds.), *Handbook of reporting methods* (pp. 42–77). Boston, MA: Houghton Mifflin.

Tevelow, A. (2000). Maintaining the order of things: Class, the gospel of scientific efficiency and the invention of policy expertise in America, 1865–1921. In C. A. Stabile (Ed.), *Turning the century: Essays in media and cultural studies* (pp. 33–54). Boulder, CO: Westview.

Whitaker, W. R., Ramsey, J. E., & Smith, R. D. (2000). *Media writing: Print, broadcast and public relations.* New York: Longman.

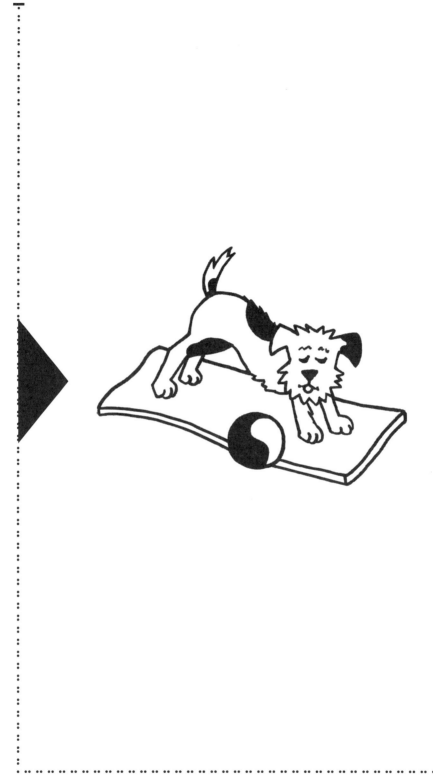

PART

4

Balance
Breathe
Renew

CHAPTER 17

Mind over Multitasking

What Would Buddha Do?

▶ PEG OLIVEIRA

Never his mind on where he was, what he was doing.
 Yoda, *The Empire Strikes Back,* 1980

Generally assumed to be the antithesis of multitasking, being mindful means focusing attention on what you are experiencing from moment to moment. This is a challenge in our fast-moving, image-switching, multimedia world. The irony is that in this age punctuated by the pressure to be more efficient and flooded with products that enable us to do more things, at once, faster, many of us are turning to mindfulness-based training like meditation and yoga. Are we seeking a reprieve from the frenetic mind-toggling needed to meet the demand we sense for productivity? Or, ironically, could training the mind to be mindful provide a backdoor entrée to enhanced juggling of all that is required in contemporary life?

We live with the norm of frenetic schedules, hurried children, and over-committed calendars. This chapter acknowledges these pressures and explores whether multitasking and mindfulness are opposing paths to getting the

business (busy-ness?) of life done, or whether, at their core, multitasking and mindfulness are complementary processes for managing the cognitive overload that is inevitable for those of us unable or unwilling to commit to a cloistered life.

The Curious Rise of Mindfulness in an Age of Multitasking

There were times when I could not afford to sacrifice the bloom of the present moment to any work, whether of the head or hand.

Henry David Thoreau, *Walden*, 1949

Today, lives move rapidly and can change with little notice. There are few givens. We have more choices, but with opportunities come instabilities. We can no longer rely on keeping the same career, let alone job, for a lifetime. Marriage no longer holds the promise of "'til death do us part." As such, we spend more time weighing options, considering possible outcomes, and making decisions.

Not only do our lives move faster and change more abruptly but they also lack the ebb and flow of a balance between being and doing imposed on us by nature and physical labor. Technology, mobile offices, and 24-hour services have eradicated the distinction between night and day. There is no off-season. Many workers are expected to be available by e-mail, phone, or pager 24/7—anytime and from any place (Kleinman, 2007). Technology has the capacity to quietly siphon personal time that was once protected. We are tethered to a technological leash, leaving us always on-call and constantly subject to interruptions and additional work requirements. As Carl Honoré (2004) states in the book *In Praise of Slowness*, "in this media-drenched, data-rich, channel-surfing, computer-gaming age, we have lost the art of doing nothing, of shutting out the background noise and distractions, of slowing down and simply being alone with our thoughts" (p. 11). This leaves us in a constant state of arousal. There is no time for reflection or enjoyment of the present. We are always looking ahead to the next task that needs attention.

Young people are also finding ways of packing more into their days. *Time* magazine covers "Generation M"—*M* for multitasking—made up of over-stimulated teenagers who constantly split their time and attention between instant messaging, Facebook, MySpace, their iPods, cell phones, and blogs (Wallis, 2006).

According to a 2005 Kaiser Family Foundation study, children and teens are spending more time using newer media, such as computers, the Internet, and video games, without cutting back on the time they spend with older

media, such as television, print, and music (Roberts, Foehr, & Rideout, 2005). Researchers who measured children's nonschool use of television, videos, music, video games, computers, movies, and print found that the total amount of media content young people are exposed to each day has increased by more than an hour from 2000 to 2005, from 7½ to 8½ hours per day (Roberts et al., 2005). This means that on average children are spending the equivalent of a full-time workweek using media. And some are putting in overtime!

How do they manage to pack this much media content into their day? Media multitasking, using more than one medium at a time, allows them to watch television and surf the Web simultaneously (see McDonald and Meng, chapter 9, for an extensive discussion of trends in the multitasking of entertainment). From a quarter to a third of the children in the study said they use another media "most of the time" while watching television (24 percent), reading (28 percent), listening to music (33 percent), or using a computer (33 percent) (Roberts et al., 2005).

Naomi Baron (2008) studied the multitasking activities of university undergraduates by asking them to complete a survey while they participated in at least one instant messaging conversation. The results revealed that 98 percent of participants were engaged in at least one other computer-based or offline activity while instant messaging. Baron (2008) used focus groups to further probe why the participants multitask while using a computer. The majority responded that they felt pressed for time and multitasking enabled them to get more done. Some simply reported that they multitasked while using computers because they were bored or commented that their attention spans are too short to do only one thing at a time.

It is not fair to blame technology for the imbalance it merely enables. A culture that believes more is more and government policies that support this culture play substantial roles in setting the context for and perpetuating the situation. A study by the Families and Work Institute reported that 45 percent of workers in the U.S. felt they were expected to perform too many tasks at the same time (D'Ausilio, 2005). Paid leave is vanishing (Take Back Your Time, 2008). Unlike 127 other countries, the U.S. has no minimum paid leave law. Working Americans average a little over two weeks of vacation per year, while Europeans average five to six weeks. One in four U.S. workers gets no paid vacation at all (Ray & Schmitt, 2007).

The situation is especially challenging for parents who do not have paid maternity leave and cannot afford to take unpaid maternity leave, as well as for those who are afraid to use the leave to which they are legally entitled because they fear they could be laid off or demoted if they do. An analysis of paid leave laws in 168 countries found that 163 of these countries guaranteed paid leave to women in connection with childbirth (Heymann, Earle,

Simmons, Breslow, & Kuehnhoff, 2004; see also Oppenheimer & Oliveira, 2007). The U.S. is one of only two industrialized nations—Australia is the other—without a guaranteed paid leave law (Heymann et al., 2004; see also Oppenheimer & Oliveira, 2007). According to the U.S. Department of Labor (2007), only 8 percent of workers have paid family leave benefits. Importantly, only 5 percent of the lowest-earning workers (earning less than $15 per hour) have paid family leave.

Take Back Your Time is a U.S. and Canadian initiative to challenge the epidemic of overwork and overscheduling. According to Take Back Your Time (2008), Americans are putting in longer hours on the job now than in the 1950s, and more than the citizens of any other industrialized country. Ironically, this drive is costing us. According to Take Back Your Time reports, job stress and burnout cost the U.S. economy more than $300 billion a year. Take Back Your Time warns that the burden of productivity and efficiency results in time poverty, a lack of sufficient time to care for our health, families and relationships, communities, and environment.

It isn't only adults feeling the burn of time poverty and rushed lives. Remarkably, the Junior Girl Scouts offer a merit badge in relaxing (Girl Scouts of America, 2008). It is called the "Stress Less Merit Badge." To earn the badge, girls may practice focused breathing, read an inspirational book, or create a personal stress kit with things that help relax them. That not doing is now worthy of a merit badge raises disturbing questions. Aside from the heavy demands of Girl Scout cookie season, what is it that is so stressful about life for these young girls?

Time poverty is a problem. It reduces time for exercise, increases dependence on fast foods, and inevitably threatens our health. Time poverty threatens our relationships and weakens our communities as we find less time for one another and for our children. Importantly, it leaves us little time for ourselves, for self-development, or for spiritual growth. Or does it?

Despite our objective time poverty, the number of people turning to mindfulness-based training, like meditation and yoga, is growing, particularly among young people. The 2008 Yoga in America study conducted by *Yoga Journal* found that Americans spend $5.7 billion a year on yoga classes and products, including equipment, clothing, vacations, and media. This figure represents an increase of 87 percent compared to the previous study in 2004. The poll reports that 5,050 respondents were surveyed, constituting a statistically representative sample of the U.S. population. The study found that 6.9 percent of adults in the U.S., or 15.8 million people, practice yoga. Of current nonpractitioners, nearly 8 percent, or 18.3 million Americans, say they are very or extremely interested in yoga, triple the number from the 2004 study; 4.1 percent of nonpractitioners, or about 9.4 million people, say they will definitely try yoga within the next year. A 2007 *Washington Post*

article reports that 10 million Americans say they meditate (Ellison, 2007).

In an episode of Matt Groening's celebrated satirical American cartoon sitcom *The Simpsons*, Lisa Simpson converted to Buddhism with the help of Richard Gere. There can be no doubt that yoga is now an established part of U.S. culture! Perhaps these trends in mindfulness-based training show that we are awakening to the strain of stimulus overload. Or, are we looking to these practices to sharpen our multitasking abilities and to allow us to do even more even faster with the help of focused brains and efficient minds?

The Myth of Multitasking

I think your suggestion is, can we do two things at once? Well, we're of the view that we can walk and chew gum at the same time.
<div style="text-align: right">Richard Armitage, U.S. Deputy Secretary of State, on the wars in Afghanistan and Iraq, June 2, 2004. (Armitage announced his resignation on November 16, 2004.)</div>

Place your right hand atop your head and your left hand at your belly. Now simultaneously pat your head and rub your belly. Notice the unsynchronized cacophony of movement between your stuttering right hand atop your head, slowing, and stopping, and speeding up again, willing the left hand at your belly to circle, circle, circle!

Now try this. Start patting your head with your right hand. Keep it going. Now start rubbing your belly with your left hand. Success! The trick is to set one hand in motion, then leaving it to flow rhythmically onward, initiate the movement of the left hand at the belly. Why is this so much easier?

It is easier because multitasking does not work. Yes, of course we can walk and chew gum at the same time, but that does not mean we can do any two or more things at once. We can only do those things at the same time because at least one of them is automatic. We cannot do two things at once that both require thinking without one or both of them taking a hit in efficiency or depth of thought, or both.

Not being able to think about two things at once means that we cannot truly multitask things that we need to think about. Instead, what it seems that our brains do is task switch. We pay less concerted attention to either one task at any one time, and there is a net loss in productivity as a result. As such, it takes more time to multitask a set of actions than it does to do them sequentially, unless one or both of the activities is set on automatic pilot.

Yet we are regularly encouraged to do two or more things at once, and we take pride in our perceived ability to successfully multitask. We believe

we can e-mail and talk on the phone at the same time, but we cannot, at least not without a loss in time, quality of interaction, and the ability to think deeply. Researchers at the University of Utah used simulators to study the effects of talking on a cell phone or text messaging while driving (Strayer & Drews, 2004). They found that drivers who multitasked were more than five times as likely to have accidents compared to those who did not.

A Carnegie Mellon University study found that drivers did not need to be dialing, holding, or even talking into a cell phone to be distracted (Just, Keller, & Cynkar, 2008). Simply listening intently is enough to impair driving. Study participants used a driving simulator while inside an MRI (magnetic resonance imaging) brain scanner. They steered a car along a virtual winding road at a fixed, challenging speed, either while they were undisturbed, or while they were deciding whether a sentence they heard was true or false.

The driving-while-listening condition produced a 37 percent decrease in activity of the brain's parietal lobe, which is associated with driving. This portion of the brain integrates sensory information and is critical for spatial sense and navigation. Activity was also reduced in the occipital lobe, which processes visual information. The other impact of driving while listening found in this study was a significant deterioration in the quality of driving. Participants who were listening committed more lane maintenance errors, such as hitting a simulated guardrail and deviating from the middle of the lane (Just et al., 2008).

Driving and listening draw on two different brain networks, as such it could be that the brain could work independently on each task. The results from this study suggest, however, that there is only so much that the brain can do at one time that requires some thought no matter how different the two tasks are.

Despite research showing that drivers' full attention and not just their eyes need to be on the road, no state completely bans all types of cell phone use (handheld and hands-free) for all drivers. Only five states (California, Connecticut, New Jersey, New York, and Washington), the District of Columbia, and the Virgin Islands have enacted cell phone laws prohibiting driving while talking on handheld cell phones; and even these laws still allow the use of hands-free devices while driving (Governors Highway Safety Association, 2008).

Researchers report that doing two or more things at once may decrease efficiency (Rubinstein, Meyer, & Evans, 2001; see also Yeung, Nystrom, Aronson, & Cohen, 2006). Researchers from the U.S. Federal Aviation Administration and from the University of Michigan studied patterns in the amount of time lost when people switched repeatedly between two tasks of varying complexity and familiarity, such as solving math problems or clas-

sifying geometric objects (Rubinstein et al., 2001). The researchers found time was lost in just switching from one task to another. Also, it took significantly longer to switch between more complex tasks and tasks that were relatively unfamiliar.

Research on the mechanics of the brain helps explain why this is the case. Brain science has long identified a bottleneck (dual-task interference) that exists in the brain that prevents us from doing two complex things at once (see, for example, Howell & Fleishman, 1982; Koch & Prinz, 2002). Research at the Human Information Processing Laboratory at Vanderbilt University confirms that even though it seems as though people are able to do two things at once, the brain actually shuts down one of the functions briefly as it undertakes the other task (Marois & Dux, 2006). Study participants were given two tasks. The first was to press the correct key on a computer keyboard after hearing one of eight sounds. The other task was to speak the correct vowel after seeing one of eight images. No delay was found if the participants were given the tasks one at a time. In contrast, the response to the second task was delayed by up to a second when the study participants were given the two tasks at about the same time.

Using functional magnetic resonance imaging (fMRI), the researchers revealed that the bottleneck was caused by the inability of the lateral frontal and prefrontal cortex and also the superior frontal cortex to process the two tasks at once. The fMRI of these brain regions showed that the neural response to the second task was postponed until the response to the first was completed (Marois & Dux, 2006).

What about children? The young certainly appear to be adept at multitasking: e-mailing, instant messaging, and listening to iPods, all at the same time. However, research conducted at the Institute for the Future of the Mind at Oxford University says that the multitasking abilities of the young may be a myth (Westwell, 2007). A group of 18- to 21-year-olds and a group of 35- to 39-year-olds were given 90 seconds to translate images into numbers, using a simple code. The younger group did 10 percent better than the older group when not interrupted. When both groups were interrupted by a phone call, a short text message, or an instant message, the older group matched the younger group in speed and accuracy. The results suggest that while older people think more slowly, they are better able to block out interruptions and to choose what to focus on than younger people.

What effect might the attempt to juggle one too many balls have on us, especially if it is, essentially, impossible to do well? In *CrazyBusy*, Edward Hallowell (2007), a psychiatrist who has studied attention deficit disorder for more than a decade, suggests that pressure for productivity and efficiency and to attend to multiple stimuli is instilling in us the drive for breadth at the expense of depth. Hallowell suggests that the result is something that

he calls attention deficit trait (ADT). Unlike attention deficit disorder (ADD), people are not born with ADT; rather, it is induced by modern life in which people become so busy attending to so many inputs and outputs that they become increasingly distracted, irritable, impulsive, restless, and, over the long term, underachieving.

Hallowell (2007) warns that the great seduction of the information age is that it allows us to create the illusion, for ourselves and others, of doing work and of being productive and creative when we really are not. We are just treading water: working longer, sleeping less, missing out on free time, overloading the brain, and yet, having less to show for it. Even if we succeed at multitasking without any obvious deleterious effects, there is a cost: some tasks that would benefit from thought have to be put on automatic pilot. Simply responding to bits of stimulation does not allow us to think deeply, and it robs us of the fulfillment that comes from creative activity.

What do these findings suggest for the young people in the previously mentioned Kaiser Family Foundation 2005 study that found Generation M attempting to juggle various types of media for eight hours of screen time a day (Roberts et al., 2005)? More specifically, what effect on learning and comprehension might result when two-thirds of the time that children are doing homework on the computer they are doing something else, too?

Distractions can inhibit a child from learning new facts or concepts (Foerde, Knowlton, & Poldrack, 2006). Even when a child succeeds at learning something while multitasking, the ability to remember what was learned later, or, importantly, to apply it in other contexts, will be diminished because when an individual is distracted, the brain bypasses the hippocampus, a portion of the brain that is responsible for making new memories and relies instead on the striatum, a portion of the brain that helps in recalling how to do tasks that have been done so often that they have become second nature. Information processed in the striatum is tied closely to the specific situation in which it is learned. This makes retrieving that information more difficult in a different setting and makes it challenging to transfer that learning to a different situation.

Taming the Monkey Mind

Mindfulness is the miracle by which we can call back in a flash our dispersed mind and restore it to wholeness so that we can live each minute of life.
 Thich Nhat Hanh, *The Miracle of Mindfulness*, 1999, p. 14

Simply put, mindfulness is the practice of paying attention to everything that is happening to you from moment to moment. While one could argue that the same is true in multitasking, there are important distinctions between

the two. Essentially, while multitasking is thinking about what's next, mindfulness is attending to what's now. Most important, in mindfulness, you must bring your full awareness not just to the activity you are engaged in but also to your inner experience of it.

Examples from a cross section of religious texts, contemplative traditions, and philosophers demonstrate that humanity has revered the benefits and wrestled with the challenges of mindfulness for centuries. For instance, the *Ramayana,* a sacred Hindu scripture that first appears as an oral composition somewhere between 750 and 500 B.C., acknowledges the challenge of stilling the mind as being led astray by the "monkey mind." Monkey mind refers to mental activity that creates busy-ness and impedes awareness of and identification with the truth of the moment and, ultimately, the true self. This, it is proposed, is at the core of suffering.

In *Interbeing,* Thich Nhat Hanh (1998) details the Fourteen Mindfulness Trainings that assist us to become aware of what is going on in our bodies, our minds, and the world. With awareness, we can live fully present in each moment we are alive. Ultimately, mindful awareness can help us to understand the true nature of our interdependence with everyone and everything else.

The Yoga Sutra of Patanjali is an ancient foundational Sanskrit text of Yoga philosophy (Feuerstein, 1979). In this text, Patanjali sets out the definition of yoga, in Sanskrit, as *yoga citta vritti nirodhah* (chap. 1, v. 2). In essence, Patanjali is stating that the goal of yoga is the cessation of the busyness of the mind. To be clear, this does not mean the mind will not think, or even wander, but, rather, yoga gives us the tools to bring the mind back from its wandering to present moment awareness. To accomplish this, Patanjali prescribes adherence to eight limbs, or steps, called Ashtanga Yoga. The first five limbs set the precursors essential to living a life that complements a quiet mind, such as actions one is to avoid as well as things one should do. The last three limbs together comprise the most specific techniques of taming the mind: *dharana* (concentration), *dhyana* (meditation), and *samadhi* (absorption or enlightenment).

Dharana is the fixation of attention in one direction. Basically, *dharana* is mono-tasking; it is developing concentration by doing one activity at a time, eliminating the habit of multitasking. Through the practice of *dharana,* we learn to treat each moment as a full experience of equal worth to the moments that came before and the moments yet to come.

Dhyana is perfect contemplation, or meditation. *Dhyana* is designed to catch the mind in its wandering, and, over and over, return it to a deep state of awareness. It involves consistently bringing attention back to a single point of focus with the intention of knowing the truth about it.

The last limb is *samadhi*, which means to merge. When we succeed in becoming fully attentive to an object and so absorbed in it that our mind becomes completely one with it, we achieve a state of *samadhi*, or enlightenment.

In Zen, the corresponding approach to mindfulness is "just sitting" meditation. Unlike Ashtanga Yoga, however, as Shunryu Suzuki (1970) writes in *Zen Mind, Beginner's Mind*,

> These forms are not a means of obtaining the right state of mind. To take this posture itself is the purpose of our practice. When you have this posture, you have the right state of mind, so there is no need to try to attain some special state. When you try to attain something, your mind starts to wander about somewhere else. When you do not try to attain anything, you have your own body and mind right here. (pp. 26–27)

The point is to take this practice of "just sitting" off the meditation cushion and into everyday life toward a total absorption in all activity.

What all of these traditions have in common is the recognition that we are beings with active minds that are tempted to wander and the practice of catching the mind in its habitual wandering and reeling it back to the present moment. Science agrees that this mindfulness may be worth the effort not only because multitasking does not work but also because being mindful is good for us. An analysis of the long-term effects of Jon Kabat-Zinn's Mindfulness-Based Stress Reduction Program on the brains of workers in demanding jobs at a biotechnology firm found that, compared to a control group, the program participants experienced a decrease in negative emotions after the course (Davidson et al., 2003; cf. Coffey & Hartman, 2008; Wahbeh, Elsas, & Oken, 2008). The difference was still present four months later. After mindfulness training, electroencephalogram brainwave recordings showed greater activity in the left prefrontal cortex—the area associated with happiness and optimism—than in the right. Before the course and in the control subjects, the right-left activity was more even.

Living in a Multitasking World, Mindfully

Not even for a moment can anyone remain without performing actions. Everyone is unwittingly made to act by the primary qualities born of nature.

Mahatma Gandhi, The Bhagavad Gita, 2000

In *Awakening the Buddha Within*, Lama Surya Das (1998) tells the story of an evolved Buddhist teacher who is having tea with a friend. While conversing with his friend, the teacher calmly bends over and helps an ant out the door, never missing a beat in the conversation. Das uses this story as an example of a highly mindful individual. The teacher was able to attend to

his friend and, simultaneously, to attend to the needs of the ant. Was the teacher being mindful, or was he multitasking?

Multitasking is ingrained in us. Human beings have always had a capacity to attend to several things at once. In fact, many evolutionary psychologists have argued that multitasking has wrongly been given a bad name in a world in which women evolved to multitask, stirring the pot while feeding an infant, while men had to be highly focused on hunting or risk being the hunted. In *The Mommy Brain: How Motherhood Makes Us Smarter*, Katherine Ellison (2005) reviews a body of research that supports the number of ways in which motherhood improves women's minds. The research Ellison presents shows that having babies contributes to enrichment of the brain. In short, the hormonal surge of pregnancy and the enrichment of the brain from intense new experiences imposed on mothers that come from daily interaction with their children lead to neurogenesis, or the brain's process of growing and changing through the development of new neurons. This brain plasticity strengthens a number of skills, including multitasking, memory, attention, problem solving, prioritizing, and learning.

But can we assume that the brilliance of evolution that served humans of yesteryear still serves us equally well today? It is possible that in the life of the past, when people were forced to rise and retire with the sun and the moon, the dangers of overwork and the burdens of overdoing were held in check. Life had a built-in pause. With this rest stop eradicated, people burn the wick at both ends.

If employers will not willingly ensure this balance for people, maybe government should. What is needed is a cultural shift toward valuing and feeling deserving of time to rest. It will take an uprising of demand for paid family leave for all parents, paid sick leave and vacation time for all workers, and prorated benefits for part-time workers. For now, it is undeniable that multitasking is receiving unprecedented honor in this more is more culture. We seem driven to defy the rules of nature and addicted to the adrenaline rush of stress. Even if it is just treading water, we are reluctant to surrender the appearance constant activity gives us of working hard.

Then why, in this stimulus-addicted and multitasking-doomed world, are so many people engaging in mindfulness-based practices? Might it be that overwhelmed and suffering from time poverty, we desperately want to believe we can affect our mental and physical health with brief stress-reduction workouts? We think if we can get yoga abs in 30 minutes a day, why not yoga mind? If yoga and meditation instill focus and discipline, maybe we can strengthen our multitasking muscles through these practices, just like we would train on a treadmill for a marathon.

Or might it be that multitasking truly removes us from the experience of our activities and robs us of the opportunity to engage creatively? Feeling

that loss, perhaps we are in search of some self-worth that is independent of our accomplishments. Even if we are unwilling to give up the rat race, perhaps we wish to at least be assured that the meaning of our lives is not only determined by the sum of our acts but also by the intention and focus placed on these acts. And maybe once given a taste of what it feels like to be present, even for just a blink, we yearn for more.

Was the Buddhist teacher being mindful or was he multitasking when he helped the ant to freedom? It depends. Mindfulness aims to tame the monkey mind and to allow us to see reality. Ironically, unlike stereotypical depictions of the passive recluse meditating in a cave, mindfulness is more than the absence of doing. The goal is not inaction, but, rather, consciously choosing right action, according to clear perception of the truth of the moment. For this reason, from the outside, we can't know simply by someone's actions if they are being mindful. Only the teacher himself knows if his observable actions are in relation to his being present, moment to moment, with his internal experience as well as his external environment, or if he was simply distracted by an ant.

The Bhagavad Gita emphasizes that it is the mind's mission to resist the unknown and to create an illusion of safety using an arsenal of beliefs, identities, and distractions that shelter us from uncertainty. Tools such as meditation and yoga train the mind to be more discerning. With practice, we learn to sift the illusions of the mind from the truth of the moment, to come back to that truth over and over, and to challenge ourselves to have the courage to act according to that truth more often.

Being mindful does not mean we will never multitask. Rather than practicing multitasking abstinence, what is needed is to break the mind's addiction to defining itself by the rush of struggle and achievement. It is not necessarily the doing that is problematic, but, rather, our relationship to the doing. Doing becomes problematic when it nurtures a reliance on achieving for self-worth and a false sense of security. Afraid of becoming irrelevant, we cling to doing, imposing our own agenda and trying to control the future, rather than tapping into the organic unpredictable flow of pure being that is available in the present.

In *A New Earth,* Ekhart Tolle (2005) proposes that there is a deep-seated collective delusion that we are the sum of our minds' thoughts and our emotions, leading people to place an exaggerated emphasis on the needs of the ego. This dysfunction causes individuals to act in desperation to enhance and protect a false sense of self. It is not the act that is good or bad, according to Tolle, but, rather, whether the act is "in the service of the ego or in the service of the Truth" (p. 70).

Importantly, like Arjuna, the great warrior protagonist of *The Bhagavad Gita,* mindfulness challenges us to remain unattached to the outcomes of

our actions, to see the doings of our lives as if through the eyes of an omniscient witness, free of judgment. As Jon Kabat-Zinn (1994) teaches, "the only way you can do anything of value is to have the effort come out of non-doing and to let go of caring whether it will be of use or not. Otherwise, self-involvement and greediness can sneak in and distort your relationship to the work, or the work itself, so that it is off in some way, biased, impure, and ultimately not completely satisfying, even if it is good" (p. 39).

Conclusion

The pressure and pace of the current culture of efficiency seem almost purposely intent on obstructing our ability to stay mindful. There are innumerable incentives to work harder and faster and little encouragement to slow down and experience life. If these outer forces are not enough, there are powerful inner forces that sabotage our attempts to create calm in the midst of a chaotic world. At the core is the monkey mind, obsessed with thinking, judging, planning, and doing. The reality is that no matter how still we can be on the meditation cushion or off, doing is always happening. The point is not to become non-doers, but, rather, to relate to our doing in the most healthful way possible. Mindfulness is the space within which the doing takes place. A culture of efficiency is not synonymous with a culture of busyness. The gift of mindfulness is the efficiency that is derived from maintaining balance between a deep connection to our actions, being in touch with our feelings about the actions, and getting things done consciously.

References

Armitage, R. L. (2004). *Press availability at NATO*. U.S. Department of State. Retrieved June 5, 2008, from http://www.state.gov/s/d/former/armitage/remarks/33033.htm.

Baron, N. (2008). *Always on: Language in an online and mobile world*. New York: Oxford University Press.

Coffey, K. A., & Hartman, M. (2008). Mechanisms of action in the inverse relationship between mindfulness and psychological distress. *Complementary Health Practice Review, 13*(2), 79–91.

Das, L. S. (1998). *Awakening the Buddha within*. New York: Broadway Books.

D'Ausilio, R. (2005). *Multitasking part II: De-stressing*. TMCnet. Retrieved July 22, 2008, from http://www.tmcnet.com/news/2005/nov/1215030.htm.

Davidson R. J., Kabat-Zinn, J., Schumacher, J., Rosenkranz, M., Muller, D., Santorelli, S. F., et al. (2003). Alterations in brain and immune function produced by mindfulness meditation. *Psychosomatic Medicine, 65*(4), 564–570.

Ellison, K. (2005). *The mommy brain: How motherhood makes us smarter*. Cambridge, MA: Basic Books.

Ellison, K. (2007, January 23). Giving meditation a spin. *Washington Post*. Retrieved June 5, 2008, from http://www.washingtonpost.com/wp-dyn/content/article/2007/01/19/AR2007011901443.html.

Feuerstein, G. (1979). *The Yoga Sutra of Patanjali*. Rochester, VT: Inner Traditions International.

Foerde, K., Knowlton, B. J., & Poldrack, R. (2006). Modulation of competing memory systems by distraction. *Proceedings of the National Academy of Sciences of the United States of America*. Retrieved June 5, 2008, from http://www.pnas.org/cgi/content/abstract/103/31/11778.

Gandhi, M. K. (2000). *The Bhagavad Gita*. Berkeley, CA: Berkeley Hills Books.

Girl Scouts of America. (2008). *Junior Girl Scout insignia list*. Retrieved June 5, 2008, from http://www.girlscouts.org/program/gs_centeral/insignia/list/junior.asp.

Governors Highway Safety Association. (2008). Retrieved June 26, 2008, from http://www.ghsa.org/html/stateinfo/laws/cellphone_laws.html.

Hallowell, E. (2007). *CrazyBusy*. New York: Ballantine.

Hanh, T. N. (1998). *Interbeing*. Berkeley, CA: Parallax Press.

Hanh, T. N. (1999). *The miracle of mindfulness*. Boston, MA: Beacon Press.

Heymann, J., Earle, A., Simmons, S., Breslow, S., & Kuehnhoff, A. (2004). *The work, family, and equity index: Where does the United States stand globally?* Boston: Project on Global Working Families at the Harvard School of Public Health. Retrieved June 26, 2008, from http://www.hsph.harvard.edu/globalworkingfamilies/images/report.pdf.

Honoré, C. (2004). *In praise of slowness: Challenging the cult of speed*. San Francisco: Harper.

Howell, W. C., & Fleishman, E. A. (Eds.). (1982). *Human performance and productivity* (Vol. 2). Hillsdale, NJ: Erlbaum.

Just, M. A., Keller, T. A., & Cynkar, J. A. (2008). A decrease in brain activation associated with driving when listening to someone speak. *Brain Research, 1205*, 70–80.

Kabat-Zinn, J. (1994). *Wherever you go there you are*. New York: Hyperion.

Kleinman, S. (Ed.). (2007). *Displacing place: Mobile communication in the twenty-first century*. New York: Peter Lang.

Koch, I., & Prinz, W. (2002). Process interference and code overlap in dual-task performance. *Journal of Experimental Psychology: Human Perception and Performance, 28*, 192–201.

Marois, R., & Dux, P. (2006). Isolation of a central bottleneck of information processing with time-resolved fMRI. *Neuron, 52*, 1109–1120.

Oppenheimer, C., & Oliveira, P. (2007). *Beyond child care centers: Supporting parents' caregiving through paid family leave*. Connecticut Voices for Children. Retrieved June 26, 2008, from http://www.ctkidslink.org/pub_detail_383.html.

Ray, R., & Schmitt, J. (2007). *No-vacation nation*. Center for Economic and Policy Research. Retrieved June 23, 2008, from http://www.cepr.net/index.php/publications/reports/no-vacation-nation.

Roberts, D. F., Foehr, U. G., & Rideout, V. (2005). *Generation M: Media in the lives of 8 to 18 year olds*. Kaiser Family Foundation. Retrieved June 5, 2008, from http://www.kff.org/entmedia/7251.cfm.

Rubinstein, J., Meyer, D., & Evans, J. (2001). Executive control of cognitive processes in task switching. *Journal of Experimental Psychology: Human Perception and Performance, 27*(4), 763–797.

Strayer, D. L., & Drews, F. A. (2004). Profiles in distraction: Effects of cell phone conversations on younger and older drivers. *Human Factors, 46,* 640–650.

Suzuki, S. (1970). *Zen mind, beginner's mind.* Boston, MA: Shambhala Publications.

Take back your time. (2008). Retrieved June 5, 2008, from http://www.timeday.org.

Thoreau, H. D. (1949). *Walden.* New York: Houghton Mifflin.

Tolle, E. (2005). *A new Earth.* New York: Penguin.

U.S. Department of Labor, Bureau of Labor Statistics. (2007). *National compensation survey: Employee benefits in private industry in the United States.* Retrieved June 26, 2008, from http://www.bls.gov/ebs/.

Wahbeh, H., Elsas, S. M., & Oken, B. S. (2008). Mind-body interventions: Applications in neurology. *Neurology, 70*(24): 2321–2328.

Wallis, C. (2006). The multitasking generation. *Time.* Retrieved June 5, 2008, from http://www.time.com/time/magazine/article/0,9171,1174696,00.html.

Westwell, M. (2007). *Disruptive communication and attentive productivity.* Institute for the Future of the Mind. Retrieved June 23, 2008, from http://www.iii-p.org/research/results.html.

Yeung, N., Nystrom, L. E., Aronson, J. A., & Cohen, J. D. (2006). Between-task competition and cognitive control in task switching. *Journal of Neuroscience, 26*(5), 1429–1438.

Yoga in America study. (2008). *Yoga Journal.* Retrieved June 5, 2008, from http://www.yogajournal.com/advertise/press_releases/10.

CHAPTER 18

Transportation Transformation

▸ HOLLY PARKER

Transportation is a part of everyone's life, the details of which are often passionately discussed and defended. Whenever I explain my profession as "promoter of sustainable transportation," a rich conversation ensues. The case for sustainable transportation has been made on countless magazine covers, in television commercials, National Public Radio stories, Web sites, and blogs since Al Gore's film about global warming, *An Inconvenient Truth,* won an Academy Award for Best Documentary Feature in 2007. Now that we can no longer deny that car emissions adversely impact the environment and human health, we must continue to advance technologies that transport us sustainably.

The foundations for sustainable transportation are pedestrian and bicycle trips. They are free, they burn calories, and they create virtually no emissions. Wow! Could it be that simple? Of course not. The bicycle and our feet cannot advance us the required distances and with appropriate velocity to keep pace in a culture that emphasizes multitasking, mobility, and efficiency.

While observing car drivers, I have seen ties tied, makeup applied, children fed, conference calls held, affection lent, and text messages sent. We typically travel by whatever means is fastest and easiest, which allows us to accomplish the most tasks in the least time. We drive alone from point to point if we can afford it.

This chapter examines how technology can enhance the speed, ease, and attractiveness of using sustainable modes of transportation. It also discusses how drive-alone trips (and parking) can be reduced at the times of day when demand is highest using financial disincentives.

And while we are on the topic of financial disincentives, it should be noted that people in the U.S. drove less in the first half of 2008 than they did over the same period a year earlier, due to the higher cost of gasoline, and healthcare professionals should rejoice (Ripley, 2008). According to Michael Morrisey and David Grabowski, "If gas remains at $4 per gallon for a year or more, [we should] expect as many as 1,000 fewer [traffic-related] fatalities a month. That means annual deaths could be cut by almost one-third—a public-health triumph" (Ripley, 2008).

The other side of the argument that we need to travel distances too far to be feasibly covered on foot or by bicycle is the reality that 40 percent of all trips are less than two miles (Davis, Diegel, & Boundy, 2008). A one-mile distance can be covered on foot in 15 minutes. A three-mile trip by bike can be accomplished in 15 minutes. Do we really not have the time? What if you could justify skipping the gym workout because you were exercising regularly while you ran errands or commuted to work? How much time would you save by not going to the gym?

The U.S. Centers for Disease Control and Prevention (CDC) have been concerned about people's sedentary lifestyle and its relationship to the obesity epidemic for over a decade. Only 15 percent of children's trips to school are made on foot or by bicycle; the remainder are by car, school bus, public transit, or other modes of transportation (CDC, 2005). It's no coincidence that over the past three decades, the prevalence of overweight children has tripled.

According to economist Charles Courtemanche, "a permanent $1 hike in [gasoline] prices may cut obesity ten percent, saving thousands of lives and billions of dollars a year" (Ripley, 2008). There is a growing body (pun intended) of longitudinal research by country on the correlation between obesity and car dependency, and Courtemanche's prediction is supported by research conducted in North America, Australia, and several European countries by John Pucher of Rutgers University. Pucher's research shows that countries with the highest rates of active transportation (defined as walking, bicycling, and transit use) have the lowest obesity rates (Bassett, Pucher, Buehler, Thompson, & Crouter, 2008; Pucher & Buehler, 2008). If it is true

that people can never be too thin or too wealthy, then driving alone to nearly every destination practically insures that these goals will remain unachievable.

Driving is expensive. On average, people in the U.S. spend 18 percent of their income on transportation, according to the U.S. Department of Energy (Davis, Diegel, & Boundy, 2008). Because only 0.7 percent of those expenditures are for public transportation, it can be assumed that the majority of these costs are car related. In their 2008 *Your Driving Costs* brochure, the American Automobile Association (AAA) estimates that, on average, Americans spend between $7,096 and $9,158 per year to own, operate, and maintain their cars. These estimates are based on the average price of gasoline in late 2007, when the brochure went to press; at that time gas cost $2.94 per gallon.

In addition to walking and cycling, the sustainable alternatives to driving alone include public or private transit, sharing the ride, and not leaving home in the first place to shop or go to work.

Planning Bicycle or Walking Trips

There are increasingly more Internet resources for planning bike or walking routes. Being able to map out a route and know the distance in advance (accomplished in minutes) helps people overcome the fear of the unknown. Google Maps offers walking and public transportation directions in addition to driving directions. Gmaps pedometer (www.gmap-pedometer.com) allows users to plan and calculate the distance of each leg of walking or biking trips, and www.walkscore.com helps users to find an array of local destinations, such as grocery and hardware stores, pharmacies, cafes, restaurants, bars, and so forth that are within walking and biking distance of the addresses users enter into the application.

Reducing Traffic Speed to Encourage Bicycling, Walking, and Living

Traffic calming is the application of engineering technology to streets in order to lower vehicle speeds and increase safety for all users. By altering the behavior of car drivers through well-designed physical improvements to the streetscape, neighborhood revitalization can be measured in increases of street use by walkers, cyclists, children, and other parties previously threatened by high vehicle volumes and speeds. Traffic calming can be as simple as striping narrower car travel lanes or as complex as redesigning the curbs

or designing and building a roundabout (traffic circle) in the middle of an intersection.

Making Transit Better

If the cost of driving and public health issues related to driving are not enough to compel people to use more sustainable transportation modes, the transit industry hopes to attract new riders by making route and schedule information easier to access and understand. Some transit entities are also offering Internet access onboard transit vehicles as rider incentives.

Several transit authorities' Web sites now provide trip planning features that allow users to enter origin and destination points to receive specific instructions on which bus or train to take, including which direction and how far to walk between transfer points. Tri-Met in Portland, Oregon, and the Washington Metropolitan Area Transit Authority in Washington, DC, were early adopters of this technology. In addition to online trip planning, the Massachusetts Bay Transit Authority in Boston offers riders "T-alerts" via e-mail or cell phone that announce delays of 15 minutes or more for specific routes. In August 2008, Southern California's Metrolink commuter train began providing real-time transit updates by way of Twitter, a social messaging utility that sends updated train status "tweets" to its riders' cell phones or computers.

As of the printing of this book, Google Transit provides a transit planning service for 96 regional and municipal transit systems in the U.S., as well as for transit systems across the globe. It is similar to getting driving directions from www.mapquest.com, only instead of showing people how to drive to their destinations, this service tells people how to use transit, including the distance and direction to walk between transfer points. Users can plan transit trips to minimize time, number of transfers, or walking distance. For New Yorkers in transit, this concept has been further refined by hopstop.com, which provides a 360-degree view of the streetscape at each point along the route and displays a big green arrow pointing users in their travel direction.

Some public and private transit providers offer wireless Internet access in their buses. This can be accomplished through wireless mesh networking, which uses all client devices (cell phones, handheld and laptop computers, and so forth) as relay points for network traffic to improve Internet connectivity. With high speeds and wireless connections, time on the transit vehicle can be spent working on the Internet, checking e-mail, and more.

Google, which provides free employee shuttle bus service from more than a dozen cities in the San Francisco Bay area to its Mountain View,

California, headquarters, offers wireless Internet access on their environmentally friendly, biodiesel-powered buses, allowing the company to get up to an additional hour of work out of their employees on each trip (Helft, 2007).

Greyhound Bus has also recognized the attraction of onboard Internet access. It started the Bolt bus system to serve the Boston, New York, Philadelphia, Washington, DC corridor. In addition to free wireless Internet, riders are rewarded for booking in advance with lower fares, as little as $1.

AC Transit in the San Francisco Bay area provides both Wi-Fi access on their transit buses and NextBus technology, which uses satellite technology to locate buses in real time, so riders can tell when the next bus will arrive by reading an electronic board at the bus stop or by checking online or via cell phone.

Campus Transit Innovations

Universities are ideal environments for innovative transit technologies like these because campuses are typically compact, and many of the constituents do not have cars on campus, especially in urban settings. Moreover, students may be more receptive to innovations. Trans-Loc, a company started by a recent graduate of North Carolina State University, feeds real-time transit data to riders through cell phone signals, beaming information via cell phone text messaging, Web-enabled phone, or computer. As of late 2008, nine university campuses in the U.S. are using Trans-Loc's Transit Visualization System, and five other universities in the U.S. as well as a municipal bus system are using their competitor Syncromatics' system. The University of Virginia recently began putting in place the HoosWhere system, which allows users to locate buses by landline phone, Web-enabled cell phone, on the Web via desktop or laptop, or by one of several bus finders located at popular bus stops.

Auckland, New Zealand, has taken a phased approach to implementing global positioning system (GPS) tracking throughout their municipal transit system. Begun in 1998, it is now robust and easy to use. Several subway systems also provide real-time transit information on the waiting platform, including the Washington, DC, Metro system as well as systems in Valencia, Spain and Vienna, Austria.

These technologies respect the value of transit riders' time and make transit more attractive. If people can check the location of their bus by phone or computer before leaving their residence or office, they know whether they have time to send one more e-mail, have another cup of coffee, or need to dash out immediately to catch the bus.

For the scheduled transit trip, software is available that allows rides to be organized efficiently for seniors, the mobility impaired, or the airport bound. Rides scheduled in advance get entered into the software that determines efficient routes. Social services and transit agencies use customized software, but even casual users can organize their trips using Web sites such as www.trackroad.com or www.routemenow.com.

Some taxi companies and other on-demand transportation providers, including Yale University, use dispatch software that generates automated calls to riders' cell phones when vehicles are four minutes away. This respects riders' time and increases their security because it allows them to wait indoors until their transport arrives.

Bus Rapid Transit

Another way that transit has been improved is through Bus Rapid Transit, which allows buses to approach the speed and reliability of rail transit while benefiting from the flexibility of bus systems that can change course as a city expands or changes. Bus Rapid Transit vehicles generally operate on exclusive bus lanes, allowing them to keep a rapid transit-type schedule regardless of traffic. Buses can get intersection priority by remotely actuating or extending a green light as they approach an intersection. Further efficiencies can be realized when platforms are built with ticket kiosks to enable prepayment of fares and at-grade boarding, which facilitates lightning-fast baby carriage and wheelchair loading.

Bicycle Technology

Perhaps the most exciting advance in bicycling technology is the development of bike-sharing programs in cities around the world. Over 85 cities make bicycles available for hourly or daily rental. The latest bike-sharing technology involves smart racks and/or kiosks that release rental bikes with the swipe of a credit or debit card. It is Zipcar for bikes. (See Brazeal, chapter 7, for a description of Zipcar technology.)

In July 2007, Paris implemented the largest-scale bike-sharing project in history, Vélib. There are 20,600 bicycles distributed at approximately 1,450 stations. The city saw a 5 percent drop in car traffic in less than a year. Four hundred full-time staff members maintain the bikes and redistribute them on a regular basis. The first half hour of use is free, and bikes can be returned at the 30-minute mark and checked out again for an additional 30 minutes for free, or renters can pay an incremental charge per hour at a station.

The Dutch company Bike Dispenser offers a device that releases bikes from covered receptacles with the swipe of a membership card. Think PEZ dispenser for vehicles.

A Canadian smart card technology developer manufactures a smart rack that dispenses bicycles using solar power. The terminal is space efficient and free or inexpensive. A Healthcare company in Louisville, Kentucky, and the City of Tulsa, Oklahoma, have adopted this system.

Paul Demaio, president of Metro Bike in Washington, DC, has a bike-sharing blog that provides a thorough resource on this topic: bike-sharing.blogspot.com.

Bike Technologies That Overcome the Obstacles

Technologies that make bikes adoptable by a broader constituency include the automatic shifting of the Trek Lime and the electric-assist bicycle. Electric-assist bicycles are relatively environmentally friendly, healthy, efficient, and affordable. They expand mobility and save people time and money. For would-be cyclists discouraged by steep inclines or distance, electric bicycles open up new possibilities for getting around. They come with motors, chargers, speed controllers, and batteries. Battery-powered systems make these bicycles easier to pedal, and, on selected models, riders can drive up to the legal speed limit of 20 miles per hour without pedaling. Batteries on these bikes typically only need three to five hours to charge.

The Aerorider hybrid tricycle assists riders' pedaling efforts with an electric motor. Worry no more about exposure to the elements or about tiring on the long trek; the rider is covered by a fiberglass shell in this vehicle.

If you say you can't use a bike for transportation because you won't be able to carry groceries or other purchases, then you don't know about Xtracycle. This company makes a kit that transforms a bike into a load- and passenger-hauling sport utility bicycle. Of course, a good rear rack and pannier system provides carrying capacity for groceries, a change of clothes, yard sale items, potluck dinner offerings, and so forth. I have carried everything from a pizza to an ironing board on my bike with a simple rear rack and bungee cords.

Segway

No discussion of leading-edge transportation technology could ignore the Segway PT (Personal Transporter), the environmentally friendly, electric-powered device that uses gyroscopic technology to simulate human balance as it transports a rider at two to three times the normal human walking speed. According to inventor Dean Kamen, "gyroscopes are more sensitive than the inner ear, computers are faster than typical reflexes, and motors

are more powerful than the muscles in our legs" ("Interview with Dean Kamen," n.d.). With half the world's population living in cities, and car transportation becoming a less and less efficient way to get around, the Segway is a last-mile solution; in other words, it can fill in gaps in a transportation system.

Rideshare Matching

Even carpooling goes high-tech in the Internet age. In the U.S. there are many online rideshare matching Web sites that allow users to—at simplest—enter origin and destination points, time of travel, and usually other information, too, such as preferences for music volume, traveling with a woman or man, and smoking or nonsmoking. The more complex sites allow potential carpoolers to communicate directly with each other over e-mail or by text message once they have viewed their location relative to the potential match's location on a sophisticated map interface. The developers of these systems have thought through the safety and security implications of riding with strangers and mitigate them in various ways: some provide their applications through Facebook (as well as off Facebook) so that users can opt to match only with friends or friends of friends, for example.

More Technologies and Services That Support Car-Free Living

The first and most obvious solution to automobile dependency does not require technology but, rather, common sense: live close to where you work and play. Of course, this is not always possible, but employers can help make it a reality for their employees who are in a position to make a housing change. For example, Yale University in New Haven, Connecticut, has a Homebuyer Program that offers faculty and staff financial incentives to purchase homes in a number of proximate neighborhoods. Employees who qualify receive up to $30,000 over ten years toward the payment of their mortgages. This benefit provides a powerful incentive to Yale employees to live near their jobs and to reduce or even eliminate transportation costs because they can avail themselves of the free Yale shuttle bus or walk or bike to campus.

So, you don't need a car to commute to work, but what about for grocery shopping? Peapod and other grocery delivery services allow people to phone in or place their grocery orders online with a minimum $60 order plus delivery charge ($6.95 for orders over $100; $9.95 for orders under $100). Ethnic groceries can be procured and delivered from www.ethnicgrocer.com. Organic offerings are available from www.netgrocer.com. Groceries? Check.

How do you pick up your friend from the airport—or make any kind of short local trip? Zipcar rents cars by the hour to its members with a simple online or phone reservation system. Short local trip? Check. But how do you get out of town on weekends? Rental car. Many have frequent flyer-type programs that reward regular use. Should you begin to despair about the expense of these services, refer back to the AAA estimates of car ownership and usage costs. Weekend escape? Check. And rental cars or Zipcars are only necessary when public transit or private bus or train options are unavailable.

Financial Influences

Everyone understands the concept of the toll, but until recently in the U.S., they have only been used on highways. Tolls were originally conceived of as a means for paying back the cost of constructing the road. Congestion pricing is a relatively new idea that charges road users for the negative environmental and quality-of-life impacts traffic congestion has on a city, raising funds for improving public transportation systems. To discourage driving to an urban area during peak traffic hours, a toll is charged automatically.

In London, license plate recognition technology is used to identify vehicles driving into the clearly defined congestion zone so that they can be charged an £8 fee (about US$15.50) between 7:00 a.m. and 6:00 p.m. Monday through Friday. London has seen a 21 percent reduction in traffic since implementing the congestion charge in 2003. Travel times for all users and air quality have improved. Cycling has increased by 43 percent within the congestion zone. So Londoners get healthier riding bikes, breathe fresher air, and transport themselves expeditiously. The Swedish Parliament voted in 2007 to make a congestion charge in Stockholm permanent, and Toronto has been successfully using congestion pricing on its Highway 407 since 1997. Remarkably, Singapore has been doing this since 1975.

Another means for reducing demand for driving is to charge more for parking. According to Donald Shoup (2005), professor of urban planning at the University of California at Los Angeles, a major cause of traffic congestion is the percentage of people who are cruising for parking. Almost 70 percent of all cars in one L.A. business district surveyed over a 12-hour period were cruising for parking. Extrapolated out to a year, this equates to 950,000 extra vehicle miles traveled, 47,000 gallons of gasoline wasted, and 730 tons of carbon dioxide emissions. Charging too little for parking makes people complacent about leaving their car in the parking space for long periods of time, while other drivers circle around the neighborhood wasting gasoline and emitting greenhouse gases in search of parking spaces. Finding the price point that results in 85 percent meter occupancy creates the right balance between parking supply and demand, according to Shoup's research. Many

cities worldwide have installed parking meters that accept credit cards, so that parking prices can be increased without requiring drivers to keep pounds of coins in their cars to pay for it. During peak periods, charges can be increased to encourage drivers to use public transportation, their feet, or bicycles when traffic congestion and the corresponding potential for cruising is worst. These new smart meters can also charge incrementally more per hour to discourage all-day meter feeding and to keep the parking spaces turning over to serve more constituents.

Some new parking meters zero-out each time a new vehicle parks, thereby generating more revenue for a city to make streetscape or other improvements by eliminating the chance that parkers may, to their delight, find time left on the meter.

In-car parking meters have value loaded onto them via users' credit or debit cards. They debit down hourly, possibly making drivers more aware of the amount it costs to park than they might be if they paid 25 cents per hour at meters, or monthly or annual parking fees.

These meter technologies may sound expensive and draconian, but as with congestion pricing, the additional funds generated can be used to enhance the quality of life for everyone by improving the streetscape and/or other modes of transportation. Furthermore, the construction of parking spaces in the U.S. ranges in cost from a few thousand dollars per space for a surface parking space to over $100,000 per space for underground parking garage spaces. With technology, municipalities and parking providers can finally begin to approach a return on their investment as their communities come alive with pedestrians and cyclists. And when we remove the steel bubble surrounding people, they begin interacting more with others and patronizing additional businesses.

Telecommuting

Why not just remove the need for employees and meeting participants to leave their homes or offices in the first place? Telecommuting and video conferencing technologies have made this a reality. According to a 2008 survey, 14 percent of private sector employees and 17 percent of federal employees telecommute in the U.S. (CDW-G, 2008). The same survey shows that 76 percent of private sector employers in the U.S. provide technical support for remote workers.

Sun Microsystems conducted an Open Work Energy Measurement Project in 2008, which compared energy use at home, in the office, and during commuting. Key findings included:

- Sun employees saved more than $1,700 per year in gas and vehicle deterioration by working at home an average of 2.5 days a week;

▸ Office equipment energy consumption is double that of home office consumption. Only 64 watts per hour of energy consumption are needed at home, compared to 130 watts at the office; and
▸ Commuting accounted for 98 percent of each employee's carbon footprint for work, compared to less than 1.7 percent of total carbon emissions to power office equipment (Sun Microsystems, 2008).

Conclusion

As neighborhoods, and, increasingly, world-class cities demand reduced traffic congestion and speeds, many of the technologies described in this chapter are being adopted as practical solutions to the outdated approach to transportation planning that accommodates cars—with bicyclists, pedestrians, and transit riders as afterthoughts. As more of these technologies are applied, the alternatives to driving alone will become increasingly competitive with the car for moving us quickly and practically. Maybe you'll never be too thin or too wealthy, but leave your car in the driveway and see what happens to your waistline and your wallet.

References

American Automobile Association. (2008). *Your driving costs* [Brochure]. Retrieved October 8, 2008, from http://www.aaaexchange.com/Assets/Files/20073261133460.YourDrivingCosts2007.pdf.

Bassett, D., Pucher, J., Buehler, R., Thompson, D., & Crouter, S. (2008). Walking, cycling, and obesity rates in Europe, North America and Australia. *Journal of Physical Activity and Health, 5,* 795–814.

CDW-G. *Telework report.* (2008). Retrieved December 19, 2008, from http://telecommutect.com/employers/pr_4_1_08.pdf.

Centers for Disease Control and Prevention (CDC). (2005). *Kids walk-to-school.* Retrieved September 27, 2008, from http://www.cdc.gov/nccdphp/dnpa/kidswalk/then_and_now.htm.

Davis, S., Diegel, S. W., & Boundy, R. G. (2008). *Transportation energy data book* (27 ed.). Retrieved September 27, 2008, from http://wwwcta.ornl.gov/data/tedb27/Edition27_Full_Doc.pdf.

Helft, M. (2007, March 10). Google's buses help its workers beat the rush. *New York Times.* Retrieved November 28, 2008, from http://www.nytimes.com/2007/03/10/technology/10google.html.

Kamen, D. (n.d.). *Interview with Dean Kamen.* Retrieved November 26, 2008, from http://www.massivechange.com/media/MOV_DeanKamen.pdf.

Pucher, J., & Buehler, R. (2008). Cycling for everyone: Lessons from northern Europe. Transportation Research Board. *Transportation Research Record, 2074,* 58–65.

Ripley, A. (2008). 10 things you can like about $4 gas. *Time.* Retrieved December 19, 2008, from http://www.time.com/time/specials/packages/article/0,28804,1819594_1819592,00.htm.

Shoup, D. C. (2005). *The high cost of free parking.* Chicago: Planners Press, American Planning Association.

Sun Microsystems. (2008). *Sun Microsystems study finds open work program saves employees time and money, decreases carbon output.* Retrieved December 19, 2008, from http://www.sun.com/aboutsun/pr/2008–06/sunflash.20080609.2.xml.

CHAPTER 19

The Future Starts at 5:00

▶ DAVID F. DONNELLY

"The Future" used to play well as a popular coming attraction. A new and improved world was on its way, and it was cool. Today, the future is an abstract hodgepodge alluded to less frequently and often in conflicting and contradictory terms. Why? Why was the future a more coherent and more popular theme in the past? Why has it lost its popularity today? Might the phenomenon that gave rise to future visions be playing a role in their decline?

Yesterday's Tomorrows

The twentieth century rode in on a wave of new technologies. And innovation often sparked visions, with technological marvels at the center of futuristic visions. Photography, the telegraph, telephone, motion picture, automobile, and airplane—the fantastic assortment of nineteenth-century innovations of the Industrial Revolution—all contributed to change. This was the age of invention. The world was changing, and it seemed to be dramatically break-

ing away from the past. Life would be easier and more exciting in this new era. The turn-of-the-century wave of technological optimism even gave rise to a new art movement, futurism, which embraced the speed and pace of the mechanical age.

As the world witnessed the horrors of World War I, the marvel turned to dread as people saw the downside of technological prowess. In the wake of the war, the U.S. experienced a brief respite in the 1920s with a period of prosperity and peace, and our attitude about technology improved. Many Americans enjoyed their present. The stock market crash of 1929, however, and the economic depression that ushered in the 1930s dramatically changed the national mood. The present for many was oppressive and bleak. And it dragged on and on, as the economy and the whole world appeared to have stalled.

With the benefit of hindsight, it seems logical, almost predictable, that the world would turn away from a present that seemed to drag slowly on to imagine and envision a better future. A persuasively optimistic vision of the future emerged in the 1930s. This "better tomorrow" appeared with its own distinct aesthetic, as iconic futuristic images appeared across pop culture, in magazines, books, and films. Donald Duck visited the "Museum of Modern Marvels" in the Disney cartoon *Modern Inventions* (King, 1937), where he saw hydraulic potato peelers, pneumatic pencil sharpeners, and robot nursemaids. Films with titles like *Just Imagine* (Butler, 1930) depicted futuristic cities with 250-story skyscrapers and multilayered highways with nine levels of traffic. Fashion designers even showed what people would be wearing in the future ("Future Fashion," n.d.).

In the world of tomorrow envisioned in the 1930s, Buck Rogers cruised space, while the masses back on Earth drove futuristic flying cars or traveled via sleek monorails and personal jet packs, wore Dick Tracy wristwatch two-way TV/radios, and commanded domesticated robots. At the end of the decade, visitors to the 1939 World's Fair in New York City, known as "The World of Tomorrow," marveled at a new tomorrow and left the fair pinned with a lapel button that proclaimed *I HAVE SEEN THE FUTURE*. As essayist E. B. White (1977) observed after his visit, here was a future where "rugs did not slip" (p. 115). The fair was the embodiment and culmination of the building optimism that promised anything was possible. Technology would rescue us, and innovation would eliminate social problems to create a better tomorrow. As writer Warren Longwell (n.d.) later noted, "The fair became a two-year celebration dedicated to the blessings of democracy and the wonders of technology, and it was this latter purpose, the apotheosis of technology, that captured the imagination of the fairgoers in a way unlikely to ever be seen again."

Artists and designers of the 1930s envisioned the future with some uniformity. It was sleek and streamlined, more deco than art deco. This embodi-

ment was conjured with a high level of consistency. We knew what the future would look like. We saw what we would be wearing, what we would be driving, where we would be living. This made the future concrete, so real it was intoxicating and irresistible. The future served as a major and much needed diversion.

The outbreak of World War II brought a hefty dose of reality. Required to concentrate our energies on what needed to be done, the present took on a new urgency and focus. The pressing, all-encompassing tasks of the war effort realigned our thoughts, the somber and immediate displaced the whimsical and the pending.

The relief brought by the postwar period of the 1950s gave us the opportunity to dream again. There was unprecedented economic prosperity in postwar America. The comforts of a new home, of a new American Dream, of a new life, allowed us to indulge in optimistic, euphoric extrapolation. Things were getting better, and they would be even better tomorrow. Our rediscovered penchant for dreaming about tomorrow gained traction through the 1950s, and in the 1960s, the future reached a second peak of popularity.

In the 1960s, Walter Cronkite took us to the future in his television series *The Twentieth Century*. The decade's space race sparked our imagination. In the future, a sassy robot cleans George Jetson's spaceship house, people inhabit the surface of Mars, Captain Kirk and colleagues discover strange new worlds in the final frontier, as Barbarella floats in zero gravity on her way to a distant planet. Those who opt to stay on Earth enjoy clean, crime-free city streets, extensive leisure time, robot pals, and wondrous, gadget-filled, stress-free lives.

As in the 1930s, the world of tomorrow envisioned in the 1960s became so tangible that we saw what it would look like. This time, it is curvy, white plastic, fluorescent, and neon. And like the 1930s, people could visit the future at the World's Fair of 1964, where they got a sneak peak at the coming better world of tomorrow, enjoying highlights such as Futurama's home of the future, the city of tomorrow, and the Underwater City.

The 1960s saw the rise of "future studies" as the topic was granted credibility and legitimacy by the founding of organizations such as the World Future Society in 1966 and the Institute for the Future in 1968. Throughout the 1960s, futurists enthralled audiences with their apparent ability to conjure prescient visions of what was to come. The future was popular once again, and we were infatuated with it.

But reality once again brought us back to the present. The fascination began to mix with anxiety. Suddenly the future was, according to pundit Alvin Toffler (1970) in his popular book *Future Shock*, "shocking," and as we were unprepared for the level of change, we faced "an abrupt collision

with the future" (p. 9). The 1970s ushered in the Me Decade, when we were prone to look inward, not outward. We became more self-absorbed. A growing need for instant gratification, along with short attention spans, and the rush to keep up with rapid changes combined to form a zeitgeist based on the present.

The advent of the Internet sparked a brief flurry of highly optimistic future visions. In the early 1990s, the Digerati emerged, high-tech futurists, some of whom were overly eager to be quoted for their seemingly profound insight into what was coming. They espoused a new digital world of bits and bliss, free, equal, and democratic. But in subsequent years, the burst of the dot-com bubble, profusion of Internet porn, beheadings Webcast by terrorists, extreme cases of cyberbullying, immeasurable amount of spam, and the undeniable crass commercialization of the Web, all brought the futuristic hyperbole down a few notches.

So if we were to plot the popularity of a positive, utopic future as a thematic motif in popular culture and public consciousness over the course of the twentieth century through today, we would see a rise at the turn of the twentieth century, then a decline in the teens and 1920s, a major uptick reaching a peak in the 1930s, a decline in the 1940s, another increase spiking in the mid- to late 1960s, a teeny blip of an uptick around the 1990s sparked by Web euphoria, and then a decline. A downward plummet. A downward plummet that continues to today.

Today's Tomorrows

The future is referenced today, but less frequently, and in conflicting and obtuse ways. Today's visions of tomorrow don't resonate. They are less believable. They lack the apparent uniformity of previous visions. We don't "see" the future the way people did in the past via pop culture. It has no defined aesthetic. Whither the better tomorrow?

When the future is depicted today, it is often a scary dystopia. Genetic technology, biotechnology, nanotechnology, surveillance technologies, robotics, cloning…dire visions of the future warn us that such inventions are poised to usher in an uncontrollable and regrettable future. Change accompanies these innovations, but it is not for the better.

Why did the future turn dark, from something we awaited in anxious anticipation to something we fear? In his essay "Why Do We Fear the Future?" Thomas Frey (n.d.), executive director and senior futurist at the DaVinci Institute, notes that today's "storytellers have helped grow the 'fear' market," and he places negative portrayals of the future within the larger context of a general reliance on the technique of exploiting our fears:

> To begin with, we have created huge markets for storytellers, and every good story needs a villain. Villains come in many varieties, but one of our most insidi-

ous fears is the "fear of the unknown," and a good writer can quickly build layers of conjecture around the known pieces of truth and craft settings, characters, and storylines around virtually any topic. So it is easy to turn emerging technology into a villain.

But more importantly—there is a huge market for fear. A large percentage of news stories today have a fear component. News anchors spend an inordinate amount of their newscast telling us what we should be afraid of and who we should fear. Authors, writers, and radio talk show hosts have a way of dancing on the edge of fear with every topic covered, and they do it because of the "fear" market.

Frey (n.d.) also points out that politicians leverage fear, politicians who understand that "while it can be effective to talk about how we have conquered problems of the past and build ideas around hope for the future, it is far more effective to paint a political opponent as someone to fear."

And he blames Hollywood as "the Mother of All Fear Factories":

> At the same time that the news media has been hawking its frightening look at the world around us, and political parties take polarizing stances on technologies that clearly have no defined right or wrong component to them, all of this is amateur hour compared to the impact that Hollywood can have with a single movie.
>
> There is a reason why science fiction is lumped in with the horror section in video stores.
>
> The money that a Hollywood movie earns is directly related to the scariness of the villain. Sometimes the villains are people like Darth Vader in *Star Wars* or Lex Luther in *Superman*, but very often the villains are technologies like genetic engineering in *Jurassic Park*, robotics in *I, Robot*, or nuclear power in the *China Syndrome*. And with the bad-guy connotation comes a perceptive fear around these emerging new industries, placing additional hurdles that businesses have to overcome. (Frey, n.d.)

The future today, when it is depicted, is often a scary place. It has become unsettling rather than comforting. Nightmares have replaced dreams. Frey's observations explain why fear has tinged our attitudes about the future, prompting the numerous negative depictions, but why have many of the positive visions receded?

Perhaps it is because as a society, we have lost a good bit of our faith in technology as savior. Technological progress used to be strongly linked to the more general notion of progress. The world, we were promised, would be much improved through technology. The more technologies we have, the easier and better our lives would be. Technological innovation sparked many utopian visions, as innovation ignites optimism. Now that we are thoroughly immersed in a technological world, we may be able to operate with greater

efficiency, we may have more stuff that helps us do things faster, but life is far from perfect. Many problems remain. And while new technologies solved some problems, they brought new ones. The promise of the bright, peaceful, clean, crime-free, relaxed world of tomorrow goes unfulfilled. The bright future revealed at the 1939 World's Fair, as noted by E. B. White (1977), did not smell. Well, 70 years later, the world still smells.

The utopian visions of the past, with their depictions of folks getting about via jet packs and flying cars, living underwater or on Mars, appear laughably naïve today. It is hard for us to fathom that they were taken as seriously as they were. As a society, we have changed and have become more jaded. Political assassinations, centuries-old struggles that seem to be never ending, technological prowess wielded recklessly, we had seen it all by the end of the twentieth century. Despite all of the innovations, some things never changed. Our views of visions are not tinted by rose-colored glasses. There is a cynicism that affects not only our thoughts about the future but also our thoughts about others' thoughts on the future. And this cultural attitudinal disposition goes well beyond the depictions of the future; we are a cynical, skeptical lot about everything. Just ask any advertising executive who made a living by marketing promises. As popular culture chronicler of the zeitgeist Carrie Bradshaw (played by Sarah Jessica Parker) observed in 1998, at the start of the very first episode of the television show *Sex and the City*, "WELCOME to the age of un-innocence."

Throughout the twentieth century, the new millennium presented a perfect marking point for the start of the future. It provided a concrete timetable, and it helped to build the anticipation as the future got closer every year. This made the future a little more real. In the twenty-first century, "we would..." and you could fill in the blanks with exciting hyperbole. When we actually reached the twenty-first century, reality settled in, and if we looked around, the promised future had not arrived. Hence our cynicism. While the new millennium offered a convenient foundation for future visions, today we lack such a time point to ground stories. When would the future begin for us?

And just as there is no one specific time to hang our visions on, there seems to be no recent wow-invoking technology or handful of standout key inventions on the scene to hang the visions on, either. The steam engine in the eighteenth century was a technology that stood out as a major invention. It transformed the face of America, prompting an Industrial Revolution. Later, the electronic computer emerged as a miraculous machine. Its potential was enormous, and that spurred our imaginations. Here was a machine that appeared to be able to do just about anything, and it did just about everything in the visions that emerged.

Today, we have many new technologies. We interact with them all the time; they are embedded in our daily lives. And we read about new ones almost daily. We have more technologies than ever before, and we live in a highly technological environment. Perhaps that has shifted our perspective; technologies do not stand out from the background because there is no background. Technologies are not only integral to our environment, they are our environment, like water is for fish. So if you ask young people what a technological innovation is, they might not be able to answer. Computers, the Internet, bioengineering, and so forth…today's technological marvels are really quite commonplace. They have always been there for many who have never lived in an environment that is not technologically saturated. So these innovations are not new, strange, or evocative elements; they are familiar, not curious, even as they are morphed through further innovation.

Therefore, we are not inclined to wonder where they are taking us. It is difficult to get the sort of distance we need to examine their impact. And with the rapid pace of innovation, with the acceleration of technology (and just about everything else, too), we do not have the time to ponder their impact, even if we had the inclination, which few do. With the invention of his telegraph in the 1800s, a miraculous magical invention in its day that gave people the ability to communicate easily over great distances for the first time, Samuel F. B. Morse used his device to send the public message, "What hath God wrought?" This was a query laden with awareness of the profundity of the invention and reflective of the era in which people had the time, patience, and disposition to be contemplative.

In contrast, the first e-mail, first text message, first instant message, and first cell phone call did not carry the weight or self-reflection of Morse's first message. Innovations enter the marketplace with such frequency and speed, one after another, that we are nonchalant about the new; it is hard to separate the significant from the insignificant. There is far more interest in looking to the marketplace to determine the successful from the unsuccessful than to ponder the impact of innovation, a pastime of only a handful of social scientists and social critics.

The pace of innovation today is matched by and intertwined with the pace of life, the speed of which has created enormous stress. If we think of the future, we might be inclined to think it arrives *today,* at 5:00.

The always-on, nonstop, seamless present embodied in the ubiquitous 24/7 metaphor is a relatively new phenomenon. But keeping up takes a toll, as one *New York Times* article explains: bloggers, chroniclers of the now, struggle to stay on top of moving targets, and sometimes this struggle extracts a serious physical and mental toll (Richtel, 2008). Several youthful bloggers have died mysteriously; perhaps, the *Times* article hints, as a byproduct of keeping up. This is an extreme example, but we don't need scientific data to

prove that just keeping up today, not even getting ahead, is exhausting. It is as if we live in the bizarre world Lewis Carroll (1960) conjured for Alice in *Through the Looking Glass* where the Red Queen observes, "it takes all the running you can do, to keep in place. If you want to get somewhere else you have to run twice as fast as that!" (p. 210).

Perhaps more than any other factor, the demands of the present, our "culture of efficiency," help explain why the future is less prevalent in contemporary popular culture. The future did not disappear as much as it has been sucked into the present: in short, the present today for us is all consuming.

Conclusion

The future was in people's thoughts throughout the twentieth century. Depictions of a better tomorrow ebbed and flowed, peaking in the 1930s and 1960s, and this chapter provides some thoughts on why this pattern emerged. It seems unlikely that the future will ever reach the popularity peaks of the previous century. And so, ironically, some of us can get a bit nostalgic as we look at yesterday's tomorrows. But is the receding vision of the better tomorrow a good or bad trend? And what are the implications of such a trend?

It is certainly not good if the current predisposition toward dystopian visions grows and creates an imbalance that makes us overly afraid of the future. It is important to be a little afraid of the future, but too much fear is not good. It can paralyze us, make us avoid thinking about the future. For those living in the U.S., it is in our best interest to preserve the essence of the American spirit, which is optimistic and embraces innovation. We are the people who brought forth "a new nation"; we have embraced the new since we were founded. We have been a hopeful people. If we lose that quality, we lose a great deal. However, just as we have to be careful about not creating an imbalance favoring the negative, we also have to be cognizant of the potential downside of being overly or unrealistically optimistic about the future. And we need to avoid a preoccupation with the future.

One of the definitions of futurism describes it as "a point of view that finds meaning or fulfillment in the future rather than in the past or present" (Merriam Webster, n.d.). This sounds like an unhealthy perspective; we should find meaning and fulfillment in our own time. This definition is in marked contrast to the "be here and now" philosophy espoused in Buddhist philosophy. What works for individuals as a corrective measure would benefit society as a whole. We should live in the present and find meaning there.

In large doses, the future can be a distraction, a diversion from the present. The healthy and mature perspective is one that makes a connection

between the future and the present. The future is not "out there"; it is not something we wait for. An awareness of the link between today and tomorrow allows us to see that our actions today help set us off in various directions, and hence we are connected to the future. This is a more informed view of the future, one that presents a continuum of the past, present, and future. Significant good can come out of this attitude. What it does is remind us that there are consequences to our actions. There is culpability, accountability, and responsibility as we play a role in creating the future. The future is not predetermined *for* us but shaped *by* us.

Reflecting upon past visions can inform our understanding of the present and the future. With the benefit of hindsight, we can glean perspective on why some innovations failed, why some positive portrayals went unfulfilled, why the change that occurred failed to bring us down the path to utopia. Understanding the causes of change, predicting change, and identifying the myriad impacts of change are all difficult tasks reflective of the methodological mushiness of the more speculative domains of social analysis. Nonetheless, we are in fact learning more about the process of change, and the effort has been bolstered by past visions that have missed the mark.

So, part of the maturity of our attitude toward the future is recognition of the complexity of forces at work today, and how they are connected to what we have abstractly labeled "the future." The better we are at understanding change, the better off we might be.

There was a cottage industry in the 1960s that emerged with gurus charging for glimpses of what would be. We did not possess their powerful insight or clairvoyance so we went along for the ride. They were "future experts," so we paid them to wow us and occasionally warn us. Now we and the futurism field in general are less naïve. We now know you can't forecast *the* future, you can only forecast *a* future, or more commonly, a set of futures contingent upon known and unknown variables. This is a more mature understanding of what the future is and how it can be envisioned. It goes beyond cynicism, it is realistic.

When we see visions of tomorrow, we can see them now as just that—stories about possibilities; we do not take them at face value. But these visions have value beyond entertainment. They spark our imagination. They serve as dreams and nightmares. They are thoughts and glimpses that have some unexplainable and mysterious connection with reality. We should look at them as stories and see them for what they are. We can be passive consumers of such visions, but we must always be cognizant that we are actively engaged in making our futures.

References

Butler, D. (Director). (1930). *Just imagine* [Motion Picture]. U.S.: Fox Film Corporation.

Carroll, L. (1960). *The annotated Alice: Alice's adventures in wonderland and through the looking glass.* New York: Clarkson N. Potter.

Frey, T. (n.d.). *Why do we fear the future?* Retrieved August 1, 2008, from http://www.davinciinstitute.com/page.php?ID=188.

Future fashion. (n.d.). Retrieved August 15, 2008, from http://davidszondy.com/future/fashion/year_2000.htm.

King, J. (Director). (1937). *Modern inventions* [Motion Picture]. U.S.: Disney.

Longwell, W. (n.d.). *Helium.* Retrieved August 15, 2008, from http://www.helium.com/items/232284-what-happened-to-the-idea-of-flying-cars.

Merriam Webster. (n.d.). Retrieved July 15, 2008, from http://www.merriam-webster.com/dictionary/futurism.

Richtel, M. (2008, April 6). In web world of 24/7 stress, writers blog till they drop. *New York Times,* pp. 1, 29.

Toffler, A. (1970). *Future shock.* London: Bodley Head.

White, E. B. (1977). The world of tomorrow. In E. B. White, *Essays of E. B. White* (pp. 111–117). New York: Harper & Row.

CHAPTER 20

Whither Boundaries?

The Internet and the Blurring of Work and Personal Life

▶ MARK E. HOFFMAN & CARRIE A. BULGER

It comes as no surprise that information and communication technologies such as computers and cell phones are having a dramatic impact on how we live. As Sharon Kleinman (2007) remarked in *Displacing Place,* "it is clear that in a very short time these technologies have become pivotal tools whose *ubiquity* and *utility* are distinguishing life in the early twenty-first century from earlier eras" (p. 226, emphasis added). Progress toward ubiquity can be measured by the number of high-speed, broadband Internet connections at home (cable, digital subscriber line [DSL], and, more recently, fiber optic), which mark a clear advance in convenience and speed over dial-up connections; as of 2007, half of all U.S. homes had broadband access, and it took only 10 years to reach that point, faster than the personal computer, cell phone, color television, videocassette recorder (VCR), and compact disc (CD) player proliferated, whereas only 10 percent of U.S. homes use dial-up connections (Horrigan, 2007).

The social and cultural effects of home broadband access noticeably emerged in 2004, when adoption grew by 67 percent over the previous year after growing by 50 percent from 2002 to 2003 (Horrigan & Smith, 2007). A similar transition started in the workplace in the early 1990s, when personal computers began to be more common on desktops (Wallace, 2004), and organizations began spending more money on computing and communication technologies than on other types of machines and goods (Stewart & Furth, 1994). In recent years, Internet access has become a requirement for most workers, perhaps even more important to doing their job than a desk, chair, and telephone. A visit to almost any modern workplace therefore further reveals the *ubiquity* of information and communication technologies.

The *utility* of the Internet as an essential form of communication and source of information in the U.S. home also promotes the ability for employees to work from home with greater ease, while Internet access at work equally promotes workers' ability to engage in personal online activities. The ease with which people can access work activities from home and personal activities from work reflects a blurring of the boundary between work and home; an e-mail can be sent just as easily to a coworker or a family member while at work or at home.

Blurred boundaries may present a double-edged sword. For employers, blurred boundaries may translate into greater productivity. Work is no longer bound to the workplace during working hours. Employers have access to and can make demands on employees' time away from the workplace. However, productivity during the workday is lost when employees abuse Internet access (Mahatanankoon, 2006) by cyberloafing or cyberslacking, that is, excessively attending to personal matters or recreation during work time (Caplan, 2006). For workers, blurred boundaries mean greater flexibility. Rather than be restricted by work time and place, workers can attend to personal matters during traditional work times and complete work tasks at other times. However, such flexibility can allow work to infringe on family or personal time. Consider the example of a working mother who attends to work-related e-mail first thing in the morning before getting her children to school, and, while at work, downloads the school lunch menus for the following week. Ubiquitous Internet access seems to afford this woman maximum flexibility to manage her life, which could be seen as a positive by her and her employer. However, her family might view her attention to work e-mail at home as an intrusion on their time, creating tension in the home. Likewise, her employer could view her attention to family matters on work time as a form of cyberslacking, creating difficulties at work.

The relationship between productivity and flexibility is even more intertwined and complex. For example, because computers and other information and communication technologies are perceived as increasing workers' effi-

ciency in accomplishing many tasks that had been done in other ways before the proliferation of high-tech equipment, employers, coworkers, and clients expect greater productivity from their workers, and employees respond by working longer hours, including working from home. This may lead some employees to feel that they are always on duty and that work is an unwelcome intrusion on their personal time (Towers, Duxbury, Higgins, & Thomas, 2006). Yet some employees might view these intrusions as acceptable and may even cultivate them as a means of demonstrating that they have control over where and when they work, implying autonomy and independence from working 9 to 5 (Towers et al., 2006).

There is an air of inevitability about the march of technologies and their consequences: we are resigned to the fact that e-mail messages arrive regardless of our ability or desire to respond to them. Further, not responding sometimes exacerbates the problems of overwork; at some point unanswered e-mail must be managed. To combat the assault, a number of guidelines have been offered by business consultants, technology companies, and journalists to reinforce technology-weakened boundaries. The simplest, though it appears impossible to do, is to turn off the anytime, anyplace connectivity gear. Mark Bittman (2008) goes so far as to suggest a "secular Sabbath" when one day a week the use of information and communication technologies like laptops and cell phones is prohibited (see also Berkelaar, chapter 6). Others suggest that expectations should be set at work and at home concerning e-mail and instant message (IM) response time and work time availability for family members (Steiner, 2006).

Even the very technology companies that have created the need for guidelines are looking for ways to reinforce boundaries: Google has created the "E-Mail Addict" feature that disables Gmail (Google's Web mail that can be viewed on a computer, BlackBerry-like device, or cell phone) for 15 minutes for users who lack self-control (Richtel, 2008). While these guidelines appear sensible, they are ad hoc because they are derived from personal experience and common sense rather than research and theory. To be fair, it has been only a few years since broadband sufficiently blurred boundaries for these guidelines to be meaningful for the average worker. Guidelines and features like Google's E-Mail Addict point to a need for balance between work and personal life that technological advances such as high-speed, broadband Internet access at home have disrupted. To achieve balance, we need a clearer understanding of the multifaceted ways that technologies are blurring the work and home boundaries.

Managing Multiple Roles

Given that information and communication technologies now exist and will continue to evolve, the question becomes how working people should manage the demands of their roles at work and outside of work in an environment where technology affords the blurring of the boundaries between them. One approach is to consider the consequences of technology-enabled roles from one domain enacted in another, such as reading the latest joke list and forwarding it to your brother-in-law from your work cubicle or responding to a client from the kitchen table.

The idea that people hold multiple roles in various domains has been studied for decades by social and behavioral scientists (Barnett & Baruch, 1985; Marks, 1977; Sieber, 1974). Specifically, researchers have suggested that accumulating multiple roles, for instance, holding a job and having a family, has both negative and positive outcomes for the individual. Role accumulation can result in role strain, such that there is increased stress at work and at home, but it may also result in self-enrichment, such that there are opportunities for self-growth (Marks & MacDermid, 1996; Sieber, 1974). Whether holding multiple roles in the work and nonwork domain results in positive or negative outcomes depends on the ways in which individuals organize themselves within each domain and how they construct their roles and the boundaries around each domain.

Boundary Theory: A Framework for Studying and Understanding the Internet and the Work/Home Interface

The idea that people construct boundaries between and around work and nonwork has been discussed for quite a long time (Hall & Richter, 1988; Nippert-Eng, 1996). Christena Nippert-Eng (1996) emphasized the idea that boundaries vary in strength. She suggested that strong boundaries are those that are designed to maintain a separation around domains, or segmentation of work and nonwork. When work and nonwork are segmented, elements from one domain would not be found in the other, such as family photos at the office or discussions of work at the dinner table. Weak boundaries, alternatively, are constructed such that there is little or no separation between domains, or integration of work and nonwork. In this case, the individual, or integrator, would be likely to receive personal phone calls at work or to bring work home. Nippert-Eng (1996) further emphasized the idea that boundary strength is idiosyncratic in that individuals construct boundaries to their liking. This may be done via selection of a job or occupation that

facilitates the type of boundary desired or by establishing personal norms and rules about appropriate behaviors and activities at work and at home.

Recently, these ideas were expanded and refined into what has come to be called boundary theory (Ashforth, Kreiner, & Fugate, 2000; Clark, 2000; Matthews & Barnes-Farrell, 2004, 2006). Sue Campbell Clark (2000) expanded these ideas, noting that people are "border crossers who make daily transitions between domains" and that understanding the parameters of boundaries and boundary crossing will help us to better understand how people balance work and family (p. 751). Similarly, Blake Ashforth, Glen Kreiner, and Mel Fugate (2000) examine the daily transitions between the work and nonwork domains, but they focus on other outcomes beyond work-family balance, such as the difficulty associated with such transitions, for example, role stress.

Ashforth and colleagues (2000) as well as Clark (2000) note that people are both proactive and reactive in negotiating the demands of work and nonwork via boundary construction. In other words, people are aware of the extent to which they can and would like to be flexible about attending to demands from these multiple domains and they create boundaries accordingly. They also suggest that boundaries are constructed partly based on individual preference or desire for segmented versus integrated domains but are also influenced by other issues. For example, Clark (2000) discusses the influence of the domain culture, boundary keepers, and characteristics of the boundary crosser on boundary strength. In terms of culture, she suggests that characteristics of the environment of the given domain go a long way toward shaping appropriate behavior in that domain. Ashforth and colleagues (2000) refer to this as the strength of the situation. For example, a business might have well-established rules about whether it is allowable to attend to personal issues while at the office or about whether taking work home is expected. A boundary keeper is someone who influences that boundary crosser's ability to manage and maintain the boundary. Such individuals may influence the boundary crosser to maintain a strong or weak boundary. For instance, an employee's spouse may insist that work be left at work rather than brought home.

Clark (2000) as well as Ashforth and colleagues (2000) suggest that there are different types of boundaries. Physical boundaries exist when there is a distinct demarcation between work and nonwork, for example, an office versus an apartment. Temporal boundaries exist when time-related factors distinguish work and nonwork, such as set work hours. Psychological boundaries are those created by individuals and consist of rules of behavior, thinking, or emotions deemed appropriate by the individual to each domain. Finally, Clark (2000) as well as Ashforth and colleagues (2000) suggest that

boundary strength is best described in terms of flexibility and permeability.

Flexible boundaries are those that can be relaxed when there is a need to meet demands of the other domain. For example, a working parent with a flexible work boundary could leave work early to take a sick child to a doctor's appointment. Permeability, as defined by Clark (2000), implies that elements from one domain can readily cross the boundary around the other domain. For example, receiving work-related calls at home would be related to a permeable home boundary. She also suggests that permeability could be psychological in that emotions or attitudes from one domain may spill over into the other. Ashforth and colleagues (2000) suggest something slightly different; for them, permeability entails the "degree to which a role allows one to be physically located in the role's domain but psychologically and/or behaviorally involved in another role" (p. 474).

Despite the agreement among researchers on the definition of domain flexibility, until very recently there was no reliable and valid means of measuring the concept. Russell Matthews and Janet Barnes-Farrell (2004) refined the concept and developed a measure. Specifically, they suggest that when thinking about the extent to which an individual might cross a boundary in order to meet the demands of another domain, it is important to consider both the perceived constraints of the situation and the motivation of the individual to cross the boundary. They define flexibility ability as individuals' perception that they can flex, or relax, a domain boundary to meet the demands of another domain and flexibility willingness as their willingness to do so.

We tested some of the propositions put forth by these work-life balance researchers (Bulger, Matthews, & Hoffman, 2007). Specifically, in our first study (Study 1) of 332 working people at a variety of businesses around a small city in the northeastern U.S., which used a paper-and-pencil survey, we found that there are individual differences in boundary strength and that these differences tend to form patterns. We first tested a proposition put forth by Nippert-Eng (1996) and Clark (2000) that boundaries around an individual's work domain and home domain may not necessarily be symmetric; a person may tend to have a weak boundary around his work domain and, for example, answer phone calls at work from friends and family members, while the boundary around his home domain may be strong, and he might not accept work-related calls at home. This example illustrates a situation where the home domain tends to be integrated into the work domain while the work domain is segmented from the home domain. We found that not only are individuals' tendencies to integrate and segment the two domains independent, but that individuals' tendencies in the two domains may each vary in strength from strong integrator to strong segmentor. For instance,

the employee with the weak work boundary who accepts phone calls from friends and family members has a weaker work boundary than a coworker who accepts calls from only family members.

This leads to our second finding that when considering flexibility (ability and willingness) and permeability for both work and home domains, there tend to be patterns in work and home boundary construction. Specifically, in this study we found evidence for four patterns, or clusters. In this sample, we found one cluster of individuals with weak boundaries around both home and work domains and a second cluster in which the work boundary was weak and the home domain was strong. Individuals in the latter group protect their home domain by building a strong boundary, for example, by not allowing work to be done at home, to segment home from their work domain. A third cluster of individuals seemed to be relatively neutral in their boundary management; they did not have particularly strong or weak boundaries. And, the fourth cluster indicated the ability to be flexible about boundary management but less willingness to flex their boundaries. However, we note that it is not the exact number and nature of clusters that matter because a larger sample size or a more national sample than the one we studied could yield more or fewer clusters. What is important is that in a given sample of people, groups of individuals tend to construct boundaries in similar patterns. Our findings have implications for the types of guidelines that will be helpful to people working in information technology-rich environments who are attempting to construct work-home boundaries.

As noted, though Clark (2000) and Ashforth and colleagues (2000) identify permeability as an element of boundary strength, there is some discrepancy in the way they defined the concept. Matthews and Barnes-Farrell (2006) suggest that a better conceptualization should look back to the earlier work on home and work boundaries. They suggest that to understand boundary construction, boundary management, and outcomes thereof, we should return to Hall and Richter (1988) and look at domains as they come in contact. That is, if we really want to know about how people manage multiple roles in multiple domains, and any positive or negative consequences associated with such management, we must look at the relative ease with which people move between domains as needed to manage their multiple roles. More specifically, Matthews and Barnes-Farrell (2006) suggest that it is the fluidity of movement between work and nonwork, whether physical or psychological movement, that is the important outcome of boundary strength that then has implications for outcomes like work-family balance and stress, among others. They refer to such movement as inter-domain transitions and define them as both physical (leaving one domain to attend to the other) and cognitive (thinking about the other domain while located in the focal domain).

Based on our findings in Study 1, we suggested that permeability may be measured by engagement in boundary crossing online activities (Hoffman & Bulger, 2007). In this, we echo the notion from Matthews and Barnes-Farrell (2006) that it is the fluidity of inter-domain transitions that is important to examine. In our case, however, the inter-domain transitions are represented by what individuals do online pertaining to one domain while located in the other, for example, sending or receiving personal e-mail from work.

Boundary Strength and the Internet

Clark (2000) suggests that domains that are similar will have weak boundaries, and domains that are different will have strong boundaries. Advances in Internet technology and the applications that the Internet affords, such as always available high-speed e-mail and Google Documents that allow anywhere editing and sharing of word processing, spreadsheet, and presentation documents, have had the effect of making the work and home domains more alike. Internet applications are becoming integrated into daily life (Howard, Rainie, & Jones, 2001) to the point of being entwined with offline lives (Selwyn, Gorard, & Furlong, 2005). For many people, this integration has progressed to a point that the Internet and the applications that it affords are indispensable in that they have become part of daily rituals, such as checking e-mail first thing in the morning either at home or at work (Hoffman, Novak, & Venkatesh, 2004).

A study published while dial-up was still the dominant means of Internet access from home separated users into categories (newcomers, experimenters, utilitarians, and netizens) based on the length of their Internet experience and the frequency with which they log on from home (Howard et al., 2001). Given the applications that were available at the time this study was conducted and the inconvenience of accessing these applications via a dial-up connection, these categories made sense. However, inexpensive, widely available broadband access at home minimizes the need for such distinctions today. Experience no longer seems relevant and login frequency an artifact of the slow and sometimes inconsistent connection that dial-up provides.

Broadband Internet access at home diminishes the difference between work and home domains in important ways. E-mail, for example, is an integral feature of the contemporary workplace, necessary for communicating with customers, suppliers, and coworkers. Even with the inconvenience of dial-up access, e-mail is an activity practiced by nearly all users (Howard et al., 2001). What is key is that the interface, functionality, and, most important, access to e-mail are identical in both domains, regardless of whether the account comes from an employer or an Internet service provider like

AOL. While e-mail is a popular and widely studied application, it is now one of many that appear identically in work and home domains, and as these domains become more entwined online, they become similar, at least with respect to these applications; this, according to boundary theory, promotes weaker boundaries.

In our second study (Study 2) of 379 individuals drawn from a national pool of Internet users using an Internet-based survey, we investigated the frequency with which our respondents engaged in activities online while at home and at work. In particular, we wanted to know how frequently people engaged in work-related activities online at home and personal activities online at work. E-mail was by far the most frequent activity. Thirty-eight percent of our respondents indicated that they checked their work e-mail from home several times a day; 37 percent indicated checking their personal e-mail from work several times a day. This may be no surprise given the ubiquity of e-mail; however, respondents also engaged in instant messaging, reading publications, making purchases, and conducting searches relevant to the opposite domain. For instance, more than half the sample suggested that they conducted a work-related Internet search at home at least once a month. The same was true of conducting a personal Internet search at work.

What these findings suggest is that the online activities afforded by applications like e-mail that are equally available in the home and work domains remove a structural component of the boundary between work and home domains. The responsibility for maintaining the boundary then falls on the individual. Someone who prefers integration might show no ill effects of blurring, while for someone who prefers segmentation this can create a problem. Segmentors must construct the preferred boundary. In this sense, the activities, particularly boundary crossing activities that individuals engage in and the extent to which they engage in them, give us insight into how boundaries are managed.

For instance, when a woman online in her home responds to a friend's e-mail about a dinner party and then immediately afterward responds to a coworker's e-mail about their company's business plan, she transitions psychologically from the home domain to the work domain. The fluidity of transitions between the work and home domains in this example is afforded by the technology, but we do not know for certain to what extent the woman's boundary strength is influenced by other factors, such as her preference for boundary crossing. How are inter-domain transitions, what individuals actually do, related to flexibility ability, whether individuals perceive that they can relax a domain boundary, and to flexibility willingness, whether individuals are willing to relax a domain boundary?

In our second study, we found that for both the work and home domains, inter-domain transitions measured by online boundary crossing (for example,

frequency of sending and receiving personal e-mail at work) are significantly predicted by work flexibility ability and home flexibility willingness. This means that people who perceive that their work boundary is flexible—they have access to technology that affords inter-domain transitions, supportive policies, and/or supporting coworkers—are more likely to cross the home-work boundary in both directions. Someone willing to flex their home boundary is more likely to cross the home-work boundary in both directions. Similarly, perceived inability to flex the work boundary and unwillingness to flex the home boundary predict segmentation.

The results of our studies support the proposition that boundaries are individually constructed (Ashforth et al., 2000; Clark, 2000; Nippert-Eng, 1996). We know that work and home boundaries are not necessarily symmetric and that the strength of a particular boundary varies between strong integration and strong segmentation. The simplistic notion that there are two categories is false, and the more nuanced notion of a segmentation-integration continuum is more accurate; however, a segmented home boundary does not imply a segmented work boundary. Individual boundary construction is supported by the findings from Study 2 that suggest the perceived flexibility of the work domain boundary and the willingness of an individual to flex the home domain boundary predict inter-domain transitions for boundary crossing behavior in both directions. Variations in technical support at work, workplace policies, and coworkers' attitudes all influence individuals' perceived flexibility and variations in their willingness to flex the home boundary.

Consequences of Boundary Construction

Ad hoc advice like "turn off the computer/cell phone/BlackBerry" appears to be directed to people whose home boundary is weaker than they would prefer. But consider someone who has an instant messaging application available at work. Often, instant messaging is done with friends and family members. In the absence of employer policies or coworkers' attitudes dissuading workers from this use of instant messaging in the workplace, the perceived opportunity to cross the work boundary into the home/personal domain exists; flexibility ability is high. If the employee would prefer not to respond to instant messages from a family member or friend at work (low flexibility willingness) yet feels compelled and does (inter-domain transition), there may be consequences such as poor work-life balance, stress, or health symptoms. Turning off the instant message application lowers flexibility ability, removing the obligation to respond. But this requires the individual to construct a boundary where one does not exist.

Our studies provide insights about the consequences of various boundary management strategies. In Study 1, we investigated the relationship between boundary strength and work/personal life interference (for instance, "I often neglect my personal needs because of the demands of my work") and work/personal life enhancement (for example, "My personal life gives me the energy to do my job") (Bulger, Matthews, & Hoffman, 2007). We found that lower ability to flex the work domain boundary and a more permeable home boundary predicted work interference with personal life. In other words, if people perceive their work boundary as inflexible or engage in boundary crossing online activities at home, they are likely to report that work is interfering with their personal life. We also found that lower ability to flex the home boundary and a permeable work boundary predicted personal life interference with work. That means that if people perceive their home boundary to be inflexible or engage in boundary crossing online activities at work, they are likely to report that home is interfering with their work life.

Lower flexibility ability is a perceived constraint on individuals' ability to engage in boundary crossing activities. As noted, these might be technology limitations, formal or informal policies, or coworkers' or family members' attitudes. It is clear that engagement in online boundary crossing activities may lead to interference; however, it is interesting that less flexible work and home boundaries are associated with work interfering with personal life. Because lower flexibility implies segmentation, it should guard against interference, yet our findings suggest the opposite.

When we investigated work/personal life enhancement we found that willingness to flex the home boundary predicted work enhancement of personal life. We also found that willingness to flex the work boundary predicted personal life enhancement of work. If individuals are willing to engage in boundary crossing online activities at home or at work, the activity tends to enhance the domain. Taken together, these results paint an intriguing picture. If someone is constrained from engaging in boundary crossing online activities or is possibly expected to by their employer or spouse, for example, there is a tendency toward work/personal life interference. Alternatively, if someone is willing to engage in boundary crossing online activities, there is a tendency toward work/personal life enhancement. Consider a man who is willing to cross the home boundary by doing work at home during the evening or on weekends. In this case his willingness to work from home enhances his personal life. If, however, he is unable to work at home due to his spouse's expectations or lack of a suitable workspace, then personal life interferes with work.

In Study 2, we investigated the relationship between inter-domain transitions, work/personal life interference, segmentation preferences, and health

symptoms (Bulger, Hoffman, & Matthews, 2008). Segmentation preferences (Kreiner, 2006) measure an individual's preference for segmentation of the home and work boundaries (for example, "I don't like home issues popping up while I'm on work time"). Segmentation preferences differ from flexibility willingness in that preferences measure whether an individual wants to engage in an inter-domain transition, while flexibility willingness measures whether an individual is willing to engage in a boundary crossing transition (for instance, "While at work, I am willing to take time off from work to deal with my family and personal life responsibilities"). Health symptoms measure how frequently various health symptoms have occurred during the previous three months (for example, "How often have you experienced headaches?") (Schat, Kelloway, & Desmaris, 2005).

We found that when people who prefer to segment their work domain from their home domain engage in inter-domain transitions, there is the significant likelihood of work interfering with their personal lives (Bulger, Hoffman, & Matthews, 2008). Further, there is a significant likelihood of health symptoms such as frequent headaches, neck and back pain, or difficulty sleeping. In the home domain we did not find the same relationship with health symptoms; however, we did find that personal life interference with work is likely for people who prefer to segment the home domain from the work domain while engaging in inter-domain transitions. The implication suggests that, for example, a woman who prefers segmented domains yet engages in inter-domain transitions is at the least likely to experience work interference with her personal life. At worst she will experience negative health symptoms related to this stress.

What happens when there is a mismatch between flexibility ability and flexibility willingness? If a person is willing to flex their work boundary, for example, but perceives the boundary as inflexible because of limitations of boundary crossing technology such as slow or limited Internet access, workplace policies limiting boundary crossing activities, or attitudes of coworkers or family members, what outcomes are likely? To answer this question, we examined data gathered from Study 2 (Farias, Bulger, & Hoffman, 2009). In addition to boundary strength measures of flexibility (ability and willingness) for the work and home domains, we measured turnover intention (for instance, "I will probably look for a new job in the next year"), organizational commitment (for instance, "I am very interested in what others think about my organization"), and job satisfaction (for instance, "All in all, I am satisfied with my job").

We found that for individuals who report mismatch in perceived ability and willingness to flex the boundary of either domain, either more willing or more able, there is a greater turnover intention and less organizational commitment; job satisfaction is not affected (Farias, Bulger, & Hoffman,

2009). These results suggest that mismatch in the flexibility of either domain does not affect whether individuals are satisfied with their jobs, but it does affect whether they will continue to work at their current organization. These findings underscore the importance of understanding that boundary construction is a highly individual endeavor and suggest that if individuals are not able to construct boundaries to their liking there may be negative consequences.

Conclusion

So far, our findings suggest that managing work and home lives in our increasingly technology-enabled world is no easy feat. For someone who prefers to segment domains or is less willing to flex a boundary, turning off technology like e-mail or instant messaging that affords online boundary crossing is a means to construct a stronger boundary. Deciding to do so is likely to result in better work-life balance, fewer health symptoms, and greater organizational commitment. But this may also lead to problems if this individual is expected to be "always on." And, there are those who are willing to engage in boundary crossing online activities that find it enhances their work-life balance, because, for example, they can work from home when they prefer to do so. Problems may arise for these people if they are required to "turn it off" as part of an effort to help individuals maintain boundaries.

Setting expectations helps. In the work domain, for example, if a man who prefers segmentation from the home domain can set family members' or friends' expectations by letting them know that e-mail or instant messages will not be answered during work hours, or, perhaps, only at break time. Alternatively, if he prefers integration, then no such limitation is necessary. Setting expectations modifies the domain culture by establishing informal policies either at work or at home; this changes the perceived ability to flex the boundary, resulting in a stronger or weaker boundary.

Understanding that people construct boundaries and that, as Nippert-Eng (1996) noted, constructed boundaries are idiosyncratic allows us to go beyond ad hoc guidelines from business consultants, technology companies, and journalists by applying boundary theory to aid the boundary construction process. Boundaries are constructed at home and at work. The goal is to construct them in ways that minimize negative outcomes, such as interference (work with personal life or personal life with work) or health symptoms, and that maximize positive outcomes, such as enhancement (work with personal life or personal life with work) or job satisfaction. To achieve these outcomes people need to understand their preference for segmentation at home and at work, and their willingness to flex either boundary. In each domain, there are limitations that can be modified, and there are those that

cannot. Setting the expectations of coworkers or family members is an example of a limitation that may be modified to manage boundary strength to more closely match preference and willingness.

Workplace policies against boundary crossing online activities possibly enforced by technology, such as filters or monitors, or lack of a suitable location to work from home, are examples of limitations that cannot be modified and that might not match an individual's preference or willingness. In the latter case, it is important to recognize the mismatch and search for ways to manage the boundary, or, instead, to be prepared to manage the outcomes. Boundary strength is only one component of a person's life situation; however, awareness of the factors that contribute to boundary strength might meaningfully contribute to decision making that promotes a better work-life balance.

In the beginning of this chapter, we made much of the fact that broadband Internet access has changed in a substantial way people's abilities to engage in boundary crossing online activities. Dial-up Internet access was slow and inconvenient by comparison; it limited perceived and actual ability to flex boundaries. But what technologies will come next, and how will they impact people's work-life balance? Broadband "hot spots," such as those at airports and coffee shops, are beginning to give way to wireless access nearly everywhere (Jassem, 2007). As this trend continues, boundary strength as influenced by perceived availability will decrease, promoting greater blurring. However, this is an extrapolation of our current understanding. User categories based on length of experience and log on frequency from home (Howard et al., 2001) now seem quaint because they reflect the technical limitations of dial-up. Will work-home boundaries matter to people in the future in the same ways that they do today, or is this concern an artifact of the limitations of hot spot broadband?

The goal of ubiquitous or pervasive computing is to create and deploy human-centered computing that "will be freely available everywhere, like batteries and power sockets, or oxygen in the air we breathe" (MIT Project Oxygen, 2004). Søren Petersen (2007) suggests that computing and the online activities it affords will become mundane: uninteresting and routine. Referring to a computing device as an appliance tends to promote this idea; however, that we no longer look at the device as a computing device is more to the point. Smart phones allow us to communicate, find information, share photos and videos, and much more. Boundary crossing, which was somewhat clunky with dial-up, has been much smoother with hot spot broadband, and it will be fluid in the pervasive wireless computing world of the near future in which, for example, devices embedded in prescription labels will automatically monitor and order people's medications. Instead of on- and offline life being entwined, they will be indistinguishable.

Does this mean that the ideas presented in boundary theory will be likewise quaint and outdated? To the contrary, we suspect that in a world where life on- and offline are indistinguishable, boundary blurring will be complete and, therefore, boundary construction will be even more crucial if individuals are to maintain their work and home lives to their liking: managing boundaries will be managing life.

References

Ashforth, B. E., Kreiner, G. E., & Fugate, M. (2000). All in a day's work: Boundaries and micro role transitions. *Academy of Management Review, 25,* 472–491. Mahwah, NJ: Erlbaum.

Barnett, R. C., & Baruch, G. K. (1985). Women's involvement in multiple roles and psychological distress. *Journal of Personality and Social Psychology, 49,* 135–145.

Bittman, M. (2008, March 2). I need a virtual break. No, really. *New York Times,* p. ST1.

Bulger, C. A., Hoffman, M. E., & Matthews, R. A. (2008, March). Predicting health outcomes: Understanding segmentation preferences, transitions, and work/nonwork interference. Poster presented at the 7th International Conference on Occupational Stress and Health, Healthy and Safe Work through Research, Practice and Partnerships, Washington, DC.

Bulger, C. A., Matthews, R. A., & Hoffman, M. E. (2007). Work and personal life boundary management: Boundary strength, work/personal life balance and the segmentation-integration continuum. *Journal of Occupational Health Psychology, 12,* 365–375.

Caplan, S. E. (2006). Problematic internet use in the workplace. In M. Andandarajan, T. S. H. Teo, & C. A. Simmers (Eds.), *The internet and workplace transformation* (pp. 63–79). Armonk, NY: M. S. Sharpe.

Clark, S. C. (2000). Work/family border theory: A new theory of work/family balance. *Human Relations, 53,* 747–770.

Farias, N., Bulger, C. A., & Hoffman, M. E. (2009, April). Border theory under the microscope: Examining the impact of a mismatch between the two central components of border strength. Poster presented at the 24th Annual Conference of the Society for Industrial and Organizational Psychology, New Orleans, LA.

Hall, D. T., & Richter, J. (1988). Balancing work life and home life: What can organizations do to help? *Academy of Management Review, 2,* 213–223.

Hoffman, D. L., Novak, T. P., & Venkatesh, A. (2004). Has the internet become indispensable? *Communications of the ACM, 47*(7), 37–42.

Hoffman, M. E., & Bulger, C. A. (2007). Internet technology blurring of the boundary between work and home domains. Manuscript submitted for publication.

Horrigan, J. B. (2007). *Why we don't know enough about broadband in the U.S.* Pew Internet and American Life Project. Retrieved April 27, 2008, from http://www.pewinternet.org/pdfs/Backgrounder.MeasuringBroadband.pdf.

Horrigan, J. B., & Smith, A. (2007). *Home broadband adoption 2007.* Pew Internet and American Life Project. Retrieved April 27, 2008, from http://www.pewinternet.org/pdfs/PIP_Broadband%202007.pdf.

Howard, P. N., Rainie, L., & Jones, S. (2001). Days and nights on the Internet. *American Behavioral Scientist, 45*, 383–404.

Jassem, H. (2007). Municipal wi-fi comes to town. In S. Kleinman (Ed.), *Displacing place: Mobile communication in the twenty-first century* (pp. 21–37). New York: Peter Lang.

Kleinman, S. (2007). Anytime, any place: Mobile information and communication technologies in the culture of efficiency. In S. Kleinman (Ed.), *Displacing place: Mobile communication in the twenty-first century* (pp. 225–233). New York: Peter Lang.

Kreiner, G. E. (2006). Consequences of work-home segmentation or integration: A person-environment fit perspective. *Journal of Organizational Behavior, 27*, 485–507.

Mahatanankoon, P. (2006). Internet abuse in the workplace: Extension of the workplace deviance model. In M. Andandarajan, T. S. H. Teo, & C. A. Simmers (Eds.), *The internet and workplace transformation* (pp. 15–27). Armonk, NY: M. S. Sharpe.

Marks, S. R. (1977). Multiple roles and role strain: Some notes on human energy, time, and commitment. *American Sociological Review, 42*, 921–936.

Marks, S. R., & MacDermid, S. M. (1996). Multiple roles and the self: A theory of role balance. *Journal of Marriage and the Family, 58*, 417–432.

Matthews, R. A., & Barnes-Farrell, J. L. (2004, August). *Development of a comprehensive measure of boundary strength for work and family domains*. Paper presented at the annual meeting of the Academy of Management, New Orleans, LA.

Matthews, R. A., & Barnes-Farrell, J. L. (2006, May). *Advancing measurement of work-family boundary management practices*. Poster presented at the 21st Annual Conference of the Society for Industrial and Organizational Psychology, Dallas, TX.

MIT Project Oxygen. *Project Overview.* (2004). Retrieved June 27, 2008, from http://oxygen.csail.mit.edu/Overview.html.

Nippert-Eng, C. E. (1996). *Home and work: Negotiating boundaries through everyday life*. Chicago: University of Chicago Press.

Petersen, S. M. (2007). Mundane cyborg practice: Material aspects of broadband internet use. *Convergence: The International Journal of Research into New Media Technologies, 13*, 79–91.

Richtel, M. (2008, June 14). Lost in e-mail, tech firms face self-made beast. *New York Times*, p. A1.

Schat, A. C., Kelloway, E. K., & Desmaris, S. (2005). The physical health questionnaire (PHQ): Construct validation of a self-report scale of somatic symptoms. *Journal of Occupational Health Psychology, 10*, 363–381.

Selwyn, N., Gorard, S., & Furlong, J. (2005). Whose Internet is it anyway? Exploring adults' (non)use of the Internet in everyday life. *European Journal of Communications, 20*(1), 5–26.

Sieber, S. D. (1974). Toward a theory of role accumulation. *American Sociological Review, 39*, 567–578.

Steiner, L. M. (2006). Five tricks to tame technology. *Washington Post.* Retrieved April 27, 2008, from http://blog.washingtonpost.com/onbalance/2006/09/five_tricks_to_tame_technology.htm.

Stewart, T. A., & Furth, J. (1994, April 4). The information age in charts. *Fortune, 129*.

Towers, I., Duxbury, L., Higgins, C., & Thomas, J. (2006). Time thieves and space invaders: Technology, work and the organization. *Journal of Organizational Change Management, 19*, 593–618.

Wallace, P. (2004). *The internet in the workplace: How new technology is transforming work*. Cambridge: Cambridge University Press.

CHAPTER 21

A Technologically Gendered Paradox of Efficiency

Caring More About Work While Working in More Care

▶ ANNIS G. GOLDEN

Information and communication technologies (ICTs) promise knowledge workers increased capabilities for shaping working conditions and managing the competing demands of work and family by shifting the time and place of work and blurring work-life boundaries. It has been argued, though, that rather than transforming the conditions of work, technology reproduces traditionally gendered strategies for managing work and family with the net effect of disproportionately allocating responsibility for domestic tasks and caregiving to women (Rakow, 2007; Rakow & Navarro, 1993), while at the same time systematically disadvantaging women in the workplace when they elect to use technology to work from home, because the additional work that they do is often invisible (Perlow, 1998; Sullivan & Lewis, 2001). It has also been observed that men and women engage with technology in gendered ways (Kelan, 2007), and that masculine modes of engagement (whether practiced by men or women) displace the ethic of care associated with family relations with the ethic of instrumental efficiency associated with the work-

place (Brannen, 2005; Sabelis, 2001). Others who study work, technology, and gender, however, caution against relating technology and gender in binary modes that reproduce technological determinism and gender essentialism (Wajcman, 2007).

This chapter presents a comparative case analysis of four employees of a global high-tech organization to reveal the complicated ways that gender intersects with technology in managing work and family. The cases are drawn from a larger study of work-life interrelationships for employees at this organization, which is located outside of a small city in the northeastern U.S. and referred to here as DataTech. Ethnographic interviews with two men and two women employees reveal technological practices that point to both reproduction of traditional gender roles (and role specialization) and to role convergence, often times within the same case, though in different measures and forms. As Elisabeth K. Kelan (2007) observes in her research on how gender is implicated in the ways that ICT workers position themselves in relation to technology, close observation moves us "beyond seeing gender as a binary, to seeing it as a multiple and one that shifts in technology design and use" (p. 376).

More specifically, this chapter describes the emergence, from the use of ICTs to manage work and family, of a gendered paradox of efficiency. This type of ICT-enabled efficiency is gendered and paradoxical insofar as the efficiencies of work-family management are obtained through divided rather than single-minded attention—a more feminized approach to task management, while at the same time framing the accomplishment of additional commodified work as a primary goal, a more traditionally masculine construct. The four cases presented here illustrate the emergence of a form of gendered ICT-mediated work-life interrelationship marked by sex-role convergence in relation to work and family and gendered notions of efficiency, but also by the pluralism characteristic of a late modern, post-traditional culture (Stephen, 1994). Before presenting the cases, though, I review relevant constructs concerning gender, technology, and work-life interrelationships.

Gender, Technology, and Work-Life Interrelationships

Judy Wajcman (2007) traces the evolution of feminist theories of gender and technology from the "fatalism" of early second-wave feminism regarding technology's role in "reproducing patriarchy" given the allegedly "inherent masculinity of technology" (p. 287) to the celebration of technology's empowering potential for women espoused by cyberfeminists of the 1990s. Even more recently, Wajcman notes, we have seen the emergence of approaches

to gender and technology inspired by social construction of technology perspectives, which take a co-construction approach, thus avoiding the "twin pitfalls of technological determinism and gender essentialism" (p. 294). She calls these approaches "technofeminist"; they "do not treat technology as either inherently patriarchal or unambiguously liberating" (p. 293). From this perspective, affordances of technologies are not inscribed by designers, they emerge during use. Moreover, technologies may have contradictory effects, and the same technological artifact may have different meanings for different people. In Wajcman's technofeminist view, technology is "both a source and a consequence of gender relations" (p. 293).

Research that focuses more specifically on gender, technology, and work-life interrelationships reflects tensions between technological determinism and social construction of technology as well as tensions between binary orientations to the gendering of technologically mediated work-life interrelationships and more complex, pluralistic orientations. For example, Cath Sullivan and Suzan Lewis's (2001) study of teleworkers who use ICTs to work remotely found that the participants' reasons for working at home were distinctly gendered, with women much more likely than men to indicate that they worked at home to accommodate domestic responsibilities, and men more likely to indicate that they worked from home for reasons that were personally advantageous, such as to avoid office politics or onerous commutes, or as a transition to self-employment. For the male teleworkers, involvement with domestic responsibilities was framed as a secondary motivation at best, and they most often construed their role as supportive to their wives. Thus, telework and its associated technologies appeared not to alter the gendered division of domestic responsibilities. Sullivan and Lewis observe that while their findings could be read as congruent with a "gendered exploitation" model of telework, the accounts of the women in their study emphasized that the flexibility of telework allowed them to realize two important aspects of their identity—caregiving and work—one traditionally associated with a feminine gender identity and the other a more masculine one. They therefore argue that the traditional dualism of exploitation and empowerment in assessing the effects of telework does not capture the complexities of these workers' lived experiences.

Paige Edley (2001) likewise examines the "gendered paradox" of empowerment and exploitation that occurs when women use ICTs to achieve greater control over the conditions of work, often in the form of moving work across the spatiotemporal boundaries of the organization in order to also carry out caregiving and other domestic responsibilities. Yet Edley observes that these women relinquish some control over their conditions of work as the employing organization's influence penetrates the home. Though Edley's study focuses only on women, she observes a phenomenon that is also noted in

Sullivan and Lewis's (2001) study of teleworkers of both sexes: women performing domestic tasks at the same time as paid employment. Edley argues that the "second shift" (Hochschild, 1989) conceptualization of the relationship between work and family implies a linearity that does not reflect the experiences of the women in her study, with the complexities of multiple roles and fluid boundaries that are created and/or enabled by ICTs.

Maggie Jackson (2002) refers to the phenomenon of being physically present in one domain of experience while virtually present in another via ICT as "dual presence" (p. 58). Attila Bruni and colleagues (2004) use the same expression in their study of small business entrepreneurs to designate the "continuous and fluid movement between different spaces of signification (home/work, reproduction/production, secretaries/entrepreneurs, housewives/working women), which facilitates the breaching of the boundaries that mark out the symbolic order of gender and entrepreneurship" (p. 423). While they observe this most acutely in the female entrepreneurs they studied, they assert that this phenomenon is not restricted to women.

The sense in which dual presence is used in this chapter has both of these associations, as well as building on the idea of "social presence," familiar from research on computer-mediated communication, which generally refers to the ability of a medium of exchange to convey the actual presence of social actors (Rice, 1993). Dual presence is therefore different from multitasking: in order to be enacting dual presence, one must not only be doing two things at once, one must be enacting social presence in some way. Dual presence is closely bound with the individual's orientation to time. Kerry Daly (1996), following Edward T. Hall's time research, identifies employment and the workplace with a different sort of time experience from domestic life. Work is identified with "monochronic time," or a "pattern of sequential behavior that is shaped by schedules, is task oriented, and is open to evaluations of success or failure" (p. 148). Susanne Tietze and Gill Musson (2005) call this "industrial time," which orients to Tayloristic principles of maximal efficiency. Home life, conversely, is identified with "polychronic time," which is "patterned by a set of *simultaneous* interactions, focused on the present, and shaped by the involvement of people in transactions" (Daly, 1996, p. 148, emphasis added). These different time orientations are gendered insofar as the traditional separate spheres discourse feminizes the domestic sphere and masculinizes the workplace (Kirby, Golden, Medved, Jorgenson, & Buzzanell, 2003; Tietze & Musson, 2005). The time orientations are also gendered in the sense that Sullivan and Lewis (2001) and others have noted; namely, that when work and home life take place in the same physical space, men are more likely to prefer separating (physically, insofar as possible) and sequencing their involvements in commodified work and domestic work, while women are more likely to enact what has been described as dual pres-

ence with respect to these two domains. Yet the accounts of the men and women employees of the organization that I studied suggest there are two aspects of ICT-mediated work-life interrelationships that complicate this binary view, creating a gendered paradox of efficiency.

First, what all of the workers seek to accomplish by using technology to move some of their work across the spatiotemporal boundary of the organization and into their homes can be construed as efficiency effects. They may wish to do more work while not further circumscribing their family commitments, or they may wish to enlarge their family commitments while not diminishing their investment of effort in paid work. Either way, they wish to do more with the same amount of time. Efficiency as a goal, in and of itself, has traditionally been associated with the technical/instrumental mode of rationality (Mumby & Stohl, 1996) and a monochronic industrial orientation to time. But the way in which at least some of the workers accomplish these efficiency effects is through a polychronic orientation to time and the enactment of dual presence (Tietze & Musson, 2005).

Second, while maintaining a co-constructionist approach to technology and gender, and awareness of research findings that indicate the lack of wholesale transformation of gendered divisions of work and family responsibilities by new technologies, I argue that these cases demonstrate that ICTs do have significant impact on users, increasing the likelihood that individuals will experience dual presence, whether because they actively seek it out as a strategy for managing work and family, or because they are drawn into it by other family members or coworkers.

The Cases: Two Men and Two Women from DataTech

Much of what we know about ICT-mediated work-life interrelationships comes from studies of full-time teleworkers. Yet full-time telework, while constituting an important trend in postindustrial, globalized workplaces, still accounts for a small fraction of the workforce in most developed countries. Much more common are the employees whose primary workplace is still an organizational location, but who move work across the work-life boundary so that they can meet the requirements of the workplace while also enacting a preferred role identity definition within their families. The four cases presented in this chapter were selected based on the variation they displayed, both within and between the cases, as well as their commonalities, with respect to work-life arrangements, ICT use, and gender identities.

Howard: Using Technology to Both Reproduce and Subvert a Gendered Division of Work-Family Responsibilities—Embracing Dual Presence

Howard, an upper-level manager at DataTech with a wife and two children ages 11 and 13, combines long-distance commuting and teleworking. During a typical week he spends four days and three nights in the city where DataTech is located and three days and four nights with his family in a city 300 miles away. Howard and his wife's arrangements have elements of traditional gender role specialization with respect to work and family as well as technologically enabled role convergence. Howard is the primary wage earner, while his wife, as he describes her, has "gone part-time recently now so she can spend more time with the kids." In comparing their respective work and family responsibilities, he observes, "her work schedule is not as hectic [as mine]. Her personal schedule, I don't know how she does it…with the kids and the baseball and soccer and softball…the dentist and the orthodontist.… Hers is every bit as hectic as mine but it's more on the family personal side."

As Howard notes, "I could change careers and spend much more time at home. But there's a value and a quality of life that I owe my family, and I want them to have, that would be in jeopardy if we were to do that." Thus, Howard uses technology to work at home as a way of maximizing his time with his family, while still maintaining the position that allows him to provide the "quality of life" for his family that he wants them to have. While Howard's strategy of managing work and family primarily reproduces a traditionally masculine primary wage earner role (and his wife's strategy of curtailing her own work involvement to take on the primary responsibility for managing the family's affairs reproduces a traditionally feminine role), elements of the ways in which he uses technology to work from home reflect strikingly more feminine modes of technologically mediated work-life interrelationships.

For example, in using technology to bring work into the home, Howard also takes the opportunity to teach his children about work, showing his daughter how to prepare a PowerPoint presentation, for instance, rather than separating his children from his work, a strategy reminiscent of preindustrial, pre-separate spheres household arrangements when tailors, weavers, physicians, farmers, writers, artists, and people with many other professions worked at home; offices, workshops, stores, and farms were typically part of or adjacent to people's homes before the Industrial Revolution.

Moreover, in contrast to the more prototypical masculine preference for a single attentional focus, as well as linear sequencing of tasks, Howard expresses a preference for being "more a part of the environment around me"

when he works at home, either setting up his notebook computer on the kitchen table and connecting wirelessly to their household's Internet connection, or working in his home office in their finished basement, side by side with his children. In short, Howard enacts a dual presence, simultaneously taking part in the worlds of his work and family.

As Tietze and Musson (2005) have observed, paid employment, when performed within the spatiotemporal boundaries of the domestic sphere, is subject to various kinds of adjustments. Traditionally, the discourses of industrial production orient to clock time, efficiency, and instrumental relationships, whereas the discourses of household production are defined by "the labour of love, based on values of care, reciprocity, and nurture" (p. 1335). When organizational employees bring work into the home, either as full-time or occasional teleworkers, both work and home, they argue, mutually adjust to each other. However, their study of teleworkers found that while discourses of industrial production do not dominate the home, the "logic of the time/money metaphor" is extremely influential (p. 1347). And thus, Howard says, "very rarely...would that door be closed....I owe 'em too much. I can't do that."

For Howard, then, technology is both a means of reproducing a gendered division of responsibility and of enacting role convergence. He uses technology to extend the time that he spends at home and to ensure that he is integrated into the life of his family as much as possible while he is there (rather than shutting himself away in a home office), but this extension and integration are motivated at least in part by his consciousness of a time debt he owes as a consequence of his commitment to a gendered provider role.

Paul: Using Technology to Subvert Gendered Divisions of Work-Family Responsibilities but Resisting Dual Presence

Paul is also in upper management at DataTech, with a wife employed full-time outside the home and two children ages 12 and 14. He oversees the work of several subordinates, as well as working on projects of his own. His job requires him to interact regularly with employees at other DataTech locations in distant time zones, which entails evening phone conversations from his home. However, this is not the only reason or occasion for Paul to work from home. He regularly leaves work one to two hours before the other employees in his department to be home for his children when his wife's schedule prevents her from being there. Negotiating this schedule was part of his conditions for accepting the job: "When I came here, I said, look, some days I [have to] leave at a certain hour to get home to get the kids....And that was the deal and I still do that. Then when I get home, I may be running them to a lesson or something. But then...I immediately get online."

In some respects, Paul positions himself as a gender nonconformist; for example, in the way he describes his alternative work arrangement at the organization he was employed by before coming to DataTech: "I was the first man with this firm ever to go part-time," but he immediately follows this statement with "and part-time there means 40 hours a week," qualifying his nonconformity with a more traditionally masculine affirmation of work involvement. Nonetheless, for Paul and his wife, who works full-time in a high-status, well-paying profession, work and family arrangements are characterized much more by role convergence than role specialization.

Technology plays an important role in Paul's strategy for managing work and family and the movement of work across the work-life boundary. He describes a typical evening as including "quick calls [with people in other time zones] or instant-messaging…checking e-mail…or I take one piece of work home and edit it." With respect to his preferences for the spatiotemporal mode of carrying out work at home, he notes,

> We have an office. And before we got wireless, [my work] was always in there. But sometimes now…I'm roaming around the house. So I'll be sitting at the island in the kitchen with the laptop…we have wireless. I'm not sure it was a good thing.…It depends on how you use it. Because I can…be at the island in the kitchen…and I've recorded the Jim Lehrer News Hour, I'll be sittin' there watchin' that and open up my laptop and get e-mail. And, and the next thing I know [my son or my daughter] is IMing [instant messaging] me…it's not good to be distracted trying to do several things at one time.

Paul has modified his schedule to facilitate an enlarged role in caregiving in his family, given the demands of his wife's job. So in this sense he uses technology to facilitate role convergence rather than role specialization. However, he nonetheless relates to the technology in a more traditionally masculine way, expressing discomfort with enacting dual presence, and a preference for a more linear arrangement of work and family, even when working in his home: first music lessons, then work, then dinner along with family interaction, then more work, perhaps in combination with time for his own interests, but not work and family interaction combined.

Paul's case presents interesting commonalities with and contrasts to Howard's. Like Howard, he negotiated an alternative work arrangement that entails doing a significant amount (though by no means the majority) of his work at home. These arrangements are notable in part because they represent exceptions to an unofficial organizational policy that precludes flexplace and widespread organizational discourse about the potential for flexplace abuse. Thus, DataTech's willingness to accommodate Howard and Paul in this respect signifies their value to the organization, which Clark (2000) notes as a key element in an employee's ability to negotiate work-life accommodations.

Also, for both Howard and Paul, their flexplace arrangements are facilitated with a similar ecology of household and organizationally supplied technologies (company laptop, family high-speed Internet connection, including wireless access). Here, however, the similarities end. Howard is the role specialized, traditional primary wage earner, who nonetheless expresses complete comfort with enacting dual presence, working side by side with his children. Paul, while much less role specialized and more gender nonconformist in his work and family arrangements, expresses discomfort with dual presence.

Summarizing research on work and gender identity, Sullivan and Lewis (2001) observe that when some aspects of men's work arrangements are feminized, such as by doing paid work within the domestic environment, in order to offset the gender identity threat that this may represent, some men may distance themselves from other feminized practices associated with managing work and family. For Sullivan and Lewis's teleworkers, this took the form of the men distancing themselves from domestic chores and caregiving activities. For Paul, this may be reflected in his more traditionally masculine monochronic technology practices. Conversely, Howard's greater comfort with dual presence may be linked to his and his wife's more traditionally role specialized approach to work and family.

Joan: Using Technology to Accomplish More Work and More Caring—A Selective Approach to Dual Presence

Joan has been with DataTech almost from its inception and rose to upper management. Work is central to her identity: "I really enjoy what I do. You couldn't be here this long if you didn't like it.... And it's a good part of my life. I mean, I spend probably an inordinate amount of time at work versus home during the week."

However, Joan is not all about work. She recounts that when her older child—now an adult—was born, she redefined her job so that she could work primarily from home: "I came in one day a week to do paperwork and show my happy little face and I did that for a year." She continues to shape her work to fit her family role in relation to her younger son, who is now a teenager. On the days that she is responsible for her son's transportation, she says:

> I'm gone by four promptly because I drop him at school in the morning, I pick him up. It's a long day for him. And so I go home, we have our dinner. At 16, you don't converse for a long period of time, and when he decides to go off and do his own thing, I usually stick my computer back on and gear back up for two or three hours. My husband will come home and we chat, we watch TV, I work on my computer, which works just fine for me.

Joan combines monochronic (linear) and polychronic (dual presence) strategies in using technology to manage her work and family roles. She uses a monochronic strategy with her son, giving him her undivided attention during dinner. She explains that she does this to facilitate connection and to demonstrate respect for the ritual of family dinner; and although she has made some adjustments recently, these adjustments have the goal of improving her connection with her son rather than accommodating her work:

> I won't sit at a dinner table with my computer. Dinner is dinner, and I've only broken down this year where my son is allowed to have a TV on, on occasion, while we eat. 'Cause it's just him and the rule's always been, if there's more than just you at that table, there's no TV, there's no computer, there's no book. This is a conversational time. It's been a bit (clears throat) painful to hold conversations with this child. So it's actually almost a better thing that he has the TV. I find that he's more conversational with the TV on.

With the ceremony of dinner concluded, though, and with her son "off... do[ing] his own thing," she enacts dual presence, dividing her attention between watching television with her husband and working on her laptop computer, which is a repository for both work and family business. She counts on this time for work and recounts being thrown off balance when other personal life concerns, such as tax season or volunteering, supplant it: "So for the last eight days, I've been trying to iron out my taxes, which is causing me undue stress here because I'm only workin' eight, nine hours a day....I do like those hours at home. It gives me my balance."

Monochronic, or linear, sequencing of tasks has been associated with traditionally masculine orientation to time and the world of work, and yet in this context we see it characterizing Joan's enactment of her role as mother. It is thus simultaneously masculine, insofar as it reflects a conscious decision to engage in an undivided attentional focus, and feminine, insofar as its goal is relational connection.

Like Paul, Joan uses technology to move work across the work-life boundary so that she can physically leave the workplace and attend to her son's instrumental needs (to be picked up from school and transported home) and their relationship, returning to work later in the evening. But unlike Paul, she is comfortable with the dual presence composed of spousal interaction and electronically mediated attention to work. Joan is sufficiently engaged by her work that using technology for work while in her husband's company fulfills an attentional need as well as a need for efficiency that keeps her work life in balance. She declares, "I hate TV alone. It's...boring"; and her husband has agreed that "he would drive when we went anywhere more than 30 minutes [away] so I could work on my computer...get something useful done." She thus combines a feminized capacity for dual presence with a more

masculine technical/instrumental mode of rationality aimed at the accomplishment of more work.

Lillian: Using Technology to Maximize the Potentialities of Dual Presence in Work and Care

Lillian, a software engineer, is a somewhat younger DataTech employee, with children ages three and five and a spouse employed full-time (and more) outside the home. She is a master of dual presence, and, like Joan, her motivation for polychronic work and family appears to be a mix of attentional engagement that work provides and efficiency:

> I cannot leave here and totally switch gears and do something different when I leave....I make sure things are happening here, while I'm home. While I'm doing my home-related things, I'm also doing work-related things. And I have no difficulty doing that....I want to do it.

She finds her work "challenging," providing her "opportunities to grow." Lillian also says, "I believe that this is a big part of my identity. This is where I feel fulfilled....I am passionate about what I do." But her work habits are clearly also driven by the need and the satisfaction of efficiency, investing "a couple of minutes from home" in order to "save...several minutes" at work.

Moreover, while she is "passionate" about her work, she also has strong feelings about how to define her role as a mother: "I don't mind doing the work from home....I don't want to put [my children] in day care and spend eleven hours here instead of nine, because it would be nice to spend eleven hours here, but I have kids, so I don't want to." So Lillian and her husband arrange their work schedules to minimize the amount of time their children spend in the care of others, with Lillian going in at 7:00 a.m. and leaving at 3:00 p.m., and her husband going to work at 9:00 a.m. and staying until much later in the day.

In addition, they "tag team" parent (Dienhart, 2001) on the weekends:

> If there is some project that I want to concentrate on and really do well and write [computer] code, for example, I have done that over the weekend. What I do is I tell my husband [and he] watches my kids, so I still know they're safe, I know they're happy. But I can come here and I put in like three, four hours and get my work done.

Lillian clearly and strongly believes that her presence at home is important to her children: "I don't want them to have...psychological problems when they grow up because Mommy was never there for them." Yet while Lillian believes her presence is important, she also does not wholly subscribe to the ideology of intensive mothering (Hays, 1996) because she positions

her husband as an adequate substitute for her own presence. Moreover, she feels that more than 40 hours a week are required to do her job well; and she notes that she wants "to move up the organization."

Thus, she uses technology to enable her to fulfill both her organizational role and her role as a mother of two young children according to her own definitions of those roles, maximizing the efficiency of her time at home by working in the center of the action there, "in the living room," where she has "this huge computer unit and it houses...four computers." From this location, she is able simultaneously to attend to work processes and her children, dividing not only her attention but her actual physical presence with all of her body available for contact with her children except the one arm she uses to enter commands on the computer: "They know I'm connecting to DataTech and they cannot touch my arm....I have told them specifically... you can touch some other part of me, but not this arm."

Lillian also uses a monochronic, linear sequencing strategy at home for work activities that exceed the limits of dual presence: "Data-related things, I can do easily from home. But when I need to actually code...I cannot do it while my children are awake....I put [these tasks] away until after 8:00 p.m., 8:30 p.m.... I cannot talk to anyone when I'm doing that."

Her strategy for using technology to manage work and family, then, like Joan's, combines a masculine single attentional focus and monochronic time orientation with a feminine polychronic dual presence strategy, though in a distinctively different way, as a result of the difference in their children's ages. For Lillian, physical presence with children constitutes social presence—it counts as a form of attention; whereas in Joan's case, physical presence counts as a form of attention with her husband but not, apparently, with her son. Lillian's young children are actively (physically) engaging her, while Joan must work to verbally engage her teenager, which surpasses the limit of dual presence. This is consistent with neurophysiological research that shows that individuals can combine a physical activity with a cognitive activity far more easily than two cognitive activities (Jackson, 2008).

The Gendered Paradox of Efficiency in Information and Communication Technology-Mediated Work-Life Interrelationships

These four cases affirm that technologically mediated work in the home does not in and of itself transform the gendered division of domestic responsibilities. Men are not taking on more domestic responsibilities simply because technology enables them to be physically present more often in the home; nor do they automatically adopt the polychronic, dual presence orientation

to combining paid work with caring work that technology can facilitate. However, technology clearly can and does facilitate role convergence. Howard's modification to his traditionally gendered role as primary breadwinner—his enactment of being dually present to his children and his work—is facilitated by technology. Technology enables Paul to modify his work schedule so that he can share caretaking responsibilities more equitably with his wife while remaining accessible to his colleagues and maintaining an undiminished level of work-related productivity. He prefers to use technology, though, to linearly sequence work and family throughout the later part of the day, rather than to enact dual presence.

Lillian and Joan's absorption with their work is typical of workers in information technology-related professions. It is a more traditionally masculine orientation to work, which has been identified as a factor that tends to alienate women from information technology work over time (Herman & Webster, 2007). Lillian and Joan, however, make ICTs work for them to fulfill more traditionally feminine caretaking roles while maintaining high work involvement. But we see the complex trade-offs they make as they choose exactly how and when to enact dual presence or to give either work or family their undivided attention.

Moreover, while spouses have been identified as active partners in shaping employees' negotiation of their work arrangements (Perlow, 1998), we also see in both the women's and the men's cases the active role that children play in shaping work that transcends organizational boundaries. Parents may enact dual presence simply by their physical presence, and, with younger children, physical contact; or children may use technology themselves to draw working parents into a dual presence mode, for example, by instant messaging their parents while the parents are working. The gendered paradox lies in the use of a feminine mode of (divided) attention to achieve efficiencies of both work and caregiving. Technology is used to create additional possibilities for interaction in the context of dual presence as well as to accomplish additional commodified work.

The Dark Side of Dual Presence

Some researchers have raised the concern that combining work and family activities in the quest for efficiency undermines the very ethic of care that the combination was intended to facilitate (Brannen, 2005; Sabelis, 2001). In her ethnographic study of Silicon Valley knowledge workers and their families, Jan English-Lueck (2002) observes that "the presence of a networked computer at home simultaneously grants an adult the privilege of working near family, and distracts that person's attention from the people in the home environment" (p. 51). Similarly, Jackson (2008) notes that

a boundaryless world means that coming home doesn't signal the end of the workday anymore than being on vacation is a time of pure relaxation or being under one roof marks the beginning of unadulterated family time. The physical and virtual worlds are always with us, singing a siren song of connection, distraction, and options. We rarely are completely present in one moment or for one another. (p. 63)

However, I argue that the four cases presented here demonstrate that such displacement of the physical by the virtual is by no means an inevitable effect of new technologies. As Jackson (2008) notes, the roots of our millennial preoccupation with efficiency significantly predate the information age; she traces them to the early twentieth-century principles of scientific management propounded by Frederick Taylor, observing that today we are all "our own efficiency experts" engaged in a "relentless quest for productivity" (p. 84). Others, including Max Weber (1905/1996), trace this influence further back, to the utilitarian individualism of Benjamin Franklin (Bellah, Madsen, Sullivan, Swidler, & Tipton, 1985). Thus, what we do with technology is at least as much driven by particular families' ways of interacting, and by broad cultural values, such as the "spirit of capitalism" that Weber observed, as it is by affordances of any technology in and of itself (cf. English-Lueck, 2002; Rakow, 2007; Wajcman, 2007).

Conclusion

The paradoxical combination of feminine and masculine time orientations plays out in different forms across these four employees' cases, reflecting not only their different positions in the organization, the family life cycle, and family forms, but also the mixture of reproduction of traditionally gendered role specialization and role convergence that is characteristic of a pluralistic, post-traditional society. As I have argued elsewhere (Golden, 2000, 2001; Golden & Geisler, 2006), what Anthony Giddens (1991) identifies as key elements of high modernity—the replacement of traditional authorities with expert systems, the pluralization of social lifeworlds, and the prevalence of mediated experiences—free us from the constraints of traditional life scripts, while conferring the twin burdens of responsibility for authoring our own scripts and uncertainty that the scripts we have written are the right ones. Such an environment offers an expanded range of possibilities for both work and family forms, but it also demands of us heightened reflexivity and greater attentiveness to those who depend on our attention. Using technology to manage work and family can disadvantage women by reproducing traditionally gendered divisions of responsibility, and disadvantage children by extending the boundaries of work into the home; however, used mindfully, technology

can also extend men's and women's abilities to engage fully with work and family.

References

Bellah, R. N., Madsen, R., Sullivan, W. M., Swidler, A., & Tipton, S. M. (1985). *Habits of the heart: Individualism and commitment in American life*. New York: Harper & Row.

Brannen, J. (2005). Time and the negotiation of work-family boundaries: Autonomy or illusion? *Time & Society, 14*(1), 113–131.

Bruni, A., Gherardi, S., & Poggio, B. (2004). Doing gender, doing entrepreneurship: An ethnographic account of intertwined practices. *Gender, Work and Organization, 11*, 406–429.

Clark, S. C. (2000). Work/family border theory: A new theory of work/family balance. *Human Relations, 53*(6), 747–770.

Daly, K. J. (1996). *Families & time: Keeping pace in a hurried culture*. Thousand Oaks, CA: Sage.

Dienhart, A. (2001). Make room for Daddy: The pragmatic potentials of a tag-team structure for sharing parenting. *Journal of Family Issues, 22*, 973–999.

Edley, P. P. (2001). Technology, employed mothers, and corporate colonization of the lifeworld: A gendered paradox of work and family balance. *Women and Language, 24*, 28–35.

English-Lueck, J. A. (2002). *Cultures@SiliconValley*. Stanford, CA: Stanford University Press.

Giddens, A. (1991). *Modernity and self-identity: Self and society in the late modern age*. Stanford, CA: Stanford University Press.

Golden, A. G. (2000). What we talk about when we talk about work and family: A discourse analysis of parental accounts. *Electronic Journal of Communication/La Revue Electronique de Communication, 10*(3/4).

Golden, A. G. (2001). Modernity and the communicative management of multiple-roles: The case of the worker-parent. *Journal of Family Communication, 1*, 233–264.

Golden, A. G., & Geisler, C. (2006). Flexible work, time, and technology: Ideological dilemmas of managing work-life interrelationships using personal digital assistants. *Electronic Journal of Communication/La Revue Electronique de Communication, 16*(3/4). Retrieved September 18, 2008, from http://www.cios.org/www/ejc/v16n34.htm.

Hays, S. (1996). *The cultural contradictions of motherhood*. New Haven, CT: Yale University Press.

Herman, C., & Webster, J. (2007). Editorial comment. *Information, Communication & Society, 10*, 279–286.

Hochschild, A. R. (1989). *The second shift: Working parents and the revolution at home*. New York: Viking.

Jackson, M. (2002). *What's happening to home? Balancing work, life, and refuge in the information age*. Notre Dame, IN: Sorin Books.

Jackson, M. (2008). *Distracted: The erosion of attention and the coming dark age*. Amherst, NY: Prometheus Books.

Kelan, E. K. (2007). Tools and toys: Communicating gendered positions towards technology. *Information, Communication & Society, 10*(3), 358–383.

Kirby, E. L., Golden, A. G., Medved, C. E., Jorgenson, J., & Buzzanell, P. M. (2003). An organizational communication challenge to the discourse of work and family research: From problematics to empowerment. In P. J. Kalbfleisch (Ed.), *Communication yearbook 27* (pp. 1–43). Thousand Oaks, CA: Sage.

Mumby, D., & Stohl, C. (1996). Disciplining organizational communication studies. *Management Communication Quarterly, 10,* 50–72.

Perlow, L. A. (1998). Boundary control: The social ordering of work and family time in a high-tech corporation. *Administrative Science Quarterly, 43,* 328–357.

Rakow, L. F. (2007). Follow the buzz: Questions about mobile communication industries and scholarly discourse. *Communication Monographs, 74,* 402–407.

Rakow, L. F., & Navarro, V. (1993). Remote mothering and parallel shift: Women meet the cellular telephone. *Critical Studies in Mass Communication, 10,* 144–157.

Rice, R. E. (1993). Media appropriateness: Using social presence theory to compare traditional and new organizational media. *Human Communication Research, 19,* 451–484.

Sabelis, I. (2001). Time management: Paradoxes and patterns. *Time & Society, 10*(2/3), 387–400.

Stephen, T. (1994). Communication in the shifting context of intimacy: Marriage, meaning, and modernity. *Communication Theory, 4,* 191–218.

Sullivan, C., & Lewis, S. (2001). Home-based telework, gender, and the synchronization of work and family: Perspectives of teleworkers and their co-residents. *Gender, Work and Organization, 8,* 123–145.

Tietze, S., & Musson, G. (2005). Recasting the home-work relationship: A case of mutual adjustment? *Organization Studies, 26,* 1331–1352.

Wajcman, J. (2007). From women and technology to gendered technoscience. *Information, Communication & Society, 10,* 287–298.

Weber, M. (1905/1996). *The Protestant ethic and the spirit of capitalism.* Los Angeles: Roxbury.

Conclusion

Win-Win Sustainability in the Culture of Efficiency

▶ SHARON KLEINMAN

We do not inherit the Earth from our ancestors; we borrow it from our children.
 Native American proverb

Any idiot can face a crisis; it is this day-to-day living that wears you out.
 Anton Chekhov

Take more vacations.
 Arthur R. Kleinman

The Culture of Efficiency: Technology in Everyday Life examines some of the major social and technological transformations of the digital age and situates them in historical context. With nuance and wit, the authors show how people are leveraging old and new technologies in innovative ways, multitasking in a burgeoning array of contexts, speeding up the stuff of life, and working hard to accomplish more and more, as they vie for better outcomes.

The Culture of Efficiency addresses fundamental questions about contemporary life:

- What are the benefits and costs of efficient pregnancy management for women, families, coworkers, employers, and the human gene pool?
- How can people care for, nurture, educate, and nutritiously feed themselves and their loved ones while keeping up with all of the other demands on their time?
- When is technology an undesirable substitution for human interaction or intervention?
- What are the advantages and trade-offs of multitasking behaviors?
- How can individuals achieve and maintain a sustainable balance in their work and personal lives?
- When is the implementation of new technology in vital domains such as healthcare, education, business, transportation, risk and disaster management, and journalism a win-win for the multiple stakeholders?
- What does responsible efficiency mean amid growing concerns about global warming and diminishing natural resources?

There are no clear-cut answers to these complicated questions, as the authors expertly convey. We must continue to develop a deeper understanding of the challenges of living in the twenty-first century, appreciating individual experience and taking a global perspective. *The Culture of Efficiency* contributes to this endeavor.

Since the Industrial Revolution, remarkable technological innovations in manufacturing, transportation, and communication have transformed processes in a broad range of domains and have accelerated the pace of life in an increasingly interconnected and industrialized world. Life in a "super-dynamic" (Rojek, 2007, p. 22), "hypercomplex society" (Qvortrup, 2003) requires progressively sophisticated systems and strategies for managing the complexity. While digital age technologies do not force people to multitask or to work more, harder, or faster, they do facilitate all of this.

In many fields, how, where, and when employees accomplish their work as well as workers' responsibilities have all changed. Collaborating across multiple geographic sites and time zones, engaging in just-in-time processes, and managing digital information are now fundamental and routine aspects of a lot of occupations, and employees are regularly expected to master and apply new and evolving technologies. Today's information and communication technologies enable people to operate in real time, multitask, and "displace place" much more easily and to a greater degree than ever before

(Kleinman, 2007). Mobile devices in particular—cell phones, handheld and laptop computers, and so forth—have become essential tools that facilitate the anytime, anywhere communication and collaboration needed for the smooth operations of today's networked organizations (Jones & Wallace, 2007). This gear also helps people to nimbly and conveniently handle the "quick-cut demands of daily living" (Birkerts, 2006, p. 246).

But the cornucopia of efficiency-oriented products and techniques described in this book is contributing to an epidemic of "time stress," feeling uncomfortably pressured because of a lack of enough time to do everything that needs to be done, and "time poverty," a deficiency of leisure time because of overwork, among some segments of the population (De Graaf, 2003). A nationally representative study of U.S. workers found that 44 percent of all U.S. employees are overworked often or very often (Galinsky et al., 2005). Many of us seem to be racing through life at a pace that is literally backbreaking. We find it difficult to imagine how to alter our circumstances to reduce the stressors on ourselves and on the environment and to be healthier. It is hard to find enough time to even sleep. Only 26 percent of adults in the U.S. slept eight hours a night in 2007, down from 38 percent in 2001 (Shellenbarger, 2007; see also National Sleep Foundation, 2008). Even leisure time activities like board games have been reworked to reflect the temporal sensibilities of time-pressed people living in the culture of efficiency. New versions of classics like Scrabble, Yahtzee, and Twister "take less time to play" because "families may not have hours to linger over a board game," according to the *Wall Street Journal* (Plank, 2008, p. D2). Adequate time to play, recharge, live for the pleasure of experience, analyze, and reflect has become a luxury that many people in the U.S. and elsewhere don't have. But we can't afford not to take the time to care for ourselves, our loved ones, our communities, and the environment. In order to responsibly address the global challenges facing us, in order to repair the world, we must continually consider what we are doing locally and how we are doing it. We must ask "efficient for whom? effective for whom?" and tease out the often contradictory advantages, effects, and implications of technologies and practices.

This is a cultural transformation. Our technological capabilities for altering the nitty-gritty aspects of life from conception onward will continue to increase, and our opportunities, priorities, and temporal sensibilities will be further transformed. *The Culture of Efficiency: Technology in Everyday Life* is not suggesting that people adopt, modify, resist, or abandon any one or another technology or practice; it is advocating that we make well-informed decisions, and it is proposing that sustainability is a worthwhile pursuit.

References

Birkerts, S. (2006). *The Gutenberg elegies: The fate of reading in an electronic age.* New York: Faber and Faber.

De Graaf, J. (Ed.). (2003). *Take back your time: Fighting overwork and time poverty in America.* San Francisco: Berrett-Koehler.

Galinsky, E., Bond, J. T., Kim, S. S., Backon, L., Brownfield, E., & Sakai, K. (2005). *Overwork in America: When the way we work becomes too much.* New York: Families and Work Institute. Retrieved December 18, 2008, from http://familiesandwork.org/summary/overwork2005.pdf.

Jones, C., & Wallace, P. (2007). Networks unleashed: Mobile communication and the evolution of networked organizations. In S. Kleinman (Ed.), *Displacing place: Mobile communication in the twenty-first century* (pp. 159–173). New York: Peter Lang.

Kleinman, S. (Ed.). (2007). *Displacing place: Mobile communication in the twenty-first century.* New York: Peter Lang.

National Sleep Foundation. (2008). *2008 Sleep in America poll.* Retrieved December 15, 2008, from http://www.sleepfoundation.org/atf/cf/%7Bf6bf2668-a1b4-4fe8-8d1a-a5d39340d9cb%7D/2008%20POLL%20SOF.PDF.

Plank, W. (2008, December 11). New versions for time-pressed families. *Wall Street Journal,* p. D2.

Qvortrup, L. (2003). *The hypercomplex society.* New York: Peter Lang.

Rojek, C. (2007). *Cultural studies.* Cambridge, England: Polity.

Shellenbarger, S. (2007, May 31). Americans get too little sleep and everyone has an excuse. *Wall Street Journal Online.* Retrieved December 18, 2008, from http://online.wsj.com/article/SB118057302987819414.html.

Afterword

Reflections

▶ JARICE HANSON

To everything there is a season….

Ecclesiastes 3:1

To everything there is a season….

The Byrds

Time is a complicated cultural construct. We talk of "saving" time, "making" time, and sometimes "wasting" time, but one thing many people agree on in the twenty-first century—we often don't seem to have enough time. If there is one thing technology presents to us that seems tautological, it probably involves time. In our desire to be more efficient, we use technology, but at the same time technology changes our relationship to time. From Lewis Mumford's 1934 treatise on power and time in *Technics and Civilization,* in which he identified the regimentation of time in the Industrial Revolution, to contemporary ideas about superstrings that portray an extra-dimensionality of time (Kaku & Thompson, 1995), the *meaning* of time, and, what time

means to people, has remained a problem that underscores the relationship of all studies of culture, values, and technology.

In his brilliant book *Time Wars: The Primary Conflict in Human History*, Jeremy Rifkin (1987) wrote:

> Time is fundamental. It is the principle that underlies and permeates our physical and biological systems. It is the language of the mind, informing our behavior and defining our personality. Time is the instrument that makes possible group interaction and the creation of culture. (p. 9)

From these words, Rifkin seems to echo the position expressed by the authors in this volume that time and efficiency are part and parcel of technology; and that a sense of time is integral to reflecting on the relationship of technology and culture.

Several of the authors of essays in this book cite French sociologist Jacques Ellul (1964), whose work so clearly articulates the concept of *technique* as a concept that bridges machine technology and human belief systems and actions. In an homage to Ellul, I would like to investigate the technique of contemporary culture addressed by the authors of this volume, and in doing so, focus most specifically on *time* (as in the technologically induced machines that promise efficiency), and on the human desire (or need) to control time through reflecting on the relationships between technologies, human beings, and culture. As we seek to understand what is meant by technique in these chapters, we can give kudos to Sharon Kleinman for her selection of essays that so beautifully mirror the stages of life, illuminate the value of human self-reflection, and offer the concept of *sustainability* as a technique that can help create a healthy balance between technology and human beings.

The organizational scheme of *The Culture of Efficiency: Technology in Everyday Life* demonstrates how technology touches every aspect of our lives, from being born, eating, and connecting; to working, playing, and resting; through the way we speed up, multitask, and displace; to our needs to create balance, breathe, and renew. When Kleinman uses the term "sustainability" as a metaphor to "promote environmental, societal, and human health long-term," she is leading us toward the realization that we have the hope of controlling technology, rather than technology controlling us (p. xiii). Perhaps because of the positive nature of the book's direction, the essays within are, for the most part, filled with hope and optimism. Each author explains how, as we uncover the impact of technologies and their social uses, we become smarter consumers, thinkers, and theorists. In her astute conclusion to *The Culture of Efficiency*, Kleinman identifies how the cultural transformation of contemporary life challenges us to be mindful of the consequences of reckless obeisance to technology and activities influenced by the presence

of technology. She wisely urges us to make informed decisions about how we use technology, and how we think of the contradictions of living in a more technologically driven society, but she also understands that there is a moral imperative to put human beings ahead of technological innovation and cultural pressure to continually speed up the pace and think (and act) as technological artifacts ourselves.

How do we make judgments about human behavior in relation to the constant drive for more technology, in a culture in which we are often prompted to continually move forward at an ever-faster pace, and never look back? Or more specifically, what must we learn to create a sustainable balance between people, technology, and the tensions between the two? My answer is that our ability to think of time and to reflect on the meaning of how we spend our time can go a long way toward nurturing ourselves and maintaining the balance that can so easily get out of whack. The essays lead me to ask two questions that cut across many of the authors' positions: (1) how do people physically and mentally adapt to technology, and (2) how can the act of reading and reflection be seen as a way for us to control time, and technology?

The Self and Adaptation to Technology Time

In the opening chapter of *Time Wars*, Rifkin (1987) writes, "It is ironic that in a culture so committed to saving time we feel increasingly deprived of the very thing we value" (p. 19). Surely we, with our superior ability to adapt to cultural surroundings, should understand how technology influences our relationship to our environment—right? Unfortunately, the human desire to overlook the root causes of everyday problems allows us to justify why we don't spend much time reflecting on the causes or solutions to problems, even though scholars and pundits have thoroughly chronicled and critiqued social life from the postindustrial to postmodern age. In 1956, C. Wright Mills identified what he called the cultural "big split" between work and leisure in the early part of the twentieth century. Toward the end of the century, Juliet B. Shor (1991) documented how American workers had willingly given up about a month of their leisure time each year in the period between 1960 and 1980, resulting in "time poverty," and "increased stress" as they sought to use more available technologies, but also because of an increased desire to increase consumption—driving them to willingly work longer hours (p. 22). Today, in a culture that further blurs the distinctions between producers and consumers, and technologies of production and consumption, we've co-opted the meaning of terms such as "work" and "leisure," and glorified concepts that further blur traditional distinctions: "life-long learning," "home office," and "edutainment," for example (Liu, 2004, p. 77).

Psychologist Richard Stivers (2004) writes of the growing body of research and theory on environmental stress from the perspective of brain activity, information processing (in the body), and the ways in which technology stimulates the urgency of activity, with the potential for leading a person toward possible loneliness and depression. And yet, a good many cell phone, computer, and Internet technologies and services are marketed as the panacea for loneliness and depression: social networking, gaming, online dating, and chat rooms, to name but a few. Internet addiction, like any compulsive activity, has grown to become a serious problem on college campuses, and in homes—most often causing problems for compulsive online gamblers and shoppers, further demonstrating the production/consumption connection found in the most pervasive technologies of the twenty-first century.

If Marshall McLuhan (1964) could drop in and see the state of multisensory technology today, he could write a long list of "thought probes" on sensory stimulation in an age of portable technology that is so small it can covertly be used in inappropriate places. Students in classrooms may have multiple screens open on their laptops, watching a television program while sending an e-mail, checking Wikipedia, and perhaps, taking notes. They may even be able to send a text by cell phone without the teacher ever really noticing—but can the body adapt to so much stimulation? Most of the research so far clearly indicates that the human body cannot react efficiently to multisensory input for very long, or the organism begins to shut down. The multitasker may think he or she is being uber-efficient, but in reality, nothing is perceived in its entirety, and nothing is cognitively processed beyond short-term memory.

Could individuals eventually develop (or program) their brains to process more input simultaneously? Perhaps—but human beings do not evolve as fast as technology does. Both body and mind may adapt in very small ways to increased environmental stress, but today, most individuals find themselves confronted by technology that doubles in speed approximately every 18 months (a principle known as Moore's Law). Human evolution cannot keep pace with cultural evolution, and the body/mind connection suffers unless the individual can exercise the will to resist (or as Kleinman has titled Part Four: [to] Balance Breathe Renew).

Ashley Montagu (1973), the noted cultural anthropologist and humanist, wrote of what he called "the Darwinian fallacy" to identify an existential loophole in Darwin's theory of evolution. The fallacy, according to Montagu, was that even though the strongest, the most powerful, and the most "evolved" individuals had the greatest potential for survival, anomalous traits still occurred. Sometimes, the perceived "weaker" members of species passed on genes, characteristics, or behaviors that could shift entire societies; those "weaknesses" sometimes became strengths over time, because their rarity

made them desirable, and others copied them. Today, some of the healthiest individuals are those who can figure out how to avoid the contemporary stresses that push them to their physical limits, and who, therefore, learn to "control" the stresses and pressures that come along with technological innovation, use, and acceptance.

An Act of Resistance: Time, Reflection, and Reading

As you might realize, if you've just finished reading this book, or a portion of this book, reading is a solitary act in which time seems to stand still. As McLuhan (1964) reminds us, print is a "hot" medium that extends one sense over others. We know that exercising one sense over others is a relaxing experience. Massage, meditation, and acts of emphasizing singular senses reduce stress and make a break with the outside environment. Ellul might identify the deliberate act of turning from technology time to personal control of time necessary for reflection, as the human mastery of technique.

In some circles, the relationship of technologies and the body has received increased attention in recent years; in part because technologies have led us toward better understanding the mysteries of body and mind, but also, because scholars still seek to find meaning beyond the physical manifestations of cultural production. Cognitive neuroscientist and child development expert Maryanne Wolf (2007) recently wrote a book titled, *Proust and the Squid: The Story and Science of the Reading Brain,* in which she identifies the way in which the act of reading can be empirically proven to reduce stress, and change the way we think of ourselves in society. She cites Marcel Proust who wrote, "I believe that reading, in its original essence, is that fruitful miracle of a communication in the midst of solitude" (p. 3). In that sense of communication, we connect with other words, thoughts, or sometimes, by creating the meaning within our own lives.

Reading is, most often, a solitary act, performed at one's own speed, and influenced by one's personal desire to engage with the material. Personal investment and attention are unique to the reader. Even if someone is reading on a commuter train where people are talking, laughing, or occupied with their cell phone conversations, the reader has the capacity to turn a busy train into a solitary place, thus controlling environment, time, and interpreting the meaning of the time spent engaged with the material.

Similarly, reflection—whether self-reflection or reflecting on what has been read—retains control of time, and it, too, can be an act of resistance in a technologically saturated environment. Having a sense of control is central to our feelings of wellness and health. This is why solitary activities that

fulfill our need to connect with something, either within ourselves or with the larger environment or culture, are so pleasurable, and those activities that make us feel good, or give us some feeling of satisfaction, are almost never considered a waste of time.

If you have enjoyed reading this book, or portions of the book, you may well be able to reflect on the value of time spent reading, and how the time we take in solitary endeavors, like reading, allows us the privilege to *control* time. The authors have presented provocative contexts, and the editor has organized and shaped the sequence of the individual chapters to unfold before us, allowing us to lose ourselves in the moments of the words, only to feel refreshed and renewed. I think you will agree with me, reading this book has been time well spent.

References

Ellul, J. (1964). *The technological society* (J. Wilkinson, Trans.). New York: Knopf. (Original work published in 1964)

Kaku, M., & Thompson, J. (1995). *Beyond Einstein: The cosmic quest for the theory of the universe.* New York: Anchor.

Liu, A. (2004). *The laws of cool: Knowledge work and the culture of information.* Chicago: University of Chicago Press.

McLuhan, M. (1964). *Understanding media: The extensions of man.* New York: McGraw-Hill.

Mills, C. W. (1956). *White collar: The American middle classes.* New York: Oxford University Press.

Montagu, A. (1973). *Darwin: Competition and cooperation.* Westport, CT: Greenwood.

Mumford, L. (1934). *Technics and civilization.* New York: Harcourt Brace.

Rifkin, J. (1987). *Time wars: The primary conflict in human history.* New York: Touchstone.

Schor, J. B. (1991). *The overworked American: The unexpected decline of leisure.* New York: Basic Books.

Stivers, R. (2004). *Shades of loneliness.* Lanham, MD: Rowman and Littlefield.

Wolf, M. (2007). *Proust and the squid: The story and science of the reading brain.* New York: HarperPerennial.

About the Contributors

Corey Anton (Ph.D., Purdue University) is associate professor of communication studies at Grand Valley State University. He has presented over 40 conference papers and addresses at national conferences and has published over 24 scholarly articles in journals such as *Communication Theory, Philosophy and Rhetoric, Human Studies, Explorations in Media Ecology, Semiotica, ETC, The Atlantic Journal of Communication, Communication Studies,* and *The American Journal of Semiotics*. His book *Selfhood and Authenticity* (State University of New York Press, 2001) was spotlighted at the National Communication Association Convention in 2002 and received the Erving Goffman Award for Outstanding Scholarship in the Ecology of Social Interaction from the Media Ecology Association in 2004.

Dominika Bednarska, a doctoral student in English and disability studies at the University of California, Berkeley, is writing a dissertation on representations of disability, gender, and sexuality in twentieth-century fic-

tion. Her writing has appeared in *What I Want from You: An Anthology of East Bay Lesbian Poets, Nobody Passes: Rejecting the Rules of Gender and Conformity,* and the *Bellevue Literary Review.*

Brenda L. Berkelaar is a doctoral student and Andrews Fellow in the Department of Communication at Purdue University. She holds an M.A. from Seton Hall University. Her research focuses on the intersections of technology, organizations, and careers. She currently studies career choice and constructions of science, technology, and engineering careers in China, Belgium, and the United States. Her work has appeared in *Management Communication Quarterly,* and she has publications forthcoming in *Communication Yearbook* and in another edited volume.

Mickey Brazeal spent about 30 years in the advertising business, the last 10 as executive creative director of Grey Advertising/Chicago. His most recent work includes national television campaigns for car waxes, corn herbicides, shampoos, spice blends, stock options, fuel additives, fruit juices, food stores, drugstores, deodorants, real estate companies, and dot-coms. During the dot-com madness, he helped launch several Internet businesses, some of which still exist. His creative awards include Addies, Tellies, Eagles, Towers, Windys, Louies, Mobius awards, NAMA Gold, an Effie, a Clio, and the Gallagher Report's Broken Pencil Award for "the most obnoxious TV commercial we've seen this month." While working as a creative director, he taught at Northwestern University. He has served as assistant director of the marketing communications program at the Illinois Institute of Technology Stuart School of Business and is currently assistant professor of marketing communication at Roosevelt University. His book *RFID and the Customer Experience* was published by Paramount in 2008.

Michael Bugeja is professor and director of the Greenlee School of Journalism and Communication at Iowa State University of Science and Technology. He is the author of 21 books, including *Living Ethics Across Media Platforms* (Oxford University Press, 2008) and the award-winning *Interpersonal Divide: The Search for Community in a Technological Age* (Oxford University Press, 2005). His commentaries on media ethics and technology have been cited internationally in outlets such as *The New York Times, The Washington Post, The Christian Science Monitor, USA Today, The Guardian* (UK), *Toronto Globe & Mail* (Canada), *Die Welt* (Germany), *China Daily, The International Herald Tribune* (France), *The Ecologist* (UK), *The Futurist,* and the Associated Press, as well as in online news editions of CBS, NBC, ABC, CNN, MSNBC, and FOX News. He writes regularly as a new media critic for *The Chronicle of*

Higher Education. His scholarship appears in numerous publications, including *Journalism Quarterly, Journalism Educator, Journalism and Mass Communication Educator, Journal of Mass Media Ethics,* and *New Media and Society*. He is a National Endowment for the Arts Fellow with creative writing in *Harper's, Poetry, Kenyon Review, New England Review,* and *Georgia Review,* among others. Prior to coming to Iowa State, he was special assistant to the president at Ohio University and associate director of and a professor in the E. W. Scripps School of Journalism. He has worked as reporter, correspondent, and state editor for United Press International. He holds an M.S. in mass communications from South Dakota State University and a Ph.D. in English from Oklahoma State University.

Carrie A. Bulger is associate professor of psychology at Quinnipiac University. She has a Ph.D. in industrial-organizational psychology from the University of Connecticut. Her research focuses on issues concerning employee stress, health, well-being, and attitudes. She has studied organizational stressors, such as work-personal life conflict, sexual harassment, and attitudes toward participation in unions. Her recent research has focused on the ways that information and communication technologies are impacting the boundaries around and between work and home and outcomes for employees. She has presented her research at national and international conferences and has been published in journals such as the *Journal of Applied Psychology, Journal of Occupational Health Psychology,* and *Sex Roles*.

Gene Burd teaches qualitative research methods and news reporting and writing at the University of Texas at Austin and previously worked on several newspapers, including the *Kansas City Star, Houston Chronicle, Albuquerque Journal,* and suburban weeklies in Los Angeles and Chicago. He was previously on the faculty at Minnesota and Marquette, and he attended UCLA, Iowa, and Northwestern (Ph.D., 1964). His specialty is urban journalism, and he was the founding benefactor of The Urban Communication Foundation.

Patrice M. Buzzanell (Ph.D., Purdue University) is professor and W. Charles and Ann Redding Faculty Fellow in the Department of Communication at Purdue University. Her primary interest is in organizational communication, specializing in career, leadership, gender, and work-life issues. She has edited *Rethinking Organizational and Managerial Communication from Feminist Perspectives* (2000), *Gender in Applied Communication Contexts* (with H. Sterk and L. Turner, 2004), and *Distinctive Qualities in Communication Research* (with D. Carbaugh, 2009). She has pub-

lished over 75 book chapters and articles in journals such as *Communication Monographs, Human Communication Research, Communication Theory,* and *Human Relations.*

André H. Caron (Ed.D., Harvard University, 1976) is full professor in the Communication Department of the University of Montreal and Bell Canada Chair in Interdisciplinary Research on Emerging Technologies. He is founding director of the Center for Youth and Media Studies (1987) and of CITÉ (2000), an interdisciplinary research center on emerging technologies. He has been a visiting scholar at Stanford University, Harvard University, the University of Leicester, and the University of Bologna. A specialist in mass media and new technologies, his research interests include broadcasting policy, political and cultural appropriations of media, and the influences of new technologies on society. He has carried out numerous quantitative investigations on the diffusion and adoption of interactive technologies in Canada, the United States, and the United Kingdom. Some of his more recent work about mobile culture has been published in *Convergence: The Journal of Research into New Media Technologies.* He is coauthor of two recent books on this topic, *Culture Mobile: Les Nouvelles Pratiques de Communication* (Les Presses de l'Université de Montréal, 2005) and *Moving Cultures: Mobile Communication in Everyday Life* (McGill-Queen's University Press, 2007).

Letizia Caronia (Ph.D., University of Bologna) is professor in the Department of Education at the University of Bologna in Italy and visiting researcher at the Center for Youth and Media Studies and at CITÉ at the University of Montreal in Canada. Her research focuses on the use of the media as a situated activity and cultural practice. For the past 15 years she has conducted qualitative and ethnographic research on the role of everyday language, interactions, and culture in the process of the domestication of information and communication technologies. She has published numerous books, articles, and essays on the relationship between everyday language, media uses, and educational practices. Her recent work includes "Growing Up Wireless: Being a Parent and Being a Child in the Age of Mobile Communication" in *Digital Literacy: Tools and Methodologies for Information Society* (IGI Publishing, 2008); "Television Culture and Media Socialization across Countries: Theoretical Issues and Methodological Approaches," with A. H. Caron, in the *International Handbook of Children, Media and Culture* (Sage, 2008); and "Mobile Culture: An Ethnography of Cellular Phone Use in Teenagers' Everyday Life" (*Convergence: The Journal of Research into New Media Technologies,*

2005). She coauthored with A. H. Caron *Moving Cultures: Mobile Communication in Everyday Life* (McGill-Queen's University Press, 2007).

Suzy D'Enbeau is a doctoral candidate in the Department of Communication at Purdue University. Her primary interest is in organizational communication, specializing in feminist theory, consumerism, and work-life issues. Her dissertation focuses on feminism, consumerism, and activism in an industrial/postindustrial economy. She holds an M.A. from Duquesne University. Her work has appeared in *Feminist Media Studies, Qualitative Inquiry,* and *Women's Studies in Communication.*

David F. Donnelly is dean of the School of Communications at Quinnipiac University. He has contributed to eight books on the media and has published in numerous journals, including *Communication Research, Telematics and Informatics, New Telecomm Quarterly,* and *The Historical Journal of Film, Radio and Television*. His research interests include the impact of technological innovation and media forecasting. He has also served as a media consultant for many national clients and as a freelance video producer on numerous productions, including *Visual Velocity,* which aired on PBS stations. He earned a Ph.D. and an M.A. from the University of Massachusetts and a B.A. from the University of Maryland.

Howard Giles (Ph.D., D.Sc., University of Bristol) is assistant dean of undergraduate education and professor (and past-chair) of communication at the University of California at Santa Barbara, with affiliated positions in linguistics and psychology. His work is in the general area of intergroup communication with a particular cross-cultural interest in intergenerational encounters as well as police-civilian interactions. He is founding editor of the *Journal of Language and Social Psychology* and the *Journal of Asian Pacific Communication* and former editor of *Human Communication Research*. He is also a former president of the International Communication Association as well as the International Association of Language and Social Psychology.

Annis G. Golden is an assistant professor in the Communication Department at the University at Albany, State University of New York. Her research, which has appeared in *Communication Yearbook, Human Relations,* and *Management Communication Quarterly,* focuses on women's and men's communicative management of their relationships to the organizations that employ them, including the ways in which these relationships are mediated by new information and communication technologies. She also studies women's health issues, with a particular interest in how women

negotiate their relationships to healthcare organizations and the role of race and ethnicity, class, and community in this process. She holds an M.A. in English from Syracuse University and a Ph.D. in communication from Rensselaer Polytechnic Institute.

Jarice Hanson is professor of communication in the Department of Communication at the University of Massachusetts, and currently holds the Verizon Chair in Telecommunications in the School of Communications and Theater at Temple University in Philadelphia. After a career in the television industry, she pursued graduate work, thinking she would write, direct, and produce television programs. It was her good fortune to find that the answers to the important questions about media and technology were better found by academic research, and since making the critical turn, she has produced 19 books and dozens of scholarly articles. Her current research deals with access to telecommunications technologies by marginalized individuals, such as the socio-economically challenged, the disabled, and women, and changes to media and information technology industries related to changing social, political, and economic policies.

Mark E. Hoffman is professor of computer science in the Department of Computer Science and Interactive Digital Design at Quinnipiac University. He earned a Ph.D. in computer science from Polytechnic University of Brooklyn, New York. Prior to joining the Quinnipiac faculty, he taught high school mathematics for 14 years followed by 16 years managing information systems for a small manufacturing company. He has presented at conferences and published in journals in technical and educational computer science, industrial and organizational psychology, and writing across the curriculum. Among other projects, he continues to study the impacts of computing technology in the workplace, at home, and on the boundaries surrounding each.

Yvonne Houy received her B.A. from the University of California, Berkeley, where she was first introduced to sustainability issues in economics and architecture courses. Her M.A. and Ph.D. are from Cornell University. Her most recent published works are about the impact of mobile technologies on urban community design and individual neuropsychology.

J. David Johnson (Ph.D., Michigan State University, 1978) has been dean of the College of Communications and Information Studies at the University of Kentucky since 1998. He has held academic positions at the University of Wisconsin-Milwaukee, Arizona State University, the State University of New York at Buffalo, and Michigan State University

and was a media research analyst for the U.S. Information Agency. He has been recognized as among the 100 most prolific authors of refereed journal articles in the communication discipline. He has been conducting network analysis, innovation, and information research for over three decades.

Nathan Jurgenson, a doctoral student in sociology at the University of Maryland, is working with George Ritzer on the theoretical implications of the bottom-up turn taken by the Internet—what has come to be known as Web 2.0. His future work will involve rethinking how sociological theory (especially postmodern thought) orients our understanding of Web 2.0, and, in turn, how Web 2.0 provides fertile ground to rethink sociological theory in areas such as knowledge production, the presentation of self, consumption, authority, exploitation, and many others. He received his M.A. in sociology from Northern Illinois University in 2007.

Julian Kilker (Ph.D., Cornell University) is associate professor of emerging technologies in the Greenspun School of Journalism and Media Studies at the University of Nevada at Las Vegas. He researches socio-technical interaction, with current projects examining user control and unintended consequences in emerging media and comparative life cycles in traditional and emerging media. His work has been published in *Management Communication Quarterly, Convergence, IEEE Technology and Society, Social Identities,* and *Visual Communication Quarterly.*

Sharon Kleinman is professor of communications at Quinnipiac University. Her research focuses on the social implications of communication technologies and on issues concerning online and place-based communities. She holds a B.A. in English and American literature from Brandeis University and an M.S. and a Ph.D. in communication from Cornell University. She is the editor of the critically acclaimed book *Displacing Place: Mobile Communication in the Twenty-first Century* (Peter Lang, 2007). Her essays have been published in scholarly journals, such as *Management Communication Quarterly, The Iowa Journal of Communication,* and *The Journal of Women and Minorities in Science and Engineering,* and in books, such as *Online Social Research: Methods, Issues, & Ethics* (Peter Lang, 2004) and *The Encyclopedia of International Media and Communications* (Academic Press, 2003). She has received numerous academic awards, including the Outstanding Faculty Scholar Award from Quinnipiac University and the Anson Rowe Prize from Cornell University. An avid mountain biker, golfer, photographer, and yoga practitioner, she lives in New Haven, Connecticut.

Penny A. Leisring is associate professor of psychology at Quinnipiac University. She holds a B.A. in psychology and child development from Connecticut College and a Ph.D. in clinical psychology from the State University of New York at Stony Brook. Her clinical interests focus on the prevention and reduction of aggressive behavior in adults and children. She conducts research examining male- and female-perpetrated intimate partner violence. Her work has been published in numerous journals, including the *Journal of Aggression, Maltreatment, and Trauma; Violence and Victims;* and the *Journal of Comparative Family Studies.* She serves on the editorial board for the *Journal of Aggression, Maltreatment, and Trauma.*

Mikaela L. Marlow (Ph.D., University of California at Santa Barbara) is assistant professor in the Department of Psychology and Communication Studies at the University of Idaho. She explores theoretical and applied intergroup communication among diverse language, ethnic, and cultural groups. Her research has been published in *Communication Yearbook, Human Communication Research,* and the *Journal of Multicultural Discourses.* She has served as Student Board Representative for the International Communication Association.

Michael L. Maynard (Ph.D., Rutgers University) is associate professor and inaugural chair of the Department of Advertising in the School of Communications and Theater at Temple University in Philadelphia. His research areas include mass media analysis, the relationship between mass communication and culture, as well as textual analysis of Japanese television and print advertising.

Daniel G. McDonald (Ph.D., University of Wisconsin, 1983) is professor of communication at Ohio State University. His research focuses on media audiences, especially in the area of intra-audience effects. Most recently, he has studied the social nature of the media experience, focusing on a blend of interpersonal and mass communication processes.

Jingbo Meng, who is from China, is a doctoral student in communication at the University of Southern California. She holds a B.A. in journalism and economics from Peking University and an M.A. in communication from Ohio State University. Her research focuses on mass media effects and audiences.

Peg Oliveira is an early care and education research and policy consultant. She has worked as a senior policy fellow for the nonprofit child advocacy organization Connecticut Voices for Children. In addition, she is a yoga

teacher in New Haven, Connecticut. She has attained the highest level of certification with the Yoga Alliance (500-Hour Experienced Registered Yoga Teacher) and has also been certified by the Baptiste Power Yoga Institute. She holds a B.A. in psychology and in English composition from Fairfield University and an M.A. and a Ph.D. in social and developmental psychology from Brandeis University.

Holly Parker lives in New Haven, Connecticut, and doesn't own a car. Instead she has 14 cars (thanks to Zipcar), 3 bikes, and trains every 20 minutes to New York City. She believes that everyone would be much happier if they would park their car at home and walk, bicycle, and use public transportation whenever possible. For the past 12 years, she has been an enthusiastic advocate and manager of sustainable transportation programs. She is director of sustainable transportation systems at Yale University where she develops and implements programs that encourage the university community to use more environmentally friendly modes of transportation. For the six years prior to her appointment at Yale, she managed Harvard University's CommuterChoice Program. Before that, she worked at the Commuter Solutions Program at Lane Transit District in Eugene, Oregon, and as a senior transportation coordinator for a consulting firm in Waltham, Massachusetts.

George Ritzer is distinguished university professor at the University of Maryland. Among his awards: Honorary Doctorate from La Trobe University in Melbourne, Australia; Honorary Patron, University Philosophical Society from Trinity College, Dublin; and the American Sociological Association's Distinguished Contribution to Teaching Award. He has chaired the American Sociological Association's Section on Theoretical Sociology, as well as the Section on Organizations and Occupations. Among his books in metatheory are *Sociology: A Multiple Paradigm Science* (1975/1980) and *Metatheorizing in Sociology* (1991). In the application of social theory to the social world, his books include *The McDonaldization of Society* (5th ed., 2008), *Enchanting a Disenchanted World* (2nd ed., 2005), and *The Globalization of Nothing* (2nd ed., 2007). He is currently working on *The Outsourcing of Everything* (with Craig Lair, Oxford University Press, forthcoming) and *Globalization: A Basic Text* (Blackwell, forthcoming). He was founding editor of the *Journal of Consumer Culture*. He edited *The Blackwell Companion to Major Social Theorists* (2000) and *The Blackwell Companion to Globalization* (2008) and coedited the *Handbook of Social Theory* (2001). He also edited the 11-volume *Encyclopedia of Sociology* (2007) and the 2-volume *Encyclopedia of Social Theory* (2005). His books have been translated into over 20

languages, with more than a dozen translations of *The McDonaldization of Society* alone.

Index

9/11
 lack of captioning during coverage of, 255, 257
 See also disaster; disaster communication; disaster preparedness/planning
24/7 digital environment, commercialization of identity in, 85

Abrams, Karen, 238
abstinence from technology, 92, 94–95, 324
 See also technology Sabbaths
academia. *See* education; universities
accessibility
 of Internet, 160
 of learning management systems, 217
action, 63

adaptability of electronic medical records, 130
advertising as reflection of norms, 48
Agger, Ben, 164
Alexander, Jennifer Karns, 64
Alfred Politz Research, Inc., 147
Allport, Gordon, 145–46
Amar, Angela, 232, 234
American Council of the Blind (ACB), 162
American Red Cross, 256
American Social Science Foundation, 271
Americans with Disabilities (ADA) evacuation plan, 246
Americans with Disabilities (ADA) Restoration Act, 160
Amish, Old Order, 91
Amusing Ourselves to Death (Postman), 86
AOL, 58

apartments, 23
architecture
 apartments, 23
 and education, 214, 224
 and environment, 33–34
 and food production, 34
 influence on outcomes, 215–16
 kitchen design, 23–25
 and social reform/revolution, 23, 24
Aristotle, 74
Arnold, Bruce, 239
Ashforth, Blake, 326, 327, 328
asset tracking. See Radio Frequency Identification (RFID)
assistive technology. See technology, assistive
Atanasoff, John Vincent, 185
attention deficit trait (ADT), 292
audience response systems, 177–78
Augustine, 74
automatic identification. See Radio Frequency Identification (RFID)
automation, 78, 97
automobile manufacturers, 52–53, 176
 See also driving
automobiles
 accidents in, 290
 American, 174, 176
 dependency on (See transportation, sustainable)
 fuel-efficient, 174, 175
 See also driving
Awakening the Buddha Within (Das), 294

Banach, Mary, 240
Barber, Randi, 230
bar codes, 107–8, 110
Bardini, Thierry, 226
Barnes-Farrell, Janet, 327, 328, 329
Baron, Naomi, 151, 287
Basile, Kathleen, 238
Bauman, Zygmunt, 52, 58
Beck, Melinda, 258
Becker, Jennifer, 235
Berger, Clarence, 143, 145
Berube, Michael, 246
The Bhagavad Gita, 296
bicycling, 302, 305–7
 See also transportation, sustainable
biological clocks, 5–6

birth
 premature, 7, 8
 scheduling of, 10–11
Bittman, Mark, 26, 324
Blackboard. See learning management systems
blind. See disabled people
bloggers, 318
blogs, 9
Bocij, Paul, 231, 232, 236, 237, 239, 240
Boer, Harry, 127
Bogart, Leo, 147
Bohlen, Joe, 130
border crossers, 326
boundaries
 boundary keepers, 326
 construction of, 326, 331, 336
 crossing, 332
 effects of on productivity, 323
 flexibility of, 327, 328, 332
 flexibility willingness, 333
 and health symptoms, 333
 as individually constructed, 331
 and Internet, 329–31
 permeability of, 327, 328, 329
 segmentation preferences, 333
 setting expectations for, 334–35
 strength of, 325–31
 types of, 326–27
 and work/personal life enhancement, 332
 and work/personal life interference, 332
The Boundaries of Blackness (Cohen), 165
boundary crossers, 326
boundary keepers, 326
boundary theory, 326
Boyer, Amy, 238
Brabazon, Tara, 181
Brailer, David, 133
brain
 enriched by motherhood, 295
 and multitasking, 291
Brand, Stewart, 266
branding, personal, 13, 14
Braungart, Michael, 33
Brenner, Donald, 125
Brick, Kelby, 254
Brinkmann, Jessica, 233
Brodie, Mollyann, 150

Index

Bross, Bruce, 233
Bruni, Attila, 342
Bufis, Vanessa, 233, 234
buses, 303–5
Bush, George W., 176
The Business of Being Born (documentary), 11

Cable & Telecommunications Association for Marketing (CTAM), 153
calculability, 52–53
Campbell, Angus, 146
Cantril, Hadley, 145–46
capitalism
 and creative destruction, 57
 and efficiency, 352
 and Internet, 56, 57, 58
 and preoccupation with efficiency, 352
carbon footprint. *See* environment
cars. *See* automobile manufacturers; automobiles; driving
Carter, Jimmy, 174
cell phones
 and car accidents, 290
 kosher, 96
 and time, 81
 use of in Japan, 42
 use of in religious practices, 95–96
Centers for Disease Control and Prevention (CDC), 246, 301
Chapman, A. L., 146
Child, Julia, 26
children
 effects of ICT-mediated work-life interrelationships on, 352
 media multitasking by, 287
 raised by same-sex couples, 16
 See also pregnancy
Christianity
 Sabbath in, 93
 use of technology for religious purposes in, 96
Cioran, E. M., 86
Clark, Sue Campbell, 326, 327, 328, 329, 346
class and discourse of personal branding, 14
clickers, 177–78
clocks
 digital, 82
 early use of, 75–76
 indoctrination into tyranny of, 73
 mechanical, 75, 77
 post-telegraphy compared to mechanical, 77
 and regulation of behavior, 75–76
 synchronization of, 72
 See also time; watches
clocks, biological, 5–6
closed captioning services, 255–56
Cohen, Cathy, 165
Cohen, Daniel, 90
Cole, Jennifer, 236, 238
Collins, Susan, 258
commitment, need for, 187
communication
 about disasters (*See* disaster communication)
 effects of disasters on, 245
 exclusion of minority/marginalized groups, 246
 and group affiliation, 251
 networks in, 251–52
 separation from transportation, 72
communication, intergroup, 251
Communication Process Model of Disasters, 248–49
compatibility
 of electronic medical records, 129
 of innovations, 127
The Complete Book of Edible Landscaping (Creasy), 31
complexity
 of electronic medical records, 130
 of innovations, 127
Confessions (Augustine), 74
connectivity, always-on, 90
Contractor, Noshir, 252
control
 desire for, 13
 in efficiency, 53
 of Internet, 56, 58
 and pregnancy, 13
 and religious practice, 98
cooking. *See* food preparation; kitchen
Le Corbusier, 24
Cortina, Lilia, 238
Courtemanche, Charles, 301
CrazyBusy (Hallowell), 291–92

Creasy, Rosalind, 31–32
credit cards
 and datamining, 178
 identification cards as, 181, 183
 overdependence on, 178
 solicitations from, 182
 students' use of, 178, 181, 182, 183
Cronkite, Walter, 314
C-section, 6, 10–11
cultural differences
 in disaster preparedness/planning, 250
 in marketing, 41
cyberstalking
 effects of on victims, 238–39
 laws regarding, 230, 231
 methods used in, 231, 232–33
 obligation to report, 241
 perpetrators, characteristics of, 237
 perpetrators, treatment for, 237
 preventative measures, 239
 steps to take against, 240–41
 See also stalking

Daly, Kerry, 342
Darwinian fallacy, 362
Das, Lama Surya, 294
datamining, 178
Davis, Keith, 237
deaf/hearing impaired. *See* disabled people
Dearing, James, 126, 128
debt, student, 177, 178–79, 180, 187
 See also loans, student
De Grazia, Sebastian, 72, 73, 77, 78, 85, 86
DeJoseph, Jeanne, 9
Dellapenta, Gary, 230
democracy and effectiveness, 64
Designing and Maintaining Your Edible Landscape Naturally (Kourik), 31
Dewey, John, 277
dharana, 293
dhyana, 293
digital technologies
 and asynchronous interaction, 83
 growth of, 71–72
dinnertime, 79, 81
disabled people
 and accessibility of learning management systems, 217
 benefits of technology for, 158–60
 and closed captioning services, 255–56
 communicative exclusion of during emergencies, 254, 257–58
 considered unproductive, 164
 deficiencies in emergency infrastructure for, 246
 employment of, 160, 165
 inclusion of in disaster preparedness/planning, 250, 256
 lifespan of, 165
 need to consider impact of actions, 165–66
 percentage of in U.S, 249–50
 relationship to time, 163, 164–65
 societal attitudes toward, 166
 See also minority/marginalized groups; technology, assistive
disaster
 as communicative process, 247–49
 discrimination in assistance during, 246
 effects on communication, 245
 effects on functional ability, 245
 See also 9/11; Hurricane Katrina
disaster communication
 channels used for, 247
 Communication Process Model of Disasters, 248–49
 perceptions of terminology in, 247–48
 types of, 247
disaster preparedness/planning
 allocation of resources, 254
 communicative exclusion of disabled people in, 257–58
 cultural differences in, 250
 exclusion of minority/marginalized groups in, 260–61
 importance of networks in, 259–60
 inclusion of disabled people in, 256
 ingroup favoritism in, 254
 intergroup issues in, 254–55
 language in, 250, 256–58
 need for consistency in, 256
 network issues in, 255–57
 technology in, 258

Index

Discipline and Punish (Foucault), 75–76
Discourses, explanation of, 89
discrimination in disaster assistance, 246
disengagement, student, 180–81
disengagement, technological, 188
dochakuka, 41
domains. *See* boundaries
dot-com bubble, 56, 59
Draper, Jan, 9
driving
 and accidents, 290
 cost of, 302
 financial disincentives for, 301, 308–9
 and obesity, 301
 sustainable alternatives to, 302 (*See also* transportation, sustainable)
dual presence, 342, 347, 348, 350, 351
Dudek, Mark, 214
During, Willem, 127
Durkheim, Emile, 98

economic systems, influence of cultural rhythms on, 99–100
economy, information, 100–101
economy, U.S., in 1979, 174
Edley, Paige, 341–42
education
 adoption of mobile learning devices, 192 (*See also* mobile learning)
 and architecture, 214, 224
 blurred with entertainment, 181, 182
 clickers, 177–78
 conflict with technology, 179
 cultural complexity of, 194
 definition of, 195–96
 effective mode of, 187
 efficiency in from students' point of view, 207
 efficiency-oriented culture of, 195
 enthusiasm for technology, 184, 191
 increase in tuition, 175
 inefficiency of technology in, 185–86
 introduction of business models into, 176
 investment in technology by, 175, 217
 need for technological disengagement in, 188
 online (*See* learning management systems)
 and student disengagement, 180–81
 student fees in, 176–77
 underwritten by business, 185
 use of inefficient technology in, 177–78
 use of iPod as recording device in, 204–5
 See also learning; students; universities
education, online. *See* learning management systems
Edwards, S. M., 186
effectiveness
 compared to efficiency, 64
 definition of, 53–54
 and democracy, 64
 of Web 1.0, 55
 of Web 2.0, 62–63
efficiency
 Americans' love of, 270–71
 compared to effectiveness, 64
 definition of, 176
 Ellul on, 275
 gendered paradox of, 350–51
 and ineffectiveness (*See* ineffectiveness)
 of media (*See* media efficiency)
 and modernity, 51–52
 and moral strategy, 273
 need for scarcity for, 61
 negative impacts of, 40
 privileging of, 90
 and rationalization, 51–52, 53
 roots of preoccupation with, 352
 as standard of success, 89
 Taylorism, 24
 tendency toward ineffectiveness, 54
 and time poverty, 357
 and time stress, 357
 vs. busyness, 297
 vs. equality, 64
efficiency, culture of, xiv, 89, 90, 91, 101, 102
egg-freezing, 5
electric/electronic revolution, 82–83
electronic medical records (EMR)
 adaptability of, 130
 case studies of, 131

compatibility of, 129
complexity of, 130
framing of, 133–34
innovation attributes of, 126–31
innovation environment of, 131–33
likelihood of success of, 135, 136–37
observability of, 129–30
relative advantage of, 128–29
resistance to acceptance of, 133–35
trialability of, 129
Ellison, Katherine, 295
Ellison, Louise, 240
Ellul, Jacques, 183–84, 275–76, 360
e-mail as asynchronous interaction, 80
English-Lueck, Jan, 351
entertainment, education blurred with, 181, 182
environment, 20–21, 30–31, 33–34, 272
equality, 64
evacuation plan, Americans with Disabilities Act, 246
Eve, Juliet, 181
evolution, 362

failures, mandated, 135–36
Families and Work Institute, 287
family size, 24
fast food
 efficiency in, 39–40
 glocalization of, 27–28
 in Japan, 43
 opposition to, 27
Fast Food Nation (Schlosser), 31
fasting, 92, 93–94
fasts, media/Internet, 92, 94, 95
fasts, non-gastronomic, 92–93
 See also media/Internet fasts
fatherhood, fractured, 12
fear, 316
feminism, 340–41
Fine, John, 147
Finn, Jerry, 240
Fisher, Bonnie, 240
Fitzpatrick, Colleen, 247, 248
Fleming, Sandford, 100
flexibility, 323–24, 327, 328
flexibility willingness, 333
flexplace arrangements, 346–47
Flores, Heather Coburn, 32
Foehr, Ulla G., 143, 150–51, 153

folksonomies, 62–63
food
 efficiency of in Japan, 43
 globalized marketplace of, 28
 local, 29–31
food, fast. *See* fast food
food, prepared, 26
food insecurity, 21, 35
Food Not Lawns (Flores), 32
food preparation
 effects of industrialization on, 23
 effects of on environment, 20–21
 efficiency in (*See* fast food)
 efficient, 22
 philosophies of, 26–27
 sustainability in, 22
 See also kitchen
food production
 and architecture, 34
 edible landscapes, 31–32
 effects of on environment, 21
 efficiency in, 21–22, 27, 28–29, 34
 farming, difficulties of, 32–33
 and food insecurity, 35
 globalization of, 30
 guerilla farming, 32
 kitchen gardens, 30–31
 local, 29–32
 precariousness of, 33
 societal attitudes toward, 31–32
 sustainability in, 27, 28–29
Foucault, Michel, 75–76, 89
framing, definition of, 125
Franklin, Benjamin, 352
Fraser, Cynthia, 241
French, Sally, 160–61, 163
Frey, Thomas, 315–16
Friday, 93
Frieze, Irene, 237
Fugate, Mel, 326
future
 anxiety about, 314–15
 cynicism toward, 317
 fear of, 315–16
 healthy perspective on, 319–20
 optimistic vision of, 313–15
Future Shock (Toffler), 314
futurism, definition of, 319

gadgets, kitchen, 25–26

Index

Gandhi, Mahatma, 92
gender
 and division of domestic responsibilities, 350–51
 and engagement with technology, 339–40
 identity and work, 347
 relationship with technology, 13–14
 role convergence, 344, 345, 346, 351
 and technology, theories of, 340–41
 and work-life balance, 340, 341
gender roles
 convergence of, 344, 345, 346, 351
 technology's reproduction of, 339
Generation M, 286, 292
Generation Y, 180
Gerber, Elaine, 158, 163
Giddens, Anthony, 352
Glaser, Mark, 94
global warming. *See* environment
glocalization
 explanation of, 40–41
 of McWrap, 44
goals, implied by efficiency, 61
Goldberg, Melvin, 147
Grabowski, David, 301
gratification behavior, 252
greenhouse gases, 20–21
Greenspan, Alan, 175
Grodzinsky, Frances, 241
Gropius, Walter, 24
groups
 and communication, 25
 and gratification behavior, 252
group vitality, 253
guerilla farming, 32

Haeg, Fritz, 32
Halberstam, Judith, 164
Hall, Douglas T., 328
Hall, Edward T., 342
Hallowell, Edward, 291–92
Hanh, Thich Nhat, 293
Hansen, Leif, 88, 89
Harward, Donald W., 180
Harwood, Jake, 252, 253
Hassan, Robert, 81
health and boundaries, 333
healthcare. *See* electronic medical records
hearing impaired. *See* disabled people

hedonic pricing, 174–75
Henry, Jules, 79
Heppner, Cheryl, 254
Hersh, Richard H., 180–81
Heschel, Abraham Joshua, 98
Hitchcock, Jayne, 238
Honda, Bill, 254
Honoré, Carl, 286
Hopp, Steven L., 29
Horvath, A., 226
Howes, Oliver, 237
humans, 63
Hurricane Katrina
 complications of assisting disabled people during, 246, 256
 evacuation behavior during, 248
 non-English speakers in, 258
 racial difference in deaths during, 252–53
 See also disaster; disaster communication; disaster preparedness/planning
Hutchinson, Martin, 175
Huygens, Christiaan, 75
hyper-individualism, 12, 14

ICT-mediated work-life interrelationships
 case studies of, 343–50
 effects on children, 352
 and gendered paradox of efficiency, 350–51
 and gender identity, 347
 and managing multiple roles, 348, 350
 See also telecommuting; work-life balance
identity, commercialization of, 85
identity, cultural, 41
ilkone, 95–96
In a Queer Place and Time (Halberstam), 164
industrialization, 23
ineffectiveness
 and effectiveness, 53–54
 of Web 1.0, 58–59
 See also effectiveness
inefficiency and humans, 63
infertility, 6
inflation, difficulty in comparing rates of, 174–75

information, rise of, 72
information economy, 100–101
innovation
 in business processes, 106
 demands of keeping up with, 318–19
 factors in implementation of, 125, 126
 framing of electronic medical records, 133–34
 innovation environment, 131–33
 mandated failures, 135–36
 motivation for implementation of, 125
 pace of, 318, 362
 squeezed successes, 135
 success of implementation of, 135
innovation attributes, 126–31
innovation environment
 definition of, 125
 of electronic medical records, 131–33
Innovation Profile, 126
In Praise of Slowness (Honoré), 286
intentionality, 194, 208
Interbeing (Hanh), 293
Internet
 accessibility of, 160
 access to in buses, 303–4
 addiction to, 187, 362
 and capitalism, 56, 57, 58
 control of, 56, 58
 dot-com bubble, 56, 59
 home broadband access, 322–23, 329
 interaction on, 57 (*See also* Web 2.0)
 kosher, 96
 and late modernity, 54
 and optimism about future, 315
 popularity of among deaf/hearing impaired, 258
 and postmodernity, 54
 and strength of boundaries, 329–31
 ubiquity of, 322–23
 utility of, 323
 See also Web 1.0; Web 2.0
Internet/media fasts, 92, 94, 95
inventory, tracking of. *See* Radio Frequency Identification (RFID)
iPods
 purposes used for, 198–99
 as recording device, 204–5
 social uses of, 203
 See also mobile learning
irrationality, 63–64
Islam
 Jama'ah, 93
 use of smart phones in, 95–96
Ito, Mizuko, 42

Jackson, Maggie, 342, 351–52
Jama'ah, 93
Japan
 and efficiency, 42–43
 fast food in, 43 (*See also* McWrap)
 and glocalization, 41
 impact of efficiency on, 40
 "just in time" system, 52–53
 ketai culture in, 42–43, 45
 multitasking in, 48–49
Jeong, Se-Hoon, 153
Jobs, Steve, 175
Jordan, Amy, 143, 151
journalism
 closeness to technology, 268
 declining zeal for, 180
 efficiency in, 268, 273–74
 and government, 270
 low public esteem for, 267
 and morality, 266, 269, 272
 muckrakers, 270–71, 272
 objectivity of, 268–69
 and religion, 272
 and scientific methodology, 269–70
 as social science, 266
 teaching of, 273
 techniques for efficiency in, 269–70
 See also media
journalism, public, 276–78
Judaism
 Sabbath in, 93
 use of cell phones in, 96
"just in case" system, 52
"just in time" system, 52–53

Kabat-Zinn, Jon, 294, 297
Kailes, June Isaacson, 250
Kaiser Family Foundation, 150, 286, 292
Kanter, Rosabeth Moss, 136
Katz, Elihu, 127
Kazmierczak, Jeff, 128

Index

Kelan, Elisabeth K., 340
ketai culture, 42–43, 45, 47–48
Kilker, Julian, 226
Kimball, Jay, 88
Kingsolver, Barbara, 32, 33
Kirchner, Corrine, 160
kitchen, history of, 22–25
kitchen gardens, 30–31
Kleinman, Sharon, 322, 360–61
Klimor, Tagit, 34
Knafo, David, 34
Kourik, Robert, 31
Krashen, Stephen, 223
Kreiner, Glen, 326
Kunstler, James Howard, 35

Lair, Daniel, 14
Lake, Ricki, 11
landscapes, edible, 31–32
Langhinrichsen-Rohling, Jennifer, 236
language in disaster preparedness/planning, 250, 256–58
Language Line Services, 256
Layne, Linda, 7, 9–10
learning
 context-free model of, 192 (*See also* mobile learning)
 efficiency in, 207
 and multitasking, 292
 See also education
learning, mobile. *See* mobile learning
learning, online. *See* learning management systems
learning management systems
 accessibility of, 217
 commercial *vs.* open-source, 225–26
 description of, 213–14
 development of, 214
 emphasis on technological features, 223
 feedback and flow in, 218–19
 inconsistencies in, 219–20
 lack of literature on design of, 216–17
 lack of pedagogical perspective in design of, 223, 225
 need for instructors' involvement in design of, 214
 need to design useable interfaces, 224–25
 need to include people in design of, 224
 nonscaffolding interface of, 220–22
 responses to usability analyses, 222–23
 standardization of, 212–13
 usability of, 215, 217–22
"Learning to Leisure?" (Eve and Brabazon), 181
Lee, Rebecca, 232
Leibenstein, Harvey, 63
Leisring, Penny, 233, 235
leisure time
 blurring with work time, 286
 and commercialization, 85–86
 in culture of efficiency, 90
 decline of, 79, 164, 357
 separation from work, 100, 101
 vs. free time, 84–85
lesbians, as mothers, 15–16
Leukefeld, Carl, 235
Levitt, Theodore, 41
Levmore, Saul, 186
Lewis, Suzan, 341, 342
libertarianism, 56, 57, 59, 60
Lieberman, Joe, 258
Lippmann, Walter, 277
loans, student
 ability to repay, 179–80
 outsourcing of, 182
 See also debt, student
locavores, 29–31
Logan, Robert, 125
Logan, T. K., 235, 236, 238
Longwell, Warren, 313

Maccoby, Eleanor, 147
Magagna, Victor, 53, 64
marketing
 and cultural differences, 41
 as cultural norm, 182
 and glocalization of food, 27–28
marketing, guerilla, 185
Martin, Joanne, 6
Marx, Karl, 164
mash-ups, 102
maternity leave, 287–88
Matthews, Russell, 327, 328, 329
McDonaldization, 39–40, 274–75
McDonald's

and cultural differences, 41
entrance to Japanese society, 40
introduction of McWrap to Japan, 44–48
Snack Wrap in U.S., 43–44
McDonough, William, 33
McLuhan, Marshall, 76, 82–83, 84–85, 362, 363
McPhee, William, 147–48
McWrap, introduction of to Japan, 44–48
Mechanic, Mindy, 236
media
as bound to time, 79–80
disadvantaging of subordinate groups by, 253
and drives toward asynchronicity, 80–81
and fear, 316
low public esteem for, 267
social dominance through, 253
time spent with, 286–87
uses and gratification, 252–53, 259
See also journalism
media, personal
and multitasking, 149
See also iPods
media efficiency, resistance to, 267
media gratification interactions, 252
media/Internet fasts, 92, 94, 95
media multitasking
definition of, 143
increase in, 142–43
by young people, 287, 292
See also multitasking; simultaneous multiple media use
Medrich, Elliott, 148
Meisner, Craig, 33
Meloy, J. Reid, 240
Mennonites, 91
menopause, predicting, 6
Messias, DeAnne, 9
Metzner, Charles, 146
Meyer, Gary, 126, 128
Miceli, Sharon, 240
Middletown Media Multitasking, 152
Mileti, Dennis, 247, 248
Millennials, 180
Miller, Kevin A., 94
Miller, Robert, 131
Miller, Will, 13

Mills, C. Wright, 361
mindfulness
benefits of, 294
definition of, 285, 292
traditions of, 293–94
vs. multitasking, 292–93, 296
minority/marginalized groups
communicative exclusion of, 246
disadvantaging of, 253
exclusion of from disaster preparedness/planning, 260–61
expendability of, 165
representation of in media, 253
See also disabled people
miscarriage, 7, 9–10
mobile learning
adoption of, 193–95
case study of, 196–207
and conception of education, 196
cultural dimension of, 193–95
and cultural frames of reference, 207–8
and efficiency-oriented culture of education, 195
and intentionality, 208
justification of, 192
optional, 197
resistance to, 199–203, 206–7
use of, 198–99
See also iPods
Model of the Theory of Public Risk Communication, 247
modernity, 51–52
modernity, late, 54
Mohr, Lawrence, 125
The Mommy Brain (Ellison), 295
Monge, Peter, 252
Montagu, Ashley, 362
Moodle, 225–26
See also learning management systems
Moore's Law, 175
morality, 266, 269, 272
Morewitz, Stephen, 237, 239
Morrisey, Michael, 301
Morse, Samuel F. B., 318
motherhood, enrichment of brain by, 295
mothers, single, 15–16
muckrakers, 270–71, 272
Mullen, Paul, 238

Index

multitasking
 and age, 153
 and brain, 291
 and changing sensibilities of time, 82
 dangers of, 295
 definition of, 144
 encouragement of by culture, 287
 of entertainment activities (*See* media multitasking; simultaneous multiple media use)
 history of, 145–50
 as ingrained, 295
 in Japan, 48–49
 and kitchen design, 24–25
 and learning, 292
 perceived ability of, 289–92
 and personal media, 149
 pressure for, 90
 prevalence of, 150–53
 and radio, 145–48, 154–55
 reasons for, 152
 research on, 150–54
 and television, 146–48, 150–53
 vs. mindfulness, 292–93, 296
 by young people, 287, 291
 See also media multitasking; simultaneous multiple media use
Mumford, Lewis, 359
Musson, Gill, 342, 345

nagara zoku, 48–49
National Organization on Disability, 246, 256
National Telecommunications and Information Administration (NTIA), 160
National Violence Against Women (NVAW) survey, 234
networks
 in communication, 251–52
 in disaster preparedness/planning, 255–60
"Network Time" (Hassan), 81
A New Earth (Tolle), 296
Nippert-Eng, Christena, 325, 327, 334
Norman, Dan, 219

obesity, 301

observability of electronic medical records, 129–30
Of Time, Work, and Leisure (De Grazia), 72, 86
O'Hair, Dan, 245
Old Order Amish, 91
online learning. *See* learning management systems
oocyte cryopreservation, 5
ovens, 25

paid leave, 287–88
parents, same-sex, 15–16
parking, cost of, 308–9
Parrott, Steve, 176
Pathé, Michele, 238
Pathways to Madness (Henry), 79
permeability, 327, 328, 329
Petersen, Søren, 335
Peterson, Eldridge, 146
Pilnick, Alison, 15
Pimlott-Kubiak, Sheryl, 238
Plain People, 91
plastic surgery, 11
podcasting. *See* mobile learning
Pomona College, 215
Postman, Neil, 86
postmodernity and Internet, 54
predictability, 53
pregnancy
 conception-pregnancy-childbirth timeline, 7–8
 and control, 13
 and hyper-individualism, 12
 and male partner, 3–4, 12
 maternity leave, 287–88
 miscarriage, 7
 monitoring, 8–10
 and plastic surgery, 11
 premature births, 7, 8
 same-sex parents, 15–16
 scheduled C-sections, 10–11
 self-semination, 15
 single mothers, 15–16
 and technology, 5–6
 timing of, 3–4
 and work-life balance, 6–7
presenteeism, 89
procedural definitions, 197
productivity

effects of blurred boundaries on, 323
emphasis on, 164
illusion of and technology, 292
privileging of, 90
relation with flexibility, 323–24
Progressive Era, 270–73
Proust and the Squid (Wolf), 363
public journalism, 276–78
Pucher, John, 301
punctuality, emphasis on, 79

radio and multitasking, 145–48, 154–55
Radio Frequency Identification (RFID)
in complex systems, 117–18
and customized products, 119
description of, 106–8
and efficient compliance, 120
and efficient sharing of resources, 111–12
and empowering collaboration, 115–17
and environmentalism, 118–19
privacy concerns regarding, 120–21
and remote administration, 108–10
and remote querying, 113–14
and removing bottlenecks, 114–15
and security, 112–13
ramayana, 293
rationality, formal, 54, 57, 58, 59, 65
rationality, substantive, 54, 65
rationalization
dimensions of, 52–54
and efficiency, 51–52, 53
formal *vs.* substantive rationality, 54
and modernity, 51–52
reduction of human element, 53
spread of, 40
tendency toward ineffectiveness, 54
Ray, Rachel, 26
reading, 363–64
reflection, 363
reform, social, 23, 24
refrigerators, 25
relative advantage
of electronic medical records, 128–29
of innovations, 127
religion
and journalism, 272
and rhythm, 98

subordination of to technology, 275–76
use of technology in, 95–98
See also fasting; Sabbath-keeping
Resick, Patricia, 236
rhythm
influence of on economic systems, 99–100
society's need for, 98
Richter, Judith, 328
Rideout, Victoria, 150
Rifkin, Jeremy, 360, 361
Ripley, Mike, 147
Rip Slyme, 40, 45–48
Ritzer, George, 39–40
Roberts, Donald F., 150
Roberts, Karl, 236
Robinson, Gail, 238
Rogers, Everett M., 127, 128
roles
convergence of, 344, 345, 346, 351
multiple, 325, 350
reproduction of by technology, 352
Rorty, Richard, 65
Rosen, Christine, 184
Rosen, Jay, 277
Roy, Abhik, 252, 253

Sabbath, explanation of, 93
Sabbath-keeping, 93–94
Sabbaths, technology, 92, 94, 95, 324
sabbatical years, 94
Sabelis, Idis, 163
salaries, starting, 180
samadhi, 294
Sanborn, Frank, 271
Santana, Shannon, 240
scaffolding, 220
Schlosser, Eric, 31
Schumacher, Ernst Friedrich, 31
Schumpeter, Joseph, 56
science, 271
Scott, Robert C., 246
segmentation preferences, 333
self-semination, 15
September 11, 2001, 255, 257
See also disaster communication; disaster preparedness/planning
Shabbat, 93, 97
Shabbos Goy, 97

Index

Shabbot6000, 97
Shannon, Lisa, 236
Sheridan, Lorraine, 234
Shor, Juliet B., 361
Shoup, Donald, 308–9
simultaneous multiple media use
 and age, 153
 definition of, 144
 early, 144–45
 history of, 145–50
 prevalence of, 150–53
 research on, 150–54
 and television, 146–48
sleep, 357
Slow Food movement, 27–29, 91
Slow movement, 92
Small Is Beautiful (Schumacher), 31
smart homes, 96–97
social exclusion, 255
social identity theory, 251
social networking sites, 81
social science
 and addressing of social problems, 272
 journalism as, 266
society
 influence of religion on, 99
 need for rhythm, 98
Sorokin, Pitirim, 143, 145
"Soul Tech" workshops, 89
Southworth, Cindy, 232, 241
Sparks, Glenn, 13
Speed King (Rip Slyme), 47
Spence-Diehl, Emily, 239, 240
spirituality. *See* fasting; religion; Sabbath-keeping
Spitzberg, Brian, 231, 232, 235
stalking
 and abusive relationships, 235–36
 definitions of, 232
 effects of on victims, 238–39
 perpetrators, characteristics of, 236–37
 prevalence of, 234–35
 and violence, 236
 vs. harassment, 232
 See also cyberstalking
Stallings, Ariel Meadow, 94
Starck, Johann Friedrich, 93
Stewart, Raymond, 147
Stivers, Richard, 362
Stout, Claude, 254, 257
stress, environmental, 362
students
 selling to, 181
 treated as customers, 181
 See also education; learning
success, squeezed, 135
Sullivan, Cath, 341, 342
Sunday, 93
surgeries, elective, 10–11
surrogate, using, 6, 15
Surviving Information Overload (Miller), 94
sustainability
 in food production, 27, 28–29
 in transportation (*See* transportation, sustainable)
"Sustainable Technology" workshops, 89
Suzuki, Shunryu, 294

tags. *See* Radio Frequency Identification (RFID)
Taheripour, Mori, 256
Take Back Your Time, 288
tasks, sequencing of, 348
Tavani, Herman, 241
Taylor, Frederick Winslow, 24, 89, 352
Taylorism, 24
Technics and Civilization (Mumford), 359
technofeminism, 341
The Technological Society (Ellul), 275
technology
 as autonomous system, 183–84
 benefits of for disabled people, 158–60
 conflict with education, 179
 dark side of, 313
 and disaster preparedness/planning, 258
 education's embrace of, 184, 191 (*See also* learning management systems; mobile learning)
 education's investment in, 175, 217
 Ellul on, 275
 environmental saturation by, 317
 and environmental stress, 362
 gender and relationship with, 13–14, 339–41, 352

home broadband access, 322–23, 329
and illusion of productivity, 292
and increased workload, 163
and increase in tuition, 175
inefficiency of in education, 185–86
and intentionality, 194, 208
journalism's closeness to, 268
kosher, 96–97
loss of faith in as savior, 316–17
mobile learning devices (*See* mobile learning)
optimism about, 312–13
power of, 184
pressure of, 88–89
reproduction of traditional gender roles by, 339, 352
resisting pressures imposed by, 92
and role convergence, 351
speed of, 362
student debt due to, 177, 180
and student disengagement, 180–81
subordination of religion to, 275–76
ubiquity of, 322–23
used to meet religious needs, 95–96
used to provide the illusion of less technology, 97–98
utility of, 323
and work-life balance, 340, 341
technology, assistive
 barriers to, 159
 benefits of, 158–60
 compared to accessibility, 162–63
 compared to human assistance, 161
 cost of, 161–62
 drawbacks of reliance on, 160–61
 lack of accessible documentation for, 159
 laws regarding, 159, 160
 need for access to, 160
 time required for, 163
technology, digital. *See* digital technologies
technology, reproductive
 opting out of, 15
 overreliance on, 12–13
 and prenatal bonding, 8–9
 and socioeconomic status, 14
"The Technology Paradox" (Edwards), 186
technology Sabbaths, 92, 94, 95, 324

telecommuting, 309–10, 341
 See also ICT-mediated work-life interrelationships
telegraph, 72, 76, 318
television
 interaction with, 149–50
 and multitasking, 146–48, 150–53
termination (job) and pregnancy, 8
textbooks, coupled with clickers, 177–78
Tietze, Susanne, 342, 345
time
 Aristotle's definition of, 74
 and asynchronous interaction, 83
 capitalistic administration of, 164
 changing sensibilities of, 82
 in communication research, 155
 and decline of leisure time, 79
 disabled people's relationship to, 163, 164–65
 and drives toward asynchronicity, 80–81
 effects of synchronization of, 72–73
 and emphasis on punctuality, 79
 experience of at home, 342
 experience of at work, 342
 gendered orientation of, 342–43
 influence of religion on notions of, 99
 meaning of, 359–60
 measuring, 100
 media as bound to, 79–80
 modern sensibilities of, 77
 and multitasking, 82
 payment for, 79
 poverty of, 288, 357, 361
 and reading, 363–64
 and reflection, 363
 as social construct, 100
 and social networking sites, 81
 standardization of, 100
 studies of distribution of, 145
 subjective measuring of, 74
 synchronized, 72–73, 77–78
 transformation of by electricity, 72
 in workplace accommodation, 163
 See also rhythm; timekeeping
time, leisure. *See* leisure time
time, work, 79, 286
 See also work-life balance

Index

Time-Budgets of Human Behavior (Sorokin and Berger), 143
timekeeping
 early methods of, 74–75
 See also clocks; time
time poverty, 288, 357, 361
time robbery, 164
time stress, 357
Time Wars (Rifkin), 360, 361
time zones, 76–77, 100
Toffler, Alvin, 314
Tolle, Ekhart, 296
traffic calming, 302–3
transportation, sustainable
 bicycle technology, 305–7
 car-free living, 307–8
 explanation of, 300
 and financial disincentives to drive, 308–9
 improving public transit, 303–5
 need for traffic calming, 302–3
 planning routes, 302
 rideshare matching, 307
trialability of electronic medical records, 129
Tucker, Sarah, 232, 241
tuition increase, 175
The Twentieth Century (television series), 314
Twenty-first Century Communication and Video Accessibility Act, 160

ultrasounds, 9
universities
 innovative transit technologies at, 304
 See also education
Unplugged (Stallings), 94
usability
 of classrooms, 214
 of learning management systems, 215, 217–22
 and work-arounds, 222–23
USA Today, 274–75

vacation, 287
Vanagunas, Stanley, 63
Van Dijk, Jan, 251, 252
Veksler, Alice, 232
Veterans Administration (VA), 134
video games, 62
Vygotsky, Lev, 223

Wajcman, Judy, 340–41
Walker, Bob, 235
Walker, Donna, 95
walking. *See* transportation, sustainable
Wal-Mart, 29
watches, 72, 77
 See also clocks; time
Waters, Alice, 26
Watts, Alan, 78
Weaver, Terri, 236
Web 1.0
 definition of, 55
 effectiveness of, 55
 efficiency of, 55, 57, 58, 59
 formal rationality of, 54, 57, 58, 59
 ideology of, 56
 ineffectiveness of, 58–59
 substantive rationality of, 65
 user experience on, 57–58
Web 2.0
 definition of, 55
 effectiveness of, 62–63
 efficiency of, 60–62, 63
 empowerment of humans in, 63
 equality in, 64
 ideology of, 57
 substantive rationality of, 54, 65
 and time, 81
 user-generated content on, 59–60
 Wikinomics of, 57
WebCT. *See* learning management systems
Weber, Max, 51, 54, 58, 63, 64, 352
White, E. B., 313, 317
"Why Do We Fear the Future" (Frey), 315–16
Wikinomics, 57
Winner, Lauren, 93
Wolf, Maryanne, 363
women. *See* gender; pregnancy
Woodruff, Allison, 97
work
 and appeal of abstinence from technology, 101
 balance with non-work, 334
 in culture of efficiency, 90

and diminishment of leisure time, 164
employment of disabled people, 160, 165
and experience of time, 342
and gender identity, 347
from home, 341–42 (*See also* telecommuting)
in information economy, 100–101
paid leave, 287–88
performed within domestic boundaries, 345
separation from leisure, 100, 101
setting expectations for, 334–35
telecommuting, 309–10
time spent at, 288
See also work-life balance

work-arounds, 222–23

work-life balance
and gender and technology, 340, 341
and pregnancy, 6–7
and termination, 8

work time, 79, 286
See also boundaries; work-life balance

World's Fair (1939), 313, 317
World's Fair (1964), 314
World War I, 313
World War II, 314

x-inefficiency, 63

yoga, 288–89, 293–94
See also mindfulness
Yoga Journal, 289
The Yoga Sutra of Patanjali, 293–94
Youens, Liam, 238
YouTube, 81

Zen, 294